Classic Essays on Photography

CLASSIC ESSAYS ON PHOTOGRAPHY

Edited by Alan Trachtenberg

Notes by Amy Weinstein Meyers

Leete's Island Books New Haven, Conn.

Foreword and Notes © 1980 by Leete's Island Books, Inc.
Library of Congress Catalogue Card Number: 78-61844
ISBN: 0-918172-07-1 (cloth); 0-918172-08-X (paper)
Published by Leete's Island Books, Inc., Box 1131, New Haven, Connecticut 06505
Manufactured in the United States of America
Designed by Susan McCrillis Kelsey

The following articles have been reprinted with permission:

"Photography at the Crossroads," by Berenice Abbott, from *Universal Photo Almanac 1951*, with permission of Berenice Abbott.

"Report,' by Dominique François Arago, from *History of Photography*, by Josef Maria Eder, with permission of Columbia University Press.

"Rhetoric of the Image," from *Image, Music, Text*, by Roland Barthes, with permission of Farrar, Straus and Giroux, Inc.

"The Modern Public and Photography," by Charles Baudelaire, from *Art in Paris 1845–1862*, with permission of Phaidon Press, Ltd.

"The Ontology of the Photographic Image," from *What Is Cinema?*, by André Bazin, © 1967 by The Regents of the University of California; reprinted by permission of the University of California Press.

"A Short History of Photography," by Walter Benjamin. Aus "Gesammelte Schriften" © Suhrkamp Verlag, Frankfurt am Main 1977. Trans. by P. Patton, reprinted from *Artforum*, vol. 15, Feb. 1977.

"Understanding a Photograph," from *The Look of Things*, by John Berger, with permission of the author.

"Five Notes for a Phenomenology of the Photographic Image," by Hubert Damisch, reprinted from *October 5, Photography: A Special Issue*, Summer 1978, with permission of The MIT Press.

"The Reappearance of Photography," by Walker Evans, from *Hound and Horn*, vol. 5, no. 1, 1931, with permission of the publishers.

"New Reports and New Vision: The Nineteenth Century," from *Prints and Visual Communication*, by William M. Ivins, Jr., with permission of Da Capo Press, Inc., and Routledge and Kegan Paul, Ltd.

"Photography," from *Theory of Film: The Redemption of Physical Reality*, by Siegfried Kracauer, © Oxford University Press, Inc. 1960. Reprinted by permission.

"Photography," from *Painting, Photography, Film*, by Laszlo Moholy-Nagy, with permission of Lund Humphries Publishers Ltd.

"Memoire on the Heliograph," by Joseph Nicéphore Niepce, from *History of Photography*, by Josef Maria Eder, with permission of Columbia University Press.

"Mechanism and Expression: The Essence and Value of Photography," by Franz Roh, reprinted from *Photo-Eye: 76 Photos of the Period*, edited by Franz Roh and Jan Tschichold, with permission of Juliane Roh.

"The Centenary of Photography," from *Occasions*, vol. 11 of *The Collected Works in English*, Paul Valéry. © 1970 by Princeton University Press. Reprinted by permission of Princeton University Press and Routledge and Kegan Paul, Ltd.

"Seeing Photographically," by Edward Weston, from *Encyclopedia of Photography*, vol. 18, with permission of Singer Communications Corp.

Contents

Introduction

Alan Trachtenberg

A common lament among photographers and their admirers is that the medium lacks a critical tradition, a tradition of serious writing. It is true that photography has seemed to inspire as much foolishness in words as banalities in pictures, and especially true that we cannot name a single writer of significance who has devoted himself or herself entirely to photographic criticism and theory. We do have a body of scholarship concerning the history of the medium, but photographic historians have rarely concerned themselves with aesthetics, or with the presuppositions governing their own notions of the field. In general, histories have provided either compilations or, on the model of conventional art history, connoisseurship. There has been little notable effort to address the medium itself, to examine its evolving character, its social and cultural properties, its complex relations with other media, and the great variety of roles it performs. Partly, although historians especially should know better, the cause of such neglect lies in the assumption that photography is unitary, a single method of making pictures, a unique visual language. On the whole, histories have passed over critical differences — of mode, of style, and even of communicative "language" — that have developed among the many quite sundry practices of photography. And insofar as a "practice" is governed by the social structure within which it occurs, photographic history has also ignored (by and large) the significant social history of the medium.

Just as noteworthy is a neglect of the *intellectual* history of the medium, a history of ideas about photography. For in spite of the fact that we cannot point to a truly substantial body of writing — comparable in any way, for example, to literary or art criticism — we can document a record of *thinking* about the medium. Of course it is impossible to separate thinking from acting; in any practice of photography, in any single picture produced by a camera, there is already an idea of the function, the character, the limits of the medium. A true intellectual history of photog-

raphy would be identical with a social and cultural history: a history of practices and the ideas that inform them. At the same time, it is perfectly legitimate to take "ideas" in the formal sense, as written expressions, and thus to document a record of writing alone. To have the full flavor and force of any particular piece of writing, we should know something about its origins, its occasion, and the historical moment traceable in its argument. A collection of essays may tend to mislead the reader if it pretends to a unity and continuity that in fact do not exist. In the field of photographic writing we cannot always be certain that writers have been aware of earlier work. We have not as yet witnessed a true community of writing, in which individuals engage with each other, criticize or complete the production of others, pose issues to be taken up again, stake positions, take stands. Something of this sort may be said to have appeared in embryonic form in the nineteenth-century journals, and carried on with high promise for a few years in Alfred Stieglitz's *Camera Work*. But in no case has it persisted or produced a collective intelligence regarding the medium.

But there are signs that such intelligence is indeed beginning to emerge, that the seriousness of the photographic medium is gaining wider recognition. The need for a history of ideas is all the more pressing, then, and this collection is offered as a modest contribution. It makes no claims for thoroughness or completeness. The selections are representative of "moments" in the development of thought about the medium in Western societies (France, England, Germany, the United States). A number of the essays are familiar landmarks, touchstones of significance (Baudelaire, Strand, Benjamin); others are less familiar, some reprinted for the first time. But the chief aim of the volume is that, assembled together, these works might serve to awaken a latent critical interest in students of the medium, as well as in serious photographers, who have much to gain from knowledge of whatever tradition already exists. Thinking can proceed only through criticism, and only through an alert, knowing criticism of existing ideas can new ideas, new practices, be born.

It will be helpful to read this collection as a continuing debate and investigation. With its official appearance in 1839 (the first known photograph was made about a dozen years earlier), photography sprung into being at a time of change and unrest in

viii

Western society. The early nineteenth-century was still the "age of revolution," still vibrating to tremors released by the great political and social revolutions in France and America just a generation earlier. The selections by Niepce, Daguerre, Arago, Talbot, Eastlake, Poe, Baudelaire, and Holmes must be read against a background of vast changes in society and in culture: rapid industrialization, the spread of railroads across Europe and the North American continent, an accelerated concentration of previously rural peoples in urban centers, and a growing stratification of society into groups of workers, shopkeepers, professionals, and a small number of industrial magnates. Expanding cities and the incessant application of machinery to the production of goods are perhaps the most important historical events that impinge upon the earlier discussions of photography, for the medium represented to its earliest commentators both science and communication: a decidedly *modern* device, a sign and prophecy of changing times. In photography the earliest writers saw a testimony to the genuine radicalness of an age of railroads, the telegraph, and mass production — an age of wondrous science and technology.

The earliest writers spoke of photography in the broadest sense. They took it as a new medium of communication, an application of science to the making of pictures, as a veritable symbol of revolution and progress. They recognized its link to other new media of communication, and to the shifts in population toward the city and its consequent enlargement of the market for pictures. No one questioned the appropriateness of calling the photograph a "picture." It developed, after all, within an existing apparatus — the camera obscura and its corrected lenses — associated with the making of perspectival pictures. The earliest terms of discussion of the photograph were terms used in regard to any picture. And the difference seemed to lie only in the making with infinitely greater speed and accuracy of the same kind of image — as far as verisimilitude was concerned — that painters and printmakers wished to achieve: an image of "reality." The oft-repeated remark by the French painter Delaroche that "from today painting is dead" meant only that a machine had appeared which could accomplish, in detail work at least, what had taken long practice and skill to achieve by hand.

But was it "art"? The next stage of discussion, represented

here by Robinson, Emerson, and Stieglitz, brought into focus the question that has continued to bedevil thinking about the photograph. Beginning as a High Victorian debate, the question was further complicated by a larger discussion of the meaning of "culture," which had particular force in England, less in America. The differences in the issues posed by writers on photography arose from differences in the actual development of the medium in the two countries. In England, legal restrictions hampered the commercial viability of the Daguerreotype, while in America that early form of the photograph (produced without a negative, as a unique image) flourished. The Daguerreotype established the portrait studio as a prominent commercial enterprise as early as the 1840s, and by the 1850s, with the invention of the wet-plate negative process, such studios often came to resemble assembly-line factories. The new process made production of paper prints feasible on a large scale, and American entrepreneurs exploited the potential for mass mechanical reproduction of a new variety of images on stereo-cards: landscapes, cityscapes, homes of the famous, national monuments, natural landmarks, virtually everything under the sun.

Of course almost identical patterns of production and distribution of a new world of images appeared in Europe and England as well, but with a significant difference. The earliest photographers of prominence in Great Britain seem to have been well-to-do amateurs, people interested in art as well as science. The Royal Photographic Society emerged early, giving a national focus to serious amateur work. Moreover, the great strength and influence of the Royal Academy and other institutions of "fine art" placed amateurs in a peculiar position. Many strived for "beauty" in their pictures, wishing to find a place for the photograph within the realm of the arts. But such a realm seemed founded upon a key principle in the larger idea of "culture," that art distinguished itself from science and industry by its special qualities of "spirit." And if "spirit" was marked by a certain organization of feelings and sensibility — the mark of "tradition" and personal "genius" — then how could one achieve true art by use of a mechanical device?

The idea of culture in whose ambience the Victorian debate about photography took place assumed a deep division within

modern society, between "work" (including industry, business, commerce, trade) and "art." And indeed major photographic activities during the last decades of the nineteenth-century displayed a corresponding separation. On one hand, amateurs pursued the "pictorialism" advocated by Robinson and modified by Emerson: with all their differences of outlook regarding the science of vision and the forms of art, both agreeing that photography must lay a claim for itself as a fine art. On the other hand, commercial practice continued, creating its own vernacular in popular portraits and in views. In addition, with advancements in the technology of photography — hand-held cameras, faster films, roll films, faster lenses — a new consideration emerged: documentation. Social investigation through photography appeared at a time (the 1890s) of sharpening cultural contrasts and conflicts and, linked to the invention of a viable half-tone process for unlimited reproduction of images in newspapers and periodicals, soon took the form of "journalism." Thus the medium seemed more and more to revel in its sheer mechanicalness, and in spontaneous pictures of the mundane, the quotidian, that held nothing in common with "art."

Amateur pictorialism then took a turn which assured, if only by severe reaction to itself, a radical break in the concept of an *art* of photography. In societies across England, Western Europe, and America, pictorialists eschewed the modern and adopted a beaux-arts definition of "beauty" as formal landscapes, nudes, still lifes, posed and studied compositions. Moreover, it also cultivated an archaic look: employing brushwork, engraving tools, dies, soft-focus lenses, it sought the appearance of a hand-made painting or print. In revulsion against these excesses, the modernist movement in photography was born, though that movement, represented here in its early stages by Stieglitz and Strand, retained some of the signs of "pictorialism" in its continuing emphasis upon the art motive. The shift in thinking about photography in amateur circles coincided with the appearance of the serious art photographer as a new social figure, a role defined and characterized early in the twentieth century by the career of Alfred Stieglitz. Through his example, younger figures like Strand, Weston, Adams, and numerous others came to recognize themselves as "artists in

photography" without apology or embarrassment. They came to see themselves as modernist visual artists in a medium that possessed its own internal validity.

But the break from amateur pictorialism among the most articulate art photographers did not produce consensus about the character and potential (social as well as aesthetic) of the medium. The idea of the "straight photograph" (unmodified by hand-work, exacting in its clarity of detail and sharpness of rendering in the print) lent itself to several interpretations. In some cases, a transcendental spiritualism adhered to the idea of the "pure" photograph; in Stieglitz and Weston, for example. In other cases — Paul Strand — clarity of image provided the best opportunity for the expression of a personal vision or "genius." For Lewis Hine, the "straight photograph" connotated accuracy and social honesty. For still others, the photograph represented a way of altering conventional vision altogether, wrenching it into new perspectives and opening new means of experience; thus, for Moholy-Nagy and Man Ray, the camera was the modernist instrument *par excellence*. And finally, for Walker Evans, the approach was a synthesis of documentation and experiment within the immediate cultural setting, of objectivity of report and subjectivity of feeling — a still further break from prior notions of what a photograph should look like.

It is worth noting that many of the writers contributing to the serious discussion of the medium have been photographers themselves. This link between idea and practice suggests a major cultural fact about the medium: its problematic status within the territory and hierarchy of objects and actions mapped by culture. Working photographers, especially those venturing outside the established, institutional roles of commercial practice, have felt a need to explain and justify, indeed to explore for themselves in words, the meaning of their work. Weston's record of the place of photography in his daily life, his *Day-Books,* is a unique example. Weston's writings also point to a special affinity between photography and literature. It is remarkable that so few visual artists have written as well and as intelligently on photography as have Poe, Baudelaire, Valéry, and many others not represented here (Hawthorne, Dickens, Henry James, Dreiser, James Agee). A number of writers also practiced photography with some earnestness: among them Lewis

Carroll, Emile Zola, and Wright Morris. A history of photographic criticism must take into account the important and largely uninvestigated transactions between photography and formal literature.

But the predominance of the photographer-writer in the critical tradition is not without ambiguous effect. Each has had to invent a rationale from the intellectual material of the moment, and yet we have looked to them for insight into the medium as a whole. A *formal* criticism, a set of analyses and arguments which attempts to delineate a general character of the medium, has yet to emerge. The canons of art history, of connoisseurship, are not likely to provide the necessary model. It is in the more venturesome and intellectually aggressive works of *cultural* critics like Walter Benjamin, William Ivins, and Roland Barthes that the beginning of a new seriousness of discussion, a synthesis of historical scholarship and aesthetic theory, might be found. Susan Sontag's recent collection of essays, *On Photography*, draws abundantly on these figures and suggests the kind of alliance of aesthetic, cultural, and political concerns criticism now requires. What we find in the concluding essays presented here is a broad, promising freedom of reference; the critic commonly aims at identifying the social and cultural work of the medium, not as "art," but wherever it is found. Particularly, as Barthes and John Berger make manifestly plain, the medium must be recognized as exercising a powerful kind of persuasion as a carrier of ideological messages in everyday life. And it is evident that any new developments in photographic criticism will require that critics take into account the communicative power of the photographic image, its "language," its "meaning," and the relevance of that meaning to our world.

Part One:
The Early Nineteenth Century

Joseph Nicéphore Niepce (1765–1833), Louis Jacques Mandé Daguerre (1787–1851), and Dominique François Arago (1786–1853)

From the Renaissance through the nineteenth century, Western man progressively developed techniques for making images to represent his visual experience of the world. By the early 1800s, Europeans were attempting to create the most convincingly illusory pictures without the interference of man's subjective hand. From experiments that produced images by reflecting light from objects onto a chemically sensitized surface emerged a revolutionary pictorial medium: photography. During the late 1820s, the wealthy French inventor Joseph Nicéphore Niepce and his brother Claude made trials with a camera obscura and sensitized paper to produce pictures for a hot-air, engine-powered lithography press they had designed. These first experiments resulted in tonally reversed pictures, known today as negatives. While testing various light-sensitive substances to produce normal pictorial shades, Joseph discovered a process that printed positive prints from negatives, but the technique was prohibitively time-consuming and yielded unacceptable images. At last, he found that a certain kind of bitumen, or asphalt, usually soluble in lavender oil, became insoluble when exposed to light. He covered a pewter plate, sensitized with bitumen, with a translucent engraving, exposed the "sandwich" to light, and then washed the plate with lavender oil. The area exposed to light was rendered insoluble, whereas the area hidden by the engraving's lines washed away. The picture was still tonally reversed, but the plate could be etched to create a positive print. Niepce next applied this technique to outdoor scenes reflected through his camera.

Simultaneously, Louis Jacques Mandé Daguerre, entrepreneur and creator of the spectacular Parisian Diorama, was also searching for a way to produce the most illusionistic images from reflected light. A mutual acquaintance, the engraver Lemaitre, put Joseph Niepce in touch with Daguerre. In the summer of 1827, when Claude Niepce fell ill in England, Joseph traveled to visit him and took advantage of a passport delay in Paris to meet with Daguerre, and the two exchanged ideas on heliography. Daguerre himself had not discovered a successful pictorial process, but he nevertheless impressed Niepce with his knowledge of making sun pictures. Daguerre also possessed fine cameras that Niepce needed for sharper, faster exposures in his experiments. In 1829, on his return to France, Niepce resumed his correspondence with Daguerre and convinced him to enter into a partnership.

3

When Niepce died in 1833, his son Isidore took his place in the cooperative efforts with Daguerre. By 1837, Daguerre had modified and perfected Niepce's process enough to produce a highly detailed, positive picture of a corner of his studio. He considered the technique his own invention and labeled his pictures daguerreotypes. Isidore reduced his own portion of the partnership. Daguerre demonstrated the daguerreotype process to the director of the Paris Observatory, the scientist Dominique François Arago. Excited by what he saw, Arago lectured on the technique to the Academy of Sciences on 7 January 1839, recommending that further investigations be carried out. A few months later, the Chamber of Deputies and the Chamber of Peers heard reports by Arago and Joseph Louis Gay-Lussac in support of a bill proposing that the government buy the daguerreotype process. Daguerre was granted 6,000 francs per annum, and Isidore Niepce, 4,000, for a complete history and description of the invention, as well as an outline of the workings of Daguerre's diorama.

Public excitement ran high as Parisians examined the daguerreotypes on display at the Chamber of Deputies. On 19 August 1839, Arago described the technical details of the process to an open meeting of the Academy of Sciences and the Academy of Fine Arts, and in September Daguerre demonstrated the procedure to an eager audience. He polished and cleaned the silver-coated side of a copper plate, which he then coated with iodine to form a layer of iodide of silver. The plate was placed in a camera obscura before the window and exposed to the Tuileries, the Quay, and the Seine. After fifteen minutes, the blank plate was removed, and hot mercury globules were fumed over the surface. It was next washed with distilled water or hyposulphite of soda, and a clear, minutely detailed picture of the scene appeared.

Daguerreotypes immediately became popular, though two major problems were pointed out from the start: the mirrorlike surface of the daguerreotype distracted the viewer, and multiple prints could not be struck directly from a single image. Reproductions could be produced only by taking individual daguerreotypes of the original. Though, initially, exposure times were too long to make portraiture practicable, this hindrance was soon removed by frenzied daguerreotypists experimenting in Europe and America. Only in England, where Daguerre had taken out a patent on his invention, did the production of daguerreotypes have a slow start. Until the late 1850s, when the ambrotype did away with the annoying glare of the surface and the paper print solved the problem of reproduction, millions of daguerreotypes were created all over the Western world.

Memoire on the Heliograph

Joseph Nicéphore Niepce

The invention which I made and to which I gave the name "heliography" consists in the automatic reproduction, by the action of light, with their gradations of tones from black to white, of the images obtained in the camera obscura.

Basic Conception of This Invention
Light in the state of combination or decomposition reacts chemically on various substances. It is absorbed by them, combines with them, and imparts to them new properties. It augments the natural density of some substances, it even solidifies them and renders them more or less insoluble, according to the duration or intensity of its action. This is, in a few words, the basis of the invention.

First Substance: Preparation
The first substance which I use, the one which makes my process most successful and which contributes more directly to the production of the effect, is asphaltum, or the so-called bitumin (pitch) of Judea, which is prepared in the following manner.

I fill half a glass with this pulverized pitch and then pour, drop by drop, lavender oil on it until the pitch will absorb no more and is entirely saturated with it. Then I pour more of this essential oil on it until it stands three "lignes" above the mixture, which is then covered and set in a place of moderate temperature until the oil is saturated by the coloring matter of the pitch. If this varnish is not of the proper consistency, it is allowed to evaporate in a dish, protecting it against moisture which would modify and finally disintegrate it. This unfortunate result is particularly to be guarded against in the camera during the cold damp season.

If a highly polished metal plate plated with silver is coated with a small amount of this cold varnish, using a very soft leather ball, it gives the plate a beautiful red color and spreads over it in a very thin uniform coating. Then the plate is placed on a hot table which is covered over with several layers of paper, from which the moisture previously has been removed, and when the varnish is no longer tacky, the plate is withdrawn to allow it to cool

5

and permit it to dry completely in a moderate temperature, protected from the influence of the moisture in the air. I must not forget to mention that this precaution is indispensable principally when the varnish is applied. In this case, however, a thin disk is sufficient, in the center of which a short peg is fixed, which is held in the mouth to keep away the moisture of the breath and condense it.

A plate prepared in this manner may be exposed immediately to the action of light; but even after prolonged exposure nothing indicates that an image really exists because the impression remains imperceptible.

It is therefore a question of developing the picture, and this can only be accomplished by the aid of a solvent.

Preparation of the Developer

Since the developer must be regulated according to the result that is to be obtained, it is difficult to determine the proportions of its composition with exactness; but all things being equal, it is desirable that it be a little weak rather than too strong; that which I prefer consists of one part lavender oil and six parts of white mineral oil or petroleum. The mixture, which at first is quite milky, becomes perfectly clear after two or three days. It can be used several times in succession, losing its solvent property only when it approaches the saturation point, which is indicated by the liquid's becoming turbid and dark in color; but it may be distilled and made as good as before.

When the plate or varnished tablet is taken out of the camera, it is placed in a white metal dish an inch deep, and longer and wider than the plate, and a plentiful quantity of this developer is poured in it, covering the plate entirely. When the plate is observed under an oblique light at a certain angle, the image can be seen to make its appearance, slowly and gradually developing, although still darkened by the oil which, saturated more or less with varnish, flows over it. The plate is then taken from the liquid and placed in a perpendicular position, in order that it may be entirely drained of all developer, after which we proceed to the last operation, which is no less important.

Washing the Plate

A very simple arrangement is required, consisting of a board

four feet long and a little wider than the plate. Two strips are nailed on lengthwise, which form a border two inches high. On top is a hinged handle which makes it possible to move the board up and down in order to give the water which is poured on it the required speed. At the bottom is a vessel which receives the liquid flowing off.

The plate is placed on the inclined board and is kept from sliding off by two small nails or hooks, which, however, must not protrude above the face of the plate. At this time of the year (winter) it must be remembered to use lukewarm water. The water is not to be poured upon the plate itself, but on the board, somewhat above the plate in order to obtain a fall sufficient to carry away the last of the oil adhering to the varnish.

The picture is now fully developed and appears perfectly and completely defined if the operation has been successful, especially if one has a perfect camera obscura at one's service.

Uses of the Heliographic Process

Since the varnish can be used with equal success on stone, metal, and glass without necessitating any change of procedure, I shall confine myself to the method of application to silvered plates and glass, calling attention once for all to the fact that in printing on copper a little wax, dissolved in lavender oil, may be added to the varnish mixture without damage.

Until now silvered plates seem to me best suited for the production of pictures, owing to their white color and their nature. It is certain that after washing, assuming that the image is quite dry, the result is satisfactory. It would be desirable, however, to obtain all gradations of tone from black to white by blackening the plate. I therefore occupied myself with this subject, using at first a solution of potassium sulphide (sulfure de potasse); but if a concentrated solution is used it attacks the varnish, and if diluted with water it turns the metal red. This twofold defect compelled me to give up this medium. The substance which I am now using with greater expectation of success is iodine, which has the property of evaporating at ordinary temperatures. In order to blacken the plate by this method, it is only necessary to place the plate against the inner side of a box that is open at the top and to put a few grains of iodine into a groove cut into the opposite side on the bottom of the box.

It is then covered with a glass, in order to observe the result, which, although it shows less rapidly, is all the more certain in its effect. The varnish can then be removed by alcohol, and not a trace will remain of the original impression. Since this process is still quite new for me, I confine myself to this simple description until experience has allowed me to collect more precise details.

Two experiments showing views on glass exposed in the camera obscura have furnished me with results which, although still faulty, seem to me quite remarkable, because this mode of application can be more easily perfected and therefore may become of special interest.

In one of these experiments the light, which had acted with less intensity, had dissolved the varnish in such a manner that the gradations of tones showed more clearly when viewed by "transmission" (i.e., transmitted light), so that the picture reproduced, up to a certain point, the well-known effects of the diorama.

In the other experiment, however, where the action of the light was more intense, the lightest parts, which were not affected by the developer, remained transparent and the gradations of the tones depended entirely and solely on the density of the more or less dark layers of the varnish. If the image is viewed on its varnished side by reflection in a mirror, and held at a certain angle, the effect is greatly enhanced, while if viewed by transmitted light, it appears confused and colorless, and, what is still more remarkable, it seemed to differentiate the separate tones of certain objects. When I considered this curious phenomenon, I believed that I might draw certain conclusions from it, which permitted a connection with Newton's theory of colored rings. It would be sufficient to assume that any prismatic ray, the green for instance, in acting on the substance of the varnish and combining with it, gave it the necessary degree of solubility, so that after the double operation of the developer and the rinsing, the layer which had formed by this method would reflect the green color. Whether this hypothesis is well founded is a matter for future investigation, but the subject seems to me of itself so interesting that it may well deserve further experiments and more exact proof.

Remarks
Although the application of the necessary media described

above undoubtedly offers no difficulty, it may happen (when the procedure is not carefully followed) that in the beginning the operation will not turn out well. I believe, therefore, that it is advisable to start in a small way by copying copper engravings in diffused light according to the following very simple method. Varnish the engraving only on the reverse side to make it thoroughly transparent. When the paper is completely dry, place it face down on the coated plate under a glass, the pressure being modified by inclining the plate at an angle of 45 degrees. By this method it is possible to make several experiments in the course of a day, using two engravings properly prepared and four small silvered plates. This can be done even in overcast weather, providing that the workroom is protected against cold and especially against moisture, which, I repeat, deteriorates the varnish to such an extent that it will float off in layers when the plate is immersed in the developer. It is for this reason that I ceased using the camera obscura during the inclement season. If the experiments which I have described are continued, one will soon be well able to carry out the details of the whole process.

In the matter of applying the varnish, I must call attention again to the fact that it can be used only in a consistency which is thick enough to form a compact yet thin coating, in order that it might resist better the action of the developer and become at the same time more sensitive to the action of light.

In respect to the use of iodine for blackening the images produced on silvered plates, as well as regarding the acid for etching the copper, it is essential that the varnish after washing be used exactly as described above in the second experiment on glass; because it becomes thus less permeable, both in acid and under the iodine vapors, particularly in those parts where it has retained full transparency, for only under these conditions can one hope, even with the best apparatus, to obtain a completely successful result.

Additions

When the varnished plate is removed for drying, it must be carefully protected not only from moisture but also from any exposure to light. In speaking of my experiments in diffused light, I have not mentioned any of these kinds of experiment on glass. I add this in order not to omit a specific improvement which relates to them. It consists simply in placing a piece of black paper

9

under the glass and in putting between the metal plate on its coated side and the copper engraving a border of cardboard on which the engraving has been tightly stretched and glued. This arrangement has the effect of making the image appear much more vivid than on a white background, which helps to accelerate the action, and, furthermore, of avoiding damaging the varnish by rubbing it against the copper engraving as in the other method, a mishap which is very hard to prevent in warm weather, even when the coating is quite dry. This disadvantage is counterbalanced, however, by the advantages offered by the experiments with silvered plates, which withstand the action of the washing better, while it is rare that the images on glass are not more or less damaged by this operation, for the simple reason that the varnish can adhere less easily to the glass, owing to its nature and its smooth surface. It would be necessary, therefore, in order to overcome this disadvantage, to improve the varnish by making it more sticky, and I believe that I have succeeded in doing this at least in so far as I may be permitted to pass judgment on this matter, although the experiments are still new and not numerous enough.

This new varnish is composed of a solution of bitumen of Judea in Dippel's animal oil, which is allowed to condense at the ordinary temperature of air to the degree of consistency required. This varnish is more greasy, tougher, and more strongly colored than the other, and it can be exposed to light as soon as the plate is coated, because it seems to solidify more rapidly, owing to the great volatility of the animal oil which causes it to dry more rapidly.

Daguerreotype

Louis Jacques Mandé Daguerre

The discovery which I announce to the public is one of the small number which, by their principles, their results, and the beneficial influence which they exert on the arts, are counted among the most useful and extraordinary inventions.

It consists in the spontaneous reproduction of the images of nature received in the camera obscura, not with their colours, but with very fine gradation of tones.

M. Nicéphore NIÉPCE, of Châlon(s)-sur-Saône, already known for his love of the arts and his numerous useful inventions, whom sudden death unexpectedly tore from his family and from science on 5 July 1833, had found after many years of research and persistent labour one principle of this important discovery; by numerous and infinitely varied experiments he had succeeded in obtaining the image of nature with the aid of an ordinary camera obscura; but his apparatus did not give the necessary sharpness, and the substances on which he operated were not sufficiently sensitive to light, so his work, however surprising in its results, was nevertheless very incomplete.

For my part, I was already occupied with similar researches. It was in these circumstances that relations were established between M. NIÉPCE and me in 1828 [sic], as a result of which we formed a partnership with the object of perfecting this discovery.

I brought to the partnership a camera obscura modified by me for this application which rendered a larger field of the image sharp and greatly influenced our later success. Some important modifications which I made to the process, combined with the continual researches of M. NIÉPCE, augured well, when death came to separate me from a man who besides vast and profound knowledge had all the qualities of the heart; may I be permitted here to pay a just tribute of esteem and regret to his memory, which will always be dear to me.

Upset by this loss, I abandoned my work for a while; but soon, pursuing it with renewed eagerness, I attained the goal which we had set ourselves.

This apparently happy result did not, however, render the effects of nature sufficiently correctly, because the operation lasted several hours.

In this state the discovery was extraordinary, but it would not have been of any utility.

I realized that the only way to succeed completely was to arrive at such rapidity that the impression could be produced in a few minutes, so that the shadows in nature should not have time to alter their position; and also that the manipulation should be simpler.

It is the solution of this principle that I announce today; this new process to which I have given my name, calling it DAGUERREOTYPE, and which differs entirely as regards rapidity, sharpness of the image, delicate gradation of the tones, and above all, the perfection of the details, is very superior to that invented by M. NIÉPCE, in spite of all the improvements which I made to it. The difference in its sensitivity to light as compared with M. Niépce's process is as 1 to 70, and compared with chloride of silver, it is as 1 to 120. In order to obtain a perfect image of nature only *three to thirty minutes at the most* are necessary, according to the season in which one operates and the degree of intensity of the light.

The imprint of nature would reproduce itself still more rapidly in countries where the light is more intense than in Paris, such as Spain, Italy, Africa, etc., etc.

By this process, without any idea of drawing, without any knowledge of chemistry and physics, it will be possible to take in a few minutes the most detailed views, the most picturesque scenery, for the manipulation is simple and does not demand any special knowledge, only care and a little practice is necessary in order to succeed perfectly.

Everyone, with the aid of the DAGUERREOTYPE, will make a view of his castle or country-house: people will form collections of all kinds, which will be the more precious because art cannot imitate their accuracy and perfection of detail; besides, they are unalterable by light. Even portraits will be made, though the unsteadiness of the model presents, it is true, some difficulties [which need to be overcome] in order to succeed completely.

This important discovery, capable of innumerable applications, will not only be of great interest to science, but it will also give a new impulse to the arts, and far from damaging those who practise them, it will prove a great boon to them. The leisured class will find it a most attractive occupation, and although the result is

obtained by chemical means, the little work it entails will greatly please ladies.

In conclusion, the DAGUERREOTYPE is not merely an instrument which serves to draw Nature; on the contrary it is a chemical and physical process which gives her the power to reproduce herself.

Report

Dominique François Arago

Report of the Commission of the Chamber of Deputies charged with the examination of a proposed bill granting, first, to M. Daguerre an annual and life pension of 6,000 francs and, second, to the son of M. Niépce, an annual life pension of 4,000 francs for the assignment to the State of their process for the fixation of images obtained in the camera obscura.

Presented by M. Arago, Deputy of the East-Pyrénées, in the French Chamber of Deputies, on July 3, 1839.

Gentlemen:

The interest aroused in this invention recently made public by M. Daguerre in this circle and elsewhere has been keen, enthusiastic, and unanimous. In all probability the Chamber awaits from its Commission no more than the approval of the proposed bill which the Minister of the Interior has presented. After careful consideration, however, the mandate with which you have charged us seems to impose upon us other duties.

We believe, however, that, while heartily approving the happy idea to grant a national reward to inventors whose interests cannot adequately be protected by the ordinary patent laws, we must furnish proof in the beginning of the cautious and scrupulous care with which this Chamber proceeds.

To subject a work of genius, such as that upon which we have to pass today, to a critical examination will serve to discourage ambitious mediocrity which might aspire to bring before this assembly its common and ephemeral productions. This will prove that you place upon a high plane the rewards which may be asked of you in the name of the national glory and that you cannot consent to lower your standards or dim their luster by a too lavish disposal of them.

These few words will serve to explain to the Chamber the lines we followed in our examination.

1. Is the process of M. Daguerre unquestionably an original invention?

2. Is this invention one which will render a valuable service to archaeology and the fine arts?

3. Can this invention become practically useful? And, finally,

4. Is it to be expected that the sciences may derive any advantage from it?

Arago proceeded to sketch earlier attempts with the camera, citing historical notes on the work of Wedgwood and others, which, however, were not at all exhaustive, and briefly outlined the early labors of Niépce and Daguerre. Arago continues:

The partnership agreement registered between Niépce and Daguerre for the joint exploitation of their photographic methods was dated December 14, 1829. The later agreements between M. Isidore Niépce, the son, as heir, and M. Daguerre mention first improvements which the Parisian painter added to the method invented by the physicist of Chalon and, secondly, entirely new processes discovered by M. Daguerre, capable of (in the language of the original document) "reproducing images sixty to eighty times more rapidly than the earlier process." This will explain the several articles of the contract between the Minister of the Interior on the one hand and MM. Daguerre and Niépce, Junior, on the other, attached to the proposed bill. It will be noted that we have just spoken when discussing the labors of M. Niépce the qualifying words: "for the photographic printing from copper engravings." As a matter of fact Niépce, after numerous fruitless experiments, had almost given up the hope of being able to fix images obtained directly in the camera obscura. The chemical preparations which he used did not darken rapidly enough under the action of light, for he required ten to twelve hours to produce the image and during the long time of exposure the shadows of the objects represented changed from one side to the other, so that the resulting pictures were flat and monotonous in tones, lacking all the pleasing effects which arise from the contrast of light and shade; and, furthermore, even apart from these difficulties, one was never certain of a successful result, because after taking innumerable precautions, inexplicable and accidental occurrences intervened, and there was sometimes a passable result, or an incomplete image resulted which showed here and there empty spaces, and, finally, when exposed to sunlight, the sensitive coating, if it did not refuse to darken, would become brittle and scale off.

When all these imperfections are enumerated and the nature and manner of their elimination is explained, an almost complete account is obtained of the credit which M. Daguerre deserves for the discovery of his method, achieved after endless laborious, delicate, and costly experiments.

Even the feeblest light rays change the sensitive substance of the daguerreotype plate. This change is effected before the shadows thrown by the sun have time to move appreciably. The results are assured if one follows certain simple rules. Finally, the effect of sunlight on the finished pictures does not diminish, even after years, either their purity, their brilliancy, or their harmony.

Your commission has made the necessary arrangements, so that on the day when the proposed bill is discussed all those Deputies who desire to examine the examples of the daguerreotype process may form their own opinions of the usefulness of this discovery. While these pictures are exhibited to you, everyone will imagine the extraordinary advantages which could have been derived from so exact and rapid a means of reproduction during the expedition to Egypt; everybody will realize that had we had photography in 1798 we would possess today faithful pictorial records of that which the learned world is forever deprived of by the greed of the Arabs and the vandalism of certain travelers.

To copy the millions of hieroglyphics which cover even the exterior of the great monuments of Thebes, Memphis, Karnak, and others would require decades of time and legions of draughtsmen. By daguerreotype one person would suffice to accomplish this immense work successfully. Equip the Egyptian Institute with two or three of Daguerre's apparatus, and before long on several of the large tablets of the celebrated work, which had its inception in the expedition to Egypt, innumerable hieroglyphics as they are in reality will replace those which now are invented or designed by approximation. These designs will exce. the works of the most accomplished painters, in fidelity of detail and true reproduction of the local atmosphere. Since the invention follows the laws of geometry, it will be possible to reestablish with the aid of a small number of given factors the exact size of the highest points of the most inaccessible structures.

These reflections, which the zealous and famous scholars and

artists attached to the army of the Orient cannot lightly dismiss without self-deception, must without doubt turn their thoughts to the work which is now being carried on in our country under the control of the Commission for Historic Monuments. A glance suffices to recognize the extraordinary role which the photographic process must play in this great national enterprise; it is evident at the same time that this new process offers economic advantages which, incidentally, seldom go hand in hand in the arts with the perfecting of production.

If, finally, the question arises whether art in itself may expect further progress from the study of these images drawn by nature's most subtle pencil, the light ray, M. Paul Delaroche will answer us.

In a report, made at our request this celebrated painter states that Daguerre's processes "are so far-reaching in the realization of certain essential requirements of art that they will be the subject of observation and study, even by the most able painters." What he stresses most about photographic images is their "unimaginable precision" of detail, which does not disturb the repose of the masses and does not detract in any way from the general effect. "The accuracy of the lines," Delaroche continues, "the nicety of form, are as perfect in Daguerre's pictures as could be desired, and at the same time one recognizes a broad and vigorous modeling as rich in tone as it is in effect. . . . The painter finds in this process an easy way of making collections for after-study and use which otherwise are obtainable only at great expense of time and labor, and yet less perfect in quality, no matter how great his talent may be." After having opposed with excellent arguments the opinions of those who imagined that photography would be detrimental to our artists and especially to our skilled engravers, M. Delaroche concludes his report with the remark: "In short the remarkable invention of M. Daguerre is a great service rendered to the Arts."

We will not presume to add anything to such testimony.

It will be recalled that among the questions which occupied us at the beginning of this report was whether this invention can become of practical use? Without disclosing anything that must remain secret until the passage and promulgation of the bill, we can say that the plates on which light produces the admirable picture images of M. Daguerre are plated tablets, i.e., copper

plates which have been coated with a thin deposit of silver. Doubtless, it would have been more advantageous not only for the comfort of travelers as well as from an economic point of view, if paper could be used. Paper impregnated with silver chloride or silver nitrate was indeed the first substance chosen by M. Daguerre, but the lack of sensitivity, the confused image, the uncertainty as to results, and the accidents which often happened during the operation of reversing lights and shadows could not but discourage so skilled an artist. Had he pursued this direction, his pictures would probably be shown in collections as experimental results among the curiosities of physics, but assuredly would never have become a subject for the consideration of this chamber. Finally, if it be said that three or four francs, the cost of a plate such as M. Daguerre uses, seems too costly, it is but fair to state that the same plate may serve successively for the taking of a hundred different pictures.

The extraordinary success of M. Daguerre's present process can be attributed in part to the fact that he uses an extremely thin coating, a veritable film. We need not concern ourselves here with the cost of the material employed; in fact the price is too small for evaluation. Only one member of the commission has seen the artist at work and has himself operated the process. It is, therefore, due to the personal responsibility of this Deputy that we can present to the members of the Chamber daguerreotype from the standpoint of practicability. Daguerreotype calls for no manipulation which anyone cannot perform. It presumes no knowledge of the art of drawing and demands no special dexterity. When, step by step, a few simple prescribed rules are followed, there is no one who cannot succeed as certainly and as well as can M. Daguerre himself.

The rapidity of the method has probably astonished the public more than anything else. In fact, scarcely ten or twelve minutes are required for photographing a monument, a section of a town, or a scene, even in dull, winter weather.

In summer sunlight the time of exposure can be reduced to half. In the southern climate two to three minutes will certainly be sufficient. We must note, however, that the ten to twelve minutes exposure in winter, the five to six minutes in summer, and the two to three minutes in the South express only the actual time during which the sensitive plate receives the image projected by the lens.

19

To this must be added the time occupied by the unpacking and mounting of the camera obscura, preparing the plate, and the short time necessary for protecting the plate from the action of light after the exposure. For all these manipulations perhaps a half to three quarters of an hour may be required. Those who fondly imagine when about to start on a journey that they will employ every moment when the coach is climbing slowly uphill in taking the scenes, will be therefore disappointed in their expectations. No less will be the disappointment of those who, astonished by the success obtained by the copying of pages and illustrations of the most ancient works, would dream of the photographic images for the reproduction and multiplication of the daguerreotype by means of lithographic print. Not alone in the moral world has every quality its defects; this principle applies also to the Arts. The perfection, delicacy, and harmony of the picture images are the result of the perfect smoothness and incalculable thinness of the coating on which M. Daguerre operates. If such a picture is rubbed or even lightly touched, or subjected to the pressure of a roller, it is destroyed past redemption; but, who could imagine anyone pulling apart a fine piece of lace or brushing the wings of a butterfly? The member of the Academy who has known for several months the preparations on which the beautiful designs submitted for our examination are produced deems it inadvisable to utilize his knowledge of the secret which had been entrusted to him by M. Daguerre, who had honored him with his confidence. He felt that before entering upon further research, thrown open to physicists by the photographic process, it would be more delicate to wait until a national award had placed in the hands of all observers the same means for further study. If we therefore discuss the scientific advantages of the invention by our compatriot, we can only hazard a conjecture. The facts, however, are clear and obvious, and we need not fear that the future will discredit our statements. The preparation used by M. Daguerre is a reagent, much more sensitive to the action of light than any heretofore known. Never have the rays of the moon, we do not mean in its natural condition, but focused by the greatest lens or the largest reflector, produced any perceptible physical effect. The plates prepared by M. Daguerre, however, bleach to such an extent, by the action of the same rays, followed by a subsequent treatment, that we may hope to be able to make photographic

20

maps of our satellite. In other words, it will be possible to accomplish within a few minutes one of the most protracted, difficult, and delicate tasks in astronomy.

An important branch of the science of observation and calculation, that which deals with the intensity of light, photometry, has so far made little progress. The physicist has no difficulty in determining the comparative intensities of two lights, one next to the other and both simultaneously visible; but there are only imperfect means for making such a comparison when the condition of simultaneity is lacking, as when a light which is now visible is to be compared with another light, which will not be visible until after the first light has disappeared.

The artificial lights available to the observer for the purpose of comparison in the above-mentioned case are rarely permanent or of desirable stability; and seldom, especially when we deal with stars, do our artificial lights possess the sufficient whiteness. This is the reason for the great discrepancies between the determinations of the comparative light intensities of the sun and moon and the sun and stars, as given by equally able scientists; for the same reason the most important conclusions are surrounded by certain reservations, when they refer to the last-mentioned comparisons concerning the humble position which our sun occupies among the milliards of suns with which the firmament is bespangled; this, even in the works of the least timid authors.

We do not hesitate to say that the reagents discovered by M. Daguerre will accelerate the progress of one of the sciences, which most honors the human spirit. With its aid the physicist will be able henceforth to proceed to the determination of absolute intensities; he will compare the various lights by their relative effects. If needs be, this same photographic plate will give him the impressions of the dazzling rays of the sun, of the rays of the moon which are three hundred thousand times weaker, or of the rays of the stars. He can compare these impressions, either by dimming the strongest lights with the aid of the excellent media which only lately have been discovered, a description of which would be out of place here, or by allowing the most intense rays to act only for a second, while continuing the action of the other rays to half an hour, as may be necessary.

Moreover, when the observer applies a new instrument in the study of nature, his expectations are relatively small in compari-

son to the succession of discoveries resulting from its use. In a case of this sort it is surely the unexpected upon which one especially must count.

Does this sound like a paradox? A few citations will prove its accuracy.

Some children accidentally placed two lenses each in opposite ends of a tube. They thus produced an instrument which enlarged distant objects and represented them as if approached. Astronomers accepted this instrument with the hope of being better able to observe stars, which had been known for ages, but which up to that time could be studied only imperfectly. Pointing this new instrument toward the firmament, they revealed myriads of new worlds. Penetrating the inner formation of the six planets of the ancients, one finds them similar to our own world, with mountains the height of which can be measured, atmospheric disturbances which can be followed, with the phenomena of formation and fusion of polar ice, analogous to the terrestrial poles and to the rotating movement which corresponds to that which creates the succession of our days and nights. Pointed toward Saturn, the tube of the Middelburg spectacle maker's children reveal a phenomenon more wonderful than any dream of the most fanciful imagination.

Could anyone have foreseen that when turned so as to observe the four moons of Jupiter it would reveal luminous rays, traveling at a speed of eighty thousand miles (300,000 km.) per second; that, attached to graduated measuring instruments it would demonstrate that no stars exist whose light reaches us in less than three years; and, finally, that if the instrument be used in certain observations one may conclude with reasonable certainty that the rays by which we perceive at any given moment were emitted by certain nebulae millions of years ago; in other words, that these nebulae, owing to the continuous propagation of light, would be visible to us several millions of years after their complete destruction?

The glass for near objects, the microscope, gives occasion for similar observations, because nature is no less admirable, no less varied in its smallness than in its immensity. When the microscope was first used for the observation of certain insects whose shapes the scientists desired to see in an enlarged size in order to delineate them more accurately, it revealed subsequently and

unexpectedly in air, in water, in short in all liquids, these animalcules, these infusoria, through which it is hoped to find sooner or later a reasonable explanation for the beginning of life. Recently directed to minute fragments of different stones of the hardest and most solid variety, of which the crust of our earth is composed, the microscope revealed to the astonished gaze of the observer that these stones once lived, that they are in reality a conglomeration of milliards and milliards of microscopic animalcules closely cemented together.

It should be remembered that this digression was necessary in order to dispell the erroneous opinion of those who would mistakenly limit the scientific application of M. Daguerre's processes to the outline we have given; indeed, the facts already justify our expectations. We could, for instance, cite certain ideas, for the rapid method of investigation, which the topographer could borrow from the photographic process, but we shall reach our goal more quickly by mentioning here a singular observation, of which M. Daguerre spoke to us yesterday. According to him, the hours of the morning and of the evening, which are equally distant from the noon hour, and at which times the sun is at the same altitude, are not, however, equally favorable for the taking of photographs.

Thus, a picture is produced, regardless of the season and under similar atmospheric conditions at seven o'clock in the morning somewhat more rapidly than at five o'clock in the afternoon; at eight o'clock faster than at four o'clock, at nine faster than at three. Supposing this result is to be verified, the meteorologist will have a new element to record in his tables, and to the ancient observations as to the state of the thermometer, barometer, and hygrometer and the visibility of the air they will have to add another element, which these early instruments do not indicate. It will be necessary to take into consideration an absorption of a peculiar character which cannot be without influence on many other phenomena, perhaps even on those belonging to the fields of physiology and medicine.

We will endeavor, gentlemen, to set forth everything which the discovery of M. Daguerre offers of interest under four aspects: its originality, its usefulness in the arts, the speed of execution, and the valuable aid which science will find in it. We have striven to make you share our convictions, which are vivid

and sincere, because we have examined and studied everything with scrupulous care, in keeping with the duty imposed by your suffrage, because, if it were possible to misjudge the importance of the daguerreotype and the place which it will occupy in the world's estimation, every doubt would have vanished at sight of the eagerness with which foreign nations pointed to an erroneous date, to a doubtful fact, and sought the most flimsy pretext in order to raise questions of priority and to try to take credit for the brilliant ornament which photography will always be in the crown of discoveries. Let us not forget to proclaim that all discussion on this point has ceased, not so much on account of the incontestable and authenticated authority of title on which MM. Niépce and Daguerre base their claims, but chiefly because of the incredible perfection which M. Daguerre attained. If it were necessary, we would not be at a loss to present here the testimony of the most eminent men of England and Germany, in the face of which everything we have said, however flattering, concerning the discovery of our compatriot would pale completely. France has adopted this discovery and from the first moment has been proud that it can present it generously to the entire world.

We were not at all surprised by the public sentiment awakened by the exposure, due to a misapprehension of motives, which seemed to indicate that the government had bartered with the inventors and that the pecuniary conditions of the contract proposed for your sanction represented a bargain. It becomes necessary, gentlemen, to re-establish the facts.

The member of the Chamber who had full power given him by the Minister of the Interior did not haggle with M. Daguerre. Their negotiations were concerned solely with the point whether the recompense which the able artist had so well merited should be a fixed pension or a single payment. M. Daguerre at once remarked that the stipulation of a lump sum might give the contract the character of a sale. It would not be the same with a pension. It is with a pension that you reward the soldier, crippled on the field of honor, the official, grown gray at his post; and thus you have honored the families of Cuvier, Jussieu, De Champollion.

Such memories must have affected the noble character of M. Daguerre; he decided to ask for a pension. At the request of the

24

Minister of the Interior, M. Daguerre himself set the amount of the pension at 8,000 francs, which was to be divided equally between him and his partner, M. Niépce's son. M. Daguerre's share was later increased to 6,000 francs, partly because of the special conditions imposed on this artist, namely, to reveal the process of painting and lighting of the canvasses of the diorama, now reduced to ashes, and especially because he has pledged himself to make public all improvements with which he may enrich his photographic methods. The importance of this pledge will certainly not seem doubtful to anyone when we state that only a little progress is required to enable M. Daguerre to make portraits of living persons by his process. As far as we are concerned, instead of fearing that M. Daguerre might delegate to others the labor of adding to his present success, we rather sought to moderate his ardor. This we frankly admit is the motive which induced us to desire that you declare the pension free from the laws of restraint and attachment, but we have found that this amendment will be superfluous according to the law of 22d Floréal of the VII year and according to the decree of the 7th Thermidor of the X year.

The commission therefore unanimously proposes that you adopt the bill of the government without change.

A Brief Historical Sketch of the Invention of the Art

William Henry Fox Talbot (1800–1877)

On a trip to Lake Como in the fall of 1833, William Henry Fox Talbot, English mathematician, scientist, and linguist, tried his hand at sketching with a camera lucida. However, Talbot soon observed that to draw well from images cast by the tool required previous mastery of the rules of drawing. He mused over the possibility of fixing the images permanently, without the use of pencil or brush. Linear and aerial perspective were considered essential compositional elements for truthful visual representations, and pictures produced by the camera lucida were in perfect perspective. High detail was another mark of pictorial accuracy, and the delicate lines and tones of these images clearly denoted the most minute aspects of the visible world. These images were made by a tool that seemed to leave man's fallible mind and hand out of most of the creative process. By directing light through a lens into a box, Talbot thought he was commanding nature to reproduce a visual image of herself in two dimensions.

When Talbot returned to England, he began to experiment, placing paper coated with light-sensitive chemicals in a camera lucida and exposing the paper to light. Pictures of the scene before the camera printed on paper, but they were tonally reversed — all the dark tones were light and all the light tones dark. Despite this drawback, Talbot announced his discovery to the Royal Society on 31 January 1839, shortly after he caught word of Daguerre's experiments with light pictures in France. By February, Talbot had found a way to correct his reversed images: he chemically stabilized a negative, placed a sheet of light-sensitized paper beneath it, and reexposed this package to the sun. In this way, many prints with the proper tonal relations could be drawn from a single negative. But the system was imperfect. Exposure times were slow, and negatives and prints could be stabilized only for a short time before fading. In addition, the fiber pattern of the paper negatives printed through, interfering with the detail of the prints. As a result, Daguerre's process became the preferred photographic technique. Though no prints could be made from daguerreotypes, their infinitesimal detail and quick exposure time made them more popular than Talbot's "photogenic drawings."

Yet Talbot continued his research. He soon found a way to fix his

27

negatives and prints permanently, and in 1840 he discovered a method for shortening exposure time. Pictures made by this new system he called Talbotypes, *or* calotypes — *from the Greek word* καλός, *meaning "beautiful," and* τύπος, *"type." The following year, Talbot patented the Talbotype, and the patent effectively stopped English experimentation for an improved photographic printing process. Three years later, he published* The Pencil of Nature, *a quarto of his own prints with accompanying text, illustrating the many uses he projected for the Talbotype. In 1852, Talbot loosened his grip on his process, demanding monetary recompense only for commercial portraits. By that time, however, the sharper, faster, collodion glass-plate negative had been introduced by the Englishman Scott Archer, and the Talbotype had no chance to compete.*

It may be proper to preface these specimens of a new Art by a brief account of the circumstances which preceded and led to the discovery of it. And these were nearly as follows.

One of the first days of the month of October 1833, I was amusing myself on the lovely shores of the Lake of Como, in Italy, taking sketches with Wollaston's Camera Lucida, or rather I should say, attempting to take them: but with the smallest possible amount of success. For when the eye was removed from the prism—in which all looked beautiful—I found that the faithless pencil had only left traces on the paper melancholy to behold.

After various fruitless attempts, I laid aside the instrument and came to the conclusion, that its use required a previous knowledge of drawing, which unfortunately I did not possess.

I then thought of trying again a method which I had tried many years before. This method was, to take a Camera Obscura, and to throw the image of the objects on a piece of transparent tracing paper laid on a pane of glass in the focus of the instrument. On this paper the objects are distinctly seen, and can be traced on it with a pencil with some degree of accuracy, though not without much time and trouble.

I had tried this simple method during former visits to Italy in 1823 and 1824, but found it in practice somewhat difficult to manage, because the pressure of the hand and pencil upon the paper tends to shake and displace the instrument (insecurely fixed, in all probability, while taking a hasty sketch by a road-

28

side, or out of an inn window); and if the instrument is once deranged, it is most difficult to get it back again, so as to point truly in its former direction.

Besides which, there is another objection, namely, that it baffles the skill and patience of the amateur to trace all the minute details visible on the paper; so that, in fact, he carries away with him little beyond a mere souvenir of the scene—which, however, certainly has its value when looked back to, in long after years.

Such, then, was the method which I proposed to try again, and to endeavour, as before, to trace with my pencil the outlines of the scenery depicted on the paper. And this led me to reflect on the inimitable beauty of the pictures of nature's painting which the glass lens of the Camera throws upon the paper in its focus—fairy pictures, creations of a moment, and destined as rapidly to fade away.

It was during these thoughts that the idea occurred to me how charming it would be if it were possible to cause these natural images to imprint themselves durably, and remain fixed upon the paper!

And why should it not be possible? I asked myself.

The picture, divested of the ideas which accompany it, and considered only in its ultimate nature, is but a succession or variety of stronger lights thrown upon one part of the paper, and of deeper shadows on another. Now Light, where it exists, can exert an action, and, in certain circumstances, does exert one sufficient to cause changes in material bodies. Suppose, then, such an action could be exerted on the paper; and suppose the paper could be visibly changed by it. In that case surely some effect must result having a general resemblance to the cause which produced it: so that the variegated scene of light and shade might leave its image or impression behind, stronger or weaker on different parts of the paper according to the strength or weakness of the light which had acted there.

Such was the idea that came into my mind. Whether it had ever occurred to me before amid floating philosophic visions, I know not, though I rather think it must have done so, because on this occasion it struck me so forcibly. I was then a wanderer in classic Italy, and, of course, unable to commence an inquiry of so much difficulty: but, lest the thought should again escape me

between that time and my return to England, I made a careful note of it in writing, and also of such experiments as I thought would be most likely to realize it, if it were possible.

And since, according to chemical writers, the nitrate of silver is a substance peculiarly sensitive to the action of light, I resolved to make a trial of it, in the first instance, whenever occasion permitted on my return to England.

But although I knew the fact from chemical books, that nitrate of silver was changed or decomposed by Light; still I had never seen the experiment tried, and therefore I had no idea whether the action was a rapid or a slow one; a point, however, of the utmost importance, since, if it were a slow one, my theory might prove but a philosophic dream.

Such were, as nearly as I can now remember, the reflections which led me to the invention of this theory, and which first impelled me to explore a path so deeply hidden among nature's secrets. And the numerous researches which were afterwards made—whatever success may be thought to have attended them—cannot, I think, admit of a comparison with the value of the first and original idea.

In January 1834, I returned to England from my continental tour, and soon afterwards I determined to put my theories and speculations to the test of experiment, and see whether they had any real foundation.

Accordingly I began by procuring a solution of nitrate of silver, and with a brush spread some of it upon a sheet of paper, which was afterwards dried. When this paper was exposed to the sunshine, I was disappointed to find that the effect was very slowly produced in comparison with what I had anticipated.

I then tried the chloride of silver, freshly precipitated and spread upon paper while moist. This was found no better than the other, turning slowly to a darkish violet colour when exposed to the sun.

Instead of taking the chloride already formed, and spreading it upon the paper, I then proceeded in the following way. The paper was first washed with a strong solution of salt, and when this was dry, it was washed again with nitrate of silver. Of course, chloride of silver was thus formed in the paper, but the result of this experiment was almost the same as before, the

chloride not being apparently rendered more sensitive by being formed in this way.

Similar experiments were repeated at various times, in hopes of a better result, frequently changing the proportions employed, and sometimes using the nitrate of silver before the salt, &c. &c.

In the course of these experiments, which were often rapidly performed, it sometimes happened that the brush did not pass over the whole of the paper, and of course this produced irregularity in the results. On some occasions certain portions of the paper were observed to blacken in the sunshine much more rapidly than the rest. These more sensitive portions were generally situated near the edges or confines of the part that had been washed over with the brush.

After much consideration as to the cause of this appearance, I conjectured that these bordering portions might have absorbed a lesser quantity of salt, and that, for some reason or other, this had made them more sensitive to the light. This idea was easily put to the test of experiment. A sheet of paper was moistened with a much weaker solution of salt than usual, and when dry, it was washed with nitrate of silver. This paper, when exposed to the sunshine, immediately manifested a far greater degree of sensitiveness than I had witnessed before, the whole of its surface turning black uniformly and rapidly: establishing at once and beyond all question the important fact, that a lesser quantity of salt produced a greater effect. And, as this circumstance was unexpected, it afforded a simple explanation of the cause why previous inquirers had missed this important result in their experiments on chloride of silver, namely, because they had always operated with wrong proportions of salt and silver, using plenty of salt in order to produce a perfect chloride, whereas what was required (it was now manifest) was, to have a deficiency of salt, in order to produce an imperfect chloride, or (perhaps it should be called) a *subchloride* of silver.

So far was a free use or abundance of salt from promoting the action of light on the paper, that on the contrary it greatly weakened and almost destroyed it: so much so, that a bath of salt water was used subsequently as a fixing process to prevent the further action of light upon sensitive paper.

This process, of the formation of a subchloride by the use of a

very weak solution of salt, having been discovered in the spring of 1834, no difficulty was found in obtaining distinct and very pleasing images of such things as leaves, lace, and other flat objects of complicated forms and outlines, by exposing them to the light of the sun.

The paper being well dried, the leaves, &c. were spread upon it, and covered with a glass pressed down tightly, and then placed in the sunshine; and when the paper grew dark, the whole was carried into the shade, and the objects being removed from off the paper, were found to have left their images very perfectly and beautifully impressed or delineated upon it.

But when the sensitive paper was placed in the focus of a Camera Obscura and directed to any object, as a building for instance, during a moderate space of time, as an hour or two, the effect produced upon the paper was not strong enough to exhibit such a satisfactory picture of the building as had been hoped for. The outline of the roof and of the chimneys, &c. against the sky was marked enough; but the details of the architecture were feeble, and the parts in shade were left either blank or nearly so. The sensitiveness of the paper to light, considerable as it seemed in some respects, was therefore, as yet, evidently insufficient for the purpose of obtaining pictures with the Camera Obscura; and the course of experiments had to be again renewed in hopes of attaining to some more important result.

The next interval of sufficient leisure which I found for the prosecution of this inquiry, was during a residence at Geneva in the autumn of 1834. the experiments of the previous spring were then repeated and varied in many ways; and having been struck with a remark of Sir H. Davy's which I had casually met with— that the *iodide* of silver was more sensitive to light than the *chloride,* I resolved to make trial of the iodide. Great was my surprise on making the experiment to find just the contrary of the fact alleged, and to see that the iodide was not only less sensitive than the chloride, but that it was not sensitive at all to light; indeed that it was absolutely insensible to the strongest sunshine: retaining its original tint (a pale straw colour) for any length of time unaltered in the sun. This fact showed me how little dependance was to be placed on the statements of chemical writers in regard to this particular subject, and how necessary it was to trust to nothing but actual experiment: for although there

could be no doubt that Davy had observed what he described under certain circumstances—yet it was clear also, that what he had observed was some exception to the rule, and not the rule itself. In fact, further inquiry showed me that Davy must have observed a sort of subiodide in which the iodine was deficient as compared with the silver: for, as in the case of the chloride and subchloride the former is much less sensitive, so between the iodide and subiodide there is a similar contrast, but it is a much more marked and complete one.

However, the fact now discovered, proved of immediate utility; for, the iodide of silver being found to be insensible to light, and the chloride being easily converted into the iodide by immersion in iodide of potassium, it followed that a picture made with the chloride could be *fixed* by dipping it into a bath of the alkaline iodide.

This process of fixation was a simple one, and it was sometimes very successful. The disadvantages to which it was liable did not manifest themselves until a later period, and arose from a new and unexpected cause, namely, that when a picture is so treated, although it is permanently secured against the *darkening* effect of the solar rays, yet it is exposed to a contrary or *whitening* effect from them; so that after the lapse of some days the dark parts of the picture begin to fade, and gradually the whole picture becomes obliterated, and is reduced to the appearance of a uniform pale yellow sheet of paper. A good many pictures, no doubt, escape this fate, but as they all seem liable to it, the fixing process by iodine must be considered as not sufficiently certain to be retained in use as a photographic process, except when employed with several careful precautions which it would be too long to speak of in this place.

During the brilliant summer of 1835 in England I made new attempts to obtain pictures of buildings with the Camera Obscura; and having devised a process which gave additional sensibility to the paper, viz. by giving it repeated alternate washes of salt and silver, and using it in a moist state, I succeeded in reducing the time necessary for obtaining an image with the Camera Obscura on a bright day to ten minutes. But these pictures, though very pretty, were very small, being quite miniatures. Some were obtained of a larger size, but they required much patience, nor did they seem so perfect as the smaller ones, for it

was difficult to keep the instrument steady for a great length of time pointing at the same object, and the paper being used moist was often acted on irregularly.

During the three following years not much was added to previous knowledge. Want of sufficient leisure for experiments was a great obstacle and hindrance, and I almost resolved to publish some account of the Art in the imperfect state in which it then was.

However curious the results which I had met with, yet I felt convinced that much more important things must remain behind, and that the clue was still wanting to this labyrinth of facts. But as there seemed no immediate prospect of further success, I thought of drawing up a short account of what had been done, and presenting it to the Royal Society.

However, at the close of the year 1838, I discovered a remarkable fact of quite a new kind. Having spread a piece of silver leaf on a pane of glass, and thrown a particle of iodine upon it, I observed that coloured rings formed themselves around the central particle, especially if the glass was slightly warmed. The coloured rings I had no difficulty in attributing to the formation of infinitely thin layers of strata of iodide of silver; but a most unexpected phenomenon occurred when the silver plate was brought into the light by placing it near a window. For then the coloured rings shortly began to change their colours, and assumed other and quite unusual tints, such as are never seen in the *"colours of thin plates."* For instance, the part of the silver plate which at first shone with a pale yellow colour, was changed to a dark olive green when brought into the daylight. This change was not very rapid: it was much less rapid than the changes of some of the sensitive papers which I had been in the habit of employing, and therefore, after having admired the beauty of this new phenomenon, I laid the specimens by, for a time, to see whether they would preserve the same appearance, or would undergo any further alteration.

Such was the progress which I had made in this inquiry at the close of the year 1838, when an event occurred in the scientific world, which in some degree frustrated the hope with which I had pursued, during nearly five years, this long and complicated, but interesting series of experiments—the hope, namely, of being the first to announce to the world the existence of the New Art—which has been since named Photography.

34

I allude, of course, to the publication in the month of January 1839, of the great discovery of M. Daguerre, of the photographic process which he has called the Daguerreotype. I need not speak of the sensation created in all parts of the world by the first announcement of this splendid discovery, or rather, of the fact of its having been made, (for the actual method made use of was kept secret for many months longer). This great and sudden celebrity was due to two causes: first, to the beauty of the discovery itself: secondly, to the zeal and enthusiasm of Arago, whose eloquence, animated by private friendship, delighted in extolling the inventor of this new art, sometimes to the assembled science of the French Academy, at other times to the less scientific judgment, but not less eager patriotism, of the Chamber of Deputies.

But, having brought this brief notice of the early days of the Photographic Art to the important epoch of the announcement of the Daguerreotype; I shall defer the subsequent history of the Art to a future number of this work.

Some time previously to the period of which I have now been speaking, I met with an account of some researches on the action of Light, by Wedgwood and Sir H. Davy, which, until then, I had never heard of. Their short memoir on this subject was published in 1802 in the first volume of the Journal of the Royal Institution. It is curious and interesting, and certainly establishes their claim as the first inventors of the Photographic Art, though the actual progress they made in it was small. They succeeded, indeed, in obtaining impressions from solar light of flat objects laid upon a sheet of prepared paper, but they say that they found it impossible to fix or preserve those pictures: all their numerous attempts to do so having failed.

And with respect to the principal branch of the Art, viz. the taking pictures of distant objects with a Camera Obscura, they attempted to do so, but obtained no result at all, however long the experiment lasted. While therefore due praise should be awarded to them for making the attempt, they have no claim to the actual discovery of any process by which such a picture can really be obtained.

It is remarkable that the failure in this respect appeared so complete, that the subject was soon after abandoned both by themselves and others, and as far as we can find, it was never

resumed again. The thing fell into entire oblivion for more than thirty years: and therefore, though the Daguerreotype was not so entirely new a conception as M. Daguerre and the French Institute imagined, and though my own labours had been still more directly anticipated by Wedgwood, yet the improvements were so great in all respects, that I think the year 1839 may fairly be considered as the real date of the birth of the Photographic Art, that is to say, its first public disclosure to the world.

The Daguerreotype

Edgar Allan Poe (1809–1849)

Unlike Charles Baudelaire, whose works he influenced, Edgar Allan Poe paid homage to the invention of photography as "the most important, and perhaps the most extraordinary triumph of modern science." In 1840, Poe published three articles on photography: the first, "The Daguerreotype," appeared in the January 15 issue of Alexander's Weekly Messenger *and the next two, on improvements in the Daguerreotype, in the April and May issues of* Burton's Gentleman's Magazine. *Both Poe and his contemporary Nathaniel Hawthorne understood photography to be an invention representative of the "miraculous" or even magical potential of the modern age. Poe, like many men of his day, delighted in what he considered the magical accuracy of the photographic image. His fascination with photographs was not based on the images' mechanical origins so much as on origins that appeared as magical. Many scientific inventions of the time seemed somewhat miraculous to the public-at-large, and Poe touted photography as representative of them all. He thought that the future results of most scientific inventions would "exceed . . . the wildest expectations of the most imaginative," and he proposed that this would be the rule for photography as well.*

This word is properly spelt Daguerréotype, and pronounced as if written Dagairraioteep. The inventor's name is Daguerre, but the French usage requires an accent on the second e, in the formation of the compound term.

The instrument itself must undoubtedly be regarded as the most important, and perhaps the most extraordinary triumph of modern science. We have not now space to touch upon the *history* of the invention, the earliest idea of which is derived from the camera obscura, and even the minute details of the process of photogeny (from Greek words signifying sun-painting) are too long for our present purpose. We may say in brief, however, that a plate of silver upon copper is prepared, presenting a surface for the action of the light, of the most delicate texture conceivable. A high polish being given this plate by means of a steatitic calcareous stone (called Daguerreolite) and containing equal parts of steatite and carbonate of lime, the fine

surface is then iodized by being placed over a vessel containing iodine, until the whole assumes a tint of pale yellow. The plate is then deposited in a camera obscura, and the lens of this instrument directed to the object which it is required to paint. The action of the light does the rest. The length of time requisite for the operation varies according to the hour of the day, and the state of the weather — the general period being from ten to thirty minutes — experience alone suggesting the proper moment of removal. When taken out, the plate does not at first appear to have received a definite impression — some short processes, however, develope it in the most miraculous beauty. All language must fall short of conveying any just idea of the truth, and this will not appear so wonderful when we reflect that the source of vision itself has been, in this instance, the designer. Perhaps, if we imagine the distinctness with which an object is reflected in a positively perfect mirror, we come as near the reality as by any other means. For, in truth, the Daguerreotyped plate is infinitely (we use the term advisedly) is *infinitely* more accurate in its representation than any painting by human hands. If we examine a work of ordinary art, by means of a powerful microscope, all traces of resemblance to nature will disappear — but the closest scrutiny of the photogenic drawing discloses only a more absolute truth, a more perfect identity of aspect with the thing represented. The variations of shade, and the gradations of both linear and aerial perspective are those of truth itself in the supremeness of its perfection.

The results of the invention cannot, even remotely, be seen — but all experience, in matters of philosophical discovery, teaches us that, in such discovery, it is the unforeseen upon which we must calculate most largely. It is a theorem almost demonstrated, that the consequences of any new scientific invention will, at the present day exceed, by very much, the wildest expectations of the most imaginative. Among the obvious advantages derivable from the Daguerreotype, we may mention that, by its aid, the height of inaccessible elevations may in many cases be immediately ascertained, since it will afford an absolute perspective of objects in such situations, and that the drawing of a correct lunar chart will be at once accomplished, since the rays of this luminary are found to be appreciated by the plate.

Photography

Lady Elizabeth Eastlake (1809–1893)

At the time of her marriage to the English neoclassical painter Sir Charles Eastlake in 1849, Lady Elizabeth Eastlake (née Rigby) had already embarked on a literary career of her own, writing on art and photography. During the early 1840s, she had worked for the publisher John Murray, in Edinburgh, at whose house she met the artist-photographer David Octavius Hill. Periodically over the next years, Hill and his partner, Robert Adamson, made portraits of her, one of which was probably the first calotype ever seen by Prince Albert, an avid enthusiast of photography. Lady Eastlake's contact with Hill and Adamson stimulated her life-long interest in photography.

Through her husband's active career as a member and then as president of the Royal Academy of Arts and his association with the National Gallery, Lady Eastlake continued to cultivate her interest in the visual arts. She translated the German art historian Gustav Waagen's Treasures of Art in Great Britain *(1854–1857) and edited the second series of his* Contributions. *Inspired by an intense reexposure to photography through Lord Eastlake's term as the first chairman of the London Photographic Society, from 1853–1855, Lady Eastlake published a long article on the association of photography and art in the* Quarterly Review *of March 1857, which is reprinted here. She was acutely aware of the interest in photography that had pervaded all classes of European society since the invention of the daguerreotype, and she saw this interest in the new medium as a social leveler.*

Like many mid-nineteenth century writers on art, Lady Eastlake tried to formulate a definition for photography. She granted the photograph the position of the most truthful pictorial report of fact but denied it the status of fine art. At the time, many popular aestheticians demanded that art works be judged against some ideal visual experience of nature, and here, in Lady Eastlake's estimation, photographs failed to meet the standard. She considered photographs unquestionably accurate when taken of subjects at close range, but faulty in tonal relations when made of subjects at any distance from the camera. Reflecting another predominant belief of the day about art, Lady Eastlake stressed the necessity that some evidence of man's creative genius and sensitivity to nature appear in an artistic work. Because she believed photographs to be the products of a wholly mechanical process of picture-making,

involving only the camera, light, and chemicals, she saw no place for evidence of man's mental powers in photographic images. Essentially, she understood photography to be a new, basically objective means of visual communication.

It is now more than fifteen years ago that specimens of a new and mysterious art were first exhibited to our wondering gaze. They consisted of a few heads of elderly gentlemen executed in a bistre-like colour upon paper. The heads were not above an inch long, they were little more than patches of broad light and shade, they showed no attempt to idealise or soften the harshnesses and accidents of a rather rugged style of physiognomy — on the contrary, the eyes were decidedly contracted, the mouths expanded, and the lines and wrinkles intensified. Nevertheless we examined them with the keenest admiration, and felt that the spirit of Rembrandt had revived. Before that time little was the existence of a power, availing itself of the eye of the sun both to discern and to execute, suspected by the world — still less that it had long lain the unclaimed and unnamed legacy of our own Sir Humphry Davy. Since then photography has become a household word and a household want; is used alike by art and science, by love, business, and justice; is found in the most sumptuous saloon, and in the dingiest attic — in the solitude of the Highland cottage, and in the glare of the London gin-palace — in the pocket of the detective, in the cell of the convict, in the folio of the painter and architect, among the papers and patterns of the millowner and manufacturer, and on the cold brave breast on the battle-field.

The annals of photography, as gathered from the London Directory, though so recent, are curious. As early as 1842 one individual, of the name of Beard, assumed the calling of a daguerreotype artist. In 1843 he set up establishments in four different quarters of London, reaching even to Wharf Road, City Road, and thus alone supplied the metropolis until 1847. In 1848 Claudet and a few more appear on the scene, but, owing to then existing impediments, their numbers even in 1852 did not amount to more than seven. In 1855 the expiration of the patent and the influence of the Photographic Society swelled them to sixty-six — in 1857 photographers have a heading to themselves and stand at 147.

These are the higher representatives of the art. But who can number the legion of petty dabblers, who display their trays of specimens along every great thoroughfare in London, executing for our lowest servants, for one shilling, that which no money could have commanded for the Rothschild bride of twenty years ago? Not that photographers flock especially to the metropolis; they are wanted everywhere and found everywhere. The large provincial cities abound with the sun's votaries, the smallest town is not without them; and if there be a village so poor and remote as not to maintain a regular establishment, a visit from a photographic travelling van gives it the advantages which the rest of the world are enjoying. Thus, where not half a generation ago the existence of such a vocation was not dreamt of, tens of thousands (especially if we reckon the purveyors of photographic materials) are now following a new business, practising a new pleasure, speaking a new language, and bound together by a new sympathy.

For it is one of the pleasant characteristics of this pursuit that it unites men of the most diverse lives, habits, and stations, so that whoever enters its ranks finds himself in a kind of republic, where it needs apparently but to be a photographer to be a brother. The world was believed to have grown sober and matter-of-fact, but the light of photography has revealed an un-suspected source of enthusiasm. An instinct of our nature, scarcely so worthily employed before, seems to have been kindled, which finds something of the gambler's excitement in the frequent disappointments and possible prizes of the photographer's luck. When before did any motive short of the stimulus of chance or the greed of gain unite in one uncertain and laborious quest the nobleman, the tradesman, the prince of blood royal, the innkeeper, the artist, the manservant, the general officer, the private soldier, the hard-worked member of every learned profession, the gentleman of leisure, the Cambridge wrangler, the man who bears some of the weightiest responsibilities of this country on his shoulder, and, though last, not least, the fair woman whom nothing but her own choice obliges to be more than the fine lady? The records of the Photographic Society, established in 1853, are curiously illustrative of these incongruities. Its first chairman, in order to give the newly instituted body the support and recognition which art was supposed

to owe it, was chosen expressly from the realms of art. Sir Charles Eastlake therefore occupied the chair for two years; at the end of which the society selected a successor quite as interested and efficient from a sphere of life only so far connected with art or science as being their very antipodes, namely, Sir Frederick Pollock, the Chief Baron of England. The next chairman may be a General fresh from the happy land where they photograph the year round; the fourth, for aught that can be urged to the contrary, the Archbishop of Canterbury. A clergyman of the Established Church has already been the editor to the journal of the society. The very talk of these photographic members is unlike that of any other men, either of business or pleasure. Their style is made up of the driest facts, the longest words, and the most high-flown rhapsodies. Slight improvements in processes, and slight varieties in conclusions, are discussed as if they involved the welfare of mankind. They seek each other's sympathy, and they resent each other's interference, with an ardour of expression at variance with all the sobrieties of business, and the habits of reserve; and old-fashioned English *mauvaise honte* is extinguished in the excitement, not so much of a new occupation as of a new state. In one respect, however, we can hardly accuse them of the language of exaggeration. The photographic body can no longer be considered only a society, it is becoming 'one of the institutions of the country.' Branches from the parent tree are flourishing all over the United Kingdom. Liverpool assists Norwich, Norwich congratulates Dublin, Dublin fraternises with the Birmingham and Midland Institute, London sympathises with each, and all are looking with impatience to Manchester. Each of these societies elect their officers, open their exhibitions, and display the same encouraging medley of followers. The necessity too for regular instruction in the art is being extensively recognised. The Council of King's College have instituted a lectureship of photography. Photographic establishments are attached to the Royal Arsenal at Woolwich; a photographic class is opened for the officers of the Royal Artillery and Engineers; lectures are given at the Royal Institution, and popular discourses at Mechanics' Institutes. Meanwhile British India has kept pace with the mother country. The Photographic Society at Bombay is only second in period of formation to that of London. Calcutta, Madras, Ben-

gal, and minor places all correspond by means of societies. The Elphinstone Institution has opened a class for instruction. Nor is the feeling of fellowship confined to our own race. The photographic and the political alliance with France and this country was concluded at about the same period, and we can wish nothing more than that they may be maintained with equal cordiality. The Duke de Luynes, a French nobleman of high scientific repute, has placed the sum of 10,000 francs at the disposal of the Paris Photographic Society, to be divided into two prizes for objects connected with the advance of the art, — the prizes open to the whole world. The best landscape photographs at the *Exposition des Beaux Arts* were English, the best architectural specimens in the London Exhibitions are French. The Exhibition at Brussels last October was more cosmopolitan than Belgian. The Emperors of Russia and Austria, adopting the old way for paying new debts, are bestowing snuff-boxes on photographic merit. These are but a few of the proofs that could be brought forward of the wide dissemination of the new agent, and of the various modes of its reception, concluding with a juxtaposition of facts which almost ludicrously recall paragraphs from the last speech from the throne; for while our Queen has sent out a complete photographic apparatus for the use of the King of Siam, the King of Naples alone, of the whole civilised world, has forbidden the practice of the works of light in his dominions!

Our chief object at present is to investigate the connexion of photography with art — to decide how far the sun may be considered an artist, and to what branch of imitation his powers are best adapted. But we must first give a brief history of those discoveries which have led to the present efficiency of the solar pencil. It appears that the three leading nations — the French, the English, and the Germans — all share in the merit of having first suggested, then applied, and finally developed the existence of the photographic element. It may not be superfluous to all our readers to state that the whole art in all its varieties rests upon the fact of the blackening effects of light upon certain substances, and chiefly upon silver, on which it acts with a decomposing power. The silver being dissolved in a strong acid, surfaces steeped in the solution became encrusted with minute particles of the metal, which in this state darkened with increased

rapidity. These facts were first ascertained and recorded, as regards chloride of silver, or silver combined with chlorine, in 1777, by Scheele, a native of Pomerania, and in 1801, in connexion with nitrate of silver, by Ritter of Jena. Here therefore were the raw materials for the unknown art; the next step was to employ them. And now we are at once met by that illustrious name to which we have alluded. Sir Humphry Davy was the first to make the practical application of these materials, and to foresee their uses. In conjunction with Mr. Thomas Wedgwood, only less eminent than his brother Josiah, Sir Humphry succeeded, by means of a camera obscura, in obtaining images upon paper, or white leather prepared with nitrate of silver — of which proceeding he has left the most interesting record in the Journal of the Royal Society for June, 1802.[1] Their aim, as the title shows, was not ambitious; but the importance lay in the first stain designedly traced upon the prepared substance, not in the thing it portrayed. In one sense, however, it was very aspiring, if colour as well as form were sought to be transferred, as would appear from the attempt to copy coloured glass; otherwise it is difficult to account for their selecting this particular material.

Besides showing the possibility of imprinting the forms of objects thus reflected in the camera, the paper in question proceeds to describe the process since known as 'Photographic Drawing,' by which leaves, or lace, or the wings of insects, or any flat and semi-transparent substances, laid upon prepared paper, and exposed to the direct action of the sun, will leave the perfect tracery of their forms. But having thus conjured up the etherial spirit of photography, they failed in all attempts to retain it in their keeping. The charm once set agoing refused to stop — the slightest exposure to light, even for the necessary purposes of inspection, continued the action, and the image was lost to view in the darkening of the whole paper. In short, they wanted the next secret, that of rendering permanent, or, in photographic language, of *fixing* the image. Here, therefore, the experiment was left to be taken up by others, though not without a memento of the prophetic light cast on the mind's eye of the great elucidator; for Sir Humphry observes, 'Nothing but a method of preventing the unshaded parts of the delineation from being coloured by the exposure to the day is wanted to render this process as useful as it is elegant.'

Meanwhile, in 1803, some remarkable experiments were made by Dr. Wollaston, proving the action of light upon a resinous substance known in commerce as 'gum guaiacum;' and in due time another workman entered the field who availed himself of this class of materials. The name of Joseph Nicéphore de Niepce is little known to the world as one of the founders of the now popular art, his contributions being exactly of that laborious and rudimental nature which later inventions serve to conceal. He was a French gentleman of private fortune, who lived at Châlons-sur-Saone, and pursued chemistry for his pleasure. Except also in the sense of time, he cannot be called a successor to Davy and Wedgwood; for it is probable that the path they had traced was unknown to him. Like them, however, he made use of the camera to cast his images; but the substance on which he received them was a polished plate of pewter, coated with a thin bituminous surface. His process is now rather one of the curiosities of photographic history; but, such as it was, it gained the one important step of rendering his creations permanent. The labours of the sun in his hands remained spell-bound, and remain so still. He began his researches in 1814, and was ten years before he attained this end. To M. Niepce also belongs the credit of having at once educed the high philosophic principle, since then universally adopted in photographic practice, which put faith before sight — the conviction of what must be before the appearance of what is. His pictures, on issuing from the camera, were invisible to the eye, and only disengaged by the application of a solvent which removed those shaded parts unhardened by the action of the light. Nor do they present the usual reversal of the position of light and shade, known in photographic language as a *negative* appearance; but whether taken from nature or from an engraving, are identical in effect, or what is called *positives*. But though, considering all these advantages, the art of Heliography, as it was called by its author, was at that early period as great a wonder as any that have followed it, yet it was deficient in those qualities which recommend a discovery to an impatient world. The process was difficult, capricious, and tedious. It does not appear that M. Niepce ever obtained an image from nature in less than between seven to twelve hours, so that the change in lights and shadows necessarily rendered it imperfect; and in a specimen we have seen, the sun is shining on opposite walls.

Deterred probably by this difficulty from any aspirations after natural scenes, M. Niepce devoted his discovery chiefly to the copying of engravings. To this he sought to give a practical use by converting his plate, by means of the application of an acid, into a surface capable of being printed by the ordinary methods. Here again he was successful, as specimens of printed impressions still show, though under circumstances too uncertain and laborious to encourage their adoption. Thus the comparative obscurity in which his merits have remained is not difficult to comprehend; for while he conquered many of the greater difficulties of the art, he left too many lesser ones for the world to follow in his steps. To these reasons may be partially attributed the little sensation which the efforts of this truly modest and ingenious gentleman created in this country, which he visited in 1827, for the purpose, he states, of exhibiting his results to the Royal Society, and of rendering homage of his discovery to his Britannic Majesty. A short memorial, drawn up by himself, was therefore forwarded, with specimens, to the hands of George IV.; but a rule on the part of the Royal Society to give no attention to a discovery which involves a secret proved a barrier to the introduction of M. Niepce's results to that body. Dr. Wollaston was the only person of scientific eminence to whom they appear to have been exhibited; and, considering their intrinsic interest, as well as the fact of his being in some sort their progenitor, it is difficult to account for the little attention he appears to have paid them. M. Niepce therefore returned to his own country, profoundly convinced of the English inaptitude for photographic knowledge.

In the mean time the indiscretion of an optician revealed to the philosopher of Châlons the fact that M. Daguerre, a dioramic artist by profession, was pursuing researches analogous to his own in Paris. This led to an acquaintance between the two, and finally to a legal partnership in the present pains and possible profits of the new art. M. Niepce died in 1833 without, it seems, contributing any further improvement to the now common stock; and M. Daguerre, continuing his labours, introduced certain alterations which finally led to a complete change in the process. Suffice it to say that, discarding the use of the bituminous varnish, and substituting a highly polished tablet of silver, he now first availed himself of that great agent in photographic

science, the action of iodine, by means of which the sensitive-ness of his plate was so increased as to render the production of the image an affair of fewer minutes than it had previously been of hours. At the same time the picture, still invisible, was brought to light by the application of the fumes of mercury, after which a strong solution of common salt removed those portions of the surface which would otherwise have continued to darken, and thus rendered the impression permanent.

Here, therefore, was a representation obtained in a few min-utes by a definite and certain process, which was exquisitely minute and clear in detail, capable of copying nature in all her stationary forms, and also true to the natural conditions of light and shade. For the fumes of mercury formed minute molecules of a white colour upon those parts of the iodised tablet darkened by the light, thus producing the lights to which the silver ground supplied the shades.

In 1839 the results of M. Daguerre's years of labour, called after himself the Daguerreotype, came forth fully furnished for use; and in the June of that year gave rise to a remarkable scene in the French Chambers. The question before the deputies was this: MM. Daguerre and Niepce jun. (for the partnership gave all the advantages of M. Daguerre's discovery to the son of his late colleague) were possessed of a secret of the utmost utility, inter-est, and novelty to the civilised world — a secret for which immense sacrifices of time, labour, and money had been made, but which, if restricted by patent for their protection, would be comparatively lost to society. A commission had therefore been appointed by the French Government to inquire into its merits, and the secret itself intrusted to M. Arago, who succeeded at once in executing a beautiful specimen of the art. Thus practi-cally convinced, he addressed the Chamber in a speech which is a masterpiece of scientific summary and philosophic conclusion. He pointed out the immense advantages which might have been derived, 'for example, during the expedition to Egypt, by a means of reproduction so exact and so rapid.' He observed that 'to copy the millions and millions of hieroglyphics which entirely cover the great monuments at Thebes, Memphis, and Carnac, &c., would require scores of years and legions of artists; whereas with the daguerreotype a single man would suffice to bring this vast labour to a happy conclusion.' He quoted the

celebrated painter De la Roche in testimony of 'the advantage to art by designs perfect as possible, and yet broad and energetic — where a finish of inconceivable minuteness in no respect disturbs the repose of the masses, nor impairs in any manner the general effect.' The scene was French in the highest sense — at once scientific, patriotic, and withal dramatic, — France herself treating for the creations of genius on the one hand, and on the other dispensing them, 'a gift to the whole world.' It was repeated in the Chamber of Peers, who, in addition to other arguments addressed to them by M. Gay-Lussac, were reminded, with a true French touch, that 'even a field of battle in all its phases may be thus delineated with a precision unattainable by any other means!' The result was that a pension of 10,000 francs was awarded for the discovery — 6000 to M. Daguerre, 4000 to M. Niepce. The seals which retained the secret were broken, and the daguerreotype became the property of the world.

We unwillingly recall a fact which rather mars the moral beauty of this interesting proceeding, viz. that by some chicanery a patent for the daguerreotype was actually taken out in England, which for a time rendered this the only country which did not profit by the liberality of the French Government. The early history of photography is not so generous in character as that of its maturity.

It may be added that all that has been since done for the daguerreotype are improvements in the same direction. It has that mark of a great invention — not to require or admit of any essential deviation from its process. Those who have contributed to perfect it are also of the same race as the inventor. The names of M. Fizeau and M. Claudet are associated with its present state. The first, by using a solution of chloride of gold, has preserved the daguerreotype from abrasion, and given it a higher tone and finish; while M. Claudet, who has variously contributed to the advance of the art, by the application of chloride of bromine with iodine, has accelerated a hundred-fold the action of the plate; at the same time, by a prolongation of a part of the process, he has, without the aid of mercury, at once converted the image into a positive, the silver ground now giving the lights instead, as before, of the shades of the picture.

We may now turn to England, and to those discoveries which, though less brilliant in immediate result, yet may be said to have

led to those practical uses which now characterise the new agent. The undivided honour of having first successfully worked out the secret of photography in England belongs to Mr. Fox Talbot. He also is a private gentleman, living in the country, and pursuing chemical researches for his own pleasure. In his case it may be strictly said that he took up the ground to which Davy and Wedgwood had made their way. Paper was the medium he adhered to from the beginning, and on which he finally gained the victory. We have no account of the repeated essays and disappointments by which this gentleman advanced step by step to the end in view. All we know is that the French success on metal and the English success on paper were, strange to say, perfectly coincident in date. Daguerre's discovery was made known in Paris in January, 1839; and in the same month Mr. Fox Talbot sent a paper to the Royal Society, giving an account of a method by which he obtained pictures on paper, rendered them unalterable by light, and by a second and simple process, which admitted of repetition to any extent, restored the lights and shadows to their right conditions.

This announcement fell, like the pictures of light themselves, upon ground highly excited in every way to receive and carry it forward. It was immediately taken up by Sir John Herschel, who commenced a series of experiments of the utmost practical importance to photography and science in general, one of the first results of which was the discovery of the hyposulphate of soda as the best agent for dissolving the superfluous salts, or, in other words, of fixing the picture. This was one of those steps which has met with general adoption. Another immediate impulse was given by a lecture read at the London Institution in April, 1839, and communicated by the Rev. J. B. Reade, recommending the use of gallic acid in addition to iodide or chloride of silver as a means of greatly increasing the sensitiveness of the preparation. Again, Mr. Robert Hunt published at the British Association at Plymouth, in 1841, another sensitive process, in which the ferrocyanate of potash was employed; and in 1844 the important use of the protosulphate of iron in bringing out, or, as it is termed, *developing* the latent picture. Other fellow-labourers might be mentioned, too, all zealous to offer some suggestion of practical use to the new-born art. Meanwhile Mr. Fox Talbot, continuing to improve on his original discovery, thought fit in

1842 to make it the subject for a patent, under the name of the calotype process. In this he is accused of having incorporated the improvements of others as well as his own, a question on which we have nothing to say, except that at this stage of the invention the tracks of the numerous exploring parties run too close to each other to be clearly identified. As to the propriety of the patent itself, no one can doubt Mr. Fox Talbot's right to avail himself of it, though the results show that the policy may be questioned. For this gentleman reaped a most inadequate return, and the development of the art was materially retarded. In the execution of a process so delicate and at best so capricious as that of photography, the experience of numbers, such as only free-trade can secure, is required to define the more or less practical methods. Mr. F. Talbot's directions, though sufficient for his own pre-instructed hand, were too vague for the tyro; and an enlistment into the ranks of the 'Pilgrims of the Sun' seldom led to any result but that of disappointment. Thus, with impediments of this serious nature, photography made but slow way in England; and the first knowledge to many even of her existence came back to us from across the Border. It was in Edinburgh where the first earnest, professional practice of the art began, and the calotypes of Messrs. Hill and Adamson remain to this day the most picturesque specimens of the new discovery.

It was at this crisis that a paper published in the 'Philosophical Transactions' of May, 1844, by Mr. George Cundell, gave in great measure the fresh stimulus that was needed. The world was full of the praise of the daguerreotype, but Mr. Cundell stood forth as the advocate of the calotype or paper process, pointed out its greater simplicity and inexpensiveness of apparatus, its infinite superiority in the power of multiplying its productions, and then proceeded to give those careful directions for the practice, which, though containing no absolutely new element, yet suggested many a minute correction where every minutia is important. With the increasing band of experimentalists who arose — for all photographers are such — now ensued the demand for some material on which to receive their pictures less expensive than the silver plate, and less capricious than paper. However convenient as a medium, this latter, from the miscellaneous nature of its antecedents, was the prolific parent of disappointment. Numerous expedients were resorted to to

50

render it more available, — it was rubbed, polished, and waxed, but, nevertheless, blotches and discolorations would perpetually appear, and that at the very moment of success, which sorely tried the photographic heart. The Journal of the Society sends up at this time one vast cry of distress on this subject, one member calling unto another for help against the common enemy. Under these circumstances many a longing eye was fixed upon glass as a substitute; and numerous experiments, among which those by Sir John Herschel were the earliest and most successful, were tried to render this material available. But glass itself was found to be an intractable material; it has no powers of absorption, and scarcely any affinities. The one thing evidently needed was to attach some transparent neutral coating of extreme tenuity to its surface, and in due time the name of Niepce again appears supplying the intermediate step between failure and success. M. Niepce de St. Victor, nephew to the inventor of heliography, is known as the author of the albumen process, which transparent and adhesive substance being applied to glass, and excited with the same chemical agents as in the calotype process, is found to produce pictures of great beauty and finish. But, ingenious as is the process, and often as it is still used, it fails of that unsurpassable fitness which alone commands universal adoption. The amalgamation of the substances is tedious and complicated, and the action of the light much slower. The albumen process was a great step, and moreover a step in the right direction; for it pointed onward to that discovery which has reduced the difficulties of the art to the lowest sum, and raised its powers, in one respect at all events, to the highest possibility, viz. to the use of collodion. The Daguerre to this Niepce was a countryman of our own — Mr. Scott Archer — who is entitled to fame not only for this marvellous improvement, but for the generosity with which he threw it open to the public. The character of the agent, too, adds interest to the invention. The birth and parentage of collodion are both among the recent wonders of the age. Gun-cotton — partly a French, partly a German discovery — is but a child in the annals of chemical science; and collodion, which is a solution of this compound in ether and alcohol, is its offspring. Its first great use was, as is well known, in the service of surgery; its second in that of photography. Not only did the adoption of this vehicle at once realise the desires of the most ardent photog-

rapher — not only, thus applied, did it provide a film of perfect transparency, tenuity, and intense adhesiveness — not only was it found easy of manipulation, portable and preservable — but it supplied that element of rapidity which more than anything else has given the miraculous character to the art. Under the magician who first attempted to enlist the powers of light in his service, the sun seems at best to have been but a sluggard; under the sorcery of Niepce he became a drudge in a twelve-hours' factory. On the prepared plate of Daguerre and on the sensitive paper of Fox Talbot the great luminary concentrates his gaze for a few earnest minutes; with the albumen-sheathed glass he takes his time more leisurely still; but at the delicate film of collodion — which hangs before him finer than any fairy's robe, and potent only with invisible spells — he literally does no more than wink his eye, tracing in that moment, with a detail and precision beyond all human power, the glory of the heavens, the wonders of the deep, the fall, not of the avalanche, but of the apple, the most fleeting smile of the babe, and the most vehement action of the man.

Further than this the powers of photography can never go; they are already more nimble than we need. Light is made to portray with a celerity only second to that with which it travels; it has been difficult to contrive the machinery of the camera to keep pace with it, and collodion has to be weakened in order to clog its wheels.

While these practical results occupied the world, more fundamental researches had been carried on. By the indefatigable exertions of Sir John Herschel and Mr. Hunt the whole scale of mineral and other simple substances were tested in conjunction with tried and untried chemical processes, showing how largely nature abounds with materials for photographic action. Preparations of gold, platinum, mercury, iron, copper, tin, nickel, manganese, lead, potash, &c., were found more or less sensitive, and capable of producing pictures of beauty and distinctive character. The juices of beautiful flowers were also put into requisition, and paper prepared with the colours of the Corchorus japonica, the common ten-weeks' stock, the marigold, the wallflower, the poppy, the rose, the Senecio splendens, &c., has been made to receive delicate though in most cases fugitive images. By these experiments, though tending little to purposes

of utility, the wide relations and sympathies of the new art have been in some measure ascertained, and its dignity in the harmonious scale of natural phenomena proportionably raised.

When once the availability of one great primitive agent is thoroughly worked out, it is easy to foresee how extensively it will assist in unravelling other secrets in natural science. The simple principle of the stereoscope, for instance, might have been discovered a century ago, for the reasoning which led to it was independent of all the properties of light, but it could never have been illustrated, far less multiplied as it now is, without photography. A few diagrams, of sufficient identity and difference to prove the truth of the principle, might have been constructed by hand for the gratification of a few sages, but no artist, it is to be hoped, could have been found possessing the requisite ability and stupidity to execute the two portraits, or two groups, or two interiors, or two landscapes, identical in every minutia of the most elaborate detail, and yet differing in point of view by the inch between the two human eyes, by which the principle is brought to the level of any capacity. Here, therefore, the accuracy and the insensibility of a machine could alone avail; and if in the order of things the cheap popular toy which the stereoscope now represents was necessary for the use of man, the photograph was first necessary for the service of the stereoscope.

And while photography is thus found ready to give its aid to other agencies, other agencies are in turn ready to co-operate with that. The invention now becoming familiar to the public by the name of photo-galvanic engraving is a most interesting instance of this reciprocity of action. That which was the chief aim of Niepce in the humblest dawn of the art, viz. to transform the photographic plate into a surface capable of being printed, which had been *bonâ fide* realised by Mr. Fox Talbot, M. Niepce de St. Victor, and others, but by methods too complicated for practical use, is now by the co-operation of electricity with photography done with the simplicity and perfection which fulfil all conditions. This invention is the work of M. Pretsch of Vienna, and deserves a few explanatory words. It differs from all other attempts for the same purpose in not operating upon the photographic tablet itself, and by discarding the usual means of varnishes and bitings in. The process is simply this. A glass tablet is

coated with gelatine diluted till it forms a jelly, and containing bichromate of potash, nitrate of silver and iodide of potassium. Upon this when dry is placed, face downwards, a paper positive, through which the light, being allowed to fall, leaves upon the gelatine a representation of the print. It is then soaked in water, and while the parts acted upon by the light are comparatively unaffected by the fluid, the remainder of the jelly swells, and rising above the general surface gives a picture in relief, resembling an ordinary engraving upon wood. Of this intaglio a cast is now taken in gutta-percha, to which the electro process in copper being applied, a plate or matrix is produced bearing on it an exact repetition of the original positive picture. All that now remains to be done is to repeat the electro process, and the result is a copper plate, in the necessary relievo, of which, as the company who have undertaken to utilise the invention triumphantly set forth, nature furnishes the materials, and science the artist, the inferior workman being only needed to roll it through the press.

And here, for the present, terminate the more important steps of photographic development, each in its turn a wonder, and each in its turn obtained and supported by wonders only a little older than itself. It was not until 1811 that the chemical substance called iodine, on which the foundations of all popular photography rest, was discovered at all; bromine, the only other substance equally sensitive, not till 1826. The invention of the electro process was about simultaneous with that of photography itself. Gutta-percha only just preceded the substance of which collodion is made; the ether and chloroform, which are used in some methods, that of collodion. We say nothing of the optical improvements purposely contrived or adapted for the service of the photograph — the achromatic lenses, which correct the discrepancy between the visual and chemical foci; the double lenses, which increase the force of the action; the binocular lenses, which do the work of the stereoscope; nor of the innumerable other mechanical aids which have sprung up for its use; all things, great and small, working together to produce what seemed at first as delightful, but as fabulous, as Aladdin's ring, which is now as little suggestive of surprise as our daily bread. It is difficult now to believe that the foundations of all this were laid within the memory of a middle-aged gentleman, by a

few lonely philosophers, incognizant of each other, each following a glimmer of light through years of toil, and looking upward to that Land of Promise to which beaten tracks and legible handposts now conduct an army of devotees. Nevertheless, there is no royal road thrown open yet. Photography is, after all, too profoundly interwoven with the deep things of Nature to be entirely unlocked by any given method. Every individual who launches his happiness on this stream finds currents and rocks not laid down in the chart. Every sanguine little couple who set up a glass-house at the commencement of summer, call their friends about them, and toil alternately in broiling light and stifling gloom, have said before long, in their hearts, 'Photography, thy name is disappointment!' But the photographic back is fitted to the burden. Although all things may be accused in turn — their chemicals, their friends, and even Nature herself — yet with the next fine day there they are at work again successively in hope, excitement, and despair, for, as Schiller says, —

'Etwas furchten, und hoffen, und sorgen
Muss der Mensch für den kommenden Morgen.'

At present no observation or experience has sufficed to determine the state of atmosphere in which the photographic spirits are most propitious; no rule or order seems to guide their proceedings. You go out on a beautifully clear day, not a breath stirring, chemicals in order, and lights and shadows in perfection; but something in the air is absent, or present, or indolent, or restless, and you return in the evening only to develop a set of blanks. The next day is cloudy and breezy, your chemicals are neglected, yourself disheartened, hope is gone, and with it the needful care; but here again something in the air is favourable, and in the silence and darkness of your chamber pictures are summoned from the vasty deep which at once obliterate all thought of failure. Happy the photographer who knows what is his enemy, or what is his friend; but in either case it is too often 'something,' he can't tell what; and all the certainty that the best of experience attains is, that you are dealing with one of those subtle agencies which, though Ariel-like it will serve you bravely, will never be taught implicitly to obey.

As respects the time of the day, however, one law seems to be thoroughly established. It has been observed by Daguerre and

subsequent photographers that the sun is far more active, in a photographic sense, for the two hours before, than for the two hours after it has passed the meridian. As a general rule, too, however numerous the exceptions, the cloudy day is better than the sunny one. Contrary, indeed, to all preconceived ideas, experience proves that the brighter the sky that shines above the camera the more tardy the action within it. Italy and Malta do their work slower than Paris. Under the brilliant light of a Mexican sun, half an hour is required to produce effects which in England would occupy but a minute. In the burning atmosphere of India, though photographical the year round, the process is comparatively slow and difficult to manage; while in the clear, beautiful, and, moreover, cool light of the higher Alps of Europe, it has been proved that the production of a picture requires many more minutes, even with the most sensitive preparations, than in the murky atmosphere of London. Upon the whole, the temperate skies of this country may be pronounced most favourable to photographic action, a fact for which the prevailing characteristic of our climate may partially account, humidity being an indispensable condition for the working state both of paper and chemicals.

But these are at most but superficial influences — deeper causes than any relative dryness or damp are concerned in these phenomena. The investigation of the solar attributes, by the aid of photographic machinery, for which we are chiefly indebted to the researches of Mr. Hunt and M. Claudet, are, scientifically speaking, the most interesting results of the discovery. By these means it is proved that besides the functions of light and heat the solar ray has a third, and what may be called photographic function, the cause of all the disturbances, decompositions, and chemical changes which affect vegetable, animal, and organic life. It had long been known that this power, whatever it may be termed — energia — actinism — resided more strongly, or was perhaps less obstructed, in some of the coloured rays of the spectrum than in others — that solutions of silver and other sensitive surfaces were sooner darkened in the violet and the blue than in the yellow and red portions of the prismatic spectrum. Mr. Hunt's experiments further prove that mere light, or the luminous ray, is little needed where the photographic or 'chemical ray' is active, and that sensitive paper placed beneath

the comparative darkness of a glass containing a dense purple fluid, or under that deep blue glass commonly used as a finger-glass, is photographically affected almost as soon as if not shaded from the light at all. Whereas, if the same experiment be tried under a yellow glass or fluid, the sensitive paper, though robbed neither of light nor heat, will remain a considerable time without undergoing any change.[2]

We refer our readers to this work for results of the utmost interest — our only purpose is to point out that the defects or irregularities of photography are as inherent in the laws of Nature as its existence — being coincident with the first created of all things. The prepared paper or plate which we put into the camera may be compared to a chaos, without form and void, on which the merest glance of the sun's rays calls up image after image till the fair creation stands revealed: yet not revealed in the order in which it met the solar eye, for while some colours have hastened to greet his coming, others have been found slumbering at their posts, and have been left with darkness in their lamps. So impatient have been the blues and violets to perform their task upon the recipient plate, that the very substance of the colour has been lost and dissolved in the solar presence; while so laggard have been the reds and yellows and all tints partaking of them, that they have hardly kindled into activity before the light has been withdrawn. Thus it is that the relation of one colour to another is found changed and often reversed, the deepest blue being altered from a dark mass into a light one, and the most golden-yellow from a light body into a dark.

It is obvious, therefore, that however successful photography may be in the closest imitation of light and shadow, it fails, and must fail, in the rendering of true chiaroscuro, or the true imitation of light and dark. And even if the world we inhabit, instead of being spread out with every variety of the palette, were constituted but of two colours — black and white and all their intermediate grades — if every figure were seen in monochrome like those that visited the perturbed vision of the Berlin Nicolai — photography could still not copy them correctly. Nature, we must remember, is not made up only of actual lights and shadows; besides these more elementary masses, she possesses innumerable reflected lights and half-tones, which play around

57

every object, rounding the hardest edges, and illuminating the blackest breadths, and making that sunshine in a shady place, which it is the delight of the practised painter to render. But of all these photography gives comparatively no account. The beau ideal of a Turner and the delight of a Rubens are caviar to her. Her strong shadows swallow up all timid lights within them, as her blazing lights obliterate all intrusive half-tones across them; and thus strong contrasts are produced, which, so far from being true to Nature, it seems one of Nature's most beautiful provisions to prevent.

Nor is this disturbance in the due degrees of chiaroscuro attributable only to the different affinities for light residing in different colours, or to the absence of true gradation in light and shade. The quality and texture of a surface has much to do with it. Things that are very smooth, such as glass and polished steel, or certain complexions and parts of the human face, or highly-glazed satin-ribbon — or smooth leaves, or brass-buttons — everything on which the light *shines*, as well as everything that is perfectly white, will photograph much faster than other objects, and thus disarrange the order of relation. Where light meets light the same instantaneous command seems to go forth as that by which it was at first created, so that, by the time the rest of the picture has fallen into position, what are called the high lights have so rioted in action as to be found far too prominent both in size and intensity.

And this brings us to the artistic part of our subject, and to those questions which sometimes puzzle the spectator, as to how far photography is really a picturesque agent, what are the causes of its successes and its failures, and what in the sense of art are its successes and failures? And these questions may be fairly asked now when the scientific processes on which the practice depends are brought to such perfection that, short of the coveted attainment of colour, no great improvement can be further expected. If we look round a photographic exhibition we are met by results which are indeed honourable to the perseverance, knowledge, and in some cases to the taste of man. The small, broadly-treated, Rembrandt-like studies representing the sturdy physiognomies of Free Church Ministers and their adherents, which first cast the glamour of photography upon us, are replaced by portraits of the most elaborate detail, and of every

size not excepting that of life itself. The little bit of landscape effect, all blurred and uncertain in forms, and those lost in a confused and discoloured ground, which was nothing and might be anything, is superseded by large pictures with minute foregrounds, regular planes of distance, and perfectly clear skies. The small attempts at architecture have swelled into monumental representations of a magnitude, truth, and beauty which no art can surpass — animals, flowers, pictures, engravings, all come within the grasp of the photographer; and last, and finest, and most interesting of all, the sky with its shifting clouds, and the sea with its heaving waves, are overtaken in their course by a power more rapid than themselves.

But while ingenuity and industry — the efforts of hundreds working as one — have thus enlarged the scope of the new agent, and rendered it available for the most active, as well as for the merest still life, has it gained in an artistic sense in like proportion? Our answer is not in the affirmative, nor is it possible that it should be so. Far from holding up the mirror to nature, which is an assertion usually as triumphant as it is erroneous, it holds up that which, however beautiful, ingenious, and valuable in powers of reflection, is yet subject to certain distortions and deficiencies for which there is no remedy. The science therefore which has developed the resources of photography, has but more glaringly betrayed its defects. For the more perfect you render an imperfect machine the more must its imperfections come to light: it is superfluous therefore to ask whether Art has been benefited, where Nature, its only source and model, has been but more accurately falsified. If the photograph in its early and imperfect scientific state was more consonant to our feelings for art, it is because, as far as it went, it was more true to our experience of Nature. Mere broad light and shade, with the correctness of general forms and absence of all convention, which are the beautiful conditions of photography, will, when nothing further is attempted, give artistic pleasure of a very high kind; it is only when greater precision and detail are superadded that the eye misses the further truths which should accompany the further finish.

For these reasons it is almost needless to say that we sympathise cordially with Sir William Newton, who at one time created no little scandal in the Photographic Society by propounding the

heresy that pictures taken slightly out of focus, that is, with slightly uncertain and undefined forms, 'though less *chemically*, would be found more *artistically* beautiful.' Much as photography is supposed to inspire its votaries with aesthetic instincts, this excellent artist could hardly have chosen an audience less fitted to endure such a proposition. As soon could an accountant admit the morality of a false balance, or a sempstress the neatness of a puckered seam, as your merely scientific photographer be made to comprehend the possible beauty of 'a slight *burr*.' His mind proud science never taught to doubt the closest connexion between cause and effect, and the suggestion that the worse photography could be the better art was not only strange to him, but discordant. It was hard too to disturb his faith in his newly acquired powers. Holding, as he believed, the keys of imitation in his camera, he had tasted for once something of the intoxicating dreams of the artist; gloating over the pictures as they developed beneath his gaze, he had said in his heart 'anch' io son pittore.' Indeed there is no lack of evidence in the Photographic Journal of his believing that art had hitherto been but a blundering groper after that truth which the cleanest and precisest photography in his hands was now destined to reveal. Sir William Newton, therefore, was fain to allay the storm by qualifying his meaning to the level of photographic toleration, knowing that, of all the delusions which possess the human breast, few are so intractable as those about art.

But let us examine a little more closely those advances which photography owes to science — we mean in an artistic sense. We turn to the portraits, our *premiers amours,* now taken under every appliance of facility both for sitter and operator. Far greater detail and precision accordingly appear. Every button is seen — piles of stratified flounces in most accurate drawing are there, — what was at first only suggestion is now all careful making out, — but the likeness to Rembrandt and Reynolds is gone! There is no mystery in this. The first principle in art is that the most important part of a picture should be best done. Here, on the contrary, while the dress has been rendered worthy of a fashion-book, the face has remained, if not so unfinished as before, yet more unfinished in proportion to the rest. Without referring to M. Claudet's well-known experiment of a falsely coloured female face, it may be averred that, of all the surfaces a few inches square the sun looks upon, none offers more diffi-

culty, artistically speaking, to the photographer, than a smooth, blooming, clean washed, and carefully combed human head. The high lights which gleam on this delicate epidermis so spread and magnify themselves, that all sharpness and nicety of modelling is obliterated — the fineness of skin peculiar to the under lip reflects so much light, that in spite of its deep colour it presents a light projection, instead of a dark one — the spectrum or intense point of light on the eye is magnified to a thing like a cataract. If the cheek be very brilliant in colour, it is as often as not represented by a dark stain. If the eye be blue, it turns out as colourless as water; if the hair be golden or red, it looks as if it had been dyed, if very glossy it is cut up into lines of light as big as ropes. This is what a fair young girl has to expect from the tender mercies of photography — the male and the older head, having less to lose, has less to fear. Strong light and shade will portray character, though they mar beauty. Rougher skin, less glossy hair, Crimean moustaches and beard overshadowing the white under lip, and deeper lines, are all so much in favour of a picturesque result. Great grandeur of feature too, or beauty of *pose* and sentiment, will tell as elevated elements of the picturesque in spite of photographic mismanagement. Here and there also a head of fierce and violent contrasts, though taken perhaps from the meekest of mortals, will remind us of the Neapolitan or Spanish school, but, generally speaking, the inspection of a set of faces, subject to the usual conditions of humanity and the camera, leaves us with the impression that a photographic portrait, however valuable to relative or friend, has ceased to remind us of a work of art at all.

And, if further proof were wanted of the artistic inaptitude of this agent for the delineation of the human countenance, we should find it in those magnified portraits which ambitious operators occasionally exhibit to our ungrateful gaze. Rightly considered, a human head, the size of life, of average intelligence, and in perfect drawing, may be expected, however roughly finished, to recall an old Florentine fresco of four centuries ago. But, 'ex nihilo, nihil fit:' the best magnifying lenses can in this case only impoverish in proportion as they enlarge, till the flat and empty Magog which is born of this process is an insult, even in remotest comparison with the pencil of a Masaccio.

The falling off of artistic effect is even more strikingly seen if

we consider the department of landscape. Here the success with which all accidental blurs and blotches have been overcome, and the sharp perfection of the object which stands out against the irreproachably speckless sky, is exactly as detrimental to art as it is complimentary to science. The first impression suggested by these buildings of rich tone and elaborate detail, upon a glaring white background without the slightest form or tine, is that of a Chinese landscape upon looking-glass. We shall be asked why the beautiful skies we see in the marine pieces cannot be also represented with landscapes; but here the conditions of photography again interpose. The impatience of light to meet light is, as we have stated, so great, that the moment required to trace the forms of the sky (it can never be traced in its cloudless gradation of tint) is too short for the landscape, and the moment more required for landscape too long for the sky. If the sky be given, therefore, the landscape remains black and underdone; if the landscape be rendered, the impatient action of the light has burnt out all cloud-form in one blaze of white. But it is different with the sea, which, from the liquid nature of its surface, receives so much light as to admit of simultaneous representation with the sky above it. Thus the marine painter has both hemispheres at his command, but the landscape votary but one; and it is but natural that he should prefer Rydal Mount and Tintern Abbey to all the baseless fabric of tower and hill which the firmament occasionally spreads forth. But the old moral holds true even here. Having renounced heaven, earth makes him, of course, only an inadequate compensation. The colour green, both in grass and foliage, is now his great difficulty. The finest lawn turns out but a gloomy funeral-pall in his hands; his trees, if done with the slower paper process, are black, and from the movement, uncertain webs against the white sky, — if by collodion, they look as if worked in dark cambric, or stippled with innumerable black and white specks; in either case missing all the breadth and gradations of nature. For it must be remembered that every leaf reflects a light on its smooth edge or surface, which, with the tendency of all light to over-action, is seen of a size and prominence disproportioned to things around it; so that what with the dark spot produced by the green colour, and the white spot produced by the high light, all intermediate grades and shades are lost. This is especially the case with hollies, laurels, ivy, and

other smooth-leaved evergreens, which form so conspicuous a feature in English landscape gardening — also with foreground weeds and herbage, which, under these conditions, instead of presenting a sunny effect, look rather as if strewn with shining bits of tin, or studded with patches of snow.

For these reasons, if there be a tree distinguished above the rest of the forest for the harshness and blueness of its foliage, we may expect to find it suffer less, or not at all, under this process. Accordingly, the characteristic exception will be found in the Scotch fir, which, however dark and sombre in mass, is rendered by the photograph with a delicacy of tone and gradation very grateful to the eye. With this exception it is seldom that we find any studies of trees, in the present improved state of photography, which inspire us with the sense of pictorial truth. Now and then a bank of tangled brushwood, with a deep, dark pool beneath, but with no distance and no sky, and therefore no condition of relation, will challenge admiration. Winter landscapes also are beautiful, and the leafless Burnham beeches a real boon to the artist; but otherwise such materials as Hobbema, Ruysdael, and Cuyp converted into pictures unsurpassable in picturesque effect are presented in vain to the improved science of the photographic artist. What strikes us most frequently is the general *emptiness* of the scene he gives. A house stands there, sharp and defined like a card-box, with black blots of trees on each side, all rooted in a substance far more like burnt stubble than juicy, delicate grass. Through this winds a white spectral path, while staring palings or linen hung out to dry (oh! how unlike the luminous spots on Ruysdael's bleaching-grounds!), like bits of the white sky dropped upon the earth, make up the poverty and patchiness of the scene. We are aware that there are many partial exceptions to this; indeed, we hardly ever saw a photograph in which there was not something or other of the most exquisite kind. But this brings us no nearer the standard we are seeking. Art cares not for the right finish unless it be in the right place. Her great aim is to produce a whole; the more photography advances in the execution of parts, the less does it give the idea of completeness.

There is nothing gained either by the selection of more ambitious scenery. The photograph seems embarrassed with the treatment of several gradations of distance. The finish of back-

ground and middle distance seems not to be commensurate with that of the foreground; the details of the simplest light and shadow are absent; all is misty and bare, and distant hills look like flat, grey moors washed in with one gloomy tint. This emptiness is connected with the rapidity of collodion, the action of which upon distance and middle ground does not keep pace with the hurry of the foreground. So much for the ambition of taking a picture. On the other hand, we have been struck with mere studies of Alpine masses done with the paper process, which allows the photograph to take its time, and where, from the absence of all foreground or intermediate objects, the camera has been able to concentrate its efforts upon one thing only — the result being records of simple truth and precision which must be invaluable to the landscape-painter.

There is no doubt that the forte of the camera lies in the imitation of one surface only, and that of a rough and broken kind. Minute light and shade, cognisant to the eye, but unattainable by hand, is its greatest and easiest triumph — the mere texture of stone, whether rough in the quarry or hewn on the wall, its especial delight. Thus a face of rugged rock, and the front of a carved and fretted building, are alike treated with a perfection which no human skill can approach; and if asked to say what photography has hitherto best succeeded in rendering, we should point to everything near and rough — from the texture of the sea-worn shell, of the rusted armour, and the fustian jacket, to those glorious architectural pictures of French, English, and Italian subjects, which, whether in quality, tone, detail, or drawing, leave nothing to be desired.

Here, therefore, the debt to Science for additional clearness, precision, and size may be gratefully acknowledged. What photography can do, is now, with her help, better done than before; what she can but partially achieve is best not brought too elaborately to light. Thus the whole question of success and failure resolves itself into an investigation of the capacities of the machine, and well may we be satisfied with the rich gifts it bestows, without straining it into a competition with art. For everything for which Art, so-called, has hitherto been the means but not the end, photography is the allotted agent — for all that requires mere manual correctness, and mere manual slavery, without any employment of the artistic feeling, she is the proper

and therefore the perfect medium. She is made for the present age, in which the desire for art resides in a small minority, but the craving, or rather necessity, for cheap, prompt, and correct facts in the public at large. Photography is the purveyor of such knowledge to the world. She is the sworn witness of everything presented to her view. What are her unerring records in the service of mechanics, engineering, geology, and natural history, but facts of the most sterling and stubborn kind? What are her studies of the various stages of insanity — pictures of life unsurpassable in pathetic truth — but facts as well as lessons of the deepest physiological interest? What are her representations of the bed of the ocean, and the surface of the moon — of the launch of the Marlborough, and of the contents of the Great Exhibition — of Charles Kean's now destroyed scenery of the 'Winter's Tale,' and of Prince Albert's now slaughtered prize ox — but facts which are neither the province of art nor of description, but of that new form of communication between man and man — neither letter, message, nor picture — which now happily fills up the space between them? What indeed are nine-tenths of those facial maps called photographic portraits, but accurate landmarks and measurements for loving eyes and memories to deck with beauty and animate with expression, in perfect certainty, that the ground-plan is founded upon fact?

In this sense no photographic picture that ever was taken, in heaven, or earth, or in the waters underneath the earth, of any thing, or scene, however defective when measured by an artistic scale, is destitute of a special, and what we may call an historic interest. Every form which is traced by light is the impress of one moment, or one hour, or one age in the great passage of time. Though the faces of our children may not be modelled and rounded with that truth and beauty which art attains, yet minor things — the very shoes of the one, the inseparable toy of the other — are given with a strength of identity which art does not even seek. Though the view of a city be deficient in those niceties of reflected lights and harmonious gradations which belong to the facts of which Art takes account, yet the facts of the age and of the hour are there, for we count the lines in that keen perspective of telegraphic wire, and read the characters on that playbill or manifesto, destined to be torn down on the morrow.

Here, therefore, the much-lauded and much-abused agent

called Photography takes her legitimate stand. Her business is to give evidence of facts, as minutely and as impartially as, to our shame, only an unreasoning machine can give. In this vocation we can as little overwork her as we can tamper with her. The millions and millions of hieroglyphics mentioned by M. Arago may be multiplied by millions and millions more, — she will render all as easily and as accurately as one. When people, therefore, talk of photography as being intended to supersede art, they utter what, if true, is not so in the sense they mean. Photography *is* intended to supersede much that art has hitherto done, but only that which it was both a misappropriation and a deterioration of Art to do. The field of delineation, having two distinct spheres, requires two distinct labourers; but though hitherto the freewoman has done the work of the bondwoman, there is no fear that the position should be in future reversed. Correctness of drawing, truth of detail, and absence of convention, the best artistic characteristics of photography, are qualities of no common kind, but the student who issues from the academy with these in his grasp stands, nevertheless, but on the threshold of art. The power of selection and rejection, the living application of that language which lies dead in his paint-box, the marriage of his own mind with the object before him, and the offspring, half stamped with his own features, half with those of Nature, which is born of the union — whatever appertains to the free-will of the intelligent being, as opposed to the obedience of the machine, — this, and much more than this, constitutes that mystery called Art, in the elucidation of which photography can give valuable help, simply by showing what it is not. There is, in truth, nothing in that power of literal, unreasoning imitation, which she claims as her own, in which, rightly viewed, she does not relieve the artist of a burden rather than supplant him in an office. We do not even except her most pictorial feats — those splendid architectural representations — from this rule. Exquisite as they are, and fitted to teach the young, and assist the experienced in art, yet the hand of the artist is but ignobly employed in closely imitating the texture of stone, or in servilely following the intricacies of the zigzag ornament. And it is not only in what she can do to relieve the sphere of art, but in what she can sweep away from it altogether, that we have reason to congratulate ourselves. Henceforth it may be hoped that we

66

shall hear nothing further of that miserable contradiction in terms 'bad art' — and see nothing more of that still more miserable mistake in life 'a bad artist.' Photography at once does away with anomalies with which the good sense of society has always been more or less at variance. As what she does best is beneath the doing of a real artist at all, so even in what she does worst she is a better machine than the man who is nothing but a machine.

Let us, therefore, dismiss all mistaken ideas about the harm which photography does to art. As in all great and sudden improvements in the material comforts and pleasures of the public, numbers, it is true, have found their occupation gone, simply because it is done cheaper and better in another way. But such improvements always give more than they take. Where ten self-styled artists eked out a precarious living by painting inferior miniatures, ten times that number now earn their bread by supplying photographic portraits. Nor is even such manual skill as they possessed thrown out of the market. There is no photographic establishment of any note that does not employ artists at high salaries — we understand not less than 1£ a day — in touching, and colouring, and finishing from nature those portraits for which the camera may be said to have laid the foundation. And it must be remembered that those who complain of the encroachments of photography in this department could not even supply the demand. Portraits, as is evident to any thinking mind, and as photography now proves, belong to that class of facts wanted by numbers who know and care nothing about their value as works of art. For this want, art, even of the most abject kind, was, whether as regards correctness, promptitude, or price, utterly inadequate. These ends are not only now attained, but, even in an artistic sense, attained far better than before. The coloured portraits to which we have alluded are a most satisfactory coalition between the artist and the machine. Many an inferior miniature-painter who understood the mixing and applying of pleasing tints was wholly unskilled in the true drawing of the human head. With this deficiency supplied, their present productions, therefore, are far superior to anything they accomplished, single-handed, before. Photographs taken on ivory, or on substances invented in imitation of ivory, and coloured by hand from nature, such as are seen at the rooms of Messrs. Dickinson, Claudet, Mayall, Kilburn, &c., are all that can be

needed to satisfy the mere portrait want, and in some instances may be called artistic productions of no common kind besides. If, as we understand, the higher professors of miniature-painting — and the art never attained greater excellence in England than now — have found their studios less thronged of late, we believe that the desertion can be but temporary. At all events, those who in future desire their exquisite productions will be more worthy of them. The broader the ground which the machine may occupy, the higher will that of the intelligent agent be found to stand. If, therefore, the time should ever come when art is sought, as it ought to be, mainly for its own sake, our artists and our patrons will be of a far more elevated order than now: and if anything can bring about so desirable a climax, it will be the introduction of Photography.

1. An account of a method of copying paintings upon glass and of making *profiles* by the agency of light upon nitrate of silver, with observations by Humphry Davy.

2. We may add, though foreign to our subject, that the same experiment applied by Mr. Hunt to plants has been attended with analogous results. Bulbs of tulips and ranunculuses have germinated beneath yellow and red glasses, but the plant has been weakly and has perished without forming buds. Under a green glass (blue being a component part of the colour) the plants have been less feeble, and have advanced as far as flower-buds; while beneath the blue medium perfectly healthy plants have grown up, developing their buds, and flowering in perfection.

Part Two:
Victorian Debates

The Stereoscope and the Stereograph

Oliver Wendell Holmes (1809–1894)

The belief in photographic objectivity characterized most popular American attitudes toward photography during the mid-nineteenth century. Speculations on the meaning of photography for society by the renowned Boston physician, poet, and humorist Oliver Wendell Holmes convey this view of photographs as direct impressions of the visible world. Though Holmes spent most of his life as a successful physician and professor at the Harvard Medical School, he cultivated an interest in contemporary American culture, which included an active concern for the new art of photography. He wrote three articles discussing the medium, "The Stereoscope and the Stereograph," "Sun-Painting and Sun-Sculpture, with a Stereoscopic Trip across the Atlantic," and "Doings of the Sunbeam," which appeared in the Atlantic Monthly *respectively in 1859, 1861, and 1863. He also was elected an honorary member of the amateur photographers' American Photographic Exchange Club.*

Holmes marveled at the invention of a process of visual representation that he thought separated the form of objects from the physical objects themselves. He described photography as a purely mechanical and objective copying procedure devoid of human selection or composition. He thought that in making photographs, the sun composed according to the same rules as mid-nineteenth-century academic realist artists, though more perfectly. And he was deeply affected by the artistic and rhetorical powers of many photographs he examined.

Holmes wrote most extensively on the three-dimensionally illusionistic photographs then in vogue, for which he coined the term stereograph. *When placed behind a specially ground pair of lenses, in a viewer Holmes invented, these double images appear as a single three-dimensional scene. Stereo pictures impressed Holmes as the most convincingly realistic representations. He went so far as to suggest that original objects lost their value now that their forms could be extracted and distributed in an infinite number of pictures. Through stereographs, the world could easily be at any man's fingertips. Holmes believed this ability to divorce form from matter to be the most significant human achievement of all time.*

71

Democritus of Abdera, commonly known as the Laughing Philosopher, probably because he did not consider the study of truth inconsistent with a cheerful countenance, believed and taught that all bodies were continually throwing off certain images like themselves, which subtile emanations, striking on our bodily organs, gave rise to our sensations. Epicurus borrowed the idea from him, and incorporated it into the famous system, of which Lucretius has given us the most popular version. Those who are curious on the matter will find the poet's description at the beginning of his fourth book. Forms, effigies, membranes, or *films,* are the nearest representatives of the terms applied to these effluences. They are perpetually shed from the surfaces of solids, as bark is shed by trees. *Cortex* is, indeed, one of the names applied to them by Lucretius.

These evanescent films may be seen in one of their aspects in any clear, calm sheet of water, in a mirror, in the eye of an animal by one who looks at it in front, but better still by the consciousness behind the eye in the ordinary act of vision. They must be packed like the leaves of a closed book; for suppose a mirror to give an image of an object a mile off, it will give one at every point less than a mile, though this were subdivided into a million parts. Yet the images will not be the same; for the one taken a mile off will be very small, at half a mile as large again, at a hundred feet, fifty times as large, and so on, as long as the mirror can contain the image.

Under the action of light, then, a body makes its superficial aspect potentially present at a distance, becoming appreciable as a shadow or as a picture. But remove the cause,—the body itself,—and the effect is removed. The man beholdeth himself in the glass, and goeth his way, and straightway both the mirror and the mirrored forget what manner of man he was. These visible films or membranous *exuviæ* of objects, which the old philosophers talked about, have no real existence, separable from their illuminated source, and perish instantly when it is withdrawn.

If a man had handed a metallic speculum to Democritus of Abdera, and told him to look at his face in it while his heart was beating thirty or forty times, promising that one of the films his face was shedding should stick there, so that neither he, nor it, nor anybody should forget what manner of man he was, the

Laughing Philosopher would probably have vindicated his claim to his title by an explosion that would have astonished the speaker.

This is just what the Daguerreotype has done. It has fixed the most fleeting of our illusions, that which the apostle and the philosopher and the poet have alike used as the type of instability and unreality. The photograph has completed the triumph, by making a sheet of paper reflect images like a mirror and hold them as a picture.

This triumph of human ingenuity is the most audacious, remote, improbable, incredible,—the one that would seem least likely to be regained, if all traces of it were lost, of all the discoveries man has made. It has become such an everyday matter with us, that we forget its miraculous nature, as we forget that of the sun itself, to which we owe the creations of our new art. Yet in all the prophecies of dreaming enthusiasts, in all the random guesses of the future conquests over matter, we do not remember any prediction of such an inconceivable wonder, as our neighbor round the corner, or the proprietor of the small house on wheels, standing on the village common, will furnish any of us for the most painfully slender remuneration. No Century of Inventions includes this among its possibilities. Nothing but the vision of a Laputan, who passed his days in extracting sunbeams out of cucumbers, could have reached such a height of delirium as to rave about the time when a man should paint his miniature by looking at a blank tablet, and a multitudinous wilderness of forest foliage or an endless Babel of roofs and spires stamp itself, in a moment, so faithfully and so minutely, that one may creep over the surface of the picture with his microscope and find every leaf perfect, or read the letters of distant signs, and see what was the play at the "Variétés" or the "Victoria" on the evening of the day when it was taken, just as he would sweep the real view with a spy-glass to explore all that it contains.

Some years ago, we sent a page or two to one of the magazines,—the "Knickerbocker," if we remember aright,—in which the story was told from the "Arabian Nights," of the three kings' sons, who each wished to obtain the hand of a lovely princess, and received for answer, that he who brought home the most wonderful object should obtain the lady's hand as his reward. Our readers, doubtless, remember the original tale, with

the flying carpet, the tube which showed what a distant friend was doing by looking into it, and the apple which gave relief to the most desperate sufferings only by inhalation of its fragrance. The railroad-car, the telegraph, and the apple-flavored chloroform, could and do realize, every day,—as was stated in the passage referred to, with a certain rhetorical amplitude not doubtfully suggestive of the lecture-room,—all that was fabled to have been done by the carpet, the tube, and the fruit of the Arabian story.

All these inventions force themselves upon us to the full extent of their significance. It is therefore hardly necessary to waste any considerable amount of rhetoric upon wonders that are so thoroughly appreciated. When human art says to each one of us, I will give you cars that can hear a whisper in New Orleans, and legs that can walk six hundred miles in a day, and if, in consequence of any defect of rail or carriage, you should be so injured that your own very insignificant walking members must be taken off, I can make the surgeon's visit a pleasant dream for you, on awaking from which you will ask when he is coming to do that which he has done already,—what is the use of poetical or rhetorical amplification? But this other invention of *the mirror with a memory*, and especially that application of it which has given us the wonders of the stereoscope, is not so easily, completely, universally recognized in all the immensity of its applications and suggestions. The stereoscope, and the pictures it gives, are, however, common enough to be in the hands of many of our readers; and as many of those who are not acquainted with it must before long become as familiar with it as they are now with friction-matches, we feel sure that a few pages relating to it will not be unacceptable. . . .

A stereoscope is an instrument which makes surfaces look solid. All pictures in which perspective and light and shade are properly managed, have more or less of the effect of solidity; but by this instrument that effect is so heightened as to produce an appearance of reality which cheats the senses with its seeming truth.

There is good reason to believe that the appreciation of solidity by the eye is purely a matter of education. The famous case of a young man who underwent the operation of couching for cataract, related by Cheselden, and a similar one reported in the

74

Appendix to Müller's Physiology, go to prove that everything is seen only as a superficial extension, until the other senses have taught the eye to recognize *depth*, or the third dimension, which gives solidity, by converging outlines, distribution of light and shade, change of size and of the texture of surfaces. Cheselden's patient thought "all objects whatever touched his eyes, as what he felt did his skin." The patient whose case is reported by Müeller could not tell the form of a cube held obliquely before his eye from that of a flat piece of pasteboard presenting the same outline. Each of these patients saw only with one eye,—the other being destroyed, in one case, and not restored to sight until long after the first, in the other case. In two months' time Cheselden's patient had learned to know solids; in fact, he argued so logically from light and shade and perspective, that he felt of pictures, expecting to find reliefs and depressions, and was surprised to discover that they were flat surfaces. If these patients had suddenly recovered the sight of *both* eyes, they would probably have learned to recognize solids more easily and speedily.

We can commonly tell whether an object is solid, readily enough with one eye, but still better with two eyes, and sometimes *only* by using both. If we look at a square piece of ivory with one eye alone, we cannot tell whether it is a scale of veneer, or the side of a cube, or the base of a pyramid, or the end of a prism. But if we now open the other eye, we shall see one or more of its sides, if it have any, and then know it to be a solid, and what kind of a solid.

We see something with the second eye, which we did not see with the first; in other words, the two eyes see different pictures of the same thing, for the obvious reason that they look from points two or three inches apart. By means of these two different views of an object, the mind, as it were, *feels round it* and gets an idea of its solidity. We clasp an object with our eyes, as with our arms, or with our hands, or with our thumb and finger, and then we know it to be something more than a surface. This, of course, is an illustration of the fact, rather than an explanation of its mechanism.

Though, as we have seen, the two eyes look on two different pictures, we perceive but one picture. The two have run together and become blended in a third, which shows us everything we

see in each. But, in order that they should so run together, both the eye and the brain must be in a natural state. Push one eye a little inward with the forefinger, and the image is doubled, or at least infused. Only certain parts of the two retina work harmoniously together, and you have disturbed their natural relations. Again, take two or three glasses more than temperance permits, and you see double; the eyes are right enough, probably, but the brain is in trouble, and does not report their telegraphic messages correctly. These exceptions illustrate the every-day truth, that, when we are in right condition, our two eyes see two somewhat different pictures, which our perception combines to form one picture, representing objects in all their dimensions, and not merely on surfaces.

Now, if we can get two artificial pictures of any given object, one as we should see it with the right eye, the other as we should see it with the left eye, and then, looking at the right picture, and that only, with the right eye, and at the left picture, and that only, with the left eye, contrive some way of making these pictures run together as we have seen our two views of a natural object do, we shall get the sense of solidity that natural objects give us. The arrangement which effects it will be a *stereoscope*, according to our definition of that instrument. How shall we attain these two ends?

An artist can draw an object as he sees it, looking at it only with his right eye. Then he can draw a second view of the same object as he sees it with his left eye. It will not be hard to draw a cube or an octahedron in this way; indeed, the first stereoscopic figures were pairs of outlines, right and left, of solid bodies thus drawn. But the minute details of a portrait, a group, or a landscape, all so nearly alike to the two eyes, yet not identical in each picture of our natural double view, would defy any human skill to reproduce them exactly. And just here comes in the photograph to meet the difficulty. A first picture of an object is taken; then the instrument is moved a couple of inches or a little more, the distance between the human eyes, and a second picture is taken. Better than this, two pictures are taken at once in a double camera. . . .

We have now obtained the double-eyed or twin pictures, or STEREOGRAPH, if we may coin a name. But the pictures are two, and we want to slide them into each other, so to speak, as in

76

natural vision, that we may see them as one. How shall we make one picture out of two, the corresponding parts of which are separated by a distance of two or three inches?

We can do this in two ways. First, by *squinting* as we look at them. But this is tedious, painful, and to some impossible, or at least very difficult. We shall find it much easier to look through a couple of glasses that *squint for us*. If at the same time they *magnify* the two pictures, we gain just so much in the distinctness of the picture, which, if the figures on the slide are small, is a great advantage. One of the easiest ways of accomplishing this double purpose is to cut a convex lens through the middle, grind the curves of the two halves down to straight lines, and join them by their thin edges. This is a *squinting magnifier;* and if arranged as that with its right half we see the right picture on the slide, and with its left half the left picture, it squints them both inward, so that they run together and form a single picture.

Such are the stereoscope and the photograph, by the aid of which *form* is henceforth to make itself seen through the world of intelligence, as thought has long made itself heard by means of the art of printing. The *morphotype*, or form-print, must hereafter take its place by the side of the *logotype*, or wordprint. The *stereograph*, as we have called the double picture designed for the stereoscope, is to be the card of introduction to make all mankind acquaintances.

The first effect of looking at a good photograph through the stereoscope is a surprise such as no painting ever produced. The mind feels its way into the very depths of the picture. The scraggy branches of a tree in the foreground run out at us as if they would scratch our eyes out. The elbow of a figure stands forth so as to make us almost uncomfortable. Then there is such a frightful amount of detail, that we have the same sense of infinite complexity which Nature gives us. A painter shows us masses; the stereoscopic figure spares us nothing,—all must be there, every stick, straw, scratch, as faithfully as the dome of St. Peter's, or the summit of Mont Blanc, or the ever-moving stillness of Niagara. The sun is no respecter of persons or of things.

This is one infinite charm of the photographic delineation. Theoretically, a perfect photograph is absolutely inexhaustible. In a picture you can find nothing which the artist has not seen before you; but in a perfect photograph there will be as many

beauties lurking, unobserved, as there are flowers that blush unseen in forests and meadows. It is a mistake to suppose one knows a stereoscopic picture when he has studied it a hundred times by the aid of the best of our common instruments. Do we know all that there is to a landscape by looking out at it from our parlor windows? In one of the glass stereoscopic views of Table Rock, two figures, so minute as to be mere objects of comparison with the surrounding vastness, may be seen standing side by side. Look at the two faces with a strong magnifier, and you could identify their owners, if you met them in a court of law.

Many persons suppose that they are looking on *miniatures* of the objects represented, when they see them in the stereoscope. They will be surprised to be told that they see most objects as large as they appear in nature. A few simple experiments will show how what we see in ordinary vision is modified in our perceptions by what we think we see. We made a sham stereoscope, the other day, with no glasses, and an opening in the place where the pictures belong, about the size of one of the common stereoscopic pictures. Through this we got a very ample view of the town of Cambridge, including Mount Auburn and the Colleges, in a single field of vision. We do not recognize how minute distant objects really look to us, without something to bring the fact home to our conceptions. A man does not deceive us as to his real size when we see him at the distance of the length of Cambridge Bridge. But hold a common black pin before the eyes at the distance of distinct vision, and one twentieth of its length, nearest the point, is enough to cover him so that he cannot be seen. The head of the same pin will cover one of the Cambridge horsecars at the same distance, and conceal the tower of Mount Auburn, as seen from Boston.

We are near enough to an edifice to see it well, when we can easily read an inscription upon it. The stereoscopic views of the arches of Constantine and of Titus give not only every letter of the old inscriptions, but render the grain of the stone itself. On the pediment of the Pantheon may be read, not only the words traced by Agrippa, but a rough inscription above it, scratched or hacked into the stone by some wanton hand during an insurrectionary tumult.

This distinctness of the lesser details of a building or a landscape often gives us incidental truths which interest us more

than the central object of the picture. Here is Alloway Kirk, in the churchyard of which you may read a real story by the side of the ruin that tells of more romantic fiction. There stands the stone "Erected by James Russell, seedsman, Ayr, in memory of his children,"—three little boys, James and Thomas and John, all snatched away from him in the space of three successive summer-days, and lying under the matted grass in the shadow of the old witch-haunted walls. It was Burns's Alloway Kirk we paid for, and we find we have bought a share in the griefs of James Russell, seedsman; for is not the stone that tells this blinding sorrow of life the true centre of the picture, and not the roofless pile which reminds us of an idle legend?

We have often found these incidental glimpses of life and death running away with us from the main object the picture was meant to delineate. The more evidently accidental their introduction, the more trivial they are in themselves, the more they take hold of the imagination. It is common to find an object in one of the twin pictures which we miss in the other; the person or the vehicle having moved in the interval of taking the two photographs. There is before us a view of the Pool of David at Hebron, in which a shadowy figure appears at the water's edge, in the right-hand farther corner of the right-hand picture only. This muffled shape stealing silently into the solemn scene has already written a hundred biographies in our imagination. In the lovely glass stereograph of the Lake of Brienz, on the left-hand side, a vaguely hinted female figure stands by the margin of the fair water; on the other side of the picture she is not seen. This is life; we seem to see her come and go. All the longings, passions, experiences, possibilities of womanhood menate that gliding shadow which has flitted through our consciousness, nameless, dateless, featureless, yet more profoundly real than the sharpest of portraits traced by a human hand. Here is the Fountain of the Ogre, at Berne. In the right picture two women are chatting, with arms akimbo, over its basin; before the plate for the left picture is got ready, "one shall be taken with the other left"; look! on the left side there is but one woman, and you may see the blur where the other is melting into thin air as she fades forever from your eyes. . . .

The very things which an artist would leave out, or render imperfectly, the photograph takes infinite care with, and so

makes its illusions perfect. What is the picture of a drum without the marks on its head where the beating of the sticks has darkened the parchment? In three pictures of the Ann Hathaway Cottage, before us,—the most perfect, perhaps, of all the paper stereographs we have seen,—the door at the farther end of the cottage is open, and we see the marks left by the rubbing of hands and shoulders as the good people came through the entry, or leaned against it, or felt for the latch. It is not impossible that scales from the epidermis of the trembling hand of Ann Hathaway's young suitor, Will Shakespeare, are still adherent about the old latch and door, and that they contribute to the stains we see in our picture.

Among the accidents of life, as delineated in the stereograph, there is one that rarely avails in any extended view which shows us the details of streets and buildings. There may be neither man nor beast nor vehicle to be seen. You may be looking down on a place in such a way that none of the ordinary marks of its being actually inhabited show themselves. But in the rawest Western settlement and the oldest Eastern city, in the midst of the shanties at Pike's Peak and stretching across the courtyards as you look into them from above the clay-plastered roofs of Damascus, wherever man lives with any of the decencies of civilization, you will find the *clothes-line*. It may be a fence, (in Ireland,)—it may be a tree, (if the Irish license is still allowed us,)—but clothes-drying, or a place to dry clothes on, the stereoscopic photograph insists on finding, wherever it gives us a group of houses. This is the city of Berne. How it brings the people who sleep under that roof before us to see their sheets drying on that fence; and how real it makes the men in that house to look at their shirts hanging, arms down, from yonder line! . . .

What is to come of the stereoscope and the photograph we are almost afraid to guess, lest we should seem extravagant. But, premising that we are to give a *colored* stereoscopic mental view of their prospects, we will venture on a few glimpses at a conceivable, if not a possible future.

Form is henceforth divorced from matter. In fact, matter as a visible object is of no great use any longer, except as the mould on which form is shaped. Give us a few negatives of a thing worth seeing, taken from different points of view, and that is all we want of it. Pull it down or burn it up, if you please. We must,

perhaps, sacrifice some luxury in the loss of color; but form and light and shade are the great things, and even color can be added, and perhaps by and by may be got direct from Nature.

There is only one Colosseum or Pantheon; but how many millions of potential negatives have they shed—representatives of billions of pictures—since they were erected! Matter in large masses must always be fixed and dear; form is cheap and transportable. We have got the fruit of creation now, and need not trouble ourselves with the core. Every conceivable object of Nature and Art will soon scale off its surface for us. Men will hunt all curious, beautiful, grand objects, as they hunt the cattle in South America, for their *skins,* and leave the carcasses as of little worth.

The consequence of this will soon be such an enormous collection of forms that they will have to be classified and arranged in vast libraries, as books are now. The time will come when a man who wishes to see any object, natural or artificial, will go to the Imperial, National, or City Stereographic Library, and call for its skin or form, as he would for a book at any common library. We do now distinctly propose the creation of a comprehensive and systematic stereographic library, where all men can find the special forms they particularly desire to see as artists, or as scholars, or as mechanics, or in any other capacity. Already a workman has been travelling about the country with stereographic views of furniture, showing his employer's patterns in this way, and taking orders for them. This is a mere hint of what is coming before long.

Again, we must have special stereographic collections, just as we have professional and other special libraries. And, as a means of facilitating the formation of public and private stereographic collections, there must be arranged a comprehensive system of exchanges, so that there may grow up something like a universal currency of these bank-notes, or promises to pay in solid substance, which the sun has engraved for the great Bank of Nature.

To render comparison of similar objects, or of any that we may wish to see side by side, easy, they should be taken, so far as possible, with camera-lenses of the same focal length, at the same distance, and viewed through stereoscopic lenses of the same pattern. In this way the eye is enabled to form the most

81

rapid and exact conclusions. If the "great elm" and the Cow-thorpe oak, if the State-House and St. Peter's, were taken on the same scale, and looked at with the same magnifying power, we should compare them without the possibility of being misled by those partialities which might tend to make us overrate the indi-genous vegetable and the dome of our native Michel Angelo.

The next European war will send us stereographs of battles. It is asserted that a bursting shell can be photographed. The time is perhaps at hand when a flash of light, as sudden and brief as that of the lightning which shows a whirling wheel standing stock still, shall preserve the very instant of the shock of contact of the mighty armies that are even now gathering. The lightning from heaven does actually photograph natural objects on the bodies of those it has just blasted,—so we are told by many witnesses. The lightning of clashing sabres and bayonets may be forced to stereotype itself in a stillness as complete as that of the tumbling tide of Niagara as we see it self-pictured.

We should be led on too far, if we developed our belief as to the transformations to be wrought by this greatest of human triumphs over earthly conditions, the divorce of form and sub-stance. Let our readers fill out a blank check on the future as they like,—we give our indorsement to their imaginations be-forehand. We are looking into stereoscopes as pretty toys, and wondering over the photograph as a charming novelty; but be-fore another generation has passed away, it will be recognized that a new epoch in the history of human progress dates from the time when He who

"never but in uncreated light
Dwelt from eternity"

took a pencil of fire from the "angel standing in the sun," and placed it in the hands of a mortal.

The Modern Public and Photography

Charles Baudelaire (1821–1867)

After completing a rigid education preparing him for success in the French government bureaucracy, Charles Baudelaire rebelled against the prospect of a conventional life and began to stake out a career as a Parisian poet and art critic. Living lavishly on an inheritance from his father, Baudelaire wrote his greatest poems, including "Les Fleurs du Mal," in the early 1840s. These works would become the basis for the French symbolist literary tradition. At the same time, he also made the acquaintance of many revolutionary French painters, including Delacroix and Courbet, who shaped his understanding of modern art. In 1844, when Baudelaire's mother suspended free access to his inheritance in order to force her son to reform his excessive life-style, Baudelaire attempted to make his living as a professional writer. He first published an art review of the Salon of 1845, an annual exhibition sponsored by the National Academy. For many years after, he continued to review the Salons, and in his review of the Salon of 1859, he included a critique on the nature of photography as art that is reprinted here.

Baudelaire was appalled that the popular definition of fine art as the accurate representation of some external reality had led men to desire mechanically produced replicas of the visual world. He defined artistic realism not in the popular sense, as a mirror of the physical, visible world, but as the reflection of the mental world of imagination, dreams, and fantasy. He feared that the public's attraction to photographic images could only drive them further toward the popular conception of realism and away from his notion of artistic truth. Baudelaire considered men fools to believe in photographs as mirrors of physical facts; he thought photography best served to aid man's memory of events. He never defined the medium past arguing that it was of a completely industrial nature, and thus devoid of influence from the human imagination, a deficiency excluding it from the realm of fine art.

My dear M****,

If I had time to amuse you, I could easily do so by thumbing through the pages of the catalogue, and extracting a list of all the ridiculous titles and laughable subjects that aim to attract the eye. That is so typical of French attitudes. The attempt to provoke astonishment by means that are foreign to the art in

83

question is the great resource of people who are not painters born. Sometimes even, but always in France, this form of vice takes hold of men who are by no means devoid of talent, and who dishonour it, in this way, by an adulterous mixture. I could parade before your eyes the comic title in the manner of the vaudevillist, the sentimental title, lacking only an exclamation mark, the pun-title, the deep and philosophical title, the misleading or trap title such as *Brutus, lâche César*. 'Oh ye depraved and unbelieving race,' says Our Lord, 'how long must I remain with you, how long shall I continue to suffer?' This people, artists and public, has so little faith in painting that it is for ever trying to disguise it, and wrap it up in sugar-coated pills, like some unpalatable physick — and what sugar! Ye Gods! Let me pick out the titles of two pictures, which, by the way, I have not seen: *Amour et gibelotte*! How your curiosity is at once whetted, is it not? I am groping about in an effort to relate intimately these two ideas, the idea of love and the idea of a skinned rabbit dished up as a stew. You can scarcely expect me to suppose that the painter's imagination has gone to the length of fixing a quiver, wings and an eye bandage on the corpse of a domestic animal; the allegory would really be too obscure. I am more inclined to think the title must have been composed, following the formula of *Misanthropie et repentir*. The true title should therefore be 'Lovers eating rabbit stew'. Then comes the question: are they young or old, a workman and his girl friend, or an old soldier and his moll sitting under a dusty arbour? Only the picture could tell me. Then we have *Monarchique, Catholique et Soldat*! This title belongs to the high-falutin, paladin type, the *Itinéraire de Paris à Jerusalem* type (oh Chateaubriand, my apologies to you! the most noble things can become means for caricature and the words of a leader of Empire for daubers' squibs). The picture boasting this title must surely represent a personage doing three things at once: fighting, attending communion, and being present at the 'petit lever' of Louis XIV. Or could it be a warrior, tattoed with a fleur de lys and devotional pictures? But what is the good of losing oneself in speculation? The simple truth is that titles such as these are a perfidious and sterile means of creating an impact of surprise. And what is particularly deplorable is that the picture may be good, however strange that may sound. This applies to *Amour et gibelotte* too.

And I noticed an excellent little group of sculpture, but unfortunately did not take down its number; and when I wanted to look up what the subject of the piece was, I read through the catalogue four times in vain. In the end you told me, of your kindness, that the piece was called *Toujours et jamais*. It really distressed me to see that a man with genuine talent could go in for the rebus sort of title.

You must forgive my having allowed myself a few moments' amusement in the manner of cheap newspapers. But, however frivolous the matter may seem to you, you will nonetheless discover there, if you examine it carefully, a deplorable symptom. To sum up my thought in a paradoxical way, let me ask you, and those of my friends who are more learned than I in the history of art, whether the taste for the silly, the taste for the witty (which comes to the same thing) have always existed, whether *Appartement à louer* and other such alembicated notions have appeared in every age, to provoke the same degree of enthusiasm as today, if the Venice of Veronese and Bassano wa. affected by these sorts of logogriph, if the eyes of Giulio Romano, Michelangelo and Bandinelli were astounded by similar monstrosities; in short I would like to know whether M. Biard is eternal and omnipresent, like God. I do not believe it, and I regard these horrors as a special form of grace granted to the French. It is true that their artists inoculate them with this taste; and it is no less true that they in their turn call upon the artists to satisfy this need; for if the artist makes dullards of the public, the latter pays him back in his own coin. They form two co-relative terms, which act upon one another with equal force. Accordingly let us watch with wonder the rate at which we are moving downwards along the road of progress (and by progress I mean the progressive domination of matter), the wonderful diffusion, occurring daily, of commonplace skill, of the skill that may be acquired simply by patience.

In this country, the natural painter, like the natural poet, is almost a monster. Our exclusive taste for the true (so noble a taste when limited to its proper purposes) oppresses and smothers the taste for the beautiful. Where only the beautiful should be looked for — shall we say in a beautiful painting, and anyone can easily guess the sort I have in mind — our people look only for the true. They are not artistic, naturally artistic;

philosophers, perhaps, or moralists, engineers, lovers of instructive anecdotes, anything you like, but never spontaneously artistic. They feel, or rather judge, successively, analytically. Other more favoured peoples feel things quickly, at once, synthetically.

I was referring just now to the artists who seek to astonish the public. The desire to astonish or be astonished is perfectly legitimate. 'It is a happiness to wonder': but also 'It is a happiness to dream'. If you insist on my giving you the title of artist or art-lover, the whole question is by what means you intend to create or to feel this impact of wonder? Because beauty always contains an element of wonder, it would be absurd to assume that what is wonderful is always beautiful. Now the French public, which, in the manner of mean little souls, is singularly incapable of feeling the joy of dreaming or of admiration, wants to have the thrill of surprise by means that are alien to art, and its obedient artists bow to the public's taste; they aim to draw its attention, its surprise, stupefy it, by unworthy stratagems, because they know the public is incapable of deriving ecstasy from the natural means of true art.

In these deplorable times, a new industry has developed, which has helped in no small way to confirm fools in their faith, and to ruin what vestige of the divine might still have remained in the French mind. Naturally, this idolatrous multitude was calling for an ideal worthy of itself and in keeping with its own nature. In the domain of painting and statuary, the present-day credo of the worldly wise, especially in France (and I do not believe that anyone whosoever would dare to maintain the contrary), is this: 'I believe in nature, and I believe only in nature.' (There are good reasons for that.) 'I believe that art is, and can only be, the exact reproduction of nature.' (One timid and dissenting sect wants naturally unpleasing objects, a chamber pot, for example, or a skeleton, to be excluded.) 'Thus if an industrial process could give us a result identical to nature, that would be absolute art.' An avenging God has heard the prayers of this multitude; Daguerre was his messiah. And then they said to themselves: 'Since photography provides us with every desirable guarantee of exactitude' (they believe that, poor madmen!) 'art is photography.' From that moment onwards, our loathsome society rushed, like Narcissus, to contemplate its trivial image on the

metallic plate. A form of lunacy, an extraordinary fanaticism, took hold of these new sun-worshippers. Strange abominations manifested themselves. By bringing together and posing a pack of rascals, male and female, dressed up like carnival-time butchers and washerwomen, and in persuading these 'heroes' to 'hold' their improvised grimaces for as long as the photographic process required, people really believed they could represent the tragic and the charming scenes of ancient history. Some democratic writer must have seen in that cheap means of spreading the dislike of history and painting amongst the masses, thus committing a double sacrilege, and insulting, at one and the same time, the divine art of painting and the sublime art of the actor. It was not long before thousands of pairs of greedy eyes were glued to the peepholes of the stereoscope, as though they were the skylights of the infinite. The love of obscenity, which is as vigorous a growth in the heart of natural man as self-love, could not let slip such a glorious opportunity for its own satisfaction. And pray do not let it be said that children, coming home from school, were the only people to take pleasure in such tomfooleries; it was the rage of society. I once heard a smart woman, a society woman, not of my society, say to her friends, who were discreetly trying to hide such pictures from her, thus taking it upon themselves to have some modesty on her behalf: 'Let me see; nothing shocks me.' That is what she said, I swear it, I heard it with my own ears; but who will believe me? 'You can see that they are great ladies,' says Alexandre Dumas. 'There are greater ones still!' echoes Cazotte.

As the photographic industry became the refuge of all failed painters with too little talent, or too lazy to complete their studies, this universal craze not only assumed the air of blind and imbecile infatuation, but took on the aspect of revenge. I do not believe, or at least I cannot bring myself to believe, that any such stupid conspiracy, in which, as in every other, wicked men and dupes are to be found, could ever achieve a total victory; but I am convinced that the badly applied advances of photography, like all purely material progress for that matter, have greatly contributed to the impoverishment of French artistic genius, rare enough in all conscience. Modern fatuity may roar to its heart's content, eruct all the borborygmi of its pot-bellied person, vomit all the indigestible sophistries stuffed down its greedy gullet by

recent philosophy; it is simple common-sense that, when industry erupts into the sphere of art, it becomes the latter's mortal enemy, and in the resulting confusion of functions none is well carried out. Poetry and progress are two ambitious men that hate each other, with an instinctive hatred, and when they meet along a pathway one or other must give way. If photography is allowed to deputize for art in some of art's activities, it will not be long before it has supplanted or corrupted art altogether, thanks to the stupidity of the masses, its natural ally. Photography must, therefore, return to its true duty, which is that of handmaid of the arts and sciences, but their very humble handmaid, like painting and shorthand, which have neither created nor supplemented literature. Let photography quickly enrich the traveller's album, and restore to his eyes the precision his memory may lack; let it adorn the library of the naturalist, magnify microscopic insects, even strengthen, with a few facts, the hypotheses of the astronomer; let it, in short, be the secretary and record-keeper of whomsoever needs absolute material accuracy for professional reasons. So far so good. Let it save crumbling ruins from oblivion, books, engravings, and manuscripts, the prey of time, all those precious things, vowed to dissolution, which crave a place in the archives of our memories; in all these things, photography will deserve our thanks and applause. But if once it be allowed to impinge on the sphere of the intangible and the imaginary, on anything that has value solely because man adds something to it from his soul, then woe betide us!

I know perfectly well I shall be told: 'The disease you have just described is a disease of boneheads. What man worthy of the name of artist, and what true art-lover has ever confused art and industry?' I know that, but let me, in my turn, ask them if they believe in the contagion of good and evil, in the pressure of society on the individual, and the involuntary, inevitable obedience of the individual to society. It is an indisputable and irresistible law that the artist acts upon the public, that the public reacts on the artist; besides, the facts, those damning witnesses, are easy to study; we can measure the full extent of the disaster. More and more, as each day goes by, art is losing in self-respect, is prostrating itself before external reality, and the painter is becoming more and more inclined to paint, not what he dreams, but what he sees. And yet *it is a happiness to dream,* and it used

to be an honour to express what one dreamed; but can one believe that the painter still knows that happiness?

Will the honest observer declare that the invasion of photography and the great industrial madness of today are wholly innocent of this deplorable result? Can it legitimately be supposed that a people whose eyes get used to accepting the results of a material science as products of the beautiful will not, within a given time, have singularly diminished its capacity for judging and feeling those things that are most ethereal and immaterial?

Idealism, Realism, Expressionism

Henry Peach Robinson (1830–1901)

As the versatile photographic paper-print process became popular after 1853, the demand grew for many different kinds of photographs. In England, photographers with purely aesthetic intents, such as Henry Peach Robinson, began to create intentionally artistic photographs. Robinson had been trained as a painter in the sentimental and allegorical styles appreciated in Victorian England, and his photographs reflect his training. He was particularly inspired by the photographs of Oscar J. Reijlander, who worked in the same styles. Robinson first stirred critical attention in 1858, with his photograph "Fading Away," depicting a sick young girl surrounded by concerned and dejected onlookers. Victorian critics took offense at what they considered the morbid reality of the scene. Despite the negative remarks made about "Fading Away," Robinson became a popular pictorialist and a prominent member of the Royal Photographic Society.

Robinson often used a technique called combination printing to create his artistic photographs. Because sensitized collodion glass plates used in paper-print photography were extremely sensitive to blue light, skies invariably printed white. To introduce clouds into pictures, some photographers made negatives exposed quickly for the sky, and then printed these negatives into ordinarily blank sky areas through combination printing. They also used combination printing to simplify the creation of artistic photographs otherwise requiring elaborate studio sets. But this technique was controversial. The convincing detail and strict perspective characterizing most contemporary photographs often caused them to be considered objective pictures of reality. The supposedly mechanical means by which photographs were made added to the belief in photographic objectivity. As a composite molded together by man, the combination print seemed to defy this conception of objectivity. Robinson believed not only in composite printing but in the necessity of a subjective element in the artistic photographic process. Contemporary art theory required adherence to conventions of realism, while at the same time demanding some evidence of the artist's genius and emotion in a picture. Though many critics maintained that photographs were purely objective, and could never be art, Robinson insisted that the photographer left at least some creative mark on his work. He developed this argument most fully in his influential textbook for photographic artists, Pictorial Effects

in Photography *(1869). Late in life, he published other works, including,* Picture Making by Photography *and* Art Photography. *Robinson's influence became particularly strong in 1888, when he was elected vice-president of the Royal Photographic Society.*

Closely allied with expression is the question of Idealism and Realism. Those who have only a superficial knowledge of the possibilities of our art contend that the photographer is a mere mechanical realist without power to add anything of himself to his production. Yet some of our critics inconsistently commit themselves to the statement that some of our pictures are nothing like nature. This is giving themselves away, for if we can add untruth we can idealise. But we go further and contend that we can add truth to bare facts.

A passion for realism is the affectation of the hour in art and literature, and is making some of our novels so dirty — in the name of art — that one scarcely likes to mention even the titles of them. It is the fashion to yearn for Nature, and to select her as bare, bald, and ugly as she is made, the particular kind being that which is the outcome not of nature, but of the errors of civilisation. But when we examine the matter closely, we find that no art to be successful, however it may try, can entirely dispense with idealism. The stage heroine studies her part in the hospitals and dies before the audience without omitting a cough, a gasp, or a groan, but she cannot do without the idealism imparted by slow music and the limelight; the realistic novelist catalogues exactly the ugly, the sordid, and even the bestial, but he is careful of his "style"; the painter ostentatiously seeks ill-favoured models, uninteresting subjects, anything will do so that it is "not literary," or amusing, or instructive or interesting, but he is careful about his drawing and colour. The realism of the moment appears to select ugliness by preference, probably because it can be made more striking and sensational. There is still the possibility of realistic beauty, and this photography sometimes attains; but a photograph is too often neither more nor less than uninteresting, colourless fact, without the negative merits of ugliness or the charm of beauty.

As I write I meet with the following which shows how exceedingly "mixed" some writers and artists are getting over some of the modern terms.

92

The author of a book on Velasquez calls that great artist a realist, on which his reviewer says: "It is difficult indeed to understand how the term could ever be applied to the supreme master of suppression and selection. There are some words which have lost all significance from the hard work put upon them. And realist is of the number. It has been asked to mean so much that it has ceased to mean anything at all. In fiction, realism is the glorification of the *Un*essential: it is that sacrifice of proportion which would exaggerate into a tragedy the drawing-on of a pair of boots; in painting it is the patient amassing of conflicting details, which exist, maybe, in nature, but which can only be observed by an eye of ever-shifting focus. And in painting, as in fiction, the single result of realism is falsity. When the novelist sets forth with his note-book you know that he will bring home a bundle of untruths. When he sticks to his fireside, he has a chance at least of inventing a probability: whereas, confronting the world with a hungry eye, he sees all things in a wrong relation, and the result is not truth but "copy." So too the conscientious painter grovels in the dust of superfluous veracity, and finds only a false effect. One inch of his canvas may have some relation to nature. The whole must ever be meaningless and void."

Idealism has been defined as the mental or intellectual part, and it is held by many that a picture can have no claim to art that does not contain its evidences to a more or less degree, and that, although the "foundation of all great work must be laid upon what is *real and true,* the further development must be *mentally and intellectually* conceived. Or, if the mental conception is the first step in the process, it must work on to what is evidently real and true."

Realism began as a protest against conventionalism, and so far was useful, but it has now become a revolt against beauty, nobility, and grandeur of style, and it must be admitted that there are occasions when revolutions are salutary. Perhaps, after all, ugliness may have a useful qualifying effect on sweetness and affectation; at present it is itself one of the worst affectations of the century.

In a review of Mr. R. A. M. Stevenson's *Art of Velasquez* (the same book noticed by another critic to whom I am indebted for the definition of realism) in the *Spectator,* a thoughtful writer

93

gives the following definition of this little understood subject (misunderstood because it was seized on by charlatans for their own purposes). The real thing like good photography, has been so overshadowed by the spurious and bad that it has not often had a chance of being understood. I have always opposed the imitations, and have consequently been accused of opposing the theory itself, and am therefore glad to be able to give a clear definition from another pen than my own.

"Once the impressionist theory of vision and painting is grasped, it is easy out of various writers, even out of Ruskin himself, to collect passages skirting it or glancing at it. It is the doctrine that Reynolds attempted to state. It is what painter after painter has more or less consciously applied, without being in words able to express it clearly.

"The name has been much against the thing with those to whom it was only a word. 'Impressionism' is a luckless enough term for a revolution in pictorial vision as radical as the introduction of chiaroscuro, of linear, or of aerial perspective. Inevitably it has been taken to mean hurried sketching. Now, a pre-Raphaelite may sketch hurriedly, but his sketch is not impressionistic, it is merely a hasty statement of his ordinary habit of vision. That habit is one of simple addition. If he has plenty of time he puts down 1, 2, 3, 4, 5, 6, 7. If he has less than half the time, he puts down 1, 2, and a bit of 3. This impressionist goes to work by summing these particulars before he puts down the result. He is therefore capable of a more rapid statement, but time is not of the essence of his procedure. His process of thought may take a longer time than the other's thoughtless enumeration. Nor, again, is a pre-Raphaelite picture made into an impressionist by blurring it over, as some have fondly imagined. (Painters will tell you that they do 'impressionist' work *sometimes*.)

"Impressionism, then, does not mean hasty impression nor misty impression. It means *unity and order of impression gained by focussing the subject.* Just as linear perspective introduced a unifying natural action of the eye into painting, with one angle of view in place of a dozen, so does impressionism follow the natural eye, with one focus for a dozen.

"Focus affects the clearness of definition in two ways. If a number of objects, A, B, C, D, E, stand at different distances

94

from the eye, and the eye rests upon and adjusts itself to C, the nearer objects, A and B, and the farther objects, D and E, are thrown out of focus and are blurred. This may be called the *focus of distance*, and to represent two objects at different depths in a picture with the same clearness of definition is to puzzle and contradict the eye.

"But there is also the *focus of attention*. According as the eye selects one feature of a scene, or allows itself to wander more freely, the definition of the parts will alter; and, if we wish in a picture that it should be known what we were looking at, a not unreasonable desire, we must follow this procedure of the eye. If I look at A and B together, my attention is more diluted than when I look at one of them, and the definition of each is weaker — it is the pattern including the two that is defined. If I look at A directly, with B still there, but not attended to, the definition of B is fainter.

"So much for form. A similar law holds with regard to colour. The impressionist will not skin off all distance till his eye reaches a flayed local colour. He will fix with himself a distance that relates all local colours in a key. Nor will he scrutinise each patch of colour in turn with equal attention. If a yellow spot is focussed in a scene, all the other colours alter; if the eye leaves the yellow to play more freely, the yellow loses its insistence, and the *colour of the scene* asserts itself.

"It is only the unthinking who will accuse impressionism, thus understood, of being an easy slap-dash kind of painting. To appreciate the exactly right force of definition for the parts in relation to the whole is a task that employs the rarest faculties of vision, since to a sensitive eye a single false accent will destroy a whole picture. If it be argued that all this is a matter of mechanical and realistic rendering of facts, the assertion is manifestly untrue. Attention is governed by feeling, every change in the definition of an object means a change in our emotion about it. Impressionism, in a word, employs the means of emphasis natural to vision. Other methods of emphasis there are, that of the decorative line, the silhouetted shape, the colour patch, and a painter may bind himself by the simpler conventions if he pleases; but, if he does not comprehend impressionistic vision, he is not full-grown in the theory of his art, and is blind to its later history and triumphs."

A pure, unadulterated machine-made (man and instrument) photograph, if colour is allowed for, is the most perfect specimen of realism the world could produce; useful in a thousand ways, it would not be art any more than a minute catalogue of the facts of nature, however full of insight, is a poem. In early days we were surprised and delighted with a photograph, *as* a photograph, just because we had not hitherto conceived possible any definition or finish that approached Nature so closely, and here was something that actually had the effect of surpassing Nature on her own grounds. But we soon wanted something more. We got tired of the sameness of the exquisiteness of the photograph, and if it had nothing to say, if it was not a view, or a portrait of something or somebody, we cared less and less for it. Why? Because the photograph told us everything about the facts of nature and left out the mystery. Now, however hard-headed a man may be, he cannot stand too many facts; it is easy to get a surfeit of realities, and he wants a little mystification as a relief.

It has been denied that our art has sufficient plasticity to admit of modifications sufficient to enable a photographer to express himself in his material. We own it is limited, yet all arts have their limitations, and to be successful must work within them. There is this difficulty, however. The grammar and language of art can be taught, but it is quite different with its poetry. Photographers want a formula for everything, but you cannot make a ten per cent. solution of idealism and give minute instructions how it is to be applied; but I think it has often been very clearly shown that photographic pictorial effect depends entirely on the man, and that he is not limited to prosaic actuality. In some recent exhibitions there were sets of pictures shown, varying from the minutely defined to those of extreme diffusion, which could have come from no other hands and minds than those which produced them; they were as individual as the works of the most mannered painters, and represented not so much the subject which was before the camera as the photographer's individual impression of the subject.

Processes have been simplified, cameras have become more fearfully and wonderfully made, lenses have acquired a flatter field, and some of them can conjure a foreground out of the dim distance; societies and conferences have multiplied, technique has, up to a certain point, improved, and all the world produces good photography; many reach the dead level of excellence, but

how few get beyond! What a pity, in one sense, it is that we do not have more that contains the "little more"; but, after all, it is good to know that there is something not easily reached still left in photography, and it also teaches that in our art, as in others, "the man's the man for a' that."

Clever writers are now discovering that it is not necessary that photography should make for realism, but, indeed, in its higher flights, may tend the other way. In an interesting article in a recent number of the *Nineteenth Century,* on "Realism of To-day," the author makes this interesting admission: —

"Perhaps one of the greatest enemies to the realism of the present day is the steady growth of photography. After all, what can be more realistic than its manner of working? A flash and there is the figure in its most natural and real condition. Laughing, crying, winking, jumping, you can fancy you see the movement, and almost hear the speech. But does that satisfy the sitter or the artist, or is it not the main object and effort of both to beautify the production by soft and harmonious effects, to tone down and shade off defects, and so to produce an idealised beauty in the subject? And is not the result far more really true to nature than the inartistic and unaided pictures that marked the first years of the raw invention? If photography has discovered that in order to be real and true it must also be ideal, it is thereby teaching us a lesson which we may do well to profit by."

This is one of the most encouraging testimonials from the outside press that the "new movement" has received. It may, however, be said to refer only to retouching, which all good artists condemn. But the sentence I have quoted refers not to a detail of practice, but to principle. It is not, however, retouching in itself that is condemnable, but the *bad* retouching, at present almost universal, which turns the human face divine into a semblance of marble busts or, still worse, turnips or apple dumplings. This is one of the instances of bad art which it is the mission of the new movement to correct.

The author of the article on Realism concludes as follows: —

"So we come back to where we began. To be real and true is the first great quality; but to conceive and superadd the highest possible ideal is also indispensable if we would ever hope to reach that perfection which is, indeed, in this world unknown, but which, in a world to come, may yet be found attainable."

Hints on Art

Peter Henry Emerson (1856–1936)

In his earliest and most influential writings, Peter Henry Emerson attacked the standard definition of photography as an "art-science." Emerson was the first to assign different styles and purposes to artistic, scientific, and commercial photography. Primarily concerned with the status of art photography, Emerson insisted that a photograph could be a picture of purely aesthetic value, reflecting an artist's spontaneous visual impression of the natural world. As an advocate of naturalism in art, he detested the sentimental genre photographs popular in Victorian England, which to him represented flirtations with artifice rather than direct artistic encounters with life.

Photographers such as the heralded Henry Peach Robinson, whose photographs Emerson particularly deplored, worked according to the stylistic and technical conventions of academic realism. Like most academic art, their pictures were created entirely in the studio using costumed models and elaborate sets. Often prints were made from composite negatives and were touched up with paint. Characteristically, these works were sharply focused and adhered to the classic rules of linear perspective. In contrast, Emerson's articles, talks, and his book Naturalistic Photography *(1889) detailed a method for producing artistic photographs based on principles of vision akin to those advanced by the revolutionary impressionist painters of the day. Emerson reasoned that human vision does not reflect the world in sharp focus: the visual image is more clearly defined in the center than at the edges, and as representations of the visual experience, photographs should follow this focal pattern. The photographer was also to choose his subject matter from life and to photograph his subject as he found it. Strengthening the arguments he voiced in print, Emerson's successful photographs of peasant life on the Norfolk Broads made a tight case for the stylistic principles of naturalistic photography. And as a judge of many international exhibitions, he was able to influence a new photographic trend by recognizing those photographers whose methods and styles resembled his own, a style which came to be known as* pictorialism.

In 1890, Emerson's campaign promoting photography as a fine art came to an abrupt halt. The chemists Hurter and Driffield had proved the unchanging ratio of exposure, density, and development, crushing Emerson's belief in the photographer's complete

control over tonal relations in his works. Emerson's narrow definition of proper photographic procedure did not allow the photographer to use more complex developing and printing methods to compensate for this limited flexibility. As a consequence, Emerson felt compelled to denounce photography as a limited art form. Nonetheless, the general impact of his work from the 1880s was not undermined by his personal shift of opinion. By the 1890s, with the formation of the English Linked Ring and the American Photo-Secession movements, photographic style had become markedly impressionistic and photographs were beginning to be exhibited, viewed, and accepted as fine art.

As practical hints for working cannot be woven into a continuous text, we will give them separately.

Never compete for prizes for "set subjects," for work of this kind leads to working from preconceived ideas, and therefore to conventionality, false sentiment, and vulgarity.

Remember that the original state of the minds of uneducated men is vulgar, you now know why vulgar and commonplace works please the majority. Therefore, educate your mind, and fight the hydra-headed monster — vulgarity. Seize on any aspect of nature that pleases you and try and interpret it, and ignore — as nature ignores — all childish rules, such as that the lens should work only when the sun shines or when no wind blows.

Æolus is the breath of life of landscape.

The chief merit of most photographs is their diagrammatic accuracy, as it is their chief vice.

Avoid the counsels of pseudo-scientific photographers in art matters, as they have avoided the study of art.

If you decide on taking a picture, let nothing stop you, even should you have to stand by your tripod for a day.

Do not climb a mast, or sit on the weathercock of a steeple, to photograph a landscape; remember no one will follow you up there to get your point of sight.

Do not talk of Rembrandt pictures, there was but one Rembrandt. Light your pictures as best you can and call them your own.

Do not call yourself an "artist-photographer" and make "artist-painters" and "artist-sculptors" laugh; call yourself a photographer and wait for artists to call you brother.

100

Remember why nearly all portrait photographs are so unlike the people they represent — because the portrait lens as often used gives false drawing of the planes and false tonality, and then comes along the retoucher to put on the first part of the uniform, and he is followed by the vignetter and burnisher who complete the disguise.

The amount of a landscape to be included in a picture is far more difficult to determine than the amount of oxidizer of alkali to be used in the developer.

Pay no heed to the average photographer's remarks upon "flat" and "weak" negatives. Probably he is flat, weak, stale, and unprofitable; your negative may be first-rate, and probably is if he does not approve of it.

Do not allow bad wood-cutters and second-rate process-mongers to produce libels of your work. Be broad and simple.

Work hard, and have faith in nature's teachings.

Remember there is one moment in the year when each particular landscape looks at its best, try and secure it at that moment.

Do not put off doing a coveted picture until another year, for next year the scene will look very different. You will never be able twice to get exactly the same thing.

Vulgarity astonishes, produces a sensation; refinement attracts by delicacy and charm and must be sought out. Vulgarity obtrudes itself, refinement is unobtrusive and requires the introduction of education.

Art is not legerdemain: much "instantaneous" work is but jugglery.

Though many painters and sculptors talk glibly of "going in for photography," you will find that very few of them can ever make a picture by photography; they lack the science, technical knowledge, and above all, the practice. Most people think they can play tennis, shoot, write novels, and photograph as well as any other person — until they try.

Be true to yourself and individuality will show itself in your work.

Do not be caught by the sensational in nature, as a coarse red-faced sunset, a garrulous waterfall, or a fifteen thousand foot mountain.

Avoid prettiness — the word looks much like pettiness — and there is but little difference between them.

No one should take up photography who is not content to work hard and study so that he can take pictures for his own eye only. The artist works to record the beauties of nature, the bagman works to please the public, or for filthy lucre, or for metal medals.

At the University of Cambridge, in our student days, it was considered "bad form" to give a testimonial to a tradesman for publication. This is still "bad form;" let the student, therefore, never let his name appear in the advertisement columns of photographic papers beneath a puff of some maker's plates or some printing papers. "Good wine needs no bush."

The value of a picture is not proportionate to the trouble and expense it costs to obtain it, but to the poetry that it contains.

Good art only appeals to the highly cultivated at the first glance, but it gradually grows on the uncultivated or the half cultivated; with bad art the case is otherwise.

Give the *life* of the model in a portrait, not his bearing towards you during a *mauvais quart d'heure*.

Do not call reflections — shadows; learn to distinguish between the two.

Always be on the look-out for a graceful movement when you are conversing with a person, thus you will learn. Keep rigidly within the limits of your medium, do not strive for the impossible, and so miss the possible.

Never judge of the merits of a painting or piece of sculpture from reproductions.

Every good work has "quality."

Do not mistake sentimentality for sentiment, and sentiment for poetry.

Spontaneity is the life of a picture.

Continual failure is a road to success — if you have the strength to go on.

The color of a landscape viewed in the direction of the sun is almost unseen; therefore turn your back on the sun if you wish to see nature's coloring, and you do!

Do not emulate the producers of photographic Christmas cards and "artistic" (?) opals; they are all worthy of the bagman.

Do not mistake sharpness for truth, and burnish for finish.

The charm of nature lies in her mystery and poetry, but no doubt she is never mysterious to a donkey.

It is not the apparatus that chooses the picture, but the *man* who wields it.

Say as much as you can, with as little material as you can.

Flatter no man, but spare not generous praise to really good work.

Lash the insincere and petty *homunculi* who are working for vanity.

Hold up to scorn every coxcomb who paints "artist-photographer" or "artist" on his door, or stamps it on his mounts.

Remember every photograph you publish goes out for better, for worse, to raise you up or pull you down; do not be in haste, therefore, to give yourself over to the enemy.

By the envy, lying, and slandering of the weak, the ignorant, and the vicious, shall you know you are succeeding, as well as by the sympathy and praise of the just, the generous, and the masters.

When a critic has nothing to tell you save that your pictures are not sharp, be certain he is not very sharp and knows nothing at all about it.

Don't be led away to photograph *bourgeois* furnished interiors, they are not worth the silver on the plate for the pleasure they will give when done. The greater the work the simpler it looks and the easier it seems to do or to imitate, but it is not so.

Photographic pictures may have one merit which no other pictures can ever have, they can be relied upon as historical records.

Art is not to be found by touring to Egypt, China, or Peru; if you cannot find it at your own door, you will never find it.

People are educated to admire nature through pictures.

Science destroys or builds up, and seeks only for bald truth. Art seeks to give a truthful impression of some beautiful phenomenon or poetic fact, and destroys all that interferes with her purpose.

Topography is the registration of bald facts about a place; it is sometimes confounded with art.

The artistic faculty develops only with culture. A man may be a Newton and at the same time never get beyond the chromographic stage in art.

Without individuality there can be no individual art, but re-

member that the value of the individuality depends on the man, for all the poetry is in nature, but different individuals see different amounts of it.

Had Constable listened to rules we might have had "fiddle-brown" trees in our pictures today.

Nature is full of surprises and subtleties, which give quality to a work, thus a truthful impression of her is never to be found in any but naturalistic works.

The undeveloped artistic faculty delights in glossy and showy objects and in brightly colored things. The appreciation of delicate tonality, in monochrome or color is the result of high development. The frugivorous ape loves bright color, and so does the young person of "culture" and the negress of the West Indies, but Corot delighted only in true and harmonious coloring.

Nature whispers all her great secrets to the sane in mind, just as she delights in giving her best physical prizes to the sane in body. Nature abhors busy insanity.

Do not be surprised if you find "stolen bits" of your photographs in the works of inferior etchers, aquarellists, and black and white draughtsmen; it pays them to steal, while it does not hurt you, for they cannot steal your "quality."

Many photographers think they are photographing nature when they are only caricaturing her.

The sun when near the horizon gives longer shadows than when near the zenith.

The shallow public like "clearness," they like to see the veins in the grass-blade and the scales on the butterfly's wing, for does it not remind them of the powerful vision of their periscopic ancestors — the Saurians.

When the vulgar herd jape at photography, stand firm and ask them if their long-eared ancestors did not jape at water-color painting and at etching.

When charlatans talk of improving photographs for the illustrated press know that they merely take a photograph and daub it with unmeaning patches of paint to hide the work of the camera, and then they advertise their dishonest fumblings as "artistic works done by hand."

Ask the critics only "fair play." Much of the criticism of today consists in the suppression of the truth of the author and the advocacy of the falsity of the critic. Criticism is as yet in the

metaphysical stage, but it will one day become rational and of some worth. Then, critics will not attempt the huge joke of "placing" people in order like a pedagogue, *e.g.*, Matthew Arnold between Gray and Wordsworth, as some wonderful person did not long ago in one of the reviews; but criticism will show us how works of art may serve to illustrate the life-history of different epochs. The huge farce of "placing" criticism will be one of the stock jokes of the twentieth century.

Part Three:
Modern Currents

Social Photography

Lewis W. Hine (1874–1940)

While his contemporaries in the Photo-Secession wrestled with questions of "art," Lewis Hine explored the possibilities of photography with another intention in mind: to show or "document" conditions of life among America's working classes. After a brief career as a teacher in the school of the Ethical Cultural Society in New York (where Paul Strand was among his students), Hine became a full-time working photographer. Caught up in the atmosphere of social reform in the Progressive Era, he associated with reform groups devoted to improving housing and working conditions in American cities and factories. His earliest pictures date from about 1905, when he began to photograph immigrants at Ellis Island. For the reform journal The Survey, *he photographed slums in Washington, D.C., and in 1907 contributed photographs of steel workers, their places of work, their homes and neighborhoods, for the* Pittsburgh Survey — *a pioneering multivolume study of a typical industrial city. But his best known and most effective pictures of these years were of child laborers in many industries across the country. As staff photographer for the National Child Labor Committee, Hine traveled tens of thousands of miles, gathering visual evidence of violations of child labor laws, often under trying circumstances. In the 1920s Hine focused chiefly on adult industrial workers, emphasizing the skill and courage of industrial "men at work," including the "skyjacks" who built the Empire State Building. In the 1930s he worked for several government agencies, notably the Tennessee Valley Authority and the National Research Project of the Works Progress Administration.*

Although Hine followed in the steps of Jacob Riis, the crusading newspaper reporter who made shocking photographs of slum conditions in New York in the 1890s, he developed a style and an approach to photography quite distinct from that of Riis. Hine's aim was not so much to shock a passive audience into fear and indignation; instead, he wished to show working people in their environments in a more detached and objective manner. Social photography was for him an educational process; a picture was a piece of evidence, a record of social injustice, but also of individual human beings surviving with dignity in intolerable conditions. More than anyone else in his generation, Hine shaped a style for engaged, sympathetic social documentary photography, and thus provided a model for the famous Farm Security Administration project of the 1930s.

109

For a moment, now, let us suppose that we as a body were working, against bitter opposition, for better conditions in the street trades of a certain state. In the heat of the conflict we have enlisted the services of a sympathetic photographer.

He has recorded some typical and appealing scenes in the life of the newsboy and his co-workers.

They show little chaps six years old selling until late at night; little girls exposed to public life with its temptations and dangers; school children starting out at 5 a.m. to peddle and going again after school and all day Saturday and Sunday; evening scenes where the little fellows work late in and out of the saloons, learning the best way to get extra money from the drunks, and where they vary the monotony between hard-luck stories by pitching pennies, far into the night hours.

We might not agree as to their exact use, but surely we would not stand in the way if it were proposed that we launch them into every possible channel of publicity in our appeal for public sympathy.

Long ago the business man settled, in the affirmative, the question, "Does Advertising Pay?" and the present status was well expressed in Collier's Weekly not long ago: "To the range of advertising there is no limit, and where all are tooting the loud bazoo, the problem of any one making himself heard is no slight one. Advertising is art; it is literature; it is invention. Failure is its one cardinal sin." Now, the social worker, with the most human, living material as his stock in trade, is still going through the old steps of doubt and conviction. But they must end one way, for the public will know what its servants are doing, and it is for these Servants of the Common Good to educate and direct public opinion. We are only beginning to realize the innumerable methods of reaching this great public.

I wonder, sometimes, what an enterprising manufacturer would do if his wares, instead of being inanimate things, were the problems and activities of life itself, with all their possibilities of human appeal. Would he not grasp eagerly at such opportunities to play upon the sympathies of his customers as are afforded by the camera.

Take the photograph of a tiny spinner in a Carolina cotton mill. As it is, it makes an appeal. Reinforce it with one of those

110

social pen-pictures of Buga's in which he says, "The ideal of oppression was realized by this dismal servitude. When they find themselves in such condition at the dawn of existence — so young, so feeble, struggling among men — what passes in these souls fresh from God? But while they are children they escape because they are little. The smallest hole saves them. When they are men, the millstone of our social system comes in contact with them and grinds them."

With a picture thus sympathetically interpreted, what a lever we have for the social uplift.

The photograph of an adolescent, a weed-like youth, who has been doffing for eight years in another mill, carries its own lesson.

Now, let us take a glance under Brooklyn Bridge at 3 a.m. on a cold, snowy night. While these boys we see there wait, huddled, yet alert, for a customer, we might pause to ask where lies the power in a picture. Whether it be a painting or a photograph, the picture is a symbol that brings one immediately into close touch with reality. It speaks a language learned early in the race and in the individual — witness the ancient picture writers and the child of today absorbed in his picture book. For us older children, the picture continues to tell a story packed into the most condensed and vital form. In fact, it is often more effective than the reality would have been, because, in the picture, the non-essential and conflicting interests have been eliminated. The picture is the language of all nationalities and all ages. The increase, during recent years, of illustrations in newspapers, books, exhibits and the like gives ample evidence of this.

The photograph has an added realism of its own; it has an inherent attraction not found in other forms of illustration. For this reason the average person believes implicitly that the photograph cannot falsify. Of course, you and I know that this unbounded faith in the integrity of the photograph is often rudely shaken, for, while photographs may not lie, liars may photograph. It becomes necessary, then, in our revelation of the truth, to see to it that the camera we depend upon contracts no bad habits.

Not long ago, a leader in social work, who had previously told me that photographs had been faked so much they were of no

use to the work, assured Editor Kellogg that the photographs of child labor in the Carolinas would stand as evidence in any court of law.

Moral: Despise not the camera, even though yellow-photography does exist.

With several hundred photos like those which I have shown, backed with records of observations, conversations, names and addresses, are we not better able to refute those who, either optimistically or hypocritically, spread the news that there is no child labor in New England?

Perhaps you are weary of child labor pictures. Well, so are the rest of us, but we propose to make you and the whole country so sick and tired of the whole business that when the time for action comes, child-labor pictures will be records of the past.

The artist, Burne-Jones, once said he should never be able to paint again if he saw much of those hopeless lives that have no remedy. What a selfish, cowardly attitude!

How different is the stand taken by Hugo, that the great social peril is darkness and ignorance. "What then," he says, "is required? Light! Light in floods!"

The dictum, then, of the social worker is "Let there be light;" and in this campaign for light we have for our advance agent the light writer — the photograph.

This is the era of the specialist. Curtis, Burton Holmes, Stoddard and others have done much along special lines of social photography. The greatest advance in social work is to be made by the popularizing of camera work, so these records may be made by those who are in the thick of the battle. It is not a difficult proposition. In every group of workers there is sure to be one at least who is interested in the camera. If you can decide that photography would be a good thing for you, get a camera, set aside a small appropriation and some definite time for the staff photographer, go after the matter with a sympathetic enthusiasm (for camera work without enthusiasm is like a picnic in the rain). The local photographer (unless he is a rare one) cannot do much for you. Fight it out yourself, for better little technique and much sympathy than the reverse. Returns? Of course they will follow. Ask Mrs. Rogers, of Indianapolis, whose plea for bath suits (on the screen) was a real factor in procuring them. Ask Mr. Weller, of Pittsburgh, one of the pioneers in social photography.

At the close of the Round Table which follows this talk, I shall be glad to meet those of you who are interested in the question of enlarging your scope in camera work. If a camera club could be the outcome, so much the better.

Apart from the charitable or pathological phases of social work, what a field for photographic art lies untouched in the industrial world.

There is urgent need for the intelligent interpretation of the world's workers, not only for the people of today, but for future ages.

Years ago, George Eliot suggested the need for the social photographer in these words:

"All honor and reverence to the divine beauty of form," says George Eliot (Adam Bede). "Let us cultivate it to the utmost in men, women and children, in our gardens, in our houses; but let us love that other beauty, too, which lies in no secret of proportion, but in the secret of deep human sympathy.

"Paint us an angel, if you can, with floating violet robe and a face paled by the celestial light; paint us a Madonna turning her mild face upward, and opening her arms to welcome the divine glory, but do not impose on us any esthetic rules which shall banish from the reign of art those old women with work-worn hands scraping carrots, those heavy clowns taking holiday in a dingy pothouse, those rounded backs and weather-beaten faces that have bent over the spade and done the rough work of the world, those homes with their tin pans, their brown pitchers, their rough curs and their clusters of onions.

"It is needful we should remember their existence, else we may happen to leave them out of our religion and philosophy, and frame lofty theories which only fit a world of extremes. Therefore, let art always remind us of them; therefore, let us always have men ready to give the loving pains of life to the faithful representing of commonplace things, men who see beauty in the commonplace things, and delight in showing how kindly the light of heaven falls on them."

Pictorial Photography

Alfred Stieglitz (1864–1946) and *Camera Work*

While an American engineering student in Berlin during the early 1880s, Alfred Stieglitz began to cultivate an interest in photography — an interest that would alter the style, composition, and subject matter of the medium for the century to come. Abandoning engineering, Stieglitz devoted himself entirely to the study of photography, under the direction of the renowned chemist H. W. Vogel. In 1887, he entered a competition sponsored by the British Amateur Photographic Society and received his first silver medal for "A Good Joke." The judge who noted the honesty and spontaneity evoked by Stieglitz's photograph was the English photographer and writer Peter Henry Emerson.

Stieglitz returned to New York in 1890, to find most American photographers moving in two distinctly different, though, to his mind, equally superficial, directions. Standard commercial portraitists were producing traditional likenesses, and supposedly more creative amateurs were composing works according to outmoded artistic conventions. Stieglitz plunged into the community of amateurs, becoming an outspoken member of the New York Society of Amateur Photographers. In his writings and speeches he stressed the serious commitment he thought photographers should make to their work. Soon his innovative articles and his impressionistic photographs of life on the city streets of New York began to win him international acclaim.

Stieglitz became editor of the American Amateur Photographer *in 1893. In that journal he voiced the necessity for artistic excellence and originality in American photography. In 1897, when the Society of Amateur Photographers merged with the New York Camera Club, Stieglitz proposed the creation of an illustrated quarterly to take the place of the Club's pamphlet,* Journal. *The resulting publication,* Camera Notes, *served in later years as the model for Stieglitz's major publishing venture,* Camera Work. *Two hand-pulled photogravures of photographs selected by Stieglitz appeared in each issue. Through these meticulous reproductions, Stieglitz conveyed his belief in photography's potential as a fine art.*

Noted essayists, humorists, and art critics, such as Charles Caffin and Sadakichi Hartmann, contributed to Camera Notes. *Their writings drew the attention of serious photographers across the country. The quarterly prompted Stieglitz's association with Clar-*

ence White, Edward Steichen, Gertrude Käsebier, and many other photographers experimenting with the pictorialist tradition. In an unprecedented show for the National Arts Club in 1902, Stieglitz brought together photographs by pictorialists whose images he had published in Camera Notes. *He titled the exhibition "The Photo-Secession," to indicate a revolt from hackneyed style and technique as well as from lax artistic standards. Stieglitz believed that photography possessed a unique aesthetic which had been ignored too long by American photographers. His convictions paralleled those of European secessionist groups, most notably the English Linked Ring. Ironically, the secessionist photographers espoused a style that was scarcely unique to photography: their works expressed the same concerns as contemporary impressionist paintings, emphasizing the mood of a spontaneous moment through atmosphere and light.*

After the 1902 exhibition, Stieglitz resigned as editor of Camera Notes. *The Photo-Secession developed into a formal group, and he was named director. Drawing on old contributors to* Camera Notes, *he began to edit and publish* Camera Work, *which appeared from 1902 to 1917. In 1905, he opened the Little Galleries, in three rooms at 291 Fifth Avenue, where, with Edward Steichen, he exhibited experimental American and European photography, painting, and sculpture, including works by Photo-Secessionists, Rodin, Matisse, Picasso, Arthur Dove, and Georgia O'Keefe, whom Stieglitz married in 1924. By 1917, when "291" closed and* Camera Work *folded, Stieglitz and many of his colleagues had altered their conception of the proper photographic style. They argued that the medium was uniquely equipped to convey the essence of physical reality through the representation of clearly focused detail, an approach that came to be known as* straight photography. *In 1924, Stieglitz was awarded the Progress Medal by the Royal Photographic Society of England. From 1925 to 1929, he directed the Intimate Gallery, which exhibited avant-garde art. In 1929, he took charge of the gallery An American Place. Though Stieglitz stopped photographing in 1937, he continued to act as an American herald for new and experimental trends in photography, painting, and sculpture until his death in 1946.*

About ten years ago the movement toward pictorial photography evolved itself out of the confusion in which photography had been born, and took a definite shape in which it could be pursued as such by those who loved art and sought some medium other than brush or pencil through which to give expression to their

ideas. Before that time pictorial photography, as the term was then understood, was looked upon as the bastard of science and art, hampered and held back by the one, denied and ridiculed by the other. It must not be thought from this statement that no really artistic photographic work had been done, for that would be a misconception; but the point is that though some excellent pictures had been produced previously, there was no organized movement recognized as such.

Let me here call attention to one of the most universally popular mistakes that have to do with photography — that of classing supposedly excellent work as professional, and using the term amateur to convey the idea of immature productions and to excuse atrociously poor photographs. As a matter of fact nearly all the greatest work is being, and has always been done, by those who are following photography for the love of it, and not merely for financial reasons. As the name implies, an amateur is one who works for love; and viewed in this light the incorrectness of the popular classification is readily apparent.

Pictures, even extremely poor ones, have invariably some measure of attraction. The savage knows no other way to perpetuate the history of his race; the most highly civilized has selected this method as being the most quickly and generally comprehensible. Owing, therefore, to the universal interest in pictures and the almost universal desire to produce them, the placing in the hands of the general public a means of making pictures with but little labor and requiring less knowledge has of necessity been followed by the production of millions of photographs. It is due to this fatal facility that photography as a picture-making medium has fallen into disrepute in so many quarters; and because there are few people who are not familiar with scores of inferior photographs the popular verdict finds all photographers professionals or "fiends."

Nothing could be farther from the truth than this, and in the photographic world to-day there are recognized but three classes of photographers — the ignorant, the purely technical, and the artistic. To the pursuit, the first bring nothing but what is not desirable; the second a purely technical education obtained after years of study; and the third bring the feeling and inspiration of the artist, to which is added afterward the purely technical knowledge. This class devote the best part of their lives to the

work, and it is only after an intimate acquaintance with them and their productions that the casual observer comes to realize the fact that the ability to make a truly artistic photograph is not acquired off-hand, but is the result of an artistic instinct coupled with years of labor. It will help to a better understanding of this point to quote the language of a great authority on pictorial photography, one to whom it owes more than to any other man, Dr. P. H. Emerson. In his work, "Naturalistic Photography," he says: "Photography has been called an irresponsive medium. This is much the same as calling it a mechanical process. A great paradox which has been combated is the assumption that because photography is not 'hand-work,' as the public say — though we find there is very much 'hand-work' *and* head-work in it — therefore it is not an art language. This is a fallacy born of thoughtlessness. The painter learns his technique in order to speak, and he considers painting a mental process. So with photography, speaking artistically of it, it is a very severe mental process, and taxes all the artist's energies even after he has mastered technique. The point is, *what you have to say and how to say it*. The originality of a work of art refers to the originality of the thing expressed and the way it is expressed, whether it be in poetry, photography, or painting. That one technique is more difficult than another to learn no one will deny; but the greatest thoughts have been expressed by means of the simplest technique, writing."

In the infancy of photography, as applied to the making of pictures, it was generally supposed that after the selection of the subjects, the posing, lighting, exposure, and development, every succeeding step was purely mechanical, requiring little or no thought. The result of this was the inevitable one of stamping on every picture thus produced the brand of mechanism, the crude stiffness and vulgarity of chromos, and other like productions.

Within the last few years, or since the more serious of the photographic workers began to realize the great possibilities of the medium in which they worked on the one hand, and its demands on the other, and brought to their labors a knowledge of art and its great principles, there has been a marked change in all this. Lens, camera, plate, developing-baths, printing process, and the like are used by them simply as tools for the elaboration of their ideas, and not as tyrants to enslave and dwarf them, as had been the case.

118

The statement that the photographic apparatus, lens, camera, plate, etc., are pliant tools and not mechanical tyrants, will even to-day come as a shock to many who have tacitly accepted the popular verdict to the contrary. It must be admitted that this verdict was based upon a great mass of the evidence — mechanical professional work. This evidence, however, was not of the best kind to support such a verdict. It unquestionably established that nine-tenths of the photographic work put before the public was purely mechanical; but to argue therefrom that all photographic work *must* therefore be mechanical was to argue from the premise to an inconsequent conclusion, a fact that a brief examination of some of the photographic processes will demonstrate beyond contradiction. Consider, for example, the question of the development of a plate. The accepted idea is that it is simply immersed in a developing solution, allowed to develop to a certain point, and fixed; and that, beyond a care that it be not over-developed or fogged, nothing further is required. This, however, is far from the truth. The photographer has his developing solutions, his restrainers, his forcing baths, and the like, and in order to turn out a plate whose tonal values will be relatively true he must resort to local development. This, of course, requires a knowledge of and feeling for the comprehensive and beautiful tonality of nature. As it has never been possible to establish a scientifically correct scale of values between the high lights and the deep shadows, the photographer, like the painter, has to depend upon his observation of and feeling for nature in the production of a picture. Therefore he develops one part of his negative, restrains another, forces a third, and so on; keeping all the while a proper relation between the different parts, in order that the whole may be harmonious in tone. This will illustrate the plastic nature of plate development. It will also show that the photographer must be familiar not only with the positive, but also with the negative value of tones. The turning out of prints likewise is a plastic and not a mechanical process. It is true that it can be made mechanical by the craftsman, just as the brush becomes a mechanical agent in the hands of the mere copyist who turns out hundreds of paint-covered canvases without being entitled to be ranked as an artist; but in proper hands print-making is essentially plastic in its nature.

An examination of either the platinum or the gum process, the two great printing media of the day, will at once demonstrate

that what has already been asserted of the plate is even more true of these. Most of the really great work of the day is done in one or the other of these processes, because of the great facility they afford in this direction, a facility which students of the subject are beginning to realize is almost unlimited. In the former process, after the print has been made, it is developed locally, as was the plate. With the actual beauties of the original scene, and its tonal values ever before the mind's eye during the development, the print is so developed as to render all these as they impressed the maker of the print; and as no two people are ever impressed in quite the same way, no two interpretations will ever be alike. To this is due the fact that from their pictures it is as easy a matter to recognize the style of the leading workers in the photographic world as it is to recognize that the Rembrandt or Reynolds. In engraving, art stops when the engraver finishes his work, and from that time on the process becomes a mechanical one; and to change the results the plate must be altered. With the skilled photographer, on the contrary, a variety of interpretations may be given of a plate or negative without any alterations whatever in the negative, which may at any time be used for striking off a quantity of purely mechanical prints. The latest experiments with the platinum process have opened up an entirely new field — that of local brush development with different solutions, so as to produce colors and impart to the finished picture all the characteristics of a tinted wash-drawing. This process, which has not yet been perfected, has excited much interest, and bids fair to result in some very beautiful work. By the method of local treatment above referred to almost absolute control of tonality, atmosphere, and the like is given to the photographer, on whose knowledge and taste depends the picture's final artistic charm or inartistic offensiveness.

In the "gum-process," long ago discarded by old-time photographers as worthless, because not facile from the mechanical point of view, but revived of recent years, the artist has a medium that permits the production of any effect desired. These effects are invariably so "unphotographic" in the popular sense of that word as to be decried as illegitimate by those ignorant of the method of producing them. In this process the photographer prepares his own paper, using any kind of surface most suited to the result wanted, from the even-surfaced plate paper to rough

drawing parchment; he is also at liberty to select the color in which he wishes to finish his picture, and can produce at will an india-ink, red-chalk, or any other color desired. The print having been made he moistens it, and with a spray of water or brush can thin-out, shade, or remove any portion of its surface. Besides this, by a system of recoating, printing-over, etc., he can combine almost any tone or color-effect.

"Retouching," says Dr. Emerson, "is the process by which a good, bad, or indifferent photograph is converted into a bad drawing or painting." It was invariably inartistic, generally destructive of values, and always unphotographic, and has to-day almost disappeared.

With the appreciation of the plastic nature of the photographic processes came the improvement in the methods above described and the introduction of many others. With them the art-movement, as such, took a more definite shape, and, though yet in its infancy, gives promise of a robust maturity. The men who were responsible for all this were masters and at the same time innovators, and while they realized that, like the painter and the engraver their art had its limitations, they also appreciated what up to their time was not generally supposed to be the fact, that the accessories necessary for the production of a photograph admitted of the giving expression to individual and original ideas in an original and distinct manner, and that photographs could be realistic and impressionistic just as their maker was moved by one or the other influence.

A cursory review of the magazines and papers the world over that devote their energies and columns to art and its progress will convince the reader that to-day pictorial photography is established on a firm and artistic basis. In nearly every art-centre exhibitions of photographs are shown that have been judged by juries composed of artists and those familiar with the technique of photography, and passed upon as to their purely artistic merit; while in Munich, the art-centre of Germany, the "Secessionists," a body of artists comprising the most advanced and gifted men of their times, whô (as the name indicates they have broken away from the narrow rules of custom and tradition) have admitted the claims of the pictorial photograph to be judged on its merits as a work of art independently, and without considering the fact that it has been produced through the medium of

121

the camera. And that the art-loving public is rapidly coming to appreciate this is evidenced by the fact that there are many private art collections to-day that number among their pictures original photographs that have been purchased because of their real artistic merit. The significance of this will be the more marked when the prices paid for some of these pictures are considered, it being not an unusual thing to hear of a single photograph having been sold to some collector for upward of one hundred dollars. Of the permanent merit of these pictures posterity must be the judge, as is the case with every production in any branch of art designed to endure beyond the period of a generation.

The field open to pictorial photography is to-day practically unlimited. To the general public that acquires its knowledge of the scope and limitations of modern photography from professional show windows and photo-supply cases, the statement that the photographer of to-day enters practically nearly every field that the painter treads, barring that of color, will come as something of a revelation. Yet such is the case: portrait work, genre studies, landscapes, and marine, these and a thousand other subjects occupy his attention. Every phase of light and atmosphere is studied from its artistic point of view, and as a result we have the beautiful night pictures, actually taken at the time depicted, storm scenes, approaching storms, marvellous sunset-skies, all of which are already familiar to magazine readers. And it is not sufficient that these pictures be true in their rendering of tonal-values of the place and hour they portray, but they must also be so as to the correctness of their composition. In order to produce them their maker must be quite as familiar with the laws of composition as is the landscape or portrait painter; a fact not generally understood. Metropolitan scenes, homely in themselves, have been presented in such a way as to impart to them a permanent value because of the poetic conception of the subject displayed in their rendering. In portraiture, retouching and the vulgar "shine" have been entirely done away with, and instead we have portraits that are strong with the characteristic traits of the sitter. In this department head-rests, artificial backgrounds, carved chairs, and the like are now to be found only in the workshops of the inartistic craftsman, that class of so-called portrait photographers whose sole claim to the artistic is the

glaring sign hung without their shops bearing the legend, *"Artistic Photographs Made Within."* The attitude of the general public toward modern photography was never better illustrated than by the remark of an art student at a recent exhibition. The speaker had gone from "gum-print" to "platinum," and from landscape to genre-study, with evident and ever-increasing surprise; had noted that instead of being purely mechanical, the printing processes were distinctly individual, and that the negative never twice yielded the same sort of print; had seen how wonderfully true the tonal renderings, how strong the portraits, how free from the stiff, characterless countenance of the average professional work, and in a word how full of feeling and thought was every picture shown. Then came the words, *"But this is not photography!"* Was this true? No! For years the photographer has moved onward first by steps, and finally by strides and leaps, and, though the world knew but little of his work, advanced and improved till he has brought his art to its present state of perfection. This is the real photography, the photography of to-day; and that which the world is accustomed to regard as pictorial photography is not the real photography, but an ignorant imposition.

Photography *and* Photography and Artistic-Photography

Marius De Zayas (1880–1961)

In 1907, the Mexican-born writer Marius De Zayas, arrived in New York and allied himself with Stieglitz's "291" Gallery. As an essayist for Camera Work, *De Zayas proclaimed the demise of art as the expression of the death of religious faith in Western culture. He reevaluated art's role as the representation of form, and envisioned photography as the herald of a new artistic age. De Zayas believed that through photography the artist could dispel convention-bound images of the world to communicate a fresh awareness. He also associated primitive art and the art of children with this new vision. He championed the avant-garde artists of his day, traveling from New York to Paris to keep up with the most revolutionary developments. In 1913 he and Paul Haviland wrote* A Study of the Modern Evolution of Plastic Art, *and in 1916 he published* African Negro Art: Its Influence on Modern Art.*

De Zayas served as an editor of the publication "291" in 1915 and 1916, while he, Agnew Ernst Meyer, Paul Haviland, and Francis Picabia started their commercial venture, the Modern Gallery. As a modernist, De Zayas wholeheartedly supported the Photo-Secession's shift away from pictorialism toward abstraction during those years, and he tried to publicize the transformation through "291." When the Modern Gallery folded in 1916, De Zayas established a gallery of his own, which lasted through 1921. For the next decade, he organized exhibitions of modern and primitive art for other New York City museums, and began to acquire his own collection of works by the more radical artists of the nineteenth and twentieth centuries.

Photography is not Art. It is not even an art.

Art is the expression of the conception of an idea. Photography is the plastic verification of a fact.

The difference between Art and Photography is the essential difference which exists between the Idea and Nature.

Nature inspires in us the idea. Art, through the imagination, represents that idea in order to produce emotions.

The Human Intellect has completed the circle of Art. Those whose obstinacy makes them go in search of the new in Art, only

125

follow the line of the circumference, following the footsteps of those who traced the closed curve. But photography escapes through the *tangent* of the circle, showing a new way to progress in the comprehension of form.

Art has abandoned its original purpose, the substantiation of religious conception, to devote itself to a representation of Form. It may be said that the soul of Art has disappeared, the body only remaining with us, and that therefore the unifying idea of Art does not exist. That body is disintegrating, and everything that disintegrates, tends to disappear.

So long as Art only speculates with Form, it cannot produce a work which fully realizes the preconceived idea, because imagination always goes further than realization. Mystery has been suppressed, and with mystery faith has disappeared. We could make a Colossus of Rhodes, but not the Sphinx.

Each epoch of the history of Art is characterized by a particular expression of Form. A peculiar evolution of Form corresponds to each one of the states of anthropological development. From the primitive races, to the white ones, which are the latest in evolution and consequently the most advanced, Form, starting from the fantastic, has evolved to a *conventional naturalism*. But, when we get to our own epoch, we find, that a special Form is lacking in Art, for Form in contemporary Art is nothing but the result of the adaptation of all the other forms, which existed previous to the conditions of our epoch. Nevertheless we cannot rightly say that a true eclecticism exists. It may be held that this combination constitutes a special form, but in fact it does not constitute anything but a special *deformation*.

Art is devouring Art. Conservative artists, with the faith of fanaticism, constantly seek inspiration in the museums of art. Progressive artists squeeze the last idea out of the ethnographical museums, which ought also to be considered as museums of art. Both build on the past. Picasso is perhaps the only artist who in our time works in search of a new form. But Picasso is only an analyst; up to the present his productions reveal solely the plastic analysis of artistic form without arriving at a definite synthesis. His labor is in opposite direction to the concrete. His starting point is the most primitive work existing, and from it he goes toward the infinite, de-solving without ever resolving.

In the savage, analysis and discrimination do not exist. He is unable to concentrate his attention upon a particular thing for

any length of time. He does not understand the difference between *similar* and *identical,* between that which is seen in dreams and that which happens in real life, between imagination and facts; and that is why he takes as facts the ideas inspired by impressions. As he lives in the sphere of imagination, the tangible form to him does not exist except under the aspect of the fantastic. It has been repeatedly proved that a faithful drawing from nature, or a photograph, are blanks to a savage, and that he is unable to recognize in them either persons or places which are most familiar to him; the real representation of form has no significance to his senses. The many experiments that Europeans have made with African Negroes, making them draw from nature, have proved that the Negroes always take from form that only which impresses them from the decorative point of view, that is to say, that which represents an abstract expression. For instance, in drawing an individual, they give principal importance to such things as the buttons of the clothes, distributing them decoratively, in an arbitrary manner, far different from the place which they occupied in reality. While they appreciate abstract form, the abstract line is to them incomprehensible, and only the combinations of lines expressing a decorative idea is appreciated by them. Therefore what they try to reproduce is not form itself, but the expression of the sentiment or the impression, represented by a geometrical combination.

Gradually, while the human brain has become perfected under the influence of progress and civilization, the abstract idea of representation of form has been disappearing. To the expression through the decorative element has succeeded the expression by the factual representation of form. Observation replaced impression, and analysis followed observation.

There is no doubt that, while the human brain has been developing, the imaginative element has been eliminated from Art. There is no doubt also, that all the elements for creative imagination have been exhausted. What is now produced in Art is that which has caused us pleasure in other works. The creative Art has disappeared without the pleasure of Art being extinct.

The contemporary art that speculates with the work of the savages, is nothing but the quantitative and the qualitative analysis of that which was precisely the product of the lack of analysis.

Imagination, creative faculty, is the principal law of Art. That

faculty is not autogenous, it needs the concurrence of another principle to excite its activity. The elements acquired by perception and by the reflective faculties, presented to the mind by memory, take a new form under the influence of the imagination. This new aspect of form is precisely what man tries to reproduce in Art. That is how Art has established false ideas concerning the reality of Form and has created sentiments and passions that have radically influenced the human conception of reality. To those under this influence, its false ideas of Form are considered as dogmas, as axiomatic truths; and to persuade us of the exactitude of their principles they allege their way of *feeling*. It is true that nature does not always offer objects in the form corresponding to those ways of feeling; but imagination always does, for it changes their nature, adapting them to the convenience of the artist.

Let us enter into some considerations upon imagination, so many times mentioned in this paper. Leaving aside all the more or less metaphysical definitions offered by the philosophers, let us consider it for what it is, that is to say, *creative* faculty, whose function consists in producing new images and new ideas. Imagination is not merely the attention which contemplates things, nor the memory which recalls them to the mind, nor the comparison which considers their relationship, nor the judgment which pronounces upon them an affirmation or a negation. Imagination needs the concourse of all these faculties, working upon the elements they offer, gathering them and combining them, creating in that way new images or new ideas.

But imagination, on account of its characteristics, has always led man away from the realization of truth in regard to Form, for the moment the latter enters under the domination of thought, it becomes a chimera. Memory, that concurrent faculty of imagination, does not retain the remembrance of the substantial representation of Form, but only its synthetic expression.

In order fully and correctly to appreciate the reality of Form, it is necessary to get into a state of perfect consciousness. The reality of Form can only be transcribed through a mechanical process, in which the craftsmanship of man does not enter as a principal factor. There is no other process to accomplish this than photography. The photographer — the true photographer — is he who has become able, through a state of perfect con-

sciousness, to possess such a clear view of things as to enable him to understand and feel the beauty of the reality of Form.

The more we consider photography, the more convinced we are that it has come to draw away the veil of mystery with which Art enveloped the represented Form. Art made us believe that without the symbolism inspired by the hallucination of faith, or without the conventionalism inspired by philosophical auto-intoxications, the realization of the psychology of Form was impossible; that is to say, that without the intervention of the imaginative faculties, Form could not express its spirit.

But when man does not seek pleasure in ecstasies but in investigation, when he does not seek the anaesthetic of contemplation, but the pleasure of perfect consciousness, the soul of substance represented by Art appears like the phantasm of that *Alma Mater* which is felt vibrating in every existing thing, by all who understand the beauty of real truth. This has been demonstrated to us in an evident manner, if not in regard to pure Art, at least in regard to science, by the great geometricians, like Newton, Lagrange and La Place; by the great philosophers, like Plato, Aristotle and Kant; and the great naturalists, like Linnaeus, Cuvier and Geoffray Saint Hilaire.

Art presents to us what we may call the emotional or intellectual truth; photography the material truth.

Art has taught us to feel emotions in the presence of a work that represents the emotions experienced by the artist. Photography teaches us to realize and feel our own emotions.

I have never accepted Art as infinite nor the human brain as omnipotent. I believe in progress as a constant and ineludible law, and I am sure we are advancing, though we are ignorant how, why and whither; nor know how far we shall go.

I believe that the influence of Art has developed the imagination of man, carrying it to its highest degree of intensity and sensibility, leading him to conceive the incomprehensible and the irrepresentable. No sooner had the imagination carried man to chaos, than he groped for a new path which would take him to that "whither," impossible to conceive, and he found photography. He found in it a powerful element of orientation for the realization of that perfect consciousness for which science has done and is doing so much, to enable man to understand reason, the cause of facts — Truth.

Photography represents Form as it is required by the actual state of the progress of human intelligence. In this epoch of fact, photography is the concrete representation of consummated facts. In this epoch of the indication of truth through materialism, photography comes to supply the material truth of Form.

This is its true mission in the evolution of human progress. It is not to be the means of expression for the intellect of man.

Photography is not Art, but photographs can be made to be Art.

When man uses the camera without any preconceived idea of final results, when he uses the camera as a means to penetrate the objective reality of facts, to acquire a truth, which he tries to represent by itself and not by adapting it to any system of emotional representation, then, man is doing Photography.

Photography, pure photography, is not a new system for the representation of Form, but rather the negation of all representative systems, it is the means by which the man of instinct, reason and experience approaches nature in order to attain the evidence of reality.

Photography is the experimental science of Form. Its aim is to find and determine the objectivity of Form; that is, to obtain the condition of the initial phenomenon of Form, phenomenon which under the dominion of the mind of man creates emotions, sensations and ideas.

The difference between Photography and Artistic-Photography is that, in the former, man tries to get at that objectivity of Form which generates the different conceptions that man has of Form, while the second uses the objectivity of Form to express a preconceived idea in order to convey an emotion. The first is the fixing of an actual state of Form, the other is the representation of the objectivity of Form, subordinated to a system of representation. The first is a process of indigitation, the second a means of expression. In the first, man tries to represent something that is outside of himself; in the second he tries to represent something that is in himself. The first is a free and

impersonal research, the second is a systematic and personal representation.

The artist photographer uses nature to express his individuality, the photographer puts himself in front of nature, and without preconceptions, with the free mind of an investigator, with the method of an experimentalist, tries to get out of her a true state of conditions.

The artist photographer in his work envelops objectivity with an idea, veils the object with the subject. The photographer expresses, so far as he is able to, pure objectivity. The aim of the first is pleasure; the aim of the second, knowledge. The one does not destroy the other.

Subjectivity is a natural characteristic of man. Representation began by the simple expression of the subject. In the development of the evolution of representation, man has been slowly approaching the object. The History of Art proves this statement.

In subjectivity man has exhausted the representation of all the emotions that are peculiar to humanity. When man began to be inductive instead of deductive in his represented expressions, objectivity began to take the place of subjectivity. The more analytical man is, the more he separates himself from the subject and the nearer he gets to the comprehension of the object.

It has been observed that Nature to the majority of people is amorphic. Great periods of civilization have been necessary to make man conceive the objectivity of Form. So long as man endeavors to represent his emotions or ideas in order to convey them to others, he has to subject his representation of Form to the expression of his idea. With subjectivity man tried to represent his feeling of the primary causes. That is the reason why Art has always been subjective and dependent on the religious idea.

Science convinced man that the comprehension of the primary causes is beyond the human mind; but science made him arrive at the cognition of the condition of the phenomenon.

Photography, and only Photography, started man on the road of the cognition of the condition of the phenomena of Form.

Up to the present, the highest point of these two sides of Photography has been reached by Steichen as an artist and by Stieglitz as an experimentalist.

The work of Steichen brought to its highest expression the aim

of the realistic painting of Form. In his photographs he has succeeded in expressing the perfect fusion of the subject and the object. He has carried to its highest point the expression of a system of representation: the realistic one.

Stieglitz has begun with the elimination of the subject in represented Form to search for the pure expression of the object. He is trying to do synthetically, with the means of a mechanical process, what some of the most advanced artists of the modern movement are trying to do analytically with the means of Art.

It would be difficult to say which of these two sides of Photography is the more important. For one is the means by which man fuses his idea with the natural expression of Form, while the other is the means by which man tries to bring the natural expression of Form to the cognition of his mind.

Is Photography a New Art?

Anonymous

When photography was first discovered, and it was realized that machinery and chemicals could make what had hitherto been held to be exclusively the product of man's most superior faculties, many asked the question, "What will the artist do when this process becomes more nearly perfected?" The amazement at the almost magical result that had been achieved was so great that enthusiasm, and expectation of further and equally startling revelations, knew no bounds. Perfect results in color were confidently expected to follow shortly — then the artists were to go into bankruptcy. The painters for their part denied the possibility of machinery ever producing art; they engaged in controversy with the photo-enthusiasts, and argued the case endlessly.

This was in the first part of the last century. What is said of photography now? Are the portrait- and landscape-painters told that their doom is sealed, and that when color photography shall be discovered, their stuff will no longer be a desideratum? To the contrary, the word photographic, in the minds of the general public, is synonymous with pedantic exactitude, illogical selection, absence of imagination, and feeling in general; in fact, anti-art. Of course, as every one interested in pictorial photography knows, there are little oases like the Secession, and corresponding European organizations, in which the tradition that photography is an art is still kept up; but, as a widespread rule, the discussion is looked upon as closed — the public has made up its mind, and so far to the other extreme has its feeling swung, that even painters dare not say that they sometimes use the camera as an aid to their work for fear of being thought inartistic.

Now, it appears to me that the whole discussion as to whether photography is or is not an art has always been, and is still being, conducted on an illogical basis. The question rightly put is, "Is photography one of the fine arts?" To either prove or disprove this question, the disputants have always entered upon long definitions of painting, etching, charcoal, watercolor, and what not, in order to find what resemblances or dissemblances there were between these arts and photography. But on the face of it, this method of reasoning is fallacious, for the question asked is not,

"Is photography one of the *graphic* arts?" but is, "Is photography one of the *fine* arts?" — and even if it can be proven beyond doubt that photography is not one of the graphic arts, it does not at all follow that it is not one of the fine arts. The conclusion I have come to after much investigation is that photography is not one of the graphic arts, but that it is one of the fine arts, and more closely allied to architecture than to painting. To prove my point, I will ask the reader to follow me through a short analysis of the different fine arts, and a little deductive reasoning.

Music makes its appeal to the sensibilities through the sense of hearing. The symbols it uses are sounds, pure sounds, without any intelligible meaning attached. The element of time enters as an all-important factor, much of the effect produced depending upon the relative duration of the different sounds, and upon the spacing between them. What is termed rhythm is another factor. Poetry, although considered an entirely different art from music, appeals largely in the same way — sounds controlled by time spacing and rhythm act through the ear upon the intelligence. In addition, then, to its musical components it contains thought, and this thought-element plays upon the sentiments, either directly, through associations, by arousing the imagination, or indirectly, through the reasoning faculties. Painting addresses through the sense of sight. It contains no elements of time, but representations of space. Its symbols of expression are colored or black-and-white imitations of fragments of nature. Though quite unlike poetry, some classes of painting, called illustrative, as the old Italian, possess a certain amount of the "thought" or literary element — even if not expressed in words — and act upon us in part like poetry. There are kinds of painting, however, in which the literary component does not exist, and these please purely through color, light and shade, and line. The art of sculpture, instead of dealing in representations of space, as does painting, deals in actual space quantities, which manifest themselves through light and shade, and line. Sculpture, curiously, although at first sight not obviously so, is dependent upon the time-element. Any single view of a piece of molded clay or marble from a single point is not sufficient to its complete understanding — it is necessary that there should combine in the mind innumerable different impressions, and these impressions are only obtainable through a series of successive views. Further, these

successive views must be presented to the mind in a logical time-sequence, such as that obtained by slowly walking around the piece of sculpture, and this, because much of the beauty of sculpture is due to what may be called the rhythmic appearing, changing, and disappearing of lines, and if the time-sequence of the successive views is not logical, the proper rhythm will not be produced, and much of the effect will be lost. The fine art of dancing, although enhanced by the color of the dancer, is really largely the same as sculpture, only the time-element is as important as in music.

It will be seen from this analysis that the fine arts differ from each other, not in that their components are totally unlike each other, but more in that the proportions of these components vary in quantity. Music and dancing have much to do with time; poetry, a little less; sculpture, still less, and painting, not at all. Poetry has much to do with literary thought; painting, a great deal less; dancing, and sculpture, still less, and music, not at all. Poetry and music are independent of the space-element; sculpture and dancing could not exist without it, and painting makes believe it possesses it. None of the fine arts possess all of the possible qualities, but each has at least one quality in common with another, and thus they all blend into each other, sometimes so subtly that it is impossible to tell where one begins and the other ends.

It would appear, however — at least according to the dictum of many learned philosophers of many ages — that there is one quality which all arts must possess, and that is what is termed the personal touch. I concede the proposition, but as almost the whole controversy as to whether photography is or is not a fine art, has turned on this single point, let us make an inquiry as to what the nature of this "personal touch" is, and see if all the arts must really possess it, and, if so, whether it can be found in photography. In painting, what is usually called the personal touch evinces itself in local touches and exaggerations, unmistakably bearing the stamp of the work of a human being. However, different paintings vary as to the quantity of the touch they possess, archaic work being more strongly flavored with it than some more recent productions. In music, the personal touch is the fingertouch of the player. That this touch is necessary for the production of true music is proven by the fact that such ma-

135

chines as musical piano-players, and Pianolas, even when exactly rendering the score, cannot make music, and the more perfectly they are constructed, the more diabolical they are. In dancing, the personal touch mutates into actual existence — it is the person, as well as the personality of the dancer. In oratory, the personality of the person becomes so important that it receives a special name, magnetism, and without it, a man may utter Aristotelian wisdom unheeded, while another, possessed of it, will talk semi- or fully-idiotic propositions to a crowd beside itself with enthusiasm. In sculpture, the personal touch is very small in quantity; it can produce its effect by running extremely close to nature. Plaster casts of parts of the living body, when that body is beautiful, produce the same esthetic sensations, although in a smaller quantity, that actual, handmade sculpture does. Not merely is this true, but when the roughnesses which imitate the coarseness of the human flesh have been smoothed down, the result is still more artistic. But, strangely, this operation of smoothing is mechanical, and rather takes from, than adds to, the personal touch. In architecture — except in primitive forms — the "personal touch" *does not exist,* and it appeals to the emotions solely through its proportions.

Now, from the above, it would appear that either architecture is not a fine art, or the personal touch is not needed in art, or there has been something wrong in my reasoning. My reasoning, however, has not been wrong, and the personal touch is necessary in the fine arts, and, also, architecture is one of these fine arts. What is, and has always been, wrong, is the conception photographers attach to the term, personal touch. There are two meanings of the word: the first is the kind we have been speaking of, of which the orator has the most; the sculptor, very little, and the architect, none — the corporeal touch. The second is the true and philosophic meaning, namely, to create with the brain, and bring into concrete existence, through one or other of the physical organs, as by the hand. But to give life by the touch of the hand does not at all imply that, after life has been given, any evidence of how it was produced shall remain — in architecture, as we have seen, it is eliminated, and whole schools of even the graphic arts, as the Asiatic, demand that the personality of the creator shall be suppressed as much as possible.

And what does creation by the brain, and bringing into exis-

tence by the hands, mean? It means only one thing — composing. Man cannot truly create; but he can stick things together in such a way as to illude into the belief that he has created; and it is this esthetic quality of composition which all the fine arts must possess, but is the only one which they must possess in common. As the truth of this proposition is possibly not evident at first sight, I must again ask the reader to follow me through a short investigation to determine what composition is. Let us begin with composition in the graphic arts.

Any and every transcription of nature to canvas or paper will not make a composition; it is essential that such elements should be present that some particular idea is conveyed to the mind of the spectator. Further, it is equally essential that no more elements than necessary shall be present, for the superfluous both contradicts and detracts from the particular idea. And it is also equally important that the composing elements be so disposed that their contours shall naturally lead the eye over the picture in such a way that there be presented an esthetically logical sequence of facts. A composition is in fact like an American anecdote. If the raconteur places the different parts of his anecdote in a wrong sequence, the point is either entirely lost or marred; if he omits or adds, the result is likewise incomplete. A composition differs, therefore, from a scientific statement, in that it is not a matter of facts which can be stated in any way, and in any order, without destroying their truth, but it is a series of facts whose truth is purely dependent upon their special juxtaposition. Now, just why a series of facts, possibly commonplace enough in themselves, and entirely uninteresting in the combinations they are usually found in in nature, should suddenly become interesting when "composed," nobody knows. Why the same rocks, fields, trees, and sky seen from one point of view should look ordinary, but when looked at from another, should tell a story which affects to our innermost depths, is a mystery that has never been solved. Ruskin, in *Modern Painters,* after solving to his own satisfaction many enigmas, gives up composition in despair. At the conclusion of this long work he says, speaking of composition, "The power of mind which accomplishes this, is as yet wholly inexplicable to me, as it was when I first defined it in the chapter on imagination associative, in the second volume." Psychologists tell us that composition in some way appeals to

the subconscious part of the brain, and that they are at work on the problem, but have not yet quite solved it. Philosophers inform us that somewhere within ourselves a sense of absolute order exists, and that when this sense perceives absolute order in nature it is pleased; but when it sees disorder it is displeased. Undoubtedly, the scientists and philosophers, as well as John Ruskin, are right as far as they go; but, unfortunately, they take us no further than we were. Therefore, all we can say is, that to compose is to give order. The sculptor and architect give order through lines and proportions, and light and shade. The orator, besides placing his ideas orderly, expresses order through his voice, gestures, and even depends upon his physical stature and bulk. The painter produces order through lines and color, and also by means of that peculiar *painter touch,* which those entering photo-polemics have so frequently mistaken for the true personal touch. The musician orders through sounds and silences, leading the mind, we know not how, agreeably from one note to the other. All art is a matter of order, and nothing else, and where order has been produced, art has been produced.

Let us now see how the truths we have been gathering apply to photography; and let us first see if photography is capable of order; for if it is not, it is not possessed of the basis essential to all the fine arts, and we need proceed no further. Let us examine portraiture.

If a photographer should photograph his sitter just as he happened into his studio, the result would, with an almost absolute certainty, not be a composition. But if he were to exercise his sense of order, and arrange the folds of the dress, the action of the figure, the background, and light and shade into a composition, and then photograph it, he would produce a work of art. To this proposition, it is frequently objected that the posed model would be the work of art, and the photograph only a photograph of a work of art. If this is true, the portrait-painter, who brings to bear all his imagination and taste in posing his model, and then copies what he sees, is not making a work of art. The proposition is absurd. The posing of the model is only a means to an end — of course, if it is a *tableau vivant* that the artist is striving for, why then, that being the end, it itself becomes the work of art.

The question of composing a landscape is more difficult, as every photographer knows. Landscapes can not be easily com-

posed. The order must be found. I know that it is generally held that nature herself will never make a picture. I also know that until recently it was universally maintained that it was impossible to talk to a person a thousand miles away. But that nature does compose, is proven by the fact that straight photographs of her have been made, which fulfill all the demands of perfect composition. How, and why, nature composes, and how, and why, philosophers have fallen into the error of arrogating the power of composition to man alone, is a subject which it would take us even longer to investigate than the present one. It is sufficient for our purpose to know that she does compose, and that the photographer can transfix her compositions to his negative. But let it be noted, fallacious as the proposition may appear, that the full credit for any such composition belongs to the photographer who has seen it, and seized it; for it is just as difficult to see and grasp the meaning of a natural composition, as it is, by the painter's more lazy method, to get a little piece here, and another little piece there, and glue them together according to the rules of the studio. In fact, if the truth be known as intelligent painters know it, the artist really never composes at all; he merely hunts nature for bits to make into such a whole as he has once actually seen, but which he was unable, owing to its fleetness or other reason, to transcribe to canvas.

Having now shown that a photograph can be a composition; that it can contain that basic life, which all works of art must contain, let us ask, through what manner of flesh, through what symbols, does the composition manifest itself to our senses. The only possible answer is, through scientific imitations of fragments of nature. In other words, photography is the art that expresses itself through symbols, which in their imitativeness of nature, are like those used in painting, but which, in their being scientifically made, and not hand-marked, are also like those used in architecture. That art may express itself through mathematically exact forms, I think I have sufficiently demonstrated; but if there remains any doubt in the mind of the reader, I will remind him that poets have on occasions used scientific symbols. Edgar Allan Poe, in his "Eureka," which he calls a prose-poem, and which it certainly is, speaks solely in scientific terms. It is true that the poem recounts his conception of the creation of the Universe; but he employs logical and material terms and

scientific conceptions to produce his effect. It is through the proper ordering of these impersonal concepts, through exactly the right juxtaposition of mathematical facts, and even figures, that he makes a song as beautiful as could be sung in terms of love.

The conclusion, then, that we have come to is, that photography is one of the fine arts, but no more allied to painting than to architecture, and quite as independent in the series as any of the other arts. As a necessary corollary, photography cannot be *pictorial,* any more than can music or oratory. Photography is photography, neither more nor less.

Photography *and* Photography and the New God

Paul Strand (1890–1976)

As a student at Ethical Cultural High School in New York, Paul Strand began to photograph under the guidance of Lewis Hine in 1907. Hine introduced his pupil to the work of the Photo-Secession, and when Strand became an independent photographer in 1911, he began to frequent Stieglitz's 291 Gallery. Though Strand broke with the impressionist style of the Secession, he worked along the lines of the movement's philosophy, adhering to the definition of photography as a fine art with aesthetic potentials of its own, but he helped to redefine those potentials and to align them with a new, "straight" approach to photography.

Harkening back to the methodological principles of Peter Henry Emerson, Strand argued the importance of separating the true photographic process from the processes of other media. His "straight" photography allowed no brush work to adulterate "pure" photographic technique. Consequently, he could not accept the gum bichromate process, so popular among secessionists for its soft, impressionist results. Strand's stylistic contention with soft-focus work, in general, stemmed from his belief that photography's strength lies in its capacity to depict detail clearly. Like many secessionists, he chose his subjects from daily life, but he photographed in sharp focus. The first Strand photographs published in Camera Work *and shown at 291, in 1916, stress abstract elements of design, while preserving the subject matter's identity. Strand carried out this dual emphasis on pure design and realistic portrayal throughout his life's work.*

Strand worked successfully with film as well as with still photography. In 1921, he produced his first film Manahatta, *with the artist Charles Sheeler. He served as Chief of Photography and Cinematography in the Department of Fine Arts of the Secretariat of Education of Mexico in 1933 and 1934. Strand spent the next forty years traveling over half the world, photographing people in their native environments and producing shows and monographs of his work.*

Photography, which is the first and only important contribution thus far, of science to the arts, finds its *raison d'être,* like all media, in a complete uniqueness of means. This is an absolute

unqualified objectivity. Unlike the other arts which are really anti-photographic, this objectivity is of the very essence of photography, its contribution and at the same time its limitation. And just as the majority of workers in other media have completely misunderstood the inherent qualities of their respective means, so photographers, with the possible exception of two or three, have had no conception of the photographic means. The full potential power of every medium is dependent upon the purity of its use, and all attempts at mixture end in such dead things as the color-etching, the photographic painting and in photography, the gum-print, oil-print, etc., in which the introduction of hand work and manipulation is merely the expression of an impotent desire to paint. It is this very lack of understanding and respect for their material, on the part of photographers themselves which directly accounts for the consequent lack of respect on the part of the intelligent public and the notion that photography is but a poor excuse for an inability to do anything else.

The photographer's problem therefore, is to see clearly the limitations and at the same time the potential qualities of his medium, for it is precisely here that honesty, no less than intensity of vision, is the prerequisite of a living expression. This means a real respect for the thing in front of him, expressed in terms of chiaroscuro (color and photography having nothing in common) through a range of almost infinite tonal values which lie beyond the skill of human hand. The fullest realization of this is accomplished without tricks of process or manipulation, through the use of straight photographic methods. It is in the organization of this objectivity that the photographer's point of view toward Life enters in, and where a formal conception born of the emotions, the intellect, or of both, is as inevitably necessary for him, before an exposure is made, as for the painter, before he puts brush to canvas. The objects may be organized to express the causes of which they are the effects, or they may be used as abstract forms, to create an emotion unrelated to the objectivity as such. This organization is evolved either by movement of the camera in relation to the objects themselves or through their actual arrangement, but here, as in everything, the expression is simply the measure of a vision, shallow or profound as the case may be. Photography is only a new road from a different direction but moving toward the common goal, which is Life.

Notwithstanding the fact that the whole development of photography has been given to the world through *Camera Work* in a form uniquely beautiful as well as perfect in conception and presentation, there is no real consciousness, even among photographers, of what has actually happened: namely, that America has really been expressed in terms of America without the outside influence of Paris art-schools or their dilute offspring here. This development extends over the comparatively short period of sixty years, and there was no real movement until the years between 1895 and 1910, at which time an intense rebirth of enthusiasm and energy manifested itself all over the world. Moreover, this renaissance found its highest aesthetic achievement in America, where a small group of men and women worked with honest and sincere purpose, some instinctively and few consciously, but without any background of photographic or graphic formulae much less any cut and dried ideas of what is Art and what isn't; this innocence was their real strength. Everything they wanted to say had to be worked out by their own experiments: it was born of actual living. In the same way the creators of our skyscrapers had to face the similar circumstance of no precedent, and it was through that very necessity of evolving a new form, both in architecture and photography that the resulting expression was vitalized. Where in any medium has the tremedous energy and potential power of New York been more fully realized than in the purely direct photographs of Stieglitz? Where a more subtle feeling which is the reverse of all this, the quiet simplicity of life in the American small town, so sensitively suggested in the early work of Clarence White? Where in painting, more originality and penetration of vision than in the portraits of Steichen, Käsebier and Frank Eugene? Others, too, have given beauty to the world but these workers, together with the great Scotchman, David Octavius Hill, whose portraits made in 1840 have never been surpassed, are the important creators of a living photographic tradition. They will be the masters no less for Europe than for America because by an intense interest in the life of which they were really a part, they reached through a national, to a universal expression. In spite of indifference, contempt and the assurance of little or no remuneration they went on, as others will do, even though their work seems doomed to a temporary obscurity. The thing they do remains the same; it is a witness to the motive force that drives.

The existence of a medium, after all, is its absolute justification, if as so many seem to think, it needs one at all, comparison of potentialities is useless and irrelevant. Whether a watercolor is inferior to an oil, or whether a drawing, an etching, or a photograph is not as important as either, is inconsequent. To have to despise something in order to respect something else is a thing of impotence. Let us rather accept joyously and with gratitude everything through which the spirit of man seeks to an even fuller and more intense self-realization.

Man having created the concept of God The Creator, found himself unsatisfied. For despite the proven pragmatic value of this image, through which the fine arts of music and literature, of architecture, painting, and sculpture, together with the less fine arts of murder, thievery and general human exploitation, had been carried to great heights, there was still something unfulfilled: the impulse of curiosity in man was still hungry.

In all ages therefore, we find the empirical thinker, the alchemist and astrologer, mathematician and philosophic experimenter, at work, frequently, as in the early Christian world, at considerable risk of his life, liberty and pursuit of happiness. Then, it was the artist alone who was able to indulge in the luxury of empirical thought under the camouflage of subject matter. In every other field of research, the scientific method was seen to be and no doubt was, inimical to all forms of Churchianity; the scientist was then, as his fellow-worker the artist is today, *persona non grata*.

But through the disintegration of the power of the Christian Church following the Reformation, scientific empirical thought found its opportunity of expression. Men's imaginations, weary of sectarian intrigue and of Holy Wars, kindled at the thought of the unknown in the form of unexplored trade routes and new sources of material wealth; and through them dreamed of a power over their fellows as potent as any which could be derived from a vested interest in God. With this change in the direction of thought, the scientist became indispensable, he began to func-

144

tion in society. For when it became apparent that craftsmanship as a means to trade growth was insufficient, that quantity and not quality of production was the essential problem in the acquisition of wealth, it was the scientist and his interpreter, the inventor who jumped into the breach.

Out of wood and metals he made hands that could do the work of a thousand men; he made backs that could carry the burden of a thousand beasts and chained the power which was in the earth and waters to make them work. Through him, men consummated a new creative act, a new Trinity: God the Machine, Materialistic Empiricism the Son, and Science the Holy Ghost.

And in the development and organization of this modern Church, the veritable artist, composer or poet, architect, painter or sculptor, has played no great part. His form of creativity based upon what Croce calls intuitive rather than intellectual knowledge, was clearly of no value in a fairly unscrupulous struggle for the possession of natural resources, for the exploitation of all materials, human and otherwise. As a consequence the artist has fallen considerably from his place of high seriousness as an integral and respected element in society, to that of a tolerated mountebank entertainer merely. With neither Popes, Princes nor any equivalent of the Rockefeller Foundation to support his experimental work, he is today in a position similar to that which the scientist occupied in the middle ages; that of heretic to existing values. That kind of life which has its being in the extension and projection of knowledge through the syntheses of intuitive spiritual activity, and its concomitant the *vita contemplativa,* is seen to be and no doubt is, a menace to a society built upon what has become the religious concept of possessiveness. It is natural therefore that the artist finds himself looked upon with a new sort of hostility which expresses itself, due possibly to the benign influence of civilization, in the form of indifference or contempt, and extends to him the privilege of starving to death. At the judgment seat of the new Trinity he has been found wanting as a waster and a non-producer.

With this increasing isolation of the seeker after intuitive knowledge, the scientist, working not so much in the field of philosophy as in those more "practical" expressions of conceptual knowledge, the natural sciences, has become more and more a part of this industrial society, nay, is largely responsible

for it. Having created the new God, he has permitted himself to be used at every step and for every purpose by its interested devotees. Printing presses or poison gas, he has been equally blind or indifferent to the implications in the use or misuse of either, with the result that the social structure which he has so irresponsibly helped to rear, is today fast being destroyed by the perversion of the very knowledge contributed by him. Virtually yanked out of comparative obscurity by the forces of evolutionary circumstance, and considerably over-inflated by his Holy Ghostship, he has made possible the present critical condition of Western Civilization, faced as it is with the alternatives of being quickly ground to pieces under the heel of the new God or with the tremendous task of controlling the heel.

Signs of this imperative revaluation of the idea of the machine are beginning to manifest themselves. And significantly, one might almost say ironically enough, not among the least important is the emerging demonstration on the part of the artist of the immense possibilities in the creative control of one form of the machine, the camera. For he it is who, despite his social maladjustment, has taken to himself with love a dead thing unwittingly contributed by the scientist, and through its conscious use, is revealing a new and living act of vision.

In order to make this clear it is necessary to record briefly the development of the use of the camera by the seeker after intuitive knowledge. The first of these to become interested in the mechanism and materials of photography was David Octavius Hill, a painter, and member of the Royal Scottish Academy. Hill came upon photography about 1842 in the following way: he had received a commission to paint a large canvas on which were to appear the recognizable portraits of a hundred or more of the well-known people of the time. Faced with this difficult task and having heard of the then recently invented process of photography, he turned to it as a help to his painting. Three years of experimentation followed and it is interesting to learn that he became so fascinated by the new medium that he seriously neglected his painting. So much so in fact, that his wife and friends found it necessary to remind him that he was an "artist." They chided him about wasting his time and finally succeeded in giving him such a bad conscience that he never photographed again. Yet the results of Hill's experimenting have given us a series of

amazing portraits which have not until recently been surpassed. They are built with the utmost simplicity upon large masses of light and dark, but unquestionably the element which makes these portraits live in the naïveté and freedom from all theory with which Hill approached his new medium. He was not concerned or hampered in his photographing by the academic standards of the time as he must have been in his painting, for as a painter he is of slight importance. Despite the primitive machine and materials with which he was compelled to work, the exposures of five to fifteen minutes in bright sunlight, this series of photographs has victoriously stood the test of comparison with nearly everything done in photography since 1845. They remain the most extraordinary assertion of the possibility of the utterly personal control of a machine, the camera.

A gap then of nearly forty years intervened during which these photographs made by Hill passed into obscurity and practically no similar experimentation was done. However, some time before their rediscovery photography had, about the year 1880, started upon a renascent and widespread development all over the world. With the invention of the dry plate, the improvements in lenses and printing papers, the process had been brought within the realm of greater certainty and ease of manipulation. And with this period begins that curious misconception of the inherent qualities of a new medium, on the part of almost everyone who has attempted to express himself through it. Without the slightest realization that in this machine, the camera, a new and unique instrument had been placed in their hands, photographers have in almost every instance, been trying to use it as a short cut to an accepted medium, painting. This misconception still persists today throughout Europe and to a large degree even here in America.

As a consequence the development of photography so beautifully and completely recorded in the numbers of *Camera Work,* is interesting not so much in the aesthetically expressive as in an historical sense. We find all through the work done in Germany, France and Italy, in England and much in America, the supreme altar of the new God, a singular lack of perception and respect for the basic nature of the photographic machine. At every turn the attempt is made to turn the camera into a brush, to make a photograph look like a painting, an etching, a charcoal drawing

or whatnot, like anything but a photograph; and always in imitation of the work of inferior painters. Moreover, with the production of this very considerable number of bastard photographs, interesting though they were temporarily, went an equally vast and foolish discussion as to whether photography was or was not an Art. Needless to say this discussion was usually as thoughtless and as uncritical of its terminology and of its standards as were the photographers of theirs. But partly through this evolution we are now fortunately becoming aware of the fact that nobody knows exactly what Art is; the word does not slip quite so glibly off the tongues of the serious-minded. And fortunately as well, a few photographers are demonstrating in their work that the camera is a machine and a very wonderful one. They are proving that in its pure and intelligent use it may become an instrument of a new kind of vision, of untouched possibilities, related to but not in any way encroaching upon painting or the other plastic arts. It has taken nearly eighty years for this clarification of the actual meaning of photography to reach from the remarkably true but instinctive approach to David Octavius Hill, to the conscious control embodied in the recent work of Alfred Stieglitz.

For it is in the later work of Stieglitz, an American in America, that we find a highly evolved crystallization of the photographic principle, the unqualified subjugation of a machine to the single purpose of expression. It is significant and interesting to note that this man is not a painter and has never felt any impulse to be one. From the very inception of his photographic work which covers a period of thirty-five years, he like Hill, was fascinated by the machine as a thing apart. In fact, Stieglitz knew nothing about painting until, as the guiding spirit in that little experimental laboratory known as "291," he gave Americans their first opportunity of seeing the development of modern painting together with that of photography. Yet with all this he has maintained in his own photographic work a unity of feeling uncontaminated by alien influences; in his own words, "no mechanicalization but always photography." In his later work, consisting almost exclusively of a series of portraits made during the past four years, the achievements possible to the camera pass out of the realm of theory and become objective realities in which certain affirmations emerge. For the first time we are

given an opportunity of examining and of drawing some conclusions concerning the means of photographic expressiveness, an expressiveness the actual nature of which, together with that of other media, may be safely left to the aestheticians to fight about among themselves.

We find first of all in this man's work a space-filling and formal sense which, in many instances, achieves as pure a synthesis of objectivity as can be found in any medium. We perceive upon the loveliness of paper a registration in monochrome of tonal and tactile values far more subtle than any which the human hand can record. We discover as well, the actuality of a new sensitivity of line as finely expressive as any the human hand can draw. And we note that all these elements take form through the machine, the camera, without resort to the imbecilic use of soft focus or uncorrected lenses, or to processes in which manual manipulation may be introduced. Nay more, we see that the use of such lenses or processes weakens or destroys entirely the very elements which distinguish photography and may make it an expression. In the work of Stieglitz there is always a full acceptance of the thing in front of him, the objectivity which the photographer must control and can never evade.

But above all, we become aware in these photographs of his, of a new factor which the machine has added to plastic expression, the element of differentiated time. The camera can hold in a unique way, a moment. If the moment be a living one for the photographer, that is, if it be significantly related to other moments in his experience, and he knows how to put that relativity into form, he may do with a machine what the human brain and hand, through the act of memory cannot do. So perceived, the whole concept of a portrait takes on a new meaning, that of a record of innumerable elusive and constantly changing states of being, manifested physically. This is as true of all objects as of the human object. With the eye of the machine, Stieglitz has recorded just that, has shown that the portrait of an individual is really the sum of a hundred or more photographs. He has looked with three eyes and has been able to hold, by purely photographic means, space-filling, tonality and tactility, line and form, that moment when the forces at work in a human being become most intensely physical and objective. In thus revealing the spirit of the individual he has documented the world of that individual,

which is today. In this sense portrait painting, already nearly a corpse, becomes an absurdity.

Now in all of this it should be well understood, that the machine is a passive and an innocent party. The control of its mechanism and materials, the fineness and sensitivity of its accomplishment are those of man. The new God shorn of its Godhood becomes an instrument of intuitive knowledge. Whether the results of its use will continue to live in the mind and spirit of the future, only time will tell. Whether or not these results come under the category of Art is irrelevant. The important fact to be noted is that today, painters, writers and musicians, even the scientists and sensitive people in every occupation, are reacting as profoundly before photographs, these untouched products of an intelligence and spirit channelling through a machine, as before any of the accepted forms of expression. So that when Croce in his "Aesthetic" writes: "And if photography be not quite an Art, that is precisely because the element of nature in it remains more or less unconquered and ineradicable." When he asks: "Do we ever feel complete satisfaction before even the best of photographs? Would not an artist vary and touch up much or little, remove or add something to the best of photographs?" the conclusion and answer are obvious. Signor Croce is speaking of the shortcomings of *photographers* and not of photography. He has not seen, for the simple reason that it did not exist when he wrote his book, fully achieved photographic expression. In the meantime the twaddle about the limitations of photography has been answered by Stieglitz and a few others of us here in America, by work done. Granting the limitations which all media have in common, it is only when the limitations of *photographers* are under examination, that the discussion becomes realistic.

Thus the deeper significance of a machine, the camera, has emerged here in America, the supreme altar of the new God. If this be ironical it may also be meaningful. For despite our seeming wellbeing we are, perhaps more than any other people, being ground under the heel of the new God, destroyed by it. We are not, as Natalie Curtis recently pointed out in *The Freeman,* particularly sympathetic to the somewhat hysterical attitude of the Futurists toward the machine. We in America are not fighting, as it may be natural to do in Italy, away from the tentacles of a

150

medieval tradition towards a neurasthenic embrace of the new God. We have it with us and upon us with a vengeance, and we will have to do something about it eventually. Not only the new God but the whole Trinity must be humanized lest it in turn dehumanize us. We are beginning perhaps to perceive that.

And so it is again the vision of the artist, of the intuitive seeker after knowledge, which, in this modern world, has seized upon the mechanism and materials of a machine, and is pointing the way. He it is who is again insisting, through the science of optics and the chemistry of light and metals and paper, upon the eternal value of the concept of craftsmanship, because that is the only way in which he can satisfy himself and because he knows that quality in work is prerequisite to quality in living. He has evolved through the conscious creative control of this particular phase of the machine a new method of perceiving the life of objectivity and of recording it. And he has done so in spite of the usual opposition and contempt with which the Accepted always greets the New, in spite of the actual deterioration of materials and in the face of a total absence of those monetary returns which work in other media occasionally brings.

In thus disinterestedly experimenting, the photographer has joined the ranks of all true seekers after knowledge, be it intuitive and aesthetic or conceptual and scientific. He has moreover, in establishing his own spiritual control over a machine, the camera, revealed the destructive and wholly fictitious wall of antagonism which these two groups have built up between themselves. Rejecting all Trinities and all Gods he puts to his fellow workers this question squarely: What is the relation between science and expression? Are they not both vital manifestations of energy, whose reciprocal hostility turns the one into the destructive tool of materialism, the other into anemic phantasy, whose coming together might integrate a new religious impulse? Must not these two forms of energy converge before a living future can be born of both?

151

Franz Roh (1890–1965), Laszlo Moholy-Nagy (1895–1946), Man Ray (1890–1976)

In the early 1920s, two avant-garde painters, working independently, voiced their objections to the judgment of photographs from a traditional aesthetic standpoint. Man Ray, an American artist working in Paris, and Laszlo Moholy-Nagy, a Hungarian artist in Berlin, both believed that photography possessed expressive potentials distinct from any other visual media. Their characterization of photography coincided with the attempt of Stieglitz and the "straight" photographers to define photography as a unique pictorial medium that could present man with new ways of seeing the world. However, unlike Stieglitz and his followers, Man Ray and Moholy-Nagy were unconcerned with the intentions photographers posited for their photographs. They measured the value of a print only by its power to invoke a fresh visual experience. Their opinions were reflected in the writings of the Munich art critic Franz Roh. In Mechanism and Expression *(1929), part of which is reprinted here, Roh wrote that nineteenth- and early twentieth-century photographers had used the medium incorrectly to imitate the conventions of traditional painting. Roh admitted, however, that as culturally determined objects, visual images created during the same time period must necessarily resemble one another. He merely wished to keep a tendency toward imitation from stagnating innovative expression.*

Both Man Ray and Moholy-Nagy produced unusual photographic images in unconventional ways, demonstrating how the medium's potential might expand once traditional techniques and aesthetic standards were renounced. They created abstract photograms and Rayographs without the use of a camera. Moholy-Nagy believed the photogram to be the essence of the most basic photographic process: he allowed patterns of light to play upon a sensitized sheet of paper, creating simple designs and avoiding the elaborations made by the complex reflections passed through a camera's lens. Nonetheless, both he and Man Ray valued and produced more conventional pictures. Adapting the concept of "found objects" to photography, they examined traditional, realistic portrayals for the interesting ways in which objects were related to each other. Man Ray was one of the first photographers to appreciate the aesthetic value of Eugène Atget's photographs.

Man Ray began his artistic career after high school, with courses in architectural drawing and engineering in New York City. In 1910, he met Alfred Stieglitz and began to visit Gallery 291. After the first exhibition of his paintings in 1912, and his first one-man show at the Daniel Gallery in 1915, he met Marcel Duchamp, with whom he

worked in a New York Dadaist group for several years. In 1920, Man Ray began to make photographs, and a year later he moved to Paris, where he produced his first Rayographs, publishing twelve of these as a book entitled Champs Delicieux. He also joined the Parisian Dadaists and became a professional photographer specializing in fashion illustration and portraiture. In 1922, the Libraire Six sponsored his first Paris showing of paintings and photographs. From 1923 through 1929, he made several films, including Le Retour á la Raison (1923), Emak Bakia (1926), and Les Mystères du Chateau de Dé (1929). He held his first exhibition at the Gallerie Surréaliste in 1926. Man Ray returned to the United States in 1940, actively continuing his career as a painter and photographer. In 1950, he went back to Paris, where he concentrated on painting but pursued his photographic work privately.

Moholy-Nagy began his career as an artist and photographer in 1918, after completing law studies and serving in the First World War. Impressed by the work of the German Expressionists and the Russian avant-garde, he moved first to Vienna and then to Berlin. He held his first exhibition of paintings in 1921, and in 1923 he joined the Bauhaus at Weimar, where he taught and collaborated with the other faculty members on many design projects. With Walter Gropius, he planned, edited, and designed, Bauhaus Bucher, which included two of his own books. In 1928, he resigned from the Bauhaus and began work on the Deutsche Werkbund exhibition "Film und Foto," held at Stuttgart in 1929. As a stage designer in Berlin, he continued his experiments with film, photographs, and combined media. After a year spent in Paris and Amsterdam, Moholy-Nagy moved to London, where he worked on the effects for H. G. Well's film, Things to Come (1935). After several one-man exhibitions in New York and London, he became the first director of New Bauhaus in Chicago, and, in 1937, the director of the Chicago Institute of Design.

Mechanism and Expression

Franz Roh

the history of photography hitherto shows two culminating periods, the first at the beginning of development (daguerre), the second at the end (see the photoes of this volume and many "anonymous" pictures published in illustrated

154

papers). the greatest part of what has been produced between this beginning and end is questionable, because a frank or disguised attempt was made to imitate the charm that belongs either to painting or to graphic art. this of course was a deviation from the proper task of photography, a task which, though one cannot entirely escape the manner of seeing of his time and will always show a certain kinship to contemporaneous art, ought never to have sunk to imitation. the present bloom has not spread widely enough, for, after the misharvests of the nineteenth century, the ideals of visual formation in the broad public are still tainted. yet it may be taken for granted that true visual culture will expand more and more, and that (possibly in ten years already) we shall encounter as little semblance, pretence and bluff, as in mediaeval painting and graphic art, where no "kitsch" is met with.

two circumstances are decisive whenever **cultural table-land** is to rise: in several places and at the same time single volcanoes must smoke, showering new pictorial ideas upon the land, sowing fertilizing lava. the existing soil must be of a kind to absorb and amalgamate manure. the supposition from above is already realized by single photographers such as appear in this book. the condition from below is also given: the appliances of new photographic technique are so simple that in principle **everybody** can handle them. the technique of graphic art (to keep comparison on the plane of black-and-white formation) was so complicated and slow, that up to the present time people were met with, who though absolutely possessing the visual power of forming, yet had neither leisure nor perseverance nor skill to learn the way of realization. the relation between conception and the medium of expression was too complicated. from this viewpoint it is characteristic that in this book non-professionals get a hearing. amateur signifies "one who loves the thing", and dilettante means "one who delights in the thing." the german werkbund exhibition "film and photo", 1929, this most important event in the visual field in the last few years, showed next to nothing by so-called **professional photographers,** who so often petrify in conventionality of manner. a renewed proof that rejuvenescence and elevation in various realms of life, of art, and also of scientific research, often proceed from **outsiders,** who remained impartial. thus this new bloom of photography also belongs largely to the

155

field (now tilled by me) of misjudged history of general non-professional productivity.

the importance to the history of mankind of development of instruments such as the camera, lies in obtaining increasingly complex results while the handling of the apparatus becomes more and more simple. to maintain that "short cuts" by relieving him of all effort, lead but to man's greater dullness and laziness, is romanticism in the minor key. the field of mental struggle is but changed to another place. the "raphaels without hands" can now become productive. for it was likewise romanticism (this time in the major key), to assert that everyone who has something to say will find a way of saying it. only when the technical media have become so simple that everybody can learn to apply them, will they become a keyboard for the expression of many.

the statement is right, that not to be able to handle a camera will soon be looked upon as equal to illiteracy. I even believe that in schools the instruction in photography will soon be introduced in the so-called drawing lessons (while antiquated branches are dropped, let us hope). pedagogics — though of necessity coming after — always include in the program of instruction the techniques that begin to become a general accomplishment of adults. in the days of charlemagne only the **scholar** could write, some centuries later all **cultivated** people mastered the technique, and still later every child. a similar process in a more limited space of time; in 1900 the typewriter was found only in remote special offices, today it is in use in all establishments, and tomorrow, meanwhile having become cheaper, every pupil will have one, whole classes of tiny children will drum in chorus on noiseless little typewriters.

the camera will likewise soon have passed those three typical stages. for it is not only the medium of wonderful pictorial **sport,** but has extremely practical backgrounds. today already the enormous increase of illustrated papers indicates how indirect view (written) is giving way to direct report (pictures of interesting incidents). thereby new possibilities take rise, not so much for draftsmen as for photographer-reporters in the broadest sense, at least for the grasping ones among them. whosoever in 1800 on a long journey wrote a diary of 300 pages, would in the present time take home 100 metres of leika-film-band that con-

tain more complete memories than the word, being charged with contemplation. making use of the international language of outer environment that fundamentally neither changes after centuries nor after countries, the effect extends over a vast area of space and time. with regard to sociology it may be stated that photography serves the capitalistic upper classes by its steadily increasing insertion into advertisement. by a photograph we can gain a more accurate notion of the articles offered than by ever so suggestive a drawing. on the other hand the camera supplies a want of the lower classes: for we often meet a common man on a sunday excursion attempting to fix an incident of his holiday experience. all the more important is it therefore, that books providing a good horizontal section of the best results of time should come to the masses.

from reporting in the broadest sense, as one of the main provinces of human craving for life, such pictorial preparation should be severed as aims at producing a **surface imbued with expression.** here some misinstructed people still raise the question, whether — in principle — to produce a photo full of expression and finished to the very corners can be an impelling inner necessity. what we mean is the question whether we are — exclusively in this sense — concerned here with **art.** commonplace men and "connoisseurs", both of whom generally are misforms of existence, still often meet in refusing to the most finished of photographs the quality mark of "art." either there is here but the semblance of a problem, since the definition of art is wholly time-bound, arbitrary and ungreat, or human sight is totally deformed and susceptible only to one kind of beauty even opposite nature. if however we understand art as an end in itself, called forth by man and filled with "expression", good photographs are included. yet should art be understood but as manual production expressed **by the human hand** under guidance of the mind (what would be unwise, indeed), we can establish a new category without diminishing the aesthetic value of these forms. it is a grave, subjectivist error to believe that forms pervaded by the aesthetic arise exclusively when every line has sprung from the "smelting-pot of the soul", i.e. the mind-guided hand of man himself. of the three vast realms of all expressive appearance the above limiting definition would contain but **one.** neither aesthetic perfection of certain forms in **nature,** nor of certain **machines**

157

likewise not created for expression, would be possible.

in this book we encounter forms quite coming up to the above definition, that in fact establishes but one rate, one **quality**. they are the photoes in which we wish nothing to be moved, raised or levelled, no part to be either materialized or dematerialized, &c. there surely are people who will declare even of the **best** of photos that they do not reach graphic art in power of expression. yet that this is not a question of **photography** can be demonstrated, inasmuch as the very same people usually also refuse new painting and new graphic art, whether it be abstract, constructivist, or objectivist art. whosoever finds the photographs in this book, for instance, far-fetched in section, stiff and unorganic (I have met such people), generally has the same reproach ready for painting and graphic of the younger generation. sufficient proof that this has nothing at all to do with a special problem of "photography and mechanism," but rather with the new, tenser, and more constructive seeing.

photography is not mere **print** from nature, for it is (mechanically) a turning of all colour value, and even of depth in space, and structure in form. never-the-less the worth of photography lies in the aesthetic value of nature itself. is it but necessary to master the implements of photography to become a good photographer? by no means: as in other fields of expression personality is required. the peculiar human valuation of form at the time is expressed in the photo just as it is in graphic art. to all probability — of course for the trained eye only — the locating of anonymous photoes as to period and country is only more difficult **in degree** than locating works of graphic art, painting and sculpture. and this even when the contents of a photograph (costume or the like) cannot be dated or located, and there are but a series of landscapes or of animals to compare.

this **individual constant quality** that, as in the arts, is remarkably lasting, suffices to show that a good **photo** is also based on an organizing, individualizing principle. it often occurs that photographs taken by the **one** will always appear uninteresting, though he be skilled in technique, while photoes by the **other,** who considers himself but an amateur and whose work is not technically perfect, yet invariably are of forcible effect. contrary to graphic art the principle of organization in photography does not lie in all-ruling manual re-forming of any bit of reality, but in the act of

158

selecting an in every way fruitful fragment of that reality. if in the graphic arts there are a thousand forms of **recasting and reducing** the exterior world, there are a hundred possibilities of **focus, section and lighting** in photography, and above all in the **choice** of the object.

this **limited** range of possibilities permits of realizing significant individualization. we generally overrate the number of the few elements required to obtain ingenious forms. what a simple and confined instrument is the piano (to change to another field). with its ever-returning octave, and yet by constantly changing combination of the given elements, every pianist can draw forth a world of his own from these few series of tones.

the choice of the object is already a creative action. "tell me with whom you associate and I shall tell you who you are" is a saying applicable also to the section of reality before which we stop. as distinctive as it is of a man what women move him, so characteristic is it of the photographer before which forms he stands spellbound, which focal angles and springs of light enthrall him. how organizing the general principle of photography can act at times is indicated by the fact that the diltheynohl doctrine of types, applicable only to psychically conditioned formations, may be applied, particularly if the index of period is added, thus stating that since about 1920 **all** types have a dash of so-called duality tension.

our book does not only mean to say "the world is beautiful", but also: the world is exciting, cruel and weird, therefore pictures were included that might shock aesthetes who stand aloof. — there are five kinds of applied photography: the reality-photo, the photogram, photomontage, photo with etching or painting, and photoes in connection with typography.

the **photogram** hovers excitingly between abstract geometrical tracery and the echo of objects. in this tension there often is a peculiar charm. these pictures, as is known, are taken without a camera, only by the meeting of certain objects with sensitive paper. by exposing them a long or short time, holding them close or far, letting sharp or subdued artificial light shine upon them, schemes of luminosity are obtained that so change the colour, outline and moulding of objects as to make them lose body and appear but a lustrous strange world and abstraction. while going from snowiest white, across thousands of shades of grey, down

159

to the deepest black the most transparent tone degrees are gained, and by intersection and convergence an optic semblance of space that can suggest the most distant distance as well as plastic closeness. as with all human systems of disposition, it is at first difficult to "calculate" the effect of objects while still in the process of taking them, yet gradually one acquires a feeling for the result. in the beginning there are often but chance hits. it is however a noted error on the part of idealistic subjectivism to conjecture that fully expressive effects cannot be called forth in this manner. it is a question of rejecting a number of pictures. in art (as in etching for instance) the process of selection lies largely in the mentally remodelling hand (I), in photography (reality-photo) it lies in stealing upon the most suitable bit provided by environment (II). whereas in the photogram selection lies **at first in** eliminating failures — for according to the law of **probability** a stroke of luck will occur sometimes (III). constant practice and a good "instinctive disposition" will soon move the process from the third sphere to the second. with such advance a crescendo of value in all forming processes of life will be gained, and in the **quantity** of successful attempts, but not in the order of the three kinds of possible perfect hits.

just as the making of silhouettes was very popular a hundred years ago, so the photogram will become an ingenious pastime of the present day. it is far superior to the silhouette, for it permits of a thousand gradations in shade between black and white. by this means not only the intersections and disclosures mentioned above are possible, but actual penetrating of bodies, whereby the covered part remains visible and the whole charm-system of transparencies can become effective. it is however by the sublime possibilities of gradation between the poles black and white that polyphony of tones is obtainable.

new attractions have also been added to the **reality-photo.** in the first place new objects have been drawn into the sphere of fixation, a furtherance of the process. for man in the jog-trot of sensual life generally conceives but a conventional impression, and rarely actually experiences the object. thus I remember how some people, otherwise quick at grasping, would not make allowance for the taking of the paris sewerage canal, until those very same people finally arrived at understanding how expressive and almost symbolic such fragments of reality can become.

next to a new world of objects we find **the old seen anew.** here the difference in degree of intensifying plasticity becomes a pictorial means. for a long time we had photographers who clad everything in twilight (imitators of rembrandt in velvet cap, or all softening impressionist minds). today everything is **brought out clearly.** yet herein recipes are not admitted, and occasionally the palpably plastic may be put next to the optically flowing, whereby new effects are gained in pictures which the narrow intellect of the professional is inclined to point to as failures.

"wrong" focalizing, so-called mistakes in the scale of distance, sometimes will, if ingeniously used, provide new optical attractions. as also the use of the same plate over again (photographs one in another). a further means: new view in the way of **perspective.** formerly pictures were taken only in horizontal view-line. the audacious sight from above and below, which new technical achievement has brought about by sudden change of level (lift, aeroplane, &c.), has not been utilized sufficiently for pictorial purposes so far. new photoes show this up and down of appearance. here the taking of a vertical line (standing house, mast, or the like) obliquely, is stirring. the significance lies in opening astronomic perspectives so to say: vertical in this greater sense really is radial position corresponding to an imaginary centre of the earth.

comparatively new is also a further variety of the reality-photo: the **negative** print. the principle of **inversion** is known in arrangement of abstract forms, as applied in weaving and wicker-work. it occurs in music too, though seldom. why should not the same principle be applied to exterior realities though they be not in ranges? besides the inversion of **direction** an inversion of light-and-dark is well possible. this, for the present, specifically **photographic** charm cannot be experienced elsewhere, for the distinction between **a day and night view of the same reality** is quite a different thing. we might perhaps speak of a world in the major and the minor key, to indicate at least the completely changed expression of tone values.

there is furthermore the **combination of photography with graphic art or painting** to point to, of which examples are given (see max ernst's marvellous works). to maintain that here is a mingling of **heterogeneous elements** that can never combine is but an empty doctrine.

remains the **photo-"montage"** (produced by cutting, pasting and mounting). this form took rise from futurism and dadaism, and has gradually been clarified and simplified. photomontage, formerly a demolishment of form, a chaotic whirl of blown up total appearance, now shows systematic construction and an almost classic moderation and calm. how flexible, transparent and delicate is the play of forms in "leda", and crystal-hard the starry miniature world of dadamerica. the fanciful of this whole species is not factorial fantasticality, as was a certain stage of cubism, where the simple world of objects was dissected into complicating structure, but an **object-**fantasticality in which from simple fragments of reality a more complex unit is piled up. it was significant that here the principle of mosaic, that so far had been applied only to particles of colour and form, was to such an extent applied to parts of the objects themselves. though these possibilities of formation are met by the technique of photography, yet "montage" is based on a deep need of human imagination. this is shown not only in futurist pictures, but also in irish twisted ribbons, in the copulation of objects on romanesque capitals, and particularly in the paintings by bosch and bruegel, where most extraordinary forming fancy expresses itself fully in such graftings of reality. a new and rich pictorial humour is rising here. no wonder that many people think comic papers of the future will make use of this resource. it is of no moment that they will hesitate to do so, for some score years ago they let **draftsmen** of new style wait long enough too.*)

the use of photomontage for advertisements has already spread considerably, and also for outer book wraps (that appear so much more alive than the heavy, humdrum cloth covers they so mercifully conceal). the malik verlag has been leading in productions of this kind (and that at a very early date). in spite of the humour, or the merely advertising character, of these things, they should not be looked upon as trifles, or only incidental details, for they can be of demonic-fantastic effect.

we now reach the last class, the interesting **combination of photograph and type,** of which we show important specimens. we have little to say here, as these things speak for themselves and have found an extensive field in the advertising business.

the most important utilization of photography, the cinema — a marvel that has become a matter of course and yet remains a

162

lasting marvel — is not within the province of this book. we are concerned but with the statically fixed, with situations that merely pretend dynamic, while in the cinema, by **addition** of static situations, real dynamic rises. questions of form here enter an entirely new dimension.

*georges grosz writes to me: "yes! you are right. heartfield and I had already in 1915 made interesting photo-pasting-montage-experiments. at the time we founded the grosz & heartfield concern (südende 1915). the name "monteur" I invented for heartfield, who invariably went about in an old blue suit, and whose work in our joint affair was much like the work of mounting."

Photography

Laszlo Moholy-Nagy

Although it has spread enormously, nothing essentially new has been discovered in the principle and technique of photography since the process was invented. Every innovation since introduced — with the exception of X-ray photography — has been based on the artistic, reproductive concept prevailing in Daguerre's day (c. 1830): reproduction (copy) of nature in conformity with the rules of perspective. Every period with a distinctive style of painting since then has had an imitative photographic manner derived from the painterly trend of the moment.

Men discover new instruments, new methods of work which revolutionise their familiar habits of work. Often, however, it is a long time before the innovation is properly utilised; it is hampered by the old; the new function is shrouded in the traditional form. The creative possibilities of the innovation are usually slowly disclosed by these old forms, old instruments and fields of creativity which burst into euphoric flower when the innovation which has been preparing finally emerges. Thus for example **Futurist** (static) painting stated the problem of simultaneity of movement, the representation of the time impulse — a clear-cut problem which later brought about its own destruction; and this was at a time when the film was already known but far from being understood. Similarly the **painting** of the **Constructivists** which paves the way for the development on the highest level of reflected light composition such as already exists in embryo. We can also regard — with caution — some of the painters working today with representational, objective means (Neo-Classicists and painters of the 'Neue Sachlichkeit' movement) as pioneers of a new form of representational optical composition which will soon employ only **mechanical and technical means** — if we disregard the fact that these very works contain tradition-bound, often plainly reactionary elements.

In the photography of earlier days the fact was completely neglected that the light-sensitivity of a chemically prepared surface (glass, metal, paper, celluloid, etc.) was one of the basic elements of the photographic process. This surface was never re-

lated to anything other than a camera obscura obeying the laws of perspective, for fixing (reproducing) individual objects in their special character as reflectors or absorbers of light. Nor were the potentialities of this combination ever sufficiently consciously exploited.

For if people had been aware of these potentialities they would have been able with the aid of the photographic camera to *make visible* existences which cannot be perceived or taken in by our optical instrument, the eye; *i.e., the photographic camera can either complete or supplement our optical instrument, the eye.* This principle has already been applied in a few scientific experiments, as in the study of movements (walking, jumping, galloping) and of zoological, botanical and mineral forms (enlargements, microscopic photographs) and other investigations into natural history; but these experiments have remained isolated phenomena, the **interconnections** of which have not been established. We have hitherto used the capacities of the camera in a secondary sense only. This is apparent too in the so-called 'faulty' photographs: the view from above, from below, the oblique view, which today often disconcert people who take them to be accidental shots. The secret of their effect is that the photographic camera reproduces the purely optical image and therefore shows the optically true distortions, deformations, foreshortenings, etc., whereas the eye together with our intellectual experience, supplements perceived optical phenomena by means of association and formally and spatially creates a **conceptual image.** Thus in the photographic camera we have the most reliable aid to a beginning of objective vision. Everyone will be compelled to see that which is optically true, is explicable in its own terms, is objective, before he can arrive at any possible subjective position. This will abolish that pictorial and imaginative association pattern which has remained unsuperseded for centuries and which has been stamped upon our vision by great individual painters.

We have — through a hundred years of photography and two decades of film — been enormously enriched in this respect. **We may say that we see the world with entirely different eyes.** Nevertheless, the total result to date amounts to little more than a visual encyclopaedic achievement. This is not enough. We wish to **produce** systematically, since it is important for life that we create *new relationships*.

166

The Age of Light

Man Ray

In this age, like all ages, when the problem of the perpetuation of a race or class and the destruction of its enemies, is the all-absorbing motive of civilized society, it seems irrelevant and wasteful still to create works whose only inspirations are individual human emotion and desire. The attitude seems to be that one may be permitted a return to the idyllic occupations only after meriting this return by solving the more vital problems of existence. Still, we know that the incapacity of race or class to improve itself is as great as its incapacity to learn from previous errors in history. All progress results from an intense individual desire to improve the immediate present, from an all-conscious sense of material insufficiency. In this exalted state, material action imposes itself and takes the form of revolution in one form or another. Race and class, like styles, then become irrelevant, while the emotion of the human individual becomes universal. For what can be more binding amongst beings than the discovery of a common desire? And what can be more inspiring to action than the confidence aroused by a lyric expression of this desire? From the first gesture of a child pointing to an object and simply naming it, but with a world of intended meaning, to the developed mind that creates an image whose strangeness and reality stirs our subconscious to its inmost depths, the awakening of desire is the first step to participation and experience.

It is in the spirit of an experience and not of experiment that the following autobiographic images are presented. Seized in moments of visual detachment during periods of emotional contact, these images are oxidized residues, fixed by light and chemical elements, of living organisms. No plastic expression can ever be more than a residue of an experience. The recognition of an image that has tragically survived an experience, recalling the event more or less clearly, like the undisturbed ashes of an object consumed by flames, the recognition of this object so little representative and so fragile, and its simple identification on the part of the spectator with a similar personal experience, precludes all psycho-analytical classification or assimilation into an arbitrary decorative system. Questions of merit and of execution can always be taken care of by those who hold themselves aloof from even the frontiers of such experiences. For, whether

a painter, emphasizing the importance of the idea he wishes to convey introduces bits of ready-made chromos alongside his handiwork, or whether another, working directly with light and chemistry, so deforms the subject as almost to hide the identity of the original, and creates a new form, the ensuing violation of the medium employed is the most perfect assurance of the author's convictions. A certain amount of contempt for the material employed to express an idea is indispensable to the purest realization of this idea.

Each one of us, in his timidity, has a limit beyond which he is outraged. It is inevitable that he who by concentrated application has extended this limit for himself, should arouse the resentment of those who have accepted conventions which, since accepted by all, require no initiative of application. And this resentment generally takes the form of meaningless laughter or of criticism, if not of persecution. But this apparent violation is preferable to the monstrous habits condoned by etiquette and estheticism.

An effort impelled by desire must also have an automatic or subconscious energy to aid its realization. The reserves of this energy within us are limitless if we will draw on them without a sense of shame or of propriety. Like the scientist who is merely a prestidigitator manipulating the abundant phenomena of nature and profiting by every so called hazard or law, the creator dealing in human values allows the subconscious forces to filter through him, colored by his own selectivity, which is universal human desire, and exposes to the light motives and instincts long repressed, which should form the basis of a confident fraternity. The intensity of this message can be disturbing only in proportion to the freedom that has been given to automatism or the subconscious self. The removal of inculcated modes of presentation, resulting in apparent artificiality or strangeness, is a confirmation of the free functioning of this automatism and is to be welcomed.

Open confidences are being made every day, and it remains for the eye to train itself to see them without prejudice or restraint.

Seeing Photographically

Edward Weston (1886–1958)

Edward Weston started his photographic career as a Photo-Secessionist, making softly focused pictures emphasizing simple geometric forms and patterns of light. Along with many secessionists, in the early 1920s, he began to alter his style. While photographing in Mexico in 1924, he decided that the true nature of photography rests in the clearly detailed, realistic depiction of the physical world. To avoid loss of detail, he chose to use an 8x10 camera, to set rapid shutter speeds, and to contact-print his negatives. Unlike nineteenth-century realist painters and photographers, he believed the essence of life lay in simplicity, rather than in variety of form. His photographs are characterized by subtle changes in the tones and textures of simple, recognizable subjects. Like most "straight" photographers, Weston did not believe in cropping final prints but thought the creative process was based in the act of visualizing beforehand, through the lens, a beautiful and informative representation of some portion of the world. To him, the resulting negative and print attested to the beauty and truth of the pre-visualization. He claimed that once the pre-visualization had occurred, the outcome could not be changed and still remain a truthful work of art.

Several photographers influenced by Weston's philosophy and style joined him in 1932 to form "Group f.64." The group included Ansel Adams, Imogen Cunningham, John Paul Edwards, Sonia Noskowiak, Henry Swift, and Willard Van Dyke. The group's name represented the small apertures at which they set their lenses to produce their highly focused images. Excluded from museums and galleries for their unconventional work, they held their own exhibitions. The M. H. de Young Memorial Museum sponsored their first cooperative exhibition in 1932.

In 1937, Weston became the first photographer to receive a John Simon Guggenheim Memorial Foundation Fellowship. His last photographs, from 1948, were made near his home in Carmel, at Point Lobos, on the California coast. That year, he contracted Parkinson's disease and could no longer photograph; however, friends provided monetary support enabling him to direct his sons in the printing of 1,000 negatives he had chosen as his best work.

169

Each medium of expression imposes its own limitations on the artist — limitations inherent in the tools, materials, or processes he employs. In the older art forms these natural confines are so well established they are taken for granted. We select music or dancing, sculpture or writing because we feel that within the *frame* of that particular medium we can best express whatever it is we have to say.

The Photo-Painting Standard

Photography, although it has passed its hundredth birthday, has yet to attain such familiarization. In order to understand why this is so, we must examine briefly the historical background of this youngest of the graphic arts. Because the early photographers who sought to produce creative work had no tradition to guide them, they soon began to borrow a ready-made one from the painters. The conviction grew that photography was just a new kind of painting, and its exponents attempted by every means possible to make the camera produce painter-like results. This misconception was responsible for a great many horrors perpetrated in the name of art, from allegorical costume pieces to dizzying out-of-focus blurs.

But these alone would not have sufficed to set back the photographic clock. The real harm lay in the fact that the false standard became firmly established, so that the goal of artistic endeavor became photo-painting rather than photography. The approach adopted was so at variance with the real nature of the medium employed that each basic improvement in the process became just one more obstacle for the photo-painters to overcome. Thus the influence of the painters' tradition delayed recognition of the real creative field photography had provided. Those who should have been most concerned with discovering and exploiting the new pictorial resources were ignoring them entirely and, in their preoccupation with producing pseudo-paintings, departing more and more radically from all photographic values.

As a consequence, when we attempt to assemble the best work of the past, we most often choose examples from the work of those who were not primarily concerned with esthetics. It is in commercial portraits from the daguerreotype era, records of the Civil War, documents of the American frontier, the work of

170

amateurs and professionals who practiced photography for its own sake without troubling over whether or not it was art, that we find photographs that will still stand with the best of contemporary work.

But in spite of such evidence that can now be appraised with a calm, historical eye, the approach to creative work in photography today is frequently just as muddled as it was eighty years ago, and the painters' tradition still persists, as witness the use of texture screens, handwork on negatives, and ready-made rules of composition. People who wouldn't think of taking a sieve to the well to draw water fail to see the folly in taking a camera to make a painting.

Behind the photo-painter's approach lay the fixed idea that a straight photograph was purely the product of a machine and therefore not art. He developed special technics to combat the mechanical nature of his process. In this system the negative was taken as a point of departure — a first rough impression to be "improved" by hand until the last traces of its unartistic origin had disappeared.

Perhaps if singers banded together in sufficient numbers, they could convince musicians that the sounds they produced through *their machines* could not be art because of the essentially mechanical nature of their instruments. Then the musician, profiting by the example of the photo-painter, would have his playing recorded on special discs so that he could unscramble and rescramble the sounds until he had transformed the product of a good musical instrument into a poor imitation of the human voice!

To understand why such an approach is incompatible with the logic of the medium, we must recognize the two basic factors in the photographic process that set it apart from the other graphic arts: the nature of the recording process and the nature of the image.

Nature of the Recording Process
Among all the arts photography is unique by reason of its instantaneous recording process. The sculptor, the architect, the composer all have the possibility of making changes in, or additions to, their original plans while their work is in the process of execution. A composer may build up a symphony over a long

period of time; a painter may spend a lifetime working on one picture and still not consider it finished. But the photographer's recording process cannot be drawn out. Within its brief duration, no stopping or changing or reconsidering is possible. When he uncovers his lens every detail within its field of vision is registered in far less time than it takes for his own eyes to transmit a similar copy of the scene to his brain.

Nature of the Image

The image that is thus swiftly recorded possesses certain qualities that at once distinguish it as photographic. First there is the amazing precision of definition, especially in the recording of fine detail; and second, there is the unbroken sequence of infinitely subtle gradations from black to white. These two characteristics constute the trademark of the photograph; they pertain to the mechanics of the process and cannot be duplicated by any work of the human hand.

The photographic image partakes more of the nature of a mosaic than of a drawing or painting. It contains no *lines* in the painter's sense, but is entirely made up of tiny particles. The extreme fineness of these particles gives a special tension to the image, and when that tension is destroyed — by the intrusion of handwork, by too great enlargement, by printing on a rough surface, etc. — the integrity of the photograph is destroyed.

Finally, the image is characterized by lucidity and brilliance of tone, qualities which cannot be retained if prints are made on dull-surface papers. Only a smooth, light-giving surface can reproduce satisfactorily the brilliant clarity of the photographic image.

Recording the Image

It is these two properties that determine the basic procedure in the photographer's approach. Since the recording process is instantaneous, and the nature of the image such that it cannot survive corrective handwork, it is obvious that *the finished print must be created in full before the film is exposed.* Until the photographer has learned to visualize his final result in advance, and to predetermine the procedures necessary to carry out that visualization, his finished work (if it be photography at all) will present a series of lucky — or unlucky — mechanical accidents.

Hence the photographer's most important and likewise most difficult task is not learning to manage his camera, or to develop, or to print. It is learning to *see photographically* — that is, learning to see his subject matter in terms of the capacities of his tools and processes, so that he can instantaneously translate the elements and values in a scene before him into the photograph he wants to make. The photo-painters used to contend that photography could never be an art because there was in the process no means for controlling the result. Actually, the problem of learning to see photographically would be simplified if there were fewer means of control than there are.

By varying the position of his camera, his camera angle, or the focal length of his lens, the photographer can achieve an infinite number of varied compositions with a single, stationary subject. By changing the light on the subject, or by using a color filter, any or all of the values in the subject can be altered. By varying the length of exposure, the kind of emulsion, the method of developing, the photographer can vary the registering of relative values in the negative. And the relative values as registered in the negative can be further modified by allowing more or less light to affect certain parts of the image in printing. Thus, within the limits of his medium, without resorting to any method of control that is not photographic (i.e., of an optical or chemical nature), the photographer can depart from literal recording to whatever extent he chooses.

This very richness of control facilities often acts as a barrier to creative work. The fact is that relatively few photographers ever master their medium. Instead they allow the medium to master them and go on an endless squirrel cage chase from new lens to new paper to new developer to new gadget, never staying with one piece of equipment long enough to learn its full capacities, becoming lost in a maze of technical information that is of little or no use since they don't know what to do with it.

Only long experience will enable the photographer to subordinate technical considerations to pictorial aims, but the task can be made immeasurably easier by selecting the simplest possible equipment and procedures and staying with them. Learning to see in terms of the field of one lens, the scale of one film and one paper, will accomplish a good deal more than gathering a smattering of knowledge about several different sets of tools.

The photographer must learn from the outset to regard his

process as a whole. He should not be concerned with the "right exposure," the "perfect negative," etc. Such notions are mere products of advertising mythology. Rather he must learn the kind of negative necessary to produce a given kind of print, and then the kind of exposure and development necessary to produce that negative. When he knows how these needs are fulfilled for one kind of print, he must learn how to vary the process to produce other kinds of prints. Further he must learn to translate colors into their monochrome values, and learn to judge the strength and quality of light. With practice this kind of knowledge becomes intuitive; the photographer learns to see a scene or object in terms of his finished print without having to give conscious thought to the steps that will be necessary to carry it out.

Subject Matter and Composition

So far we have been considering the mechanics of photographic seeing. Now let us see how this camera-vision applies to the fields of subject matter and composition. No sharp line can be drawn between the subject matter appropriate to photography and that more suitable to the other graphic arts. However, it is possible, on the basis of an examination of past work and our knowledge of the special properties of the medium, to suggest certain fields of endeavor that will most reward the photographer, and to indicate others that he will do well to avoid.

Even if produced with the finest photographic technic, the work of the photo-painters referred to could not have been successful. Photography is basically too honest a medium for recording superficial aspects of a subject. It searches out the actor behind the make-up and exposes the contrived, the trivial, the artificial, for what they really are. But the camera's innate honesty can hardly be considered a limitation of the medium, since it bars only that kind of subject matter that properly belongs to the painter. On the other hand it provides the photographer with a means of looking deeply into the nature of things, and presenting his subjects in terms of their basic reality. It enables him to reveal the essence of what lies before his lens with such clear insight that the beholder may find the recreated image more real and comprehensible than the actual object.

It is unfortunate, to say the least, that the tremendous capacity

174

photography has for revealing new things in new ways should be overlooked or ignored by the majority of its exponents — but such is the case. Today the waning influence of the painter's tradition, has been replaced by what we may call *Salon Psychology,* a force that is exercising the same restraint over photographic progress by establishing false standards and discouraging any symptoms of original creative vision.

Today's photographer need not necessarily make his picture resemble a wash drawing in order to have it admitted as art, but he must abide by "the rules of composition." That is the contemporary nostrum. Now to consult rules of composition before making a picture is a little like consulting the law of gravitation before going for a walk. Such rules and laws are deduced from the accomplished fact; they are the products of reflection and after-examination, and are in no way a part of the creative impetus. When subject matter is forced to fit into preconceived patterns, there can be no freshness of vision. Following rules of composition can only lead to a tedious repetition of pictorial clichés.

Good composition is only the strongest way of seeing the subject. It cannot be taught because, like all creative effort, it is a matter of personal growth. In common with other artists the photographer wants his finished print to convey to others his own response to his subject. In the fulfillment of this aim, his greatest asset is the directness of the process he employs. But this advantage can only be retained if he simplifies his equipment and technic to the minimum necessary, and keeps his approach free from all formula, art-dogma, rules, and taboos. Only then can he be free to put his photographic sight to use in discovering and revealing the nature of the world he lives in.

Berenice Abbott (b. 1898) and Walker Evans (1903–1975)

Berenice Abbott and Walker Evans began their photographic careers voicing the new-realist principle of the "straight" photographers that the nature of the photographic medium could be best expressed through clearly focused, highly detailed pictures. Both believed photography had taken two disastrous turns, first toward sentimental Victorian allegorization in the nineteenth century, and next toward impressionistic Photo-Secessionism in the early twentieth century. Abbott portrayed Henry Peach Robinson and Alfred Stieglitz as the villains who had led photographers astray, and she popularized the little-known early twentieth-century French photographer Eugène Atget as the one man who had championed the true, realistic nature of photography through the mistaken years. Evans echoed Abbott's approval of Atget's work in his own writings.

Berenice Abbott began her artistic career studying sculpture and painting in New York City from 1918 to 1921. She continued her studies in Paris and Berlin for the next two years. In 1924, she had her first taste of photographic work, assisting Man Ray with his portraiture. The following year, Abbott discovered the genius of Atget, and upon his death in 1927, a collection of his prints and negatives came into her possession. In her drive to popularize Atget's work, Abbott helped to promote the publication of the monograph Atget Photographe de Paris, *in 1930.*

Abbott's own photographs were first exhibited in Paris in 1926. In 1929, she returned to the United States and was commissioned by Fortune *magazine to make a set of photographic portraits of American businessmen.* Life *magazine then invited her to make a series of photographs of scientific subjects. At this time, she also began to photograph New York City life and architecture on her own. Some of her work appeared in the Deutsche Werkbund exhibit "Film und Foto," in Stuttgart. Through the depression years, Abbott was a member of the United States Government Federal Art Project, "The Changing New York Program," which enabled her to continue photographing the city. In 1938, Abbott began a twenty-year teaching career at the New School for Social Research, in New York. In 1964, she revived her life-long interest in publicizing the work of Atget, publishing* The World of Atget. *Abbott now resides in Maine and continues to print from her negatives.*

Walker Evans attended Phillips Academy, in Andover, Massachusetts, where he developed a keen interest in literature and the desire to become a writer. In 1922, he entered Williams College;

however, after an unhappy freshman year, he left school forever. A small allowance from his father enabled him to live in Paris for a year in 1926, but he became frustrated with writing and returned to New York, where he began to take photographs. Like Berenice Abbott, Evans worked avidly against the Photo-Secession style. He particularly objected to what he saw as the superficial artiness and commercial slickness of Edward Steichen's photographs. Evans's first project — photographing American architectural environments — would continue for the rest of his life.

To support himself as he established his photographic reputation, Evans worked at several jobs, among them stock clerk for Henry L. Doherty's Wall Street firm where his friend, the poet Hart Crane, also worked. Evans's first published photographs appeared as illustrations to Crane's first edition of The Bridge, *in 1930. In the spring of 1931, Evans and Lincoln Kirstein began to photograph Victorian houses in the Boston vicinity. As an editor of* Hound and Horn, *Kirstein had published a number of Evans's pictures in his journal the year before. From 1935 through 1937, Evans served the government, documenting the effect of the depression on people in New York, Pennsylvania, and West Virginia. He worked under the Resettlement Security Administration, which became the Farm Security Administration soon after he joined its photographic corps. During this time of continuous employment, Evans produced more photographs than in any other period of his life.*

In 1936, Evans shared a Fortune *magazine commission with the writer James Agee to explore the lives of Southern share-croppers. The two men lived with a poor family for several months to become intimately acquainted with conditions there. The share-croppers' story was told visually and verbally in* Let Us Now Praise Famous Men: Three Tenant Families, *which was published not by* Fortune *but by Houghton Mifflin in 1941.*

In 1938 and 1941, Evans experimented with a new photographic style and technique, giving up his usually meticulous compositional procedure. Hiding a Contax camera beneath his coat, he secretly photographed people on the New York City subways. In 1966, the Museum of Modern Art mounted an exhibition of forty-one of these pictures and Houghton Mifflin concurrently published Many Are Called, *containing eighty-nine of the portraits. During the 1940s, Evans took similar pictures of people on the streets of Chicago.*

In 1943, Evans became a contributing editor of Time, *rejoining James Agee, who also worked for the magazine. In 1945, Evans moved to* Fortune *as an associate editor, and he remained there for*

the next twenty years. In this capacity, he designed many of his own photo-essays, for which he wrote the texts and captions. He also published photo-essays in other journals over these years. In 1971, the Museum of Modern Art held a huge retrospective exhibition of Evans's work, including two hundred of his photographs. Evans became professor of graphic design at Yale University in 1965, a post he held until his death in 1975.

Photography at the Crossroads

Berenice Abbott

The world today has been conditioned, overwhelmingly, to visualize. The *picture* has almost replaced the *word* as a means of communication. Tabloids, educational and documentary films, popular movies, magazines, and television surround us. It almost seems that the existence of the word is threatened. The picture is one of the principal mediums of interpretation, and its importance is thus growing ever vaster.

Today the challenge to photographers is great because we are living in a momentous period. History is pushing us to the brink of a realistic age as never before. I believe there is no more creative medium than photography to recreate the living world of our time.

Photography gladly accepts the challenge because it is at home and in its element: namely, realism — real life — the *now*. In fact, the photographic medium is standing at its own crossroads of history, possibly at the end of its first major cycle. A decision as to which direction it shall take is necessary, and a new chapter in photography is being made — as indeed many new chapters are now taking the place of many older ones.

The time comes when we progress, must go forward, must grow. Else we wither, decay, die. This is as true of photography as for every other human activity in this atom age. It is more important than ever to assess and value photography in the contemporary world. To understand the *now* with which photography is essentially concerned, it is necessary to look at its roots, to measure its past achievements, to learn the lessons of its

tradition. Let us briefly span its beginnings — they were truly spectacular.

The people who were interested in photography and who contributed to its childhood success were most serious and capable. In the early years of the nineteenth century, a tremendous amount of creativeness and intelligence was invested in the new invention. Enthusiasm among artists, scientists, intellectuals of all kinds, and the lay public, was at a high pitch. Because of the interest in and demand for a new picture-making medium, technical development was astonishingly rapid.

The aesthetic counterpart of such rapid growth is to be seen in photographers like Brady, Jackson, O'Sullivan, Nadar, and their contemporaries. There was such a boom in technical progress, as has not been surpassed even today. The recently published *History of Photography* by J. M. Eder, translated by Edward Epstean, documents this acceleration in detail.

America played a healthy and vital part in the rise of photography. American genius took to the new medium like the proverbial duck to water. An extremely interesting study of photography in the United States — an important book for everyone — is Robert Taft's *Photography and the American Scene*. Here the material and significant growth of the medium is integrated with the social and economic growth of our country.

In photography, America neither lagged nor slavishly imitated, and we can boast of a sound American tradition. Portraits flourished as in no other country. The Civil War created a demand for millions of "likenesses" of the young men marching off to the front. The newness of our country was of course another stimulus to growth, with many people sending pictures of themselves to relatives left behind in the westward movement, or to prospective brides and husbands in the "Old Country." The migratory, restless population of the United States flowed west, over the Alleghenies from Pennsylvania into Ohio and other states of the Western Reserve, past the Mississippi and into the west; and wherever they went, they left little hoards, little treasures of old photographs — invaluable archives for the historian today. In the winning of the frontier, photographers also played their part, going with U.S. Geologic Survey expeditions after the Civil War. Among these, William H. Jackson stands as a shining example.

180

This organic use of photography produced thousands of straight-forward, competent operators, whereas in England there were comparatively few; apparently because a monopoly of all patents tied up the photographic process and prevented the spread of interest in and use of the new invention. Here in the United States, it was virtually impossible to make such a monopoly stick.

This ferment and enthusiasm produced fine results. Our daguerreotypes were superb. They were acclaimed all over Europe and systematically won all the first prizes at the international exhibitions. People were wild with enthusiasm for these realistic "speaking likenesses," and everybody was doing it. In fact, anyone could afford the photograph, whereas before only the wealthy could pay the price to have their portraits painted. As a result, the photographic business flourished.

After a whole-hearted start with Yankee ingenuity, money got into photography along with pseudo-artists; commercialism developed with a bang. And as with any business which, as it grows, serves the greatest common denominator, so with photography. Cash took over. Instead of the honest, realistic likeness, artificial props with phony settings began to be used. A period of imitating the unreal set in. Supply houses sprang up, with elaborate Grecian urns and columns and fancy backdrops — all for the greatest possible show and ostentation. Retouching and brush work also set in. What was thought to be imitation or emulation of painting became rampant.

It need not be added that the imitation was of bad painting, because it had to be bad, dealing largely or wholly with the sentimental, the trite and pretty, the picturesque. Thus photography was torn from its moorings, the whole essence of which is realism.

Much of this was due to a terrible plague, imported from England in the form of Henry Peach Robinson. He became the shining light of photography, charged large prices, took ribbon after ribbon. He lifted composition bodily from painting, but the ones he chose were probably some of the worst examples in history. Greatest disaster of all, he wrote a book in 1869 entitled *Pictorial Photography*. His system was to flatter everything. He sought to correct what the camera saw. The inherent genius and dignity of the human subject was denied.

Typical of his sentimental pictures were his titles, and titles of other photographers of the period: "Poor Joe," "Hard Times," "Fading Away," "Here Comes Father," "Intimate Friends," "Romantic Landscape," "By the Stream," "End of a Winter's Day," "Kiss of Dew," "Fingers of Morning." If some of the subject matter and titles are not too far removed from some of today's crop of pictorialists, then obviously the coincidence of similar thinking has the same sentimental unrealistic foundation in common. This Robinsonian school had an influence second to none — it stuck, simply, because it made the practice and theory of photography *easy*. In other words, flattery pays off. Thus today there are still many photographers of the Pictorial School who continue to emulate the "master" of 1869.

As a popular art form, photography has expanded and intensified its activity in recent years. The most noticeable trend has been the widespread distribution which gives photography much of its strength and power, demands that there be a greater sense of awareness on the part of photographers and editors alike.

Unfortunately, along with growth and the strength it signifies, goes the possibility of a decline in our photographic sensibilities and output. Actually, the progress of photography is frequently delayed by inadequate equipment, which needs fundamental, far-reaching improvement. This is not to condemn the industry as a whole, but rather certain segments of it, for their stationary outlook and lack of proper perspective. Photography gains much of its strength from the vast participation of the amateur, and of course this is the market where mass production thrives.

But — it is high time industry paid attention to the serious and expert opinion of experienced photographers, and to the needs of the professional worker as well. This is important because a good photographer cannot fulfill the potential of contemporary photography if he is handicapped with equipment and materials made for amateurs only, or simply for a quick turnover. The camera, the tripod, and other picture-taking necessities, too often designed by draftsmen who never took a serious picture in their lives, must be vastly better machines if they are to free the photographer creatively, instead of dominating his thinking.

Many photographers spend too much time in the darkroom, with the result that creative camera work is seriously interfered with. The stale vogue of drowning in technique and ignoring

content adds to the pestilence and has become, for many, part of today's general hysteria. *". . . and craftsmanship I set up as a pedestal for art; Became the merest craftsman; to my fingers I lent a docile, cold agility, And sureness to my ear. I stifled sounds, And then dissected music like a corpse, Checked harmony by algebraic rules."*

Apart from the foregoing gripes, what then makes a picture a creative piece of work? We know it cannot be just technique. Is it content — and if so, what is content? These are basic questions that enlightened photographers must answer for themselves.

Let us first say what photography is *not*. A photograph is not a painting, a poem, a symphony, a dance. It is not just a pretty picture, not an exercise in contortionist techniques and sheer print quality. It is or should be a significant document, a penetrating statement, which can be described in a very simple term — selectivity.

To define selection, one may say that it should be focused on the kind of subject matter which hits you hard with its impact and excites your imagination to the extent that you are forced to take it. Pictures are wasted unless the motive power which impelled you to action is strong and stirring. The motives or points of view are bound to differ with each photographer, and herein lies the important difference which separates one approach from another. Selection of proper picture content comes from a fine union of trained eye and imaginative mind.

To chart a course, one must have a direction. In reality, the eye is no better than the philosophy behind it. The photographer creates, evolves a better, more selective, more acute seeing eye by looking ever more sharply at what is going on in the world. Like every other means of expression, photography, if it is to be utterly honest and direct, should be related to the life of the times — the pulse of today. The photograph may be presented as finely and artistically as you will; but to merit serious consideration, must be directly connected with the world we live in.

What we need is a return, on a mounting spiral of historic understanding, to the great tradition of realism. Since ultimately the photograph is a statement, a document of the *now*, a greater responsibility is put on us. Today, we are confronted with reality on the vastest scale mankind has known. Some people are still unaware that reality contains unparalleled beauties. The fantas-

tic and unexpected, the ever-changing and renewing is nowhere so exemplified as in real life itself. Once we understand this, it exercises a dynamic compulsion on us, and a photo-document is born.

The term "documentary" is sometimes applied in a rather derogatory sense to the type of photography which to me seems logical. To connect the term "documentary" with only the "ash-can school" is so much sheer nonsense, and probably stems from the bad habit of pigeon-holing and labelling everything like the well-known 57 varieties. Actually, documentary pictures include every subject in the world — good, bad, indifferent. I have yet to see a fine photograph which is not a good document. Those that survive from the past invariably are, and can be recognized in the work of Brady, Jackson, Nadar, Atget, and many others. Great photographs have "magic" — a revealing word that comes from Steichen. I believe the "magic" photographers are documentarians only in the broadest sense of the word.

According to Webster, anything "documentary" is: "that which is taught, evidence, truth, conveying information, authentic judgment." Add to that a dash of imagination, take for granted adequate technique to realize the intention, and a photographer's grasp will eventually equal his reach — as he turns in the right direction at the crossroads.

The Reappearance of Photography

Walker Evans

The real significance of photography was submerged soon after
its discovery. The event was simply the linking of an already
extant camera with development and fixation of image. Such a
stroke of practical invention was an indirect hit which in applica-
tion was bound to become tied up in the peculiar dishonesty of
vision of its period. The latter half of the nineteenth century
offers that fantastic figure, the art photographer, really an un-
successful painter with a bag of mysterious tricks. He is by no
means a dead tradition even now, still gathered into clubs to
exhibit pictures of misty October lanes, snow scenes, reflets
dans l'eau, young girls with crystal balls. In these groups arises
the loud and very suspicious protest about photography being an
art. So there is in one of the anthologies under review a photo of
a corpse in a pool of blood *because you like nice things*.

Suddenly there is a difference between a quaint evocation of
the past and an open window looking straight down a stack of
decades. The element of time entering into photography
provides a departure for as much speculation as an observer
cares to make. Actual experiments in time, actual experiments in
space exactly suit a post-war state of mind. The camera doing
both, as well as reflecting swift chance, disarray, wonder, and
experiment, it is not surprising that photography has come to a
valid flowering — the third period of its history.

Certain men of the past century have been renoticed who
stood away from this confusion. Eugene Atget worked right
through a period of utter decadence in photography. He was
simply isolated, and his story is a little difficult to understand.
Apparently he was oblivious to everything but the necessity of
photographing Paris and its environs; but just what vision he
carried in him of the monument he was leaving is not clear. It is
possible to read into his photographs so many things he may
never have formulated to himself. In some of his work he even
places himself in a position to be pounced upon by the most
orthodox of surréalistes. His general note is lyrical understand-
ing of the street, trained observation of it, special feeling for
patina, eye for revealing detail, over all of which is thrown a
poetry which is not "the poetry of the street" or "the poetry of

Paris," but the projection of Atget's person. The published reproductions are extremely disappointing. They and the typography and the binding make the book look like a pirated edition of some other publication.

America is really the natural home of photography if photography is thought of without operators (sic). Except that Edward Steichen has made up a book that happens to stand on the present shelf, the American problem is almost too sad to restate — and too trite. Steichen is photography off its track in our own reiterated way of technical impressiveness and spiritual nonexistence. In paraphrase, his general note is money, understanding of advertising values, special feeling for parvenu elegance, slick technique, over all of which is thrown a hardness and superficiality that is the hardness and superficiality of America's latter day, and has nothing to do with any person. The publication of this work carries an inverted interest as reflection of the Chrysler period.

Without money, post-war Germany experimented with photography heavily and thoroughly. There was an efficient destruction of romantic art-photography in a flood of new things which has since lost its force. But the medium was extended and insisted upon, even though no German master appeared. The German photo renascence is a publishing venture with political undertones. Renger-Patzsch's hundred photos make a book exciting to run through in a shop and disappointing to take home. His *is* a photo method, but turns out to be precisely the method that makes it said "painting is no longer necessary, the world can be photographed." It is a roundabout return to the middle period of photography.

Photo-eye is a nervous and important book. Its editors call the world not only beautiful but exciting, cruel, and weird. In intention social and didactic, this is an anthology of the "new" photography; yet its editors knew where to look for their material, and print examples of the news photo, aerial photography, microphotography, astronomical photography, photomontage and the photogram, multiple exposure and the negative print. The pictures are introduced by an essay which must be quoted (leaving its extraordinary English translation as it is in the book):

186

the importance to the history of mankind of development of instruments such as the camera, lies in obtaining increasingly complex results, while the handling of the apparatus becomes more and more simple. to maintain that "short cuts" by relieving him of all effort, lead but to man's greater dulness and laziness, is romanticism in the minor key. the field of mental struggle is but changed to another place. . . . is it but necessary to master the implements of photography to become a good photographer? by no means: as in other fields of expression personality is required. the peculiar human valuation of form at the time is expressed in the photo just as it is in graphic art. . . . it often occurs that photographs taken by the one will always appear uninteresting, though he be skilled in technique, while photos by the other, who considers himself but an amateur and whose work is not technically perfect, yet invariabley are of forcible effect. . . . some misinstructed people still raise the question whether. . . to produce a photo full of expression and finished to the very corners can be an impelling inner necessity. what we mean is the question whether we are . . . concerned here with *art*. commonplace men and "connoisseurs," both of whom generally are misforms of existence, still often meet in refusing to the most finished of photographs the quality mark of "art." either there is here but the semblance of a problem, since the definition of art is wholly time-bound, arbitrary and ungreat, or human sight is totally deformed and susceptible only to one kind of beauty even opposite nature. if however we understand art as an end in itself, called forth by man and filled with "expression," good photographs are included.

Photographie is the French equivalent to *Photo-eye* with the added intention of giving a history of photography. It is without tendency but has lost consistency by a de luxe process of reproduction. An essay on *photographie vision du monde* could be a good deal briefer than the one which prefaces this collection. But it is valuable, in its French-intellectual way, a respectable statement of the functions and possibilities of photography. The

187

reproductions do little to illustrate this essay.

Finally the photo document is directed into a volume, again in Germany. *Antlitz der Zeit* is more than a book of "type studies"; a case of the camera looking in the right direction among people. This is one of the futures of photography foretold by Atget. It is a photographic editing of society, a clinical process; even enough of a cultural necessity to make one wonder why other so-called advanced countries of the world have not also been examined and recorded.

Part Four:
Some Recent Themes and Issues

The Centenary of Photography

Paul Valéry (1871–1945)

During the late 1880s and early 1890s, while studying law at Montpellier, Paul Valéry began to cultivate an interest in poetry and architecture, and his poems were published in Symbolist journals. Following in Baudelaire's footsteps, Valéry developed a passion for Edgar Allan Poe, as well as for Joris Karl Huysmans and Stéphane Mallarmé. He met Mallarmé in 1891 and joined the author's artistic circle. During the next year, however, he gave up his artistic pursuits to reflect on the processes of the human intellect. From 1897 through 1900, Valéry worked as a civil servant in the French War Office, and for the next twenty-two years, he served as the private secretary to Edouard Lebey, director of the French press association. In this capacity, Valéry became one of the best-informed French analysts of current events.

In 1912, pressed by his friend André Gide, Valéry again took up his poetic endeavors. He published a collection of poems, La Jeune Parque, *in 1917, which ultimately established his reputation as one of France's major contemporary poets. In addition to writing poetry, Valéry composed essays and speeches on a wide range of subjects, including photography, which he described as an objective process of illustration, mirroring physical facts. Reflecting Baudelaire's interest in photography's impact on painting, Valéry expressed concern over photography's impact on writing. Whereas Baudelaire cast photography's influence only in negative terms, Valéry pictured the medium's role in a more positive light, suggesting that historically photography, as an objective recording process, may have given writers a clearer sense of how to construct a realistic scene. He proposed that the medium also may have redefined realism by exposing those unrelated objects composing a scene that the writer's eyes miss in their selective scanning. No longer was the author dependent upon his imagination to represent physical reality, for photographs could be his guide. And as photography filled the role of the objective recorder, literature actually became free to develop its true character as the expression of abstract thought. Valéry admired the altered perception of reality he believed photographs to have given man, and praised the capacity of these images to contribute valuable information to man's knowledge of the universe.*

The Academy, invited to take part in this ceremony marking the centenary of a truly French invention, indeed one of the most admirable to emerge in the course of the nineteenth century, could not fail to pay its own respects to our great compatriots who hit on the principle of photography and were the first to fix an image of visible objects by employing the very light those objects reflect.

We, however, are a Society devoted particularly to the cult of Letters, which at first glance show no obvious affinity to photography, nor do they appear to be more affected by it in spirit or practice than by many other modern products of human ingenuity.

We all know that drawing, painting, and the imitative arts as a whole were able to exploit this power of a sensitized plate to capture forms instantaneously. Directly the process of fixation made it possible to study, at one's leisure, beings in motion, a great many errors of observation came to light: the renderings of certain artists, persuaded that they had caught a horse's gallop or a bird's flight, were proved, by this means, to be utterly fanciful. Thanks to photography, the eye grew accustomed to anticipate what it should see, and to see it; and it learned not to see nonexistent things which, hitherto, it had seen so clearly.

Yet, this possession of the means of reproducing natural and living appearances through a simple transformation of physical energy seems to have had no certain effect on Letters nor to offer them any marked advantage.

On the contrary, this marvelous invention might — or so it would seem at first — ultimately restrict the importance of the art of writing and act as its substitute rather than help enlarge its scope to enrich it with valuable insights. It is a very largely illusory claim that language can convey the idea of a visual object with any degree of precision. The writer who depicts a landscape or a face, no matter how skillful he may be at his craft, will suggest as many different visions as he has readers. Open a passport for proof of this: the description scrawled there does not bear comparison with the snapshot stapled alongside it.

Thus we might be discouraged from making further efforts to describe what photography can automatically record, and we must recognize that the development of this process and of its functions has resulted in a kind of progressive eviction of the

word by the image. In fact, it is as if the image, in published form, has been led, by its overweening desire to steal the place of words, to steal some of their more irritating vices as well — prolixity and facility. I might add that photography even makes so bold as to practice an art in which the word has, from time immemorial, specialized: the art of lying.

So it must be agreed, then, that bromide proves stronger than ink, whenever the mere presence of things suffices, whenever the thing speaks for itself without benefit of proxy, that is, without having recourse to the wholly arbitrary transmissions of a language.

As for myself, I see no harm whatever in this, and am strongly inclined to believe that it might in a way benefit literature. I mean that the proliferation of photographic images I mentioned could indirectly work to the advantage of Letters, Belles-Lettres that is, or rather, Letters that truly merit that adjective. If photography, which is now capable of conveying color and movement, not to mention depth, discourages us from describing, it is because we are thus reminded of the limits of articulate language and are advised, as writers, to put our tools to a use more befitting their true nature. A literature would purify itself if it left to other modes of expression and production the tasks which they can perform far more effectively, and devoted itself to ends it alone can accomplish. It would thus protect itself and advance along its true paths, one of which leads toward the perfecting of language that constructs or expounds abstract thought, the other exploring all the variety of poetic patterns and resonances.

Let me remark here that when photography first made its appearance, the descriptive genre in Letters was becoming an all-invading fashion. The background and outward aspects of life figured almost disproportionately in works of verse and prose alike. Between 1820 and 1840, this background was, on the whole, imaginary. There grew up around landscapes and forms a romanticism whose cavalier treatment of people as well as objects was inclined to total flights of fancy; it invented an Orient and a Middle Ages cut whole cloth from the sensibility of the period, with the aid of some small erudition.

And then came Daguerre. With him, the photographic vision was born and it spread by singular leaps and bounds throughout the world. A marked revision occurred in all standards of visual

knowledge. Man's way of seeing began to change, and even his way of living felt the repercussions of this novelty, which immediately passed from the laboratory into everyday use, creating new needs and hitherto unimagined customs. Now everyone had his portrait done: a luxury once reserved for the privileged few. Traveling photographers scoured the countryside. Not one event in human existence went unrecorded in some snapshot. No marriage was complete without a picture showing the couple in wedding dress; an infant was scarcely born — a few days old — he was brought before a lens; decades later the man he grew into might stand amazed and affected before the photograph of this baby whose future he has used up. Every family kept its album, one of those albums that allow us to revisit the past: portraits that we find touching in retrospect, apparel that now seems quaint, moments in time that have become such as they were, relatives, friends, and people we do not recognize, who played some essential or random role in our lives. In short, photography laid down a real pictorial record of the social life. If he had lived a bit longer, Balzac, who searched tombstones and signboards for unusual names to give his countless creatures, would surely have found in these archives of faces an excellent stimulant to his genius.

But with the advent of photography, and following in Balzac's footsteps, realism asserted itself in our literature. The romantic vision of beings and objects gradually lost its magic. The scenic backdrop showed itself for the canvas or cardboard it was. A new imperative held sway, requiring that poetic invention stand clearly apart from any narrative claiming to represent reality. I do not mean by this that the literary system of Flaubert, of Zola or of Maupassant owes its formula to the advent of photography, since I dread searching for causes in a realm where they cannot fail to be found. I am doing no more than take a snapshot of an era. It is far from certain that objects close together on a photographic plate have anything in common beyond their nearness. The more we are tempted to see some underlying connection between the phenomenon called ''Realism'' and the phenomenon called ''Photography,'' the more we must beware of exploiting a coincidence.

The Empire of Letters is not, however, limited to the provinces of Poetry and the Novel. It extends into the vast do-

mains of History and Philosophy, whose vague frontiers sometimes disappear altogether where they border on the territories of Science and on the forests of Legend.

It is here, in these vague regions of knowledge, that the coming of Photography, or the mere idea of it, acquires remarkable and specific importance for it introduces into these venerable disciplines a new condition, perhaps a new uncertainty, a new kind of reagent whose effects have certainly not as yet been sufficiently explored.

History is a narrative to which we apply what will distinguish it from mere storytelling. We invest it with our present energy and whatever fund of images we can draw from the present. We color it with our likes and dislikes; we also construct systems of events and, to the extent that our heart and power of mind permit, we give a kind of life and substance to people, to institutions, to incidents, and to dramas bequeathed us in documents as mere verbal outlines, and often bare ones at that. For some people, History amounts to something like a picture-book, an operatic scenario, a stage performance, or a series of generally critical situations. Of these tableaux, which our mind creates and then submits to, some depict wonders, enchantments, theatrical effects too beautiful to believe, which we sometimes interpret as symbols, or poetic transpositions of real events. For other people, whose interest takes a more abstract turn, History is a catalogue of human experiences to be consulted much as one would consult meteorological records, in the identical hope that the past will divulge something of the future.

The mere notion of photography, when we introduce it into our meditation on the genesis of historical knowledge and its true value, suggests this simple question: *Could such and such a fact, as it is narrated, have been photographed?*

Since History can apprehend only sensible things, being based on verbal testimony relayed through words, everything on which it grounds its affirmations can be broken down into things witnessed, into moments that were caught in "quick takes" or could have been caught had a cameraman, some star news photographer, been on hand. *All the rest is literature.* All that is left consists of those components of the narrative or of the thesis that originate in the mind and are consequently imaginary, mere constructions, interpretations, bodiless things by nature invisi-

ble to the photographic eye, inaudible to the phonographic ear so that they could not have been observed and transmitted intact. As a result, any discussion about the causal value of certain facts, about their importance and their meaning, revolves around non-historical factors: they are the ventures of our critical or inventive faculties, more or less controlled by documents.

I leave out altogether the problems of authenticity. On this point, however, photography teaches us new reasons to be cautious. Prior to its invention, any fact, provided a sufficient number of people swore that they had seen it with their own eyes, was considered incontestable. Not one court of law, not one historian would not have accepted it, even if reluctantly. Yet, just a few years ago, a snapshot was proof enough to demolish the testimony of some hundred people who swore to having seen, with their own eyes, a fakir pull himself up a rope that he had just cast into the air where it hung, miraculously suspended.

In any event, the natural outcome of these reflections would be a sort of Philosophy of Photography, which might in turn soon lead us back to Philosophy itself, if this digression did not threaten to take me outside my competence, my present assignment, and the limits set by the object and the occasion of this ceremony.

In a few words, I shall give a cursory idea of what a philosopher might have to say if he turned his thought to this invention of ours.

Photography could, for example, prompt us to revive, if not rejuvenate, the ancient and difficult problem of *objectivity*. That little story of the fakir goes to show that the awkward and somewhat desperate solution of eliciting testimony from the few, in order to establish for all mankind a thing's objective existence, was easily destroyed by a mere sensitized plate. It must be admitted that we cannot open our eyes without being unconsciously disposed not to see some of the things before us, and to see others which are not there. The snapshot has rectified our errors both of *deficiency* and of *excess*. It shows us what we would see if we were uniformly sensitive to everything that light imprints upon our retinas, and nothing else. Thus it might not be impossible at least to limit, if not to abolish, the classic problem I mentioned, by ascribing objective value to every impression whose replica, whose likeness, we are able to capture — impar-

196

tial light being the only intermediary between the model and its representation.

But there are other, very intimate and very ancient, affinities between light and Philosophy. In every age, philosophers — the theorist of knowledge and the mystic alike — have shown a rather remarkable predilection for the most commonly known phenomena of optics, very often making use of them, and sometimes subtle use, to picture the relation between consciousness and its objects, or to describe the illusions and insights of the mind. Many telltale expressions of this remain in our vocabulary. We speak figuratively of clarity, reflection, speculation, lucidity, and ideas; and, when trying to express abstract thought, we avail ourselves of a whole visual rhetoric. What could be more natural than to compare what we take to be the unity of our consciousness, complementary to and as it were the opposite of the variety of our knowledge, with the source of light which reveals the infinite multiplicity of visible things, each individually formed out of myriads of solar images? The blue of the sky is created by countless mirrors whose smallness we can compute. Moreover, the vicissitudes of light among bodies can give rise to any number of effects which we cannot resist comparing with the states of our inner sense of perception. What has proved most seductive to thinkers, however, and furnished the theme for their most brilliant variations, are the deceptive properties of certain aspects of light. What would become of philosophy if it did not have the means of questioning appearances? Mirages, sticks that break the moment they are immersed in water and miraculously straighten out when they are withdrawn from their bath, all the tricks that our eye accepts have figured in this memorable and inexhaustible enumeration.

You may be sure that I shall not neglect to mention here the most celebrated of all such allegories. What is Plato's famous cave if not a *camera obscura,* the largest ever conceived, I suppose? If Plato had reduced the mouth of his grotto to a tiny hole and applied a sensitized coat to the wall that served as his screen, by developing the rear of the cave he could have obtained a gigantic film, and heaven knows what astounding conclusions he might have left regarding the nature of our knowledge and the essence of our ideas . . .

But is there any emotion more deeply philosophical than the

one we experience as we anxiously wait — beneath that rather diabolical red light which turns a glowing cigarette into a green diamond — for the emergence to visibility of that mysterious *latent image,* on the exact nature of which Science has not yet made up its mind?

Little by little, here and there, a few spots emerge like the first stutterings of awakening consciousness. These fragments multiply, cluster, form a whole; and, watching this configuration as its disparate elements, each one trivial in itself, proceed by leaps to form a recognizable picture, we cannot but think of certain precipitations as they occur in our minds, of memories that come into focus, of certitudes that suddenly crystallize, of the creation of certain rare lines of verse that fall into place, abruptly wresting themselves from the chaos of our inner speech.

All in all, can one think of a subject more deserving of the philosopher's meditation than the enormous increase in the number of stars as well as in the number of cosmic radiations and energies whose record we owe to photography?

Such breathtaking progess would, on deeper consideration, seem to suggest a truly odd prospect. Will it not be necessary henceforth to define the Universe as the simple product of whatever means we have at our disposal in a given era of bringing within the human ken events that are infinitely various or remotely distant? If the number of stars should strictly depend on whatever methods we invent to compute and number them, and if we reckon the future in terms of recent achievements, then it could almost be said that the numeration of the Universe is a function of time.

These prodigious results ought to make us think with special feeling of the continual efforts, of the countless experiments, of the self-denial and perseverance of inventors. I am thinking of the researches carried out under the most straitened circumstances, of the haphazard tools they themselves improvised, and the loneliness of their speculations. But, even more than this, what commands my respect is the disinterestedness that makes their glory complete. And their glory rebounds upon the nation.

Walter Benjamin (1892–1940) and William M. Ivins, Jr. (1881–1961)

Born in Berlin, Walter Benjamin moved to Switzerland in 1917 to attend the University at Berne. In 1919, he received his diploma upon the completion of his thesis on the concept of art criticism in German romanticism. The following year, he returned to Berlin where he worked on translations of works by Baudelaire and Goethe. Over the next years, Benjamin devoted himself to the writing of his major work on the history of the German Baroque drama, Ursprung des deutschen Trauerspiels. *During the late 1920s, he launched his professional career as a literary critic and essayist, contributing articles to many European journals and reviews. He became an ardent Marxist, writing critiques of modern society deriding the moral and intellectual attitudes of the middle class. In* The Work of Art in the Age of Mechanical Reproduction, *he describes how photography has altered the elitist nature of art works by enabling excellent reproductions to be disseminated amongst the middle and lower classes.*

In 1931 Benjamin published "A Short History of Photography" in Literarische Welt, *in which he examines people's varied attitudes toward the medium, from its invention to his own time, and investigates the changing influence that photography and the more traditional art media have had on one another over time.*

William Ivins was also concerned with the interplay of photography with other artistic media. Ivins argues in Prints and Visual Communication *(1953) that, unlike any other reproducible print, the photograph has no syntax of its own — that is, no physical matrix inherent only to photographs into which a message is translated and by which it is communicated.*

A Short History of Photography

Walter Benjamin

The fog which obscures the beginnings of photography is not quite as thick as that which envelops the beginnings of printing. Perhaps more discernible for photography was the fact that many had perceived that the hour for the invention had come. Independently of each other men were striving for the same goal — fixing the pictures made by a camera obscura, itself well

known at least since Leonardo. When, after about five years of effort, Niépce and Daguerre succeeded at the same time, the state snatched up the invention, encouraged by patent law difficulties facing the inventors, and made it public.

With that step were established conditions for a continually accelerated pace of development which for a long time prevented any look backward. And so the historical or perhaps philosophical questions which accompany the rise and fall of photography for decades went unconsidered. If those questions are beginning to enter our consciousness today it is for a specific reason. The most recent literature seizes on the striking fact that the flowering of photography, the achievement of Hill and Cameron, of Hugo and Nadar — occurs in its first decade.[a] That is the decade which preceded its industrialization. Not to say, of course, that in this early period the peddlers and charlatans had not gotten hold of the new technology and turned it to profit; they did that on a massive scale. But that was closer to the methods of the marketplace, where even today photography is at home, than to those of industry.

Photography first conquered the field with the visiting card, whose first producer, significantly, became a millionaire. It would not be astonishing if the types of photography which today direct our attention back to the preindustrial flourishing of photography were found to be fundamentally related to the convulsions of capitalist industry.

Nothing is easier than to utilize the attractions of pictures presented in recent publications of old photography[1] for insights into photography's basic nature. Theoretical efforts to master photography have all been thoroughly rudimentary. And however many debates were conducted about it in the last century, none broke fundamentally free from the wretched schema with which a chauvinistic little publication, the Leipzig *City Advertiser,* thought to have confronted the infernal French art early on. "To fix fleeting reflections," it was written there, "is not only impossible, as has been shown by thoroughgoing German research, but to wish to do it is blasphemy. Man is created in the image of God and God's image cannot be held fast by a human machine. At the most the pious artist — enraptured by heavenly inspiration — may at the higher command of his genius dare to reproduce those divine/human features in an instant of highest dedication, without mechanical help."

200

Here, with all the weight of its dullness, enters the philistine's concept of *art,* to which any technical development is totally foreign, which, with the provocative challenge of the new technology, feels its own end nearing. Nevertheless it was this fetishistic, fundamentally anti-technological concept of art with which the theoreticians of photography sought for almost a hundred years to do battle, naturally without coming to the slightest result. For this view understood nothing except to accredit the photographer before the exact tribunal he had overthrown.

An entirely different air, however, breathes through the argument which the physicist Arago, as spokesman for the invention of Daguerre, put before the chamber of deputies on the third of July 1839. The beauty of this speech is how it pointed out photography's applications to all aspects of human activity. The panorama it sketches out is broad enough to make painting's doubts about photography's credentials — doubts not absent from the speech itself — seem inconsequential, as well as to hint at the breadth of the invention's usefulness. "When the inventors of a new instrument," Arago said, "turn it to the observation of nature, what they had hoped for from it always seems tiny in comparison to the succession of subsequent discoveries which it contributes." This speech traverses the broad spectrum of the new technology, from astrophysics to philology; beside the prospects of photography of the stars stands the idea of assembling a body of Egyptian hieroglyphics by photography.

Daguerre's photographs were iodized silver plates exposed in the camera obscura which could be turned back and forth until, in the proper light, one could make out a delicate, light gray image. They were unique and they cost, on the average, 25 gold francs per plate. They were frequently kept in cases as decorations. In the hands of many painters they became technical aids. Just as 70 years later, Utrillo created his fascinating views of the houses on the edges of Paris not from nature but from landscape photos, so the respected English portrait painter, David Octavius Hill, based his painting of the first general synod of the Scottish church in 1843 on a large group of portrait photographs.

But he made these photographs himself. Modestly conceived as aids for his own use, they are what gave his name historical significance, while as a painter he is forgotten. To be sure, there are a few studies which reveal more about the new medium than

that series of heads: not the portraits but nameless images of people. There had been such faces in painting for a long time. If they remained in the possession of the family, then people inquired after the identity of the people represented time and time again. But after two or three generations such interest subsided: the pictures, inasmuch as they survived, did so only as testimony to the art of the painter.

In photography, however, one encounters something strange and new: in that fishwife from Newhaven who looks at the ground with such relaxed and seductive shame something remains that does not testify merely to the art of the photographer Hill, something that is not to be silenced, something demanding the name of the person who had lived then, who even now is still real and will never entirely perish into *art*. "Und ich frage: wie hat dieser haare zier/und dieses blickes die frueheren wesen umzingelt:/ wie dieser mund hier geküsst zu dem die begier/ sinnlos hinan als rauch ohne flamme sich ringelt."[b] Or one comes upon the picture of Dauthendey — the photographer and father of the poet — from around the time of his wedding, seen with the wife whom one day shortly after the birth of their sixth child he found in the bedroom of his Moscow house with arteries slashed. She is seen beside him here, he holds her; her glance, however, goes past him, directed into an unhealthy distance. If one concentrated long enough on this picture one would recognize how sharply the opposites touch here. This most exact technique can give the presentation a magical value that a painted picture can never again possess for us. All the artistic preparations of the photographer and all the design in the positioning of his model to the contrary, the viewer feels an irresistible compulsion to seek the tiny spark of accident, the here and now.

In such a picture, that spark has, as it were, burned through the person in the image with reality, finding the indiscernible place in the condition of that long past minute where the future is nesting, even today, so eloquently that we looking back can discover it. It is a different nature which speaks to the camera than speaks to the eye: so different that in place of a space consciously woven together by a man on the spot there enters a space held together unconsciously. While it is possible to give an

202

account of how people walk, if only in the most inexact way, all the same we know nothing definite of the positions involved in the fraction of a second when the step is taken.

Photography, however, with its time lapses, enlargements, etc. makes such knowledge possible. Through these methods one first learns of this optical unconsicous, just as one learns of the drives of the unconsicous through psychoanalysis. Concern with structure, cell forms, the improvement of medicine through these techniques: the camera is ultimately more closely related to these than to the moody landscape or the soulful portrait. At the same time, however, photography opens up in this material the physiognomic aspects of the world of images, which reside in the smallest details, clear and yet hidden enough to have found shelter in daydreams. Now, however, large and formulatable as they have grown, they are able to establish the difference between technology and magic as a thoroughly historical variable. Thus Blossfeldt,[2] with his astonishing photographs of plants, brought out the forms of ancient columns in horsetails, the bishop's staff in a bunch of flowers, totem poles in chestnut and acorn sprouts enlarged ten times, gothic tracery in teasel.

Therefore, too, Hill's models are certainly not far from the truth when they admit that to them "the phenomenon of photography" was still "a great secret experience," even if what that meant was only the consciousness of standing "before an apparatus which in almost no time could produce an image of the visible world that seemed as lifelike and truthful as nature itself." It has been said that Hill's camera maintained a discreet reserve. But his models, for their part, are no less reserved; they maintain a certain shyness in the face of the apparatus. The motto of a later photographer, from the period of photography's bloom — "Never look at the camera" — could have been derived from their stance. But by that was not meant the same "looking at you" of animals, men, or babies all crowded together, which involves the customer in such an unsavory manner and to which nothing can better be contrasted than the sense with which old Dauthendey spoke of the daguerreotype: "At first one does not trust himself," he reported, "to look for very long at the first pictures he has made. One shies away from the sharpness of these people, feels that the puny little faces of the

people in the pictures can see him, so staggering in the effect on everyone of the unaccustomed clarity and the fidelity to nature of the first daguerreotypes."

These first to be photographed enter the viewing space unfamed or, rather, uncaptioned. Newspapers, then, were still items of luxury, which one seldom bought but rather looked at in cafes. The photographic procedure had not yet become a tool of theirs; the fewest possible people even saw their names in print. The human face had a silence about it in which its glance rested. In short, all possibilities of this portrait art rested upon the fact that the connection between actuality and photo had not yet been entered upon. Many images by Hill were taken at the Edinburgh cemetery of Greyfriars. Nothing is more representative of this early period: it is as if the models were at home in this cemetery. And the cemetery, according to one picture that Hill made, is itself like an interior, a delineated, constricted space where gravestones lean on dividing walls and rise out of the grass floor — gravestones hollowed out like fireplaces showing in their hearts the strokes of letters instead of tongues of flame.

But this place could never have achieved its great effect had not its selection been for technical reasons. The lower sensitivity to light of the early plates made necessary a long period of exposure in the open. This, on the other hand, made it desirable to station the model as well as possible in a place where nothing stood in the way of quiet exposure. "The synthesis of expression which was achieved through the long immobility of the model," Orlik says of the early photographs, "is the chief reason besides their simplicity why these photographs, like well drawn or painted likenesses, exercise a more penetrating, longer-lasting effect on the observer than photographs taken more recently." The procedure itself caused the models to live, not *out of* the instant, but *into* it; during the long exposure they grew, as it were, into the image.

They can be sharply contrasted to the snapshot, which corresponds to the changed environment in which, as Kracauer has accurately remarked, the same fraction of a second that the exposure lasts determines "whether an athlete becomes famous enough for the photographers of the illustrated magazines to take his picture."

Everything in these early pictures was set up to last; not only the incomparable grouping of the people — whose disappearance was certainly one of the most precise symptoms of what happened to society in the second half of the century — even the folds that a garment takes in these images persists longer. One needs only look at Schelling's coat; it enters almost unnoticed into immortality; the forms which it assumes on its wearer are not unworthy of the folds in his face. In short, everything speaks to the fact that Bernhard van Brentano suspected: "that a photographer of 1850 was on the highest level of his instrument" — for the first and for a long time for the last time.

In order to understand the powerful effect of the daguerreotype in the age immediately following its discovery one must consider that the *plein air* painting of that time had begun to show entirely new perspectives to the most advanced painters. Aware that even in this area photography had to take the torch from painting, Arago said in a historical review of the early experiments of Giovanni Battista Porta: "As far as concerns the effect which depends on the incomplete transparency of our atmosphere (and which has been labeled with the accurate expression 'air perspective'), the practiced painter does not hope that the camera obscura" — he means of the copying of the images that appear in the camera obscura — "could be helpful to him in reproducing this effect exactly." At the moment when Daguerre succeeded in fixing the images in the camera obscura the painter had been distinguished on this point from the technician.

The genuine victim of photography, however, was not landscape painting but the miniature portrait. Things developed so swiftly that as early as 1840 most of the innumerable painters of miniatures had become professional photographers, at first only on the side but soon, however, exclusively. At the same time the experience of their original profession came in handy. It was not their preparation in art but in craft to which the high level of their photographic accomplishments must be credited. Very gradually this transitional generation disappeared; indeed there seems to have been a sort of Biblical blessing on those first photographers: Nadar, Stelzner, Pierson, Bayard all lived to ninety or a hundred. Finally, however, businessmen from everywhere en-

tered the ranks of professional photographers. Later, when re-
touching of the negative — through which bad painters took their
revenge on photography — gradually became practiced, a sud-
den decline in taste set in. Then was the time when photograph
albums began to appear. In the coldest places in the house, on
consoles or gueridons in the drawing room, they were most
likely to be found: leather covered with metal latches and gilt-
edged pages as thick as a finger on which the foolishly draped or
embellished figures were distributed — Uncle Alex and Aunt
Riekehe, Trudy when she was little, Papa in his first semester.
And finally to make the same complete, we ourselves: as salon
Tiroleans, yodeling, hats swinging against painted firs, or as
sailors, one leg straight and the other bent, as is appropriate,
leaning against an upholstered post.

The accessories in such portraits, with the columns, balus-
trades and little oval tables, recall the time when one had to give
the models points of support so they could remain steady during
the long exposure. If in the beginning people were satisfied sim-
ply with head holders or knee braces, soon additional acces-
sories followed, such as were present in famous paintings and
therefore had to be artistic. Next came the columns or the cur-
tain. Even in the '60s accomplished men protested against this
junk. It was said at the time in an English professional journal:
"In painted pictures the columns appear plausible, but the man-
ner in which they are applied to photography is absurd, for they
usually stand on a rug. But as everyone knows, marble or stone
columns are not commonly built with carpet as their base." At
that time arose the ateliers with their draperies and palms, gobe-
lins and easels, which stand so ambivalently between execution
and representation, torture chamber and throne room, as an
early portrait of Kafka testifies.

There in a narrow, almost humiliating child's suit, overbur-
dened with braid, stands the boy, about six years old, in a sort of
winter garden landscape. Palm fronds stand frozen in the
background. And as if it were important to make these up-
holstered tropics even more sticky and sultry, the model holds a
huge hat with broad brim like those Spaniards wear in his left
hand. He would surely vanish into this arrangement were not the
boundlessly sad eyes trying so hard to master this predetermined
landscape.

This picture in its immeasurable sadness forms a pendant to the early photographs in which people did not yet look out into a world as isolated and godforsaken as the boy here. There was an aura around them, a medium that gives their glance the depth and certainty which permeates it. And again the technical equivalent lay close at hand; it was the absolute continuum from brightest light to darkest shadow. Here, too, the law holds good concerning the advance announcement of new achievements in the older technology, in that portrait painting — before its decline — had produced a unique flourishing of the mezzotint.

The mezzotint method involves a technique of reproduction such as was united only later with the new photographic one. As in mezzotints the light in Hill's work torturously wrestles its way out of the dark: Orlik speaks of the "light's holding together" because of the long duration of the exposure which gives "these early photographs their greatness." And among the contemporaries of the invention, Delaroche remarked on the "delicate, innovative" impression which "in no way disturbed the repose of the masses." So much for the technical conditions of this auralike impression.

Many group pictures in particular retain a fleeting togetherness which appeared for a short while in the plate, before it disappeared in the original subject. It is this breathy halo, circumscribed beautifully and thoughtfully by the now outmoded oval shape of the frame. Therefore these incunabula of photography are often misrepresented by emphasis on the *artistic perfection* or *tastefulness* in them. These images were taken in rooms where every customer came to the photographer as a technician of the newest school. The photographer, however, came to every customer as a member of a rising class and enclosed him in an aura which extended even to the folds of his coat or the turn of his bow tie. For that aura is not simply the product of a primitive camera. At that early stage, object and technique corresponded to each other as decisively as they diverged from one another in the immediately subsequent period of decline. Soon, improved optics commanded instruments which completely conquered darkness and distinguished appearances as sharply as a mirror.

The photographers in the period after 1880 saw their task in simulating that aura through all the arts of retouching, in particu-

lar through what was called offsetting. The conquest of darkness by increased illumination had eliminated the aura from the picture as thoroughly as the increasing alienation of the imperialist bourgeoisie had eliminated it from reality. So a duskier tone, interrupted by artistic reflections, became fashionable, as in *Jugendstil*. Despite the weak light, the pose was always more clearly defined; its stiffness betrayed the impotence of that generation in the face of technical progress.

Thus, what is decisive in these photographs is always the relation of the photographer to his technique. Camille Recht indicated as much in a nice image. "The violinist," he wrote, "must form the tone himself, must seek it, find it quick as lightning; the pianist strikes the key: the tone resounds. An instrument is at the disposal of the painter as well as the photographer. The drawing and coloring of the painter correspond to the tone formation of the violin; the photographer shares with the pianist a mechanism which is subject to laws of limitation that the violinist is not. No Paderewski will ever earn the fame or work the almost legendary magic of a Paganini."

Continuing the comparison, however, there is a Busoni of photography, and that is Atget.[c] Both were virtuosos but at the same time forerunners. They hold in common an unmatched devotion connected with the highest precision. Even their features were similar. Atget was an actor who became disgusted with that pursuit, took off his mask and then went on to strip the makeup from reality as well. He lived in Paris poor and unknown. He gave his photographs away to admirers who could hardly have been less eccentric than he, and he died having left behind an oeuvre of more than 4,000 photographs. Berenice Abbott from New York collected these, and a selection of them has appeared in a marvelously beautiful volume published by Camille Recht.[3]

Contemporary journalism "knew nothing of the man who mostly went around the ateliers with his pictures, throwing them away for a few pennies, often only for the price of one of those picture postcards, such as showed the sights of the city around 1900, beautifully dipped in blue night, with retouched moon. He reached the pole of the highest mastery; but in the obstinate capacity of one of great ability who always lived in the shadows, he neglected to plant his flag there. So many may believe to have discovered the pole which Atget reached before them."

208

In fact, Atget's Paris photographs are the forerunners of Surrealist photography, advance troops of the broader columns Surrealism was able to field. As the pioneer, he disinfected the sticky atmosphere spread by conventional portrait photography in that period of decline. He cleansed this atmosphere, he cleared it; he began the liberation of the object from the aura, which has been the achievement of the most recent school of photography. When *Bifur* or *Variété,* periodicals of the avant-garde, were showing mere details under the captions "Westminster," "Lille," "Antwerp," or "Breslau," a piece of a balustrade, a bare treetop whose twigs cut across a gas lantern, a stone wall, or a candelabra with a life ring on which the name of the city is written, they are showing nothing but refinements of motifs which Atget discovered. He sought the forgotten and the neglected, so such pictures turn reality against the exotic, romantic, show-offish resonance of the city name; they suck the aura from reality like water from a sinking ship.

What is aura? A strange web of time and space: the unique appearance of a distance, however close at hand. On a summer noon, resting, to follow the line of a mountain range on the horizon or a twig which throws its shadow on the observer, until the moment or hour begins to be a part of its appearance — that is to breathe the aura of those mountains, that twig. Now to bring things themselves closer — and closer to the masses — is as passionate a contemporary trend as is the conquest of unique things in every situation by their reproduction. Day by day the need becomes greater to take possession of the object — from the closest proximity — in an image and the reproductions of an image. And the reproduction, as it appears in illustrated newspapers and weeklies, is perceptibly different from the original. Uniqueness and duration are as closely entwined in the latter as transience and reproducibility in the former. The removal of the object from its shell, the fragmentation of the aura, is the signature of a perception whose sensitivity for similarity has so grown that by means of reproduction it defeats even the unique.

Atget almost always passed by the "great sights and the so-called landmarks." He did not, however, pass by a long row of boot lasts, or by the Parisian courtyards where from evening until morning hand-wagons stand in rows and groups; or by the uncleared tables and the uncollected dishes, which were there at the same time by the hundred thousands all over; or by the

bordello at rue . . . no. 5, whose gigantic five appears in four different places on the facade. More noticeably, however, almost all of these pictures are empty. The Porte d'Arcueil fortifications are empty, as are the regal steps, the courts, the terrace cafes, and as is appropriate, the Place du Tertre, all empty.

They are not lonely but voiceless; the city in these pictures is swept clean like a house which has not yet found its new tenant. These are the sort of effects with which Surrealist photography established a healthy alienation between environment and man, opening the field for politically educated sight, in the face of which all intimacies fall in favor of the illumination of details. It is plain that this new vision had least absorbed what one would otherwise most understandably indulge in — the devalued representative portrait. On the other hand, the renunciation of the human image is the most difficult of all things for photography. The best Russian films taught those who did not know this that milieu and landscape only make themselves accessible to photographers who know how to grasp them in the nameless manifestations which they take in the face. Even the possibility of that is conditioned by the subject of the photograph. It was a generation which had no ambition to go down for posterity in pictures, but rather withdrew in the face of such possibilities into its living space, somewhat shyly — like Schopenhauer, in the Frankfurt picture of around 1850, receding into the depths of his armchair. Just for that reason this generation let its living space enter with it into the picture, but it did not bequeath its graces. Then for the first time in decades the Russian film provided an opportunity to show people in front of the camera who were not being photographed for their own purposes. And suddenly the human face entered the image with a new, immeasurable significance. But it was no longer a portrait. What was it?

It is the supreme accomplishment of a German photographer to have answered this question. August Sander[4] put together a series of faces that in no way stand beneath the powerful physiognomic galleries that an Eisenstein or a Pudovkin revealed, and he did so from a scientific standpoint. "His total work forms seven groups, which correspond to the existing order of society, and are to be published in about 45 portfolios of 12 photos each."[d] Sander goes from farmers, the earthbound men, and takes the viewer through all levels and professions up

on one hand to the highest representatives of civilization and down on the other to idiots. The creator came to this task not as a scholar nor instructed by racial theoreticians or social researchers, but, as the publisher says, "from direct experience." The observation is certainly an unprejudiced one, but clever, also, and tender and sensitive in the sense of Goethe's statement: "There is a sensitive empiricism which makes itself most inwardly identical with the object and thereby becomes genuine theory." Therefore it is completely in order that an observer like Döblin struck straightaway onto the scientific aspects in this work and remarked; "As there is a comparative anatomy by virtue of which we come to a conception of nature and a history of organs, so this photographer pursues comparative photography and thereby achieves a scientific standpoint above and beyond that of photographic details."

It would be a shame if economic conditions prevented the further publication of this extraordinary corpus. To the publisher, however, we can offer a more specific encouragement in addition to general ones: overnight, works like those of Sander can grow into unsuspected actuality. Power shifts, such as we face, generally allow the education and sharpening of the physiognomic conception into a vital necessity. One may come from the right or from the left — he will have to get used to being viewed according to where he comes from. One will have to see others the same way. Sander's work is more than a book of pictures: it is a book of exercises.

"There is no work of art in our age so attentively viewed as the portrait photography of oneself, one's closest friends and relatives, one's beloved," Lichtwark wrote as early as 1907, and thereby moved the investigation out of the realm of esthetic distinctions into that of social functions. Only from that angle can it strike out further. It is significant that the debate becomes stubborn chiefly where the esthetics of *photography as art* are involved, while for example the much more certain social significance of *art as photography* is hardly accorded a glance.

And the effect of photographic reproduction of works of art is of much greater importance for the function of art than the more or less artistic figuration of an event which falls prey to the camera. Indeed the amateur returning home with his mess of artistic photographs is more gratified than the hunter who comes

211

back from his encounters with masses of animals which are useful only to the trader. And the day seems to stand before the door when there will be more illustrated periodicals for photographers than game and poultry shops. So much for snapshots.

But the accents change completely if we turn from looking at photography as an art to art as photography. Anyone will be able to observe how much more easily a painting and above all, a sculpture, or architecture, can be grasped in photographs than in reality. The temptation is to attribute this to the decay of contemporary artistic perception. But preventing it is the recognition that at about the same time as the formation of the technology for reproduction the conception of great works was changing. One can no longer view them as the productions of individuals; they have become collective images, so powerful that capacity to assimilate them is related to the condition of reducing them in size. In the final effect, the mechanical methods of reproduction are a technology of miniaturization and help man to a degree of mastery over the works without which they no longer are useful.

If any one of the current relations between art and photography is clear, it is the unsettled tension which comes between the two through the photography of works of art. Many of those photographers who determine the current aspects of this technique came from painting. They turned their backs on that medium of expression after efforts to put in a clear, living connection with contemporary life. The more aware their sense of the nature of the times, the more problematic has grown their point of departure. For again, as 80 years ago, photography picked up the torch from painting. "The creative possibilities of the new," Moholy Nagy said, "are mostly discovered slowly, through old forms, old instruments, old structures which are fundamentally injured by the appearance of new things but which, under the pressure of the new, emerging things, are driven up into a last, euphoric flourishing.

"So, for example, futurist painting delineated the self-destructive, tightly constricted problematic of simultaneity of motion, the figuration of the moment in time; and this at a moment when film was known but for a long time would still not be understood. Just so, one can — with caution — view a few of the painters working today in representative, objective modes

212

(Neoclassicists and veristes) as forerunners of a new, representative, optical figuration which uses only mechanical, technical means." And Tristan Tzara, 1922: "When everything that called itself art grew palsied, the photographer ignited his thousand-candle-power lamp and step by step the light sensitive paper absorbed the blackness of a few useful objects. He discovered the carrying power of a tender delicate untouched flash, which was more important than all the constellations given us to soothe our sight." The photographers who came to photography out of the comfort of the plastic arts, not out of opportunistic daring, not accidentally, today form the avant-garde among their colleagues, because they are to some degree assured by their course of development against the greatest danger of current photography, the tendency toward the applied arts. "Photography as art," says Sasha Stone, "is very dangerous territory."

When photography has extracted itself from the connections that a Sander, a Germaine Krull, a Blossfeldt gave it, when it has emancipated itself from physiognomic, political, scientific interests — that is when it becomes "creative."

Concern for the objective becomes merely *juxtaposition;* the photographic artist's smock makes its entrance. "Spirit, conquering mechanics, gives a new interpretation to the likenesses of life." The more the crisis of current social order expands, the more firmly moments enter into oppositions against each other, the more the creative principle — by nature a deep yearning for variants, contradiction its father, imitation its mother — is made a fetish, whose features owe their life only to fashionable changes of lighting. The "creative" principle in photography is its surrender to fashion. Its motto: the world is beautiful. In it is unmasked photography, which raises every tin can into the realm of the All but cannot grasp any of the human connections that it enters into, and which, even in its most dreamy subject, is more a function of its merchandisability than of its discovery. Because, however, the true face of this photographic creativity is advertising or association; therefore its correct opposite is unmasking or construction. For the situation, Brecht says, is complicated by the fact that less than ever does a simple *reproduction of reality* express something about reality.

A photograph of the Krupp works or of the A.E.G. reveals almost nothing about these institutions. The real reality has

213

shifted over into the functional. The reification of human relations, for instance in industry, makes the latter no longer revealing. Thus in fact it is to *build something up*, something artistic, created. The accomplishment of Surrealism was to have pioneered such photographic construction. A further stage in the opposition between creative and constructive photography is shown by Russian film. It is not too much to say that the great accomplishments of its directors were only possible in a country where photography did not proceed on impulse and suggestion but on experiment and instruction. In this sense — and only in it — can we still make sense today of the greeting which the rough idealist painter Antoine Wiertz offered photography in 1855: "The fame of our age was born a few years ago: a machine which, day in and day out, has been the astonishment of our thought and the terror of our eyes. Before a century has passed, this machine will be the brush, palette, colors, grace, experience, patience, dexterity, sureness, hue, varnish, sketch, completion, extract of painting. If you do not believe that the daguerreotype kills art, well, when the daguerreotype, this giant child, has grown up, when all its art and strength have been revealed, then genius will suddenly slap a hand on the back of its neck and call out loud: Here, you belong to me now! We will work together."

How sober, even pessimistic, on the other hand, are the words in which Baudelaire, in the *Salon of 1857*, two years later, acquainted his readers with the new techniques. No more than the preceding words can they be read without a gentle shift of accent. But while they imply the opposite of Wiertz's words, they have kept their good sense as the sharpest rebuke to all the usurpations of artistic photography: "In these lamentable days a new industry has emerged, which has helped not a little in strengthening plain stupidity in its belief . . . that art is nothing other than — and *can* be nothing other than — the exact reproduction of nature. . . . A vengeful God has heeded the voices of the crowd. Daguerre is becoming its messiah." And: "If photography is allowed to help complete art in a few of its functions, then art will be as quickly ruined and cast out by it, thanks to the natural alliance which will grow up between photography and the crowd. It must therefore return to its own duty, which consists in being a servant girl to the sciences and the arts."

214

One thing, however, was not grasped either by Wiertz or by Baudelaire, and that is the direction implicit in the authenticity of the photograph. It will not always be possible to link this authenticity with reportage, whose clichés associate themselves only verbally in the viewer. The camera will become smaller and smaller, more and more prepared to grasp fleeting, secret images whose shock will bring the mechanism of association in the viewer to a complete halt. At this point captions must begin to function, captions which understand the photography which turns all the relations of life into literature, and without which all photographic construction must remain bound in coincidences.

Not for nothing were pictures of Atget compared with those of the scene of a crime. But is not every spot of our cities the scene of a crime? every passerby a perpetrator? Does not the photographer — descendant of augurers and haruspices — uncover guilt in his pictures? It has been said that "not he who is ignorant of writing but ignorant of photography will be the illiterate of the future." But isn't a photographer who can't read his own pictures worth less than an illiterate? Will not captions become the essential component of pictures? Those are the questions in which the gap of 90 years that separates today from the age of the daguerreotypes discharges its historical tension. It is in the light of these sparks that the first photographs emerge so beautifully, so unapproachably from the darkness of our grandfathers' days.

Benjamin's own notes are indicated with numbers, translator's notes with letters.

1. Helmuth Th. Bossert and Heinrich Guttmann, *Aus der Fruhzeit der Photographie, 1840-1870*. A Volume of Pictures From 200 Originals. Frankfurt, 1930. Heinrich Schwarz, *David Octavius Hill, der Meister der Photographie*. With 80 plates. Leipzig, 1931.

2. Karl Blossfeldt, *Urformen der Kunst*. Photographs of Plants. Published with an introduction by Karl Nierendorf. 120 plates. Berlin, 1930.

3. Atget, *Photographs*. Published by Camille Recht. Paris and Leipzig, 1931.

4. August Sander, *Das Antlitz der Zeit*. Berlin, 1930.

a. "Its first decade" is an exaggeration. Of the photographers Benjamin refers to Hill was the earliest (1839-49); Cameron and Nadar were not even active until the late fifties and sixties.

b. "And I ask: how did that former being surround this delicate hair, this glance; how did it kiss this mouth, around which desire curls insensibly, like smoke without a flame."

c. Busoni (1866-1924) was known for bringing an almost mystic form of romanticism to piano playing and composition. He experimented with exotic scales, worked out a new system of notation expressly for piano, and as a performer was praised for his sense of color and tone. He was also a teacher of Kurt Weill, who of course collaborated with Benjamin's friend Bertolt Brecht.

d. Since Benjamin's death, Sander's photographs have been published in Europe and in the United States in the volume *Men Without Masks*, Greenwich, Connecticut: New York Graphic Society, 1973.

New Reports and New Vision: The Nineteenth Century

William M. Ivins, Jr.

At the end of the nineteenth century photography had been known in one or another of its forms for sixty years, and some of the photomechanical processes for at least half that time. The traditional graphic processes had been defeated on most of what had been peculiarly and essentially their own ground — the making of exactly repeatable pictorial statements about the shapes and surfaces of things. The change had come about so slowly and gradually that, after the first explosion of interest and excitement which accompanied the announcements of Talbot and Daguerre in 1839, very few people were aware of what was taking place under, and especially *in,* their eyes. For a long time photographers were laughed at good-naturedly and were one of the stock subjects for jokes and caricatures. Slowly, as the community itself began to take photographs with hand cameras, there was no joke left because the photographer was everybody. As so many times before, men were doing something long before they knew what they were actually doing.

The photograph and its attendant processes took over at one and the same time two very different utilitarian functions of the graphic processes that previously had never been clearly differentiated. One of these was the reporting of portraits, views, and of what may be called news. The other was the recording of documents, curios, and works of art of all kinds. Where the requirements of the first of these functions could be and still were on occasion fulfilled by the old techniques, the other had been taken over irretrievably by photography, for the photograph made it possible for the first time in history to get such a visual record of an object or a work of art that it could be used as a means to study many of the qualities of the particular object or work of art itself. Until photography came into common use there had been no way of making pictures of objects that could serve as a basis for connoisseurship of the modern type, that is for the study of objects as particulars and not as undifferentiated members of classes. The photograph in its way did as much for

the study of art as the microscope had done for the study of biology.

Up to that time very few people had been aware of the difference between pictorial expression and pictorial communication of statements of fact. The profound difference between creating something and making a statement about the quality and character of something had not been perceived. The men who did these things had gone to the same art schools and learned the same techniques and disciplines. They were all classified as artists and the public accepted them all as such, even if it did distinguish between those it regarded as good and as poor artists. The difference between the two groups of artists was generally considered to be merely a matter of their comparative skill. They all drew and they all made pictures. But photography and its processes quietly stepped in and by taking over one of the two fields for its own made the distinction that the world had failed to see.

The blow fell first on the heads of the artists — painters, draughtsmen, and engravers — who had made factual detailed informational pictures. The photograph filled the functions of such pictures and filled them so much better and with so much greater accuracy and fullness of detail that there was no comparison. For many purposes the drawing, as for instance in such a science as anatomy, preserved its utility because it could schematically abstract selected elements from a complex of forms and show them by themselves, which the photograph could not do because it unavoidably took in all of the complex. The drawing, therefore, maintained its place as a means of making abstractions while it lost its place as a means of representing concretions. The ground was cut from under the feet not only of the humble workaday factual illustrators of books and periodicals but of artists like Meissonier and Menzel, who had built up pre-photographic reputations by their amazing skill in the minute delineation of such things as buttons, gaiters, and military harness for man and beast. An etcher like Jacquemart had gained a world-wide reputation for his ability to render the textures and sheens of precious objects, such as porcelains, glass, and metal work — but when it was discovered that the photographic processes did all that infinitely more accurately than Jacquemart could, it was also realized that Jacquemart had been merely a reporter of works of art and not a maker of them, no matter how

218

extraordinary his technical skill. The devastation caused by the photograph rapidly spread through all the gamut of the merely sentimental or informational picture, from the gaudy view of the Bay of Naples or the detailed study of peasants and cows to the most lowly advertisement for a garment or a kitchen gadget. What was more, by 1914, the periodicals had begun to be so full of the photographic pictures that the public was never able to get them out of its eyes.

The photograph was actually making the distinction that Michael Angelo had tried to point out to the Marchioness and her companions in the conversation that was related by Francesco da Hollanda — 'The painting of Flanders, Madame . . . will generally satisfy any devout person more than the painting of Italy, which will never cause him to drop a single tear, but that of Flanders will cause him to shed many; this is not owing to the vigour and goodness of that painting, but to the goodness of such devout person. . . They paint in Flanders only to deceive the external eye, things that gladden you and of which you cannot speak ill, and saints and prophets. Their painting is of stuffs, bricks, and mortar, the grass of the fields, the shadows of trees, and bridges and rivers, which they call landscapes, and little figures here and there; and all this, although it may appear good to some eyes, is in truth done without symmetry or proportion, without care in selecting or rejecting, and finally without any substance or verve.'[1] Michael Angelo was attempting to point out that the pictorial report of things which people enjoy in stories and in actual life is not the same thing as design.

Inescapably built into every photograph were a great amount of detail and, especially, the geometrical perspective of central projection and section. The accuracy of both depended merely on the goodness of the lens. At first the public had talked a great deal about what it called photographic distortion — which only meant that the camera had not been taught, as human beings had been, to disregard perspective in most of its seeing. But the world, as it became acclimated, or, to use the psychologist's word, conditioned, to photographic images, gradually ceased to talk about photographic distortion, and today the phrase is rarely heard. So far has this gone that today people actually hunt for that distortion, and, except in pictures of themselves, enjoy it when found. A short fifty years ago most of the 'shots' of

Michael Angelo's sculpture that were shown in the movie called *The Titan,* would have been decried for their distortion, but today they are praised. Thus by conditioning its audience, the photograph became the norm for the appearance of everything. It was not long before men began to think photographically, and thus to see for themselves things that previously it had taken the photograph to reveal to their astonished and protesting eyes. Just as nature had once imitated art, so now it began to imitate the picture made by the camera. Willy nilly many of the painters began to follow suit.

So long as the old graphic processes provided the only means of making exactly repeatable visual reports, men were always tempted to hypostasize something behind those reports that they could neither see, nor describe, nor report, but which was more real than the things actually contained in their reports. It was this unreachable, unknowable, *vraie vérité,* that all too often they tried to talk and argue about when they talked and thought about works of art with which they had not immediate first-hand acquaintance. When people begin to talk about nobility, grandeur, sublimity, ideality, and all that group of purely emotive verbal obfuscations, as qualities of art, the appreciation of art has become a sort of verbalist intoxication unrelated to particulars — a situation that is observable in the talk and writing of many persons who read books about art, or follow verbalist doctrines or party lines about it, instead of surrendering themselves to sharp-sighted first-hand acquaintance with it. It is interesting to notice how dry and tongue-tied so many of the people are who have had long and intimate first-hand acquaintance with works of art as compared with the volubility in abstractions of the persons who know about art through words and verbalist notions. Seen in its concretion, the greater a work of art is, the more it is a bundle, not of similarities to other things, but of differences from them. All that words can deal with, however, are similarities. The simple reason for all this is that words, with the exception of the proper names, relation words, and syntactical devices, are mere conventional symbols for similarities. Although differences are just as perceptible as similarities, the inability of words to cope with them has given rise to the notion held by many self-consciously hard-headed persons that talk about art is merely an attempt to deal with the ineffable, a thing

that for them is completely laughable. But that these differences are not statable in words does not mean that they are ineffable, for they are clearly communicable in non-verbal ways. While the photograph is far from being a perfect report, it can and does in practice tell a great many more things than any of the old graphic processes was able to, and, most importantly, when two photographs of two different things that are very much alike are laid side by side, they enable us to gain awarenesses of differences that defy description either in words or in any of the old graphic processes that preceded photography.

In order to grasp the broad meaning of the photograph as record or report of work of art or curio it is necessary to look back over the nineteenth century, and to take account of some things that happened in it, apparently completely outside the territory that photography was taking over. I refer to the astonishing gathering together in the great capitals of Europe of the arts and crafts of the distant past and the far away, which was one of the distinguishing events of the century. It was greatly hastened, if not begun, by Napoleon, when, as part of his political propaganda, he systematically looted the countries his armies invaded, and brought back to Paris the results of his efforts. He did this not so much because of the artistic importance of his loot, as because it enabled him to demonstrate to both France and the world that he had been able to assemble in Paris the objects held most holy by the peoples of Europe. There was no comparable way of symbolizing the prowess of the Empire and the French. It was the nearest thing in modern times to the triumphs of the Roman generals and proconsuls, in which the kings, the high priests, and the most sacred objects of the conquered had been paraded before the Roman populace.

In the eighteenth century hardly anyone took seriously the art of the Middle Ages, let alone of the Dark Ages, except a few students who were interested in hagiography, iconology, and the lore of the local churches. A few dilettantes, such as Horace Walpole, were fashionably and perversely amused by the view from the Castle of Otranto, but for most of them, I think it can be said, the Gothic merely provided a relatively cheap way of being smart and different from other people. The rich who had received classical educations went in sentimentally for classical sculptures, which in practice meant Roman copies, either of the

late Republic or Empire, or even of the eighteenth century itself, in which the Roman craftsmen so surprisingly and obligingly were able to supply the northern nabobs with the very 'antiques' they were in search of. No one knew the difference between a Greek original and the ancient and modern imitation, as was demonstrated in such different ways by both Winckelmann, the founder of classical archaeology, who accepted fakes, old and new, and John Thomas Smith, who, in writing the life of Nollekens, told how that sculptor in his youth had paid his way by making modern ones. If we look at the pictorial reproductions of classical art that were available to collectors in the eighteenth century and much of the nineteenth century, we can discover not only many of the reasons for their blindness but the reasons they took their interest in the objects they actually collected.

The art of ancient Egypt was practically unknown until Napoleon made his armed descent into that country. He took with him a group of scientists, archaeologists, and artists, among whom was that very curious and interesting person, Vivant Denon — perhaps the first man to have a really catholic taste in art in our modern sense of the word. The difference between the seeing Denons and the posturing Walpoles of this world is rarely discussed, but it is very important. A great cargo of ancient Egyptian artistic and archaeological loot that Napoleon shipped for Paris had the misfortune to meet a British warship, with the result that, instead of going to Marseille or Toulon and thence to the Louvre, it went up the Thames and came to rest in the British Museum. Within a few years afterwards that institution also acquired, though in less exciting manner, the Elgin marbles and the friezes from Phigaleia, that were so remarkably unlike the classical sculpture which had been fashionable during the eighteenth century that some of the best judges of the day declared the Elgin marbles to be late work of the time of Trajan. If we are honest with ourselves, the Venus of Melos is a masterpiece not so much of ancient Greek sculpture as of the taste of the eighteen-thirties.

The French Revolution and the wars that accompanied and followed it caused many of the great church and monastic treasures to be thrown upon the market, with the result that for the first time in many generations there was available to the collector and the curious a flood of mediaeval works of art of all kinds, and of manuscripts and early printed books. The opening up to

222

the curiosity hunter and the archaeologist of Greece, Egypt, and the Levant, was followed in turn by that of the Near East, and that in turn by that of the Far East and of southern Asia. Last of all to be recognized as works of art were the objects from America, Polynesia, and Africa, which had begun to accumulate in Europe as the result of exploration and armed adventure. The primary interest of those who brought most of these things back to London and Paris was not their artistic value but their curiosity.

In any case, nothing like this amassing of exotic objects had ever been known. One of the principal reasons it was so effective was that it was done by men who were so ignorant of art and taste that they gathered together everything of every kind without consideration of what the professors of art and the dilettantes might think of them. If the collections had been made in the field by the artistically educated of the day, very little that ultimately has been of great artistic interest would have been brought back. One can but imagine what such a pontiff as Ruskin would have acquired on the Guinea Coast or the islands of the Pacific.

So long as there were available only the traditional graphic processes of pictorial reproduction and publication the publication of all these strange things was not only very small in volume but very expensive and slow, and, worse than either, amazingly untruthful and distorted. As was inevitable, the print-makers rationalized their representations, and their rationality was that of their period. Also they liked to show what they imagined the objects looked like before they had been damaged or broken, and so they filled in the missing parts in their pictures out of the treasury of their ignorance, just as Thorwaldsen 'restored' the marbles from Aegina so thoroughly that he turned them into monuments not of Greek art but of early nineteenth-century taste. This desire to show ancient objects not as they have actually come down to us but as they ought to be, can be easily observed by attentive visitors to almost any of our art museums. It flourishes most in those very collections or departments which take such great pride in their scholarship and the scientific quality of their knowledge that they look down on mere aestheticism. There is curiously little difference between much of the restoration done in museums and the faking done by the unregenerate.

The gradual introduction of photographic process in the last

thirty years of the nineteenth century affected a most radical change in the methods of reproduction and publication of works of art. Not only did the reproductions become cheap, but they were dependable. Perhaps as easy a way as any to perceive this is to compare the illustrations of ancient and exotic art in the art books of the 1820's and 1830's with those in the art books of the 1870's and 1880's, and both with those in any cheapest little contemporary pamphlet or magazine. Until long after the middle of the century art books were much more a means by which the very rich could show their snobbishness than a means to convey truthful knowledge to the public. Actually the cheap modern photographic picture postcard contains so much more valid and accurate information than any of the expensive engravings and lithographs of the period of snobbery that there is no comparison between them. In this way photography introduced to the world a vast body of design and forms that previously had been unknown to it.

Objects can be seen as works of art only in so far as they have visible surfaces. The surfaces contain the brush marks, the chisel strokes, and the worked textures, the sum totals of which are actually the works of art. But the hand made prints after objects were never able to report about their surfaces. If the surface of a painting represented hair and skin, the print after the painting also represented hair and skin, but in its own forms and techniques which bore no resemblance to those embedded in the surface of the painting. In other words, the engraved representation of a painting was confined to generalized, abstract, reports about iconography and composition.

The magic of the work of art resides in the way its surface has been handled, just as the magic of a poem lies in the choice and arrangement of its words. The most exciting and the most boresome paintings can have the same objective subject matter. These differences are subjective, and these subjective differences can only be seen in the choice and manipulation of the paint, that is in their actual surfaces. If Manet and Bouguereau had painted the same model in the same light, with the same accessories, and the same iconographical composition, any engravings made from them by the same engraver would have been remarkably alike. In a way the engravings were attempts, as the philosophers might say, to represent objects by stripping them of

224

their actual qualities and substituting others for them — an undertaking which is logically impossible. The photograph, to the contrary, despite all its deficiencies, was able to give detailed reports about the surfaces, with all their bosses, hollows, ridges, trenches, and rugosities, so that they could be seen as traces of the creative dance of the artist's hand, and thus as testimony of both the ability and the deliberate creative will that went to their making.

The result of this is never referred to, but it was very important in the formation of opinion and values. Thus, to take a particular case: the engravings, saying nothing about surfaces, could easily be read, and actually were read, by a world soaked in the pseudo-classical Renaissance tradition of forms, as reporting that the sculpture of the early and middle Christian periods were merely a set of debased forms representing the inability of a degraded society and its incompetent artisans to hold to classical ideals and precedents.

With the advent of photography, however, it became impossible to maintain the opinions based on the engravings, for photography gave detailed reports about the surfaces of the Christian sculpture, with all their sharp incident, and revealed the skilful, wilful, way in which they had been worked. It thus became obvious that those works of art represented not any degeneracy of workmanship but the emergence and volitional expression of new and very different intellectual and emotional values, and, therefore, had the right to be judged on their own merits and not from the point of view of the very ideals and assumptions which they challenged and against which they were engaged in an unrelenting warfare. From Winckelmann to the present day, the lack of expression and personality of the figures of classical art has been commented upon. It is the basis on which the archaeologists have built their claims for what they describe as the ideality of classical art. Christian art, however, in conformity with the faith it represents, developed the expression and personality of its figures and made deliberate sacrifices to that end. The photographic reports of surfaces made visible the volition with which this was accomplished.

Within the closed world of classical art itself the introduction of photography in place of the old engraved reports has had remarkable results. The inability of the engraving to report about

surfaces and its restriction to iconography and composition made possible, in the early years of the last century, a sort of aesthetic transubstantiation. The discovery and bringing to western Europe of examples of Greek sculpture revealed that the actual qualities of fine Greek work were very different from those of the Roman copies with which Europe had been familiar up to that time, but the standard vocabularies, like the engravings which then provided the only available means of reproduction, were incapable of stating the differences. The result was that the world fitted the newly discovered qualities into the critical literary tradition and vocabulary of both words and pictures that had been built up about the so very different qualities of the Roman copies. No better example of the tyranny of the old methods of reproduction and their linear nets and syntaxes on the art of seeing can be desired than the dominance through the nineteenth century and into the present one of ideas and critical jargon that had their origin in the deficiencies alike of the Roman copies and the engravings after them. It is only within very recent years that the world has been able to see that the primitive Greek marbles and small bronzes were really very wonderful works of art. The current substitution of photographs of Greek pots for the familiar engraved and lithographic reproductions of dull routine modern drawings after them all brought about a notable change in the appreciation and understanding of their qualities.

Thus, luckily for the exotic and most of the early Christian and mediaeval objects, they were thought so lacking in beauty in the days of the engraved visual statement, that comparatively few of them were reproduced until after photography had taken over the task of reproducing works of art. Thanks to this they escaped the perversion both of form and of critical ideas that inevitably accompanied the older methods of reproduction.

A rarely mentioned result of this shift away from engraved reproductions is that the only prephotographic *catalogues raisonnés* of works of art that are still of use and constantly referred to are those of prints themselves. The photograph has antiquated all the rest. Its pervasion opened up the other subjects to visual scholarship as distinct from the scholarship of the texts and archives, and there began that flood of photographically illustrated catalogues and special studies that has

enabled the vast masses of material to be reduced to order. It is astonishing to notice how few of the books, for example, about old Italian painting that were written before the eighteen-eighties are still referred to for qualitative judgments as distinct from purely archival matters. The rewriting of the inventory of old Italian paintings, that was made possible by photography, was so exciting that for several generations connoisseurs and students devoted their major efforts to problems of attribution, and even devised aesthetic theories which reduced subject matter and its imaginative treatment to a very subordinate and unimportant position. However, today, now that so much has been done on the new inventory, the special students of the younger generation are finding a new interest in iconography — the discovery of what it was that the old pictures illustrated.

Thus, while on the one hand the photograph enslaved a preponderant portion of the population to the photographic versions of natural forms, the photographic reproductions of curios and works of art emancipated an important group of people from the traditional and academic points of view. In many places, but especially in Paris, with its artistic confidence in itself and its faith that all had not yet been said and discovered in art, very intelligent men came to give serious thought to the aesthetic and other problems raised by these strange forms from the past and the far away. What took place in this group may perhaps be indicated to some extent by the mid-century story about Baudelaire and the naval officer. The officer had been away from Paris for a number of years on one of the exploring expeditions to the South Seas, and had brought back with him a great many strange objects. Baudelaire went to see him. Baudelaire was holding and looking very hard at a little carving when the officer, desiring him to look at something else which he regarded as of greater interest, referred to the object in Baudelaire's hand as 'merely a negro totem'. Instead of putting it down and looking at the other object, Baudelaire held up his hand and said, 'Take care, my friend, it is, perhaps, the true God.'

The formal academic art teaching and doctrine of the nineteenth century had been based on ideas that can be traced back to the Renaissance in Italy, and were full of assumptions that were believed in as indubitable truths. Some of these indubitable truths received very hard blows during the second half

227

of the century, as for example, when the palettes were lightened, when pleineaireism made its first tentative appearance, when colours were broken down into their constituent shades, and when account began to be taken of such things as that shadows were very rarely or never brown. Many of these new ideas were based on notions derived from popular books on the physics of light and were defended as being highly scientific. Between the sharp-eyed notation of detail that was the mark of the English pre-Raphaelite painters and the new French interest in atmoshere and the envelope, as typified, for example, in the work of Claude Monet, there was little basic difference, great as was the superficial one. Each group believed in accurately reporting what it thought was the appearance of the thing seen. They merely happened to look for and to see quite different things and appearances. Where the pre-Raphaelites were greatly interested in the emotional implications of their subject matters, the French, realistically, contented themselves with ocular curiosity. But in each instance the emphasis was on verisimilitude and reporting.

One of the most important persons in the mediaeval royal courts was the king's jester, a functionary whose purpose was to keep the court amused, and who was privileged to utter home truths that would not have been permitted from the mouth of anyone else. I have little doubt that among the greatest influences in artistic Paris during much of the second half of the nineteenth century were the lithographed caricatures by Daumier. Daumier, in addition to being one of the caricaturists whose work reached the entire Parisian community two or three times a week, happened to be one of the boldest innovators of his generation and one of the great seminal forces in modern pictorial design. As caricaturist and funny man he was exempted from the trammels of pictorial convention which weighed so heavily on the solemn and the academic painters. He did with impunity things that had they been done in oil paint would have been shocking and inexcusable. The world laughed with him, the academic artists shuddered at the thought of him, and the intelligent saved and preserved his prints. When we think of the fate of most old newspapers, one of the wonders of the world is that such a vast supply of Daumier's caricatures was preserved. The print collectors did not care for the work of his maturity, because

it did not conform to the wholly artificial notions they had conceived about what constituted good lithography, but many of the painters took his work seriously and studied it hard. Anyone who is familiar with the last fifteen years of Daumier's work can see the reflections of it all through the mature work of Degas, and consequently through the work of the younger artists whom he influenced.

Degas had an independent fortune and a witty and independent mind. His fortune did for him what Daumier's position as the accredited jester had done for him. He was enabled by it to go his own way without thought of the conventional modes of pictorial conduct on which the poorer painters depended for their sales. He was led by his study of the Italian primitives, of Daumier, and of the newly discovered Japanese prints, to think about the possibilities of what happened when compositions were built up about unfamiliar points of view, unconventional cutting of the field of vision, and the arbitrary use of colour. He and the group of younger artists who came under his influence were not only the greatest draughtsmen of their time but were also those who thought most about design. Their adoption of the unconventional point of view and unconventional cutting of the field of vision, and their willingness to invent colour schemes, enabled them to find visual interest and excitement in episodes from familiar life of a kind that had either been overlooked or had come to be regarded as exhausted. There is reason to think that Degas devoted so much of his attention to the ballet simply because its costumes, its attitudes, and the lights and the colours of the stage, bore so little resemblance to those of ordinary life that he could deal with them from the point of view of design absolved from the insistent popular demand for conventional verisimilitude. Gauguin had to go to the South Seas for similar release from the iron bound convention. Poor Van Gogh achieved it by going mad; Lautrec by becoming a social outcast.

In the Metropolitan Museum in New York there is a pair of pictures by Degas that remarkably illustrates his interest in this kind of thing. The basis of one of these pictures is a monotype in monochrome. The basis of the other is a counterproof of the same monotype. So far as their iconography is concerned they are mirror images of each other — exactly alike but in different directions. Actually they are so different that many people do

229

not recognize their close relation to each other. Their colour schemes are absolutely unlike, and their masses of colour and light and shade bear no resemblance to each other. Had Degas not been over and above mere verisimilitude he could not have done them. Marvellous as they are as separate works of art, taken together they demonstrate that Degas was primarily interested in design and not in representation. Had they become known to the world through engravings such as those that Raphael Morghen made after the great Bolognese painters the fundamental differences between them would never have been known to that part of the world which depended on engraved reproductions for its knowledge of paintings. Degas made a well-known remark that the ballet provided him with a *'prétexte pour le dessin'*. This phrase has been translated as a 'pretext for (representational) drawing', but the word *'dessin'* also means the very different thing we call 'design', which has strong creative, volitional, implications — and it was in this latter sense that Degas used the word. It was not his business to imitate what he saw but to dominate what he saw and to play with it as a creator of something quite his own.

In the 1890s and the early years of this century Toulouse-Lautrec made advertising posters with which the walls of Paris were covered. A Parisian might never have been to an art exhibition, and never have looked attentively at any painting, but he could not evade the Lautrec posters, for they were everywhere before his eyes. In them great liberties were taken with traditional forms and colours. Many of them were two-dimensional in design. And they had the great quality of 'carrying' — their arbitrary and wilful patterns could be seen from afar. The solemn and the traditionally minded did not take them seriously, but many picture-makers did. And they had their undoubted effects on the public's eyes. Just as Daumier, the jester, and Degas, the rich man, had been enabled to do many things that were not permitted to the painter who lived on the sale of his canvasses, so Lautrec, the witty advertising man, was permitted to do so too. The shock of his posters was for many people an ocular liberation. The public learned from them that verisimilitude was far from being the be-all and end-all of picture-making. Incidentally, these posters made it obvious to even the most obtuse that the Impressionist emphasis on the envelope was after all not much more than reporting and had not essentially altered the

hardened tradition of picture-making — that actually Impressionism was only a technical variation on the standard academic themes, and that much of it was peculiarly empty.

Thus Degas and these younger men had discovered the difference between design and reporting, that a picture of gods and heroes and sentimental situations could be utterly trivial, and that a joke or a laundress, a bony ballet girl or café singer, or the good bourgeois and his wife, could provide the titular subject matter of as serious design as was ever contrived.

The ruling academic notions were based on silly theories about the dignity of subject matter and impossible ones about the truth of colours and shapes. Religious subject matter had begun to fall out of fashion before the end of the seventeenth century. It is doubtful whether any of the outstanding painters in France during the eighteenth and nineteenth centuries ever seriously put his mind on the traditional Bible stories from which the mediaeval and the Renaissance painters had drawn so much. Fine subject matter, other than portraits and landscape, had to be something far removed from the actualities of life, and preferably was to be taken from ancient myth or the lives of the heroes — the only subjects in which prudery permitted preoccupation with the nude female figure. As the ancient myths and the lives of the heroes were not generally known and certainly not emotionally cogitated over by the public, the dramatic element of picture-making gradually faded away. All that was left for the picture-maker-dramatist was a series of subjects that while apt to sloppy sentimentality were actually vapid and empty, because the pictures represented no one in particular. It is very difficult to arouse emotions about the human troubles and emotions of no one in particular. It may be that the frequent success of the mediaeval and later religious paintings was based on the fact that they represented very particular people about whom everybody knew and in whom everybody was very much interested — possibly the same reason that the ancient Greek drama in its time and way was so successful. In the failure to think about design all that was left was reporting of a kind that set great store by verisimilitude of a very limited and conventional sort. In the endeavour to accomplish verisimilitude it was overlooked that it can be acquired only at the cost of personality, with its emphases and omissions.

As to the truth of shapes and colours — the academic doctrine

was based on a very complete contradiction in terms. What was thought of as visual truth was actually only a conventional verisimilitude, which was a very different thing. To leave colour out of the discussion for the time being, there is no such thing as a true still representation of a form in movement. Actually there is a constant conflict between the tactile-muscular sense returns and the visual returns, no matter how accustomed we may be to their association in what we think of as a single space. What we call the shape of a figure is no more than where its parts are in relation to one another at a moment. Its movement is how its parts are changing their relation to one another at a moment. The 'where' and the 'change' are incompatible notions, as has been known ever since the days of Zeno and his paradoxes. So far as the human eye is concerned it is impossible to see a shape clearly both in motion and at a moment. The camera has taught us that when we actually 'stop' the motion of an object completely enough to see its tactile-muscular shape with sharp accuracy, that is to say to stop it for something like the one five hundredth or the one one thousandth of a second which physiologically approaches a moment, the movement departs from both the perception and the record, and all we have is a stiff frozen shape that conveys no sense of motion at all.

The only way that a sense of motion can be given to a body in a still picture is by distortion of its tactile-muscular shape at a moment. We can see this in the very simplest of shapes, let alone in such complicated ones as those of the human body. It comes out in the difference between a fast and a slow photograph of the drops of water thrown by a lawn-sprayer. In the fast photograph the drops are clearly and sharply defined and betray no sense of movement at all. In the slow photograph the drops of water are blurred and elongated in the direction of their movement. It is this distortion in the picture that makes us feel that the spray is moving. The more we elongate our representations of rain drops the faster seems their movement. If we want to represent a terrific driving downpour we actually cover our picture with parallel lines running diagonally across it.

Much the same thing is true of colour. The only way we can get the colour of a spot is by matching it, which in practice means isolating it, but when we do that we change the apparent

colour, for our perception of the apparent colour is affected not only by the colours of the adjacent areas but by their sizes and illumination. It is this, for example, that makes it impossible to get a true colour reproduction of even an abstract diagram in colour, let alone of a picture, unless we make our reproduction of the same size as that of the original and give it the same texture. There is literally no way to make a true colour reproduction on a changed scale. The implications of this should be obvious.

Another thing that the academics set up to do was to create beauty with a capital B. According to them beauty was something that the artist created. Beauty was the distinguishing mark of the work of the artist. But of course, it was only created by the real artist, who, also of course, belonged to the right trade union and abided by its rules and by-laws. From a logical point of view, I suppose, there has never been anything funnier than the idea of 'objects', the 'essence' of which was a 'quality' like 'beauty', for the making of which there were official recipes and cook books. Intrinsic beauty is today an exploded notion, though doubtless there are still many persons who believe in it.

Anyway, at the end of the nineteenth century and the beginning of this one, there were men in Paris who did not take the academics or their precepts and assumptions with any too great seriousness, and who did not hesitate to try to think about the problems presented by the arts of long ago and far away, with which they were gradually becoming familiar. Among other things these men perceived was the folly of the traditional view that the early and the exotic artists only worked the way they did because they were ignorant and unskilled, and that when we looked at their work we forgave them their errors because of their ignorance and their innocence — but that we should not forgive the work of contemporaries for such reasons. It came to be recognized in these inquiring circles which took design seriously that the primitive arts of Europe were not so ignorant and certainly not so innocent as the official academic painters believed. These groups also discovered that the Asiatics, the Polynesians, and the Africans were far from being all innocence in the ways they designed and carved objects. What these primitive and exotic artists had been ignorant of was the specifically

233

western European post-mediaeval requirement of verisimilar reporting — an activity that had been taken over by the photograph.

Thus there gradually came into being a group of artists who were so much interested in this question of innocence and ignorance and knowingness in design and representation, that they began to make experiments for themselves to see whether they might find out why it was that objects that had no verisimilitude, that had lost all their anecdotal subject matter in their transference across the ages and the seas, and that ignored the canons of taste and beauty that had been set up in post mediaeval Europe, should nevertheless be so remarkably fascinating to the modern Europeans who looked at them. Of course these men talked and wrote as well as painted and sculpted, and of course much of what they said and wrote was arrant nonsense. For, after all, that is the way men have always gone about things of this kind. No greater nonsense has ever been perpetrated than that which great thinkers in the past have put forth in their search for workable hypotheses. But in the course of time something always comes out of these discussions and this kind of moonshine. What men do in these matters is what counts, and not what they say. And so, as we look back at what was being done about the turn of the century in Paris, we have to disregard the verbal notions and ideas and look at the things that were made. If we look at these dispassionately and without any doctrinaire *parti pris,* I believe we can see a pattern in them. This pattern is that of a long and exciting series of experiments and discoveries in syntax. It may be silly of me, but I cannot help being interested in the fact that these artistic experiments were being made just at the time that such men as Frege, and Whitehead and Russell, were making their syntactical analyses of the basic notions of logic and pure mathematics.

Just as the mathematicians and logicians in their investigations into the logic and syntax of arithmetic and geometry had to make a clean distinction between pure and applied mathematics and logic, in other words to omit all thought of the subject matters to which their mathematics and logic might be applied, so the artists had to give up thinking about anecdotal subject matter and verisimilitude in their experiments and investigations into the syntax of design. In this way they learned that many of the forms

234

which had become traditional in the studios were not real in the sense of representing anything that was found in nature or having any existence aside from their utility in the drawing school, — that actually they were merely syntactical devices, and that there were many variant varieties of them, none of them any truer than the other. In the abstract it is no truer that A times B equals B times A than that they do not equal each other. In practice it all depends on what you are trying to do, and you have the privilege of taking either assumption, as it meets your problem.

To object to these experiments on the ground that they did not conform to the accepted canons of reportorial representation was and is as foolish as it would be to object to the notations of the modern logicians because it is impossible to write a funny story or report an exciting fire in them. Just as there is a subject called the Foundations of Geometry, which bears little or no resemblance to the metrical geometry of the carpenters, so the work of these artists bore little or no resemblance to the factual reporting that most of the European world demanded of what it called art.

Naturally, as soon as these experiments were sufficiently damned and belaboured a great many artists came into the game, not so much because they had any understanding of what it meant or represented, but out of curiosity, and in some instances because they mistakenly thought that it seemed to excuse incapacities in both draughtsmanship and design. It is to be doubted whether even the academics of the purest water misunderstood the movement any more thoroughly than did a lot of the most vocal of its fellow travellers. In any case, they seem to have been utterly unable to distinguish between the real and the imitation. There was, however, one peculiar difference between the men who started the investigations and the fellow travellers; the original group very rarely did anything that was deliberately offensive, or bilious, or resentful. Also, it was obvious, no matter how queer and odd their things may have seemed, that they knew very well how to handle their materials. Some of them were actually amazingly skilful draughtsmen even from the most reactionary point of view. Thus there was always a curious but indefinable sense of professional competence about their work. If it was shocking, it was not because it was in any way indecent or

vulgar but because it challenged basic assumptions. It is funny how easily we forgive and forget nastiness and immorality, and how we harbour resentment against the men who raise questions that make us look foolish.

Today, as nearly as I can make out, the little drama has come pretty nearly to its end. People no longer get excited about it. But its results, I believe, have been a permanent gain, if in no other way than that the empty verisimilitude, the particular reportorial formlessness and lack of design which marked so much of nineteenth and early twentieth-century work of the defter and slicker kinds, has tended to find its level on the insurance calendars rather than on the walls of public buildings and museums.

I am convinced that all of this has taken place very largely because the photograph and photographic processes have brought us knowledge of art that could never have been achieved so long as western European society was dependent upon the old graphic processes and techniques for its reports about art. The syntaxes of engraving had held our society tight in the little local provinciality of their extraordinary limitations, and it was photography, the pictorial report devoid of any linear syntax of its own, that made us effectively aware of the wider horizons that differentiate the vision of today from that of sixty or seventy years ago.

1. Quoted from Charles Holroyd's *Michael Angelo Buonarroti,* London, 1903, by permission of Gerald Duckworth & Co., Ltd.

André Bazin (1918–1958) and Siegfried Kracauer (1889–1966)

Many critics of the cinema have found that to develop critical methods for film analysis they must first define the nature of the photographic image. Both the noted French film critic André Bazin and the German-born American Siegfried Kracauer have written on photography in the course of their careers.

While serving in the French army, during World War II, Bazin began to express his interest in analyzing film for its cultural, sociological, and historical significance, and when the war ended, he formally began his career as the film critic for Le Parisien Libère. *As one of the first published film critics, Bazin attempted both to reach a mass audience through his journalistic critiques and to create a scholarly field of film analysis through his more specialized writings. "The Ontology of the Photographic Image," which is reprinted here, is one of his earliest pieces.*

Siegfried Kracauer's earliest interests were in architecture and urban space. But after earning a doctorate in engineering in Berlin in 1915, he turned, in the Weimar period in the 1920s, to philosophy, sociology, and eventually cinema. He served on the editorial staff of the prestigious Frankfurter Zeitung *from 1920 to 1933, when the rise of Nazism forced his sudden departure from Germany. He arrived in the United States in 1941, received a Guggenheim Foundation award, and produced his major study of German film,* From Caligari to Hitler *(1947). His other books include studies of Nazi propaganda films, Offenbach, and* History: The Last Things before the Last *(1969).*

The Ontology of the Photographic Image

André Bazin

If the plastic arts were put under psychoanalysis, the practice of embalming the dead might turn out to be a fundamental factor in their creation. The process might reveal that at the origin of painting and sculpture there lies a mummy complex. The religion of ancient Egypt, aimed against death, saw survival as depending on the continued existence of the corporeal body. Thus, by providing a defense against the passage of time it satisfied a basic

237

psychological need in man, for death is but the victory of time. To preserve, artificially, his bodily appearance is to snatch it from the flow of time, to stow it away neatly, so to speak, in the hold of life. It was natural, therefore, to keep up appearances in the face of the reality of death by preserving flesh and bone. The first Egyptian statue, then, was a mummy, tanned and petrified in sodium. But pyramids and labyrinthine corridors offered no certain guarantee against ultimate pillage.

Other forms of insurance were therefore sought. So, near the sarcophagus, alongside the corn that was to feed the dead, the Egyptians placed terra cotta statuettes, as substitute mummies which might replace the bodies if these were destroyed. It is this religious use, then, that lays bare the primordial function of statuary, namely, the preservation of life by a representation of life. Another manifestation of the same kind of thing is the arrow-pierced clay bear to be found in prehistoric caves, a magic identity-substitute for the living animal, that will ensure a successful hunt. The evolution, side by side, of art and civilization has relieved the plastic arts of their magic role. Louis XIV did not have himself embalmed. He was content to survive in his portrait by Le Brun. Civilization cannot, however, entirely cast out the bogy of time. It can only sublimate our concern with it to the level of rational thinking. No one believes any longer in the ontological identity of model and image, but all are agreed that the image helps us to remember the subject and to preserve him from a second spiritual death. Today the making of images no longer shares an anthropocentric, utilitarian purpose. It is no longer a question of survival after death, but of a larger concept, the creation of an ideal world in the likeness of the real, with its own temporal destiny. "How vain a thing is painting" if underneath our fond admiration for its works we do not discern man's primitive need to have the last word in the argument with death by means of the form that endures. If the history of the plastic arts is less a matter of their aesthetic than of their psychology then it will be seen to be essentially the story of resemblance, or, if you will, of realism.

Seen in this sociological perspective photography and cinema would provide a natural explanation for the great spiritual and technical crisis that overtook modern painting around the middle of the last century. André Malraux has described the cinema as

238

the furthermost evolution to date of plastic realism, the beginnings of which were first manifest at the Renaissance and which found a limited expression in baroque painting.

It is true that painting, the world over, has struck a varied balance between the symbolic and realism. However, in the fifteenth century Western painting began to turn from its age-old concern with spiritual realities expressed in the form proper to it, towards an effort to combine this spiritual expression with as complete an imitation as possible of the outside world.

The decisive moment undoubtedly came with the discovery of the first scientific and already, in a sense, mechanical system of reproduction, namely, perspective: the camera obscura of Da Vinci foreshadowed the camera of Niepce. The artist was now in a position to create the illusion of three-dimensional space within which things appeared to exist as our eyes in reality see them.

Thenceforth painting was torn between two ambitions: one, primarily aesthetic, namely the expression of spiritual reality wherein the symbol transcended its model; the other, purely psychological, namely the duplication of the world outside. The satisfaction of this appetite for illusion merely served to increase it till, bit by bit, it consumed the plastic arts. However, since perspective had only solved the problem of form and not of movement, realism was forced to continue the search for some way of giving dramatic expression to the moment, a kind of psychic fourth dimension that could suggest life in the tortured immobility of baroque art.[1]

The great artists, of course, have always been able to combine the two tendencies. They have allotted to each its proper place in the hierarchy of things, holding reality at their command and molding it at will into the fabric of their art. Nevertheless, the fact remains that we are faced with two essentially different phenomena and these any objective critic must view separately if he is to understand the evolution of the pictorial. The need for illusion has not ceased to trouble the heart of painting since the sixteenth century. It is a purely mental need, of itself nonaesthetic, the origins of which must be sought in the proclivity of the mind towards magic. However, it is a need the pull of which has been strong enough to have seriously upset the equilibrium of the plastic arts.

The quarrel over realism in art stems from a misunderstand-

ing, from a confusion between the aesthetic and the psychological; between true realism, the need that is to give significant expression to the world both concretely and its essence, and the pseudorealism of a deception aimed at fooling the eye (or for that matter the mind); a pseudorealism content in other words with illusory appearances.[2] That is why medieval art never passed through this crisis; simultaneously vividly realistic and highly spiritual, it knew nothing of the drama that came to light as a consequence of technical developments. Perspective was the original sin of Western painting.

It was redeemed from sin by Niepce and Lumière. In achieving the aims of baroque art, photography has freed the plastic arts from their obsession with likeness. Painting was forced, as it turned out, to offer us illusion and this illusion was reckoned sufficient unto art. Photography and the cinema on the other hand are discoveries that satisfy, once and for all and in its very essence, our obsession with realism.

No matter how skillful the painter, his work was always in fee to an inescapable subjectivity. The fact that a human hand intervened cast a shadow of doubt over the image. Again, the essential factor in the transition from the baroque to photography is not the perfecting of a physical process (photography will long remain the inferior of painting in the reproduction of color); rather does it lie in a psychological fact, to wit, in completely satisfying our appetite for illusion by a mechanical reproduction in the making of which man plays no part. The solution is not to be found in the result achieved but in the way of achieving it.[3]

This is why the conflict between style and likeness is a relatively modern phenomenon of which there is no trace before the invention of the sensitized plate. Clearly the fascinating objectivity of Chardin is in no sense that of the photographer. The nineteenth century saw the real beginnings of the crisis of realism of which Picasso is now the mythical central figure and which put to the test at one and the same time the conditions determining the formal existence of the plastic arts and their sociological roots. Freed from the "resemblance complex," the modern painter abandons it to the masses who, henceforth, identify resemblance on the one hand with photography and on the other with the kind of painting which is related to photography.

Originality in photography as distinct from originality in paint-

ing lies in the essentially objective character of photography. [Bazin here makes a point of the fact that the lens, the basis of photography, is in French called the "objectif," a nuance that is lost in English. — TR.] For the first time, between the originating object and its reproduction there intervenes only the instrumentality of a nonliving agent. For the first time an image of the world is formed automatically, without the creative intervention of man. The personality of the photographer enters into the proceedings only in his selection of the object to be photographed and by way of the purpose he has in mind. Although the final result may reflect something of his personality, this does not play the same role as is played by that of the painter. All the arts are based on the presence of man, only photography derives an advantage from his absence. Photography affects us like a phenomenon in nature, like a flower or a snowflake whose vegetable or earthly origins are an inseparable part of their beauty.

This production by automatic means has radically affected our psychology of the image. The objective nature of photography confers on it a quality of credibility absent from all other picture-making. In spite of any objections our critical spirit may offer, we are forced to accept as real the existence of the object reproduced, actually, *re*-presented, set before us, that is to say, in time and space. Photography enjoys a certain advantage in virtue of this transference of reality from the thing to its reproduction.[4]

A very faithful drawing may actually tell us more about the model but despite the promptings of our critical intelligence it will never have the irrational power of the photograph to bear away our faith.

Besides, painting is, after all, an inferior way of making likenesses, an *ersatz* of the processes of reproduction. Only a photographic lens can give us the kind of image of the object that is capable of satisfying the deep need man has to substitute for it something more than a mere approximation, a kind of decal or transfer. The photographic image is the object itself, the object freed from the conditions of time and space that govern it. No matter how fuzzy, distorted, or discolored, no matter how lacking in documentary value the image may be, it shares, by virtue of the very process of its becoming, the being of the model of which it is the reproduction; it *is* the model.

Hence the charm of family albums. Those grey or sepia shadows, phantomlike and almost undecipherable, are no longer traditional family portraits but rather the disturbing presence of lives halted at a set moment in their duration, freed from their destiny; not, however, by the prestige of art but by the power of an impassive mechanical process: for photography does not create eternity, as art does, it embalms time, rescuing it simply from its proper corruption.

Viewed in this perspective, the cinema is objectivity in time. The film is no longer content to preserve the object, enshrouded as it were in an instant, as the bodies of insects are preserved intact, out of the distant past, in amber. The film delivers baroque art from its convulsive catalepsy. Now, for the first time, the image of things is likewise the image of their duration, change mummified as it were. Those categories of *resemblance* which determine the species *photographic* image likewise, then, determine the character of its aesthetic as distinct from that of painting.[5]

The aesthetic qualities of photography are to be sought in its power to lay bare the realities. It is not for me to separate off, in the complex fabric of the objective world, here a reflection on a damp sidewalk, there the gesture of a child. Only the impassive lens, stripping its object of all those ways of seeing it, those piled-up preconceptions, that spiritual dust and grime with which my eyes have covered it, is able to present it in all its virginal purity to my attention and consequently to my love. By the power of photography, the natural image of a world that we neither know nor can know, nature at last does more than imitate art: she imitates the artist.

Photography can even surpass art in creative power. The aesthetic world of the painter is of a different kind from that of the world about him. Its boundaries enclose a substantially and essentially different microcosm. The photograph as such and the object in itself share a common being, after the fashion of a fingerprint. Wherefore, photography actually contributes something to the order of natural creation instead of providing a substitute for it. The surrealists had an inkling of this when they looked to the photographic plate to provide them with their monstrosities and for this reason: the surrealist does not consider his aesthetic purpose and the mechanical effect of the

image on our imaginations as things apart. For him, the logical distinction between what is imaginary and what is real tends to disappear. Every image is to be seen as an object and every object as an image. Hence photography ranks high in the order of surrealist creativity because it produces an image that is a reality of nature, namely, an hallucination that is also a fact. The fact that surrealist painting combines tricks of visual deception with meticulous attention to detail substantiates this.

So, photography is clearly the most important event in the history of plastic arts. Simultaneously a liberation and an accomplishment, it has freed Western painting, once and for all, from its obsession with realism and allowed it to recover its aesthetic autonomy. Impressionist realism, offering science as an alibi, is at the opposite extreme from eye-deceiving trickery. Only when form ceases to have any imitative value can it be swallowed up in color. So, when form, in the person of Cézanne, once more regains possession of the canvas there is no longer any question of the illusions of the geometry of perspective. The painting, being confronted in the mechanically produced image with a competitor able to reach out beyond baroque resemblance to the very identity of the model, was compelled into the category of object. Henceforth Pascal's condemnation of painting is itself rendered vain since the photograph allows us on the one hand to admire in reproduction something that our eyes alone could not have taught us to love, and on the other, to admire the painting as a thing in itself whose relation to something in nature has ceased to be the justification for its existence.

On the other hand, of course, cinema is also a language.

1. It would be interesting from this point of view to study, in the illustrated magazines of 1890–1910, the rivalry between photographic reporting and the use of drawings. The latter, in particular, satisfied the baroque need for the dramatic. A feeling for the photographic document developed only gradually.

2. Perhaps the Communists, before they attach too much importance to expressionist realism, should stop talking about it in a way more suitable to the eighteenth century, before there were such things as photography or cinema. Maybe it does not really matter if Russian painting is second-rate provided Russia gives us first-rate cinema. Eisenstein is her Tintoretto.

3. There is room, nevertheless, for a study of the psychology of the lesser plastic arts, the molding of death masks for example, which likewise involves a certain automatic process. One might consider photography in this sense as a molding, the taking of an impression, by the manipulation of light.

4. Here one should really examine the psychology of relics and souvenirs which likewise enjoy the advantages of a transfer of reality stemming from the "mummy-complex." Let us merely note in passing that the Holy Shroud of Turin combines the features alike of relic and photograph.

5. I use the term *category* here in the sense attached to it by M. Gouhier in his book on the theater in which he distinguishes between the dramatic and the aesthetic categories. Just as dramatic tension has no artistic value, the perfection of a reproduction is not to be identified with beauty. It constitutes rather the prime matter, so to speak, on which the artistic fact is recorded.

Photography

Siegfried Kracauer

This study rests upon the assumption that each medium has a specific nature which invites certain kinds of communications while obstructing others. Even philosophers of art concentrating on what is common to all the arts cannot help referring to the existence and possible impact of such differences. In her *Philosophy in a New Key* Susanne Langer hesitantly admits that "the medium in which we naturally conceive our ideas may restrict them not only to certain forms but to certain fields."

But how can we trace the nature of the photographic medium? A phenomenological description based on intuitive insight will hardly get at the core of the matter. Historical movements cannot be grasped with the aid of concepts formed, so to speak, in a vacuum. Rather, analysis must build from the views held of photography in the course of its evolution — views which in some way or other must reflect actually existing trends and practices. It would therefore seem advisable first to study the historically given ideas and concepts. Now this book is not intended as a history of photography — nor of film, for that matter. So it will suffice for our purposes to scrutinize only two sets of ideas about photography, those entertained in the early stages of development and relevant present-day notions. Should the thoughts of the pioneers and of modern photographers and critics happen to center on approximately the same problems, the same essentials, this would bear out the proposition that photography has specific properties and thus lend vigor to the assumption about the peculiar nature of media in general. Such similarities between views and trends of different eras should even be expected. For the principles and ideas instrumental in the rise of a new historical entity do not just fade away once the period of inception is over; on the contrary, it is as if, in the process of growing and spreading, that entity were destined to bring out all their implications. Aristotle's theory of tragedy is still being used as a valid starting-point for interpretation. A great idea, says Whitehead, "is like a phantom ocean beating upon the shores of human life in successive waves of specialization."

The following historical survey, then, is to provide the substantive conceptions on which the subsequent systematic considerations proper will depend.

Historical Survey

Early Views and Trends

With the arrival of daguerreotypy, discerning people were highly aware of what they felt to be the new medium's specific properties, which they unanimously identified as the camera's unique ability to record as well as reveal visible, or potentially visible, physical reality. There was general agreement that photography reproduces nature with a fidelity "equal to nature itself." In supporting the bill for the purchase of Daguerre's invention by the French government, Arago and Gay-Lussac reveled in the "mathematical exactness" and "unimaginable precision" of every detail rendered by the camera; and they predicted that the medium would benefit both science and art. Paris correspondents of New York newspapers and periodicals chimed in, full of praise for the unheard-of accuracy with which daguerreotypics copied "stones under the water at the edge of the stream," or a "withered leaf lying on a projecting cornice." And no less a voice than Ruskin's was added to the chorus of enthusiasm over the "sensational realism" of small plates with views of Venice; it is, said he, "as if a magician had reduced the reality to be carried away into an enchanted land." In their ardor these nineteenth-century realists were emphasizing an essential point — that the photographer must indeed reproduce, somehow, the objects before his lens; that he definitely lacks the artist's freedom to dispose of existing shapes and spatial interrelationships for the sake of his inner vision.

Recognition of the camera's recording faculty went together with an acute awareness of its revealing power. Gay-Lussac insisted that no detail, "even if imperceptible," can escape "the eye and the brush of this new painter." And as early as 1839 a New York *Star* reporter admiringly remarked that, when viewed under a magnifying glass, photographs show minutiae which the naked eye would never have discovered. The American writer and physician Oliver Wendell Holmes was among the first to capitalize on the camera's scientific potentialities. In the early

246

'sixties he found that the movements of walking people, as disclosed by instantaneous photographs, differed greatly from what the artists imagined they were, and on the grounds of his observations he criticized an artificial leg then popular with amputated Civil War veterans. Other scientists followed suit. For his *The Expression of the Emotions in Man and Animals* (1872) Darwin preferred photographs to engravings and snapshots to time exposures, arguing that he was concerned with truth rather than beauty; and snapshots could be relied upon to convey the "most evanescent and fleeting facial expressions."

Many an invention of consequence has come into being wellnigh unnoticed. Photography was born under a lucky star in as much as it appeared at a time when the ground was well prepared for it. The insight into the recording and revealing functions of this "mirror with a memory" — its inherent realistic tendency, that is — owed much to the vigor with which the forces of realism bore down on the romantic movement of the period. In nineteenth-century France the rise of photography coincided with the spread of positivism — an intellectual attitude rather than a philosophical school which, shared by many thinkers, discouraged metaphysical speculation in favor of a scientific approach, and thus was in perfect keeping with the ongoing processes of industrialization.

Within this context, only the aesthetic implications of this attitude are of interest. Positivist mentality aspired to a faithful, completely impersonal rendering of reality, in the sense of Taine's radical dictum: "I want to reproduce the objects as they are, or as they would be even if I did not exist." What counted was not so much the artist's subject matter or easily deceptive imagination as his unbiased objectivity in representing the visible world; hence the simultaneous breakthrough of *plain-air* painting devoid of romantic overtones. (Yet of course, despite their emphatic insistence on truth to reality, the intellectual *bohème* would expect such truth to serve the cause of the revolution temporarily defeated in 1848; a few years later, Courbet called himself both a "partisan of revolution" and a "sincere friend of real truth."). It was inevitable that this turn to realism in art — which gained momentum with Courbet's *Burial at Ornans* (1850) and had its short heyday after the scandal roused by *Madame Bovary* (1857) — should bring photography into

focus. Was the camera not an ideal means of reproducing and penetrating nature without any distortions? Leading scientists, artists and critics were predisposed to grasp and acknowledge the peculiar virtues of the emergent medium.

However, the views of the realists met with strong opposition, not only in the camp of the artists but among the photographers themselves. Art, the opponents held, did not exhaust itself in painterly or photographic records of reality; it was more than that; it actually involved the artist's creativity in shaping the given material. In 1853, Sir William Newton suggested that the photographic image could, and should, be altered so as to make the result conform to the "acknowledged principles of Fine Art." His suggestion was heeded. Not content with what they believed to be a mere copying of nature, numerous photographers aimed at pictures which, as an English critic claimed, would delineate Beauty instead of merely representing Truth. Incidentally, it was not primarily the many painters in the ranks of the photographers who voiced and implemented such aspirations.

With notable exceptions the "artist-photographers" of those days followed a tendency which may be called "formative," since it sprang from their urge freely to compose beautiful pictures rather than to capture nature in the raw. But their creativity invariably manifested itself in photographs that reflected valued painterly styles and preferences; consciously or not, they imitated traditional art, not fresh reality. Thus the sculptor Adam-Salomon, a top-ranking artist-photographer, excelled in portraits which, because of their "Rembrandt lighting" and velvet drapery, caused the poet Lamartine to recant his initial opinion that photographs were nothing but a "plagiarism of nature." Upon seeing these pictures, Lamartine felt sure that photography was equally capable of attaining the peaks of art. What happened on a relatively high level became firmly established in the lower depths of commercial photography: a host of would-be artist-photographers catered to the tastes of the *juste-milieu* which, hostile to realism, still went for romantic painting and the academic idealism of Ingres and his school. There was no end of prints capitalizing on the appeal of staged genre scenes, historical or not. Photography developed into a

248

lucrative industry, especially in the field of portraiture in which Disdéri set a widely adopted pattern. From 1852, his *portrait-carte de visite* ingratiated itself with the petit bourgeois, who felt elated at the possibility of acquiring, at low cost, his likeness — a privilege hitherto reserved for the aristocracy and the well-to-do upper middle class. As might be expected, Disdéri too preached the gospel of beauty. It met the needs of the market. Under the Second Empire professional photographers, no less than popular painters, sacrificed truth to conventional pictorialness by embellishing the features of their less attractive clients.

All this means that such concern with art led the artist-photographers to neglect, if not deliberately to defy, the properties of their medium, as perceived by the realists. As far back as 1843, daguerreotypists renounced camera explorations of reality for the sake of soft-focus pictures. Adam-Salomon relied on retouching the artist effect, and Julia Margaret Cameron availed herself of badly made lenses in order to get at the "spirit" of the person portrayed without the disturbing interference of "accidental" detail. Similarly, Henry Peach Robinson encouraged the use of any kind of "dodge, trick, and conjuration" so that pictorial beauty might arise out of a "mixture of the real and the artificial."

Small wonder that the champions of realism and their adversaries engaged in a lively debate. This famous controversy, which raged in the second half of the nineteenth century, with no clear-cut solution ever being reached, rested upon a belief common to both schools of thought — that photographs were copies of nature. Yet there the agreement ended. Opinions clashed when it came to appraising the aesthetic significance of reproductions which light itself seemed to have produced.

The realists, it is true, refrained from identifying photography as an art in its own right — in fact, the extremists among them were inclined to discredit artistic endeavors altogether — but strongly insisted that the camera's incorruptible objectivity was a precious aid to the artist. Photography, as a realistic-minded critic put it, reminds the artist of nature and thus serves him as an inexhaustible source of inspiration. Taine and even Delacroix expressed themselves in similar terms; the latter compared

daguerreotypy to a "dictionary" of nature and advised painters diligently to consult it.

Those in the opposite camp naturally rejected the idea that a medium confining itself to mechanical imitation could provide artistic sensations or help achieve them. Their contempt of this inferior medium was mingled with bitter complaints about its growing influence, which, they contended, lent support to the cult of realism, thereby proving detrimental to elevated art. Baudelaire scorned the worshippers of Daguerre among the artists. He claimed they just pictured what they saw instead of projecting their dreams. The artist-photographers shared these views with a difference: they were confident that photography need not be limited to reproduction pure and simple. Photography, they reasoned, is a medium which offers the creative artist as many opportunities as does painting or literature — provided he does not let himself be inhibited by the camera's peculiar affinities but uses every "dodge, trick, and conjuration" to elicit beauty from the photographic raw material.

All these nineteenth-century arguments and counterarguments now sound oblique. Misled by the naïve realism underlying them, both sides failed to appreciate the kind and degree of creativeness that may go into a photographic record. Their common outlook prevented them from penetrating the essence of a medium which is neither imitation nor art in the traditional sense. Yet stale as those old notions have become, the two divergent tendencies from which they drew strength continue to assert themselves.

Current Views and Trends
Of the two camps into which modern photography is split, one follows the realistic tradition. True, Taine's intention to reproduce the objects as they are definitely belongs to the past; the present-day realists have learned, or relearned, that reality is as we see it. But much as they are aware of this, they resemble the nineteenth-century realists in that they enhance the camera's recording and revealing abilities and, accordingly, consider it their task as photographers to make the "best statement of facts." The late Edward Weston, for instance, highly valued the unique precision with which instantaneous photography mechanically registers fine detail and the "unbroken sequence of

infinitely subtle gradations from black to white" — a testimony which carries all the more weight since he often indulges in wresting abstract compositions from nature. It is evident that Weston refers to camera revelations rather than representations of familiar sights. What thrills us today then is the power of the medium, so greatly increased by technical innovations and scientific discoveries, to open up new, hitherto unsuspected dimensions of reality. Even though the late László Moholy-Nagy was anything but a realist, he extolled records capturing objects from unusual angles or combinations of phenomena never before seen together; the fabulous disclosures of high-speed, micro- and macro-photography; the penetrations obtained by means of infrared emulsions, etc. Photography, he declares, is the "golden key opening the doors to the wonders of the external universe." Is this a poetic exaggeration? In his book, *Schoepfung aus dem Wassertropfen (Creation out of a Waterdrop)*, the German photographer Gustav Schenk uncovers the Lilliputian world contained in a square millimeter of moving plain water — an endless succession of shapes so fantastic that they seem to have been dreamed rather than found.

In thus showing the "wonders of the external universe," realistic photography has taken on two important functions unforeseeable in its earlier stages of development. (This may explain why, for instance, Moholy-Nagy's account of contemporary camera work breathes a warmth and a sense of participation absent in pertinent nineteenth-century statements.)

First, modern photography has not only considerably enlarged our vision but, in doing so, adjusted it to man's situation in a technological age. A conspicuous feature of this situation is that the viewpoints and perspectives that framed our images of nature for long stretches of the past have become relative. In a crudely physical sense we are moving about with the greatest of ease and incomparable speed so that stable impressions yield to ever-changing ones: bird's-eye views of terrestrial landscapes have become quite common; not one single object has retained a fixed, definitely recognizable appearance.

The same applies to phenomena on the ideological plane. Given to analysis, we pass in review, and break down into comparable elements, all the complex value systems that have come to us in the form of beliefs, ideas, or cultures, thereby of course

251

weakening their claim to absoluteness. So we find ourselves increasingly surrounded by mental configurations which we are free to interpret at will. Each is iridescent with meanings, while the great beliefs or ideas from which they issue grow paler. Similarly, photography has effectively impressed upon us the dissolution of traditional perspectives. Think of the many prints picturing unwonted aspects of reality — spatial depth and flatness are strangely intertwined, and objects apparently well-known turn into inscrutable patterns. All in all, the realists among the modern photographers have done much to synchronize our vision with topical experiences in other dimensions. That is, they have made us perceive the world we actually live in — no mean achievement considering the power of resistance inherent in habits of seeing. In fact, some such habits stubbornly survive. For instance, the predilection which many people show today for wide vistas and panoramic views may well go back to an era less dynamic than ours.

Second, precisely by exploding perceptual traditions, modern photography has assumed another function — that of influencing art. Marcel Duchamp relates that in 1912, when he was painting his *Nude Descending the Staircase,* Paris art circles were stimulated by stroboscopic and multiple-exposure high-speed photographs. What a change in the relationships between photography and painting! Unlike nineteenth-century photography, which at best served as an aid to artists eager to be true to nature — nature still conceived in terms of time-honored visual conventions — scientific camera explorations of the first decades of the twentieth century were a source of inspiration to artists, who then began to defy these conventions. It sounds paradoxical that, of all media, realistic photography should thus have contributed to the rise of abstract art. But the same technological advance that made possible photographs bringing our vision, so to speak, up to date has left its imprint upon painters and prompted them to break away from visual schemata felt to be obsolete. Nor is it in the final analysis surprising that the achievements in the two media do coincide up to a point. Contemporary photographic records and painterly abstractions have this in common: they are both remote from the images we have been able to form of reality in a technically more primitive age. Hence the "abstract" character of those records and the surface similarity to them of certain modern paintings.

Yet, as in the old days, formative urges still vie with realistic inventions. Although Moholy-Nagy delights in the visual conquests of realistically handled photography and readily acknowledges their impact on art, he is nevertheless much more concerned with emancipating the medium from the "narrow rendering of nature." His guiding idea is that we should learn to consider photography, no less than painting, an "ideal instrument of visual expression." "We want to create," he exclaims. Consequently, he capitalized, as did Man Ray, on the sensitivity to light of the photographic plate to produce black-and-white compositions from purposefully controlled material. All modern experimental photographers proceed in essentially the same way. It is as if they suffered from their obligations toward nature in the raw; as if they felt that, to be artists, they would have to work the given raw material into creations of an expressive rather than reproductive order. So they use, and often combine, various artifices and techniques — among them negatives, photograms, multiple exposure, solarization, reticulation, etc. — in order to mount pictures which are palpably designed to externalize what Leo Katz, an experimental photographer, calls "our subjective experiences, our personal visions, and the dynamics of our imagination."

No doubt these artistic-minded experimenters aspire to photographic values; significantly, they refrain from retouching as an interference with the alleged purity of their laboratory procedures. And yet they are clearly the descendents of the nineteenth-century artist-photographers. Much as they may be reluctant to imitate painterly styles and motifs after the manner of their predecessors, they still aim at achieving art in the traditional sense; their products could also be patterned on abstract or surrealist paintings. Moreover, exactly like the early champions of pictorialism, they tend to neglect the specific properties of the medium. In 1925, it is true, Moholy-Nagy still referred to astronomical and X-ray photographs as prefigurations of his photograms, but meanwhile the umbilical cord, tenuous anyway, between realistic and experimental photography seems to have been completely severed. Andreas Feininger suggests that "superfluous and disturbing details" should be suppressed for the sake of "artistic simplification"; the goal of photography as an art medium, he stipulates, is "not the achievement of highest possible 'likeness' of the depicted subject, but the creation of an

253

abstract work of art, featuring composition instead of documentation." He is not the only one to discount the "wonders of the external universe" in the interest of self-expression; in a publication on the German experimental photographer Otto Steinert, the latter's so-called "subjective" photography is characterized as a deliberate departure from the realistic point of view.

All of this implies that the meaning of photography is still controversial. The great nineteenth-century issue of whether or not photography is an art medium, or at least can be developed into one, fully retains its topical flavor. When tackling this perennial issue, the modern realists are wavering. In their desire to highlight the artistic potentialities of their medium they usually draw attention to the photographer's selectivity, which, indeed, may account for prints suggestive of his personal vision and rich in aesthetic gratifications. But is he for that reason on a par with the painter or poet? And is his product a work of art in the strict sense of the word? Regarding these crucial questions, there is a great deal of soul-searching in the realist camp, affirmative testimony alternating with resignation over the limitations which the medium imposes upon its adepts. No such ambivalence is found among the experimental photographers. They cut the Gordian knot by insisting that renderings of chance reality, however beautiful, cannot possibly be considered art. Art begins, they argue, where dependence upon uncontrollable conditions ends. And in intentionally ignoring the camera's recording tasks, Feininger and the others try to transform photography into the art medium which they claim it to be.

Toward the end of 1951, the *New York Times* published an article by Lisette Model in which she turned against experimental photography, pronouncing herself in favor of a "straight approach to life." The reactions to her statement, published in the same newspaper, strikingly demonstrate that the slightest provocation suffices to revive hostilities between the defenders of realism and of unfettered creativity. One letter writer, who described himself as a "frankly experimental photographer," blamed Miss Model for arbitrarily curtailing the artist's freedom to use the medium as he pleases. A second reader endorsed her article on the strength of the argument that "photographers work best within the limitations of the medium." And a third preferred

not to advance an opinion at all because "any attempt . . . to formalize and sharply define the function of our art can only lead to stagnation." Skirmishes such as these prove that the belligerents are as far apart as ever before.

In turn, the views and trends that marked the beginning of photography have not changed much in the course of its evolution. (To be sure, techniques and contents have, but that is beside the point here.) Throughout the history of photography there is on the one side a tendency toward realism culminating in records of nature, and on the other a formative tendency aiming at artistic creations. Often enough, formative aspirations clash with the desire to render reality, overwhelming it in the process. Photography, then, is the arena of two tendencies which may well conflict with each other. This state of things raises the aesthetic problems to which we now must turn.

Systematic Considerations

The Basic Aesthetic Principle
It may be assumed that the achievements within a particular medium are all the more satisfying aesthetically if they build from the specific properties of that medium. To express the same in negative terms, a product which, somehow, goes against the grain of its medium — say, by imitating effects more "natural" to another medium — will hardly prove acceptable; the old iron structures with their borrowings from Gothic stone architecture are as irritating as they are venerable. The pull of the properties of photography is, perhaps, responsible for the inconsistent attitudes and performances of some photographers with strong painterly inclinations. Robinson, the early artist-photographer who recommended that truth should be sacrificed to beauty, at the same time eulogized, as if under a compulsion, the medium's unrivaled truth to reality. Here also belongs the duality in Edward Weston's work; devoted to both abstraction and realism, he paid tribute to the latter's superiority only after having become aware of their incompatability and of his split allegiance.

Yet this emphasis on a medium's peculiarities gives rise to serious objections, one of which may be formulated as follows: The properties of a medium elude concise definition. It is there-

fore inadmissible to postulate such properties and use them as a starting-point for aesthetic analysis. What is adequate to a medium cannot be determined dogmatically in advance. Any revolutionary artist may upset all previous speculations about the "nature" of the medium to which his works belong.

On the other hand, however, experience shows that not all media obstruct a definition of their nature with equal vigor. In consequence, one may arrange the different media along a continuum according to the degree of the elusiveness of their properties. One pole of the continuum can be assigned, for instance, to painting, whose varying modes of approach seem to be least dependent upon the fixed material and technical factors. (Lessing's great attempt, in his *Laocoön*, to delineate the boundaries between painting and poetry suffered from his inability to gauge the potentialities of either art. But this does not invalidate his attempt. Notwithstanding their near-intangibility, these boundaries make themselves felt whenever a painter or poet tries to transfer to his own medium statements advanced in the other.) "There are many things beautiful enough in words," remarks Benvenuto Cellini, roughly anticipating Lessing, "which do not match . . . well when executed by an artist." That the theater is more restrictive than painting is strikingly demonstrated by an experience of Eisenstein. At a time when he still directed theatrical plays he found out by trial and error that stage conditions could not be stretched infinitely — that in effect their inexorable nature prevented him from implementing his artistic intentions, which then called for film as the only fitting means of expression. So he left the theater for the cinema. Nor does, at least in our era, the novel readily lend itself to all kinds of uses; hence the recurrent quest for its essential features. Ortega y Gasset compares it to a "vast but finite quarry."

But if any medium has its legitimate place at the pole opposite that of painting, it is photography. The properties of photography, as defined by Gay-Lussac and Arago at the outset, are fairly specific; and they have lost nothing of their impact in the course of history. Thus, it seems all the more justifiable to apply the basic aesthetic principle to this particular medium. (Since hybrid genres drawing on photography are practically nonexistent, the problem of their possible aesthetic validity does not pose itself.)

256

Compliance with the basic aesthetic principle carries implications for (1) the photographer's approach to his medium, (2) the affinities of photography, and (3) the peculiar appeals of photographs.

The Photographic Approach
The photographer's approach may be called "photographic" if it conforms to the basic aesthetic principle. In an aesthetic interest, that is, he must follow the realistic tendency under all circumstances. This is of course a minimum requirement. Yet in meeting it, he will at least have produced prints in keeping with the photographic approach. Which means that an impersonal, completely artless camera record is aesthetically irreproachable, whereas an otherwise beautiful and perhaps significant composition may lack photographic quality. Artless compliance with the basic principle has its rewards, especially in case of pictures adjusting our vision to our actual situation. Pictures of this kind need not result from deliberate efforts on the part of the photographer to give the impression of artistic creations. In fact, Beaumont Newhall refers to the intrinsic "beauty" of aerial serial photographs taken with automatic cameras during the last war for strictly military purposes. It is understood that this particular brand of beauty is an unintended by-product which adds nothing to the aesthetic legitimacy of such mechanical explorations of nature.

But if candid shots are true to the medium, it would seem natural to imagine the photographer as a "camera-eye" — a man devoid of formative impulses who is all in all the exact counterpart of the type of artist proclaimed in the realist manifesto of 1856. According to the manifesto, the artist's attitude toward reality should be so impersonal that he might reproduce the same subject ten times without any of his copies showing the slightest difference. This is how Proust conceives of the photographer in that passage of *The Guermantes Way,* where, after a long absence, the narrator enters, unannounced, the living room of his grandmother:

> I was in the room, or rather I was not yet in the room since she was not aware of my presence. . . . Of myself . . . there was present only the witness, the observer with a hat and

257

traveling coat, the stranger who does not belong to the house, the photographer who has called to take a photograph of places which one will never see again. The process that mechanically occurred in my eyes when I caught sight of my grandmother was indeed a photograph. We never see the people who are dear to us save in the animated system, the perpetual motion of our incessant love for them, which before allowing the images that their faces present to reach us catches them in its vortex, flings them back upon the idea that we have always had of them, makes them adhere to it, coincide with it. How, since into the forehead, the cheeks of my grandmother I had been accustomed to read all the most delicate, the most permanent qualities of her mind; how, since every casual glance is an act of necromancy, each face that we love a mirror of the past, how could I have failed to overlook what in her had become dulled and changed, seeing that in the most trivial spectacles of our daily life our eye, charged with thought, neglects as would a classical tragedy, every image that does not assist the action of the play and retains only those that may help to make its purpose intelligible. . . . I, for whom my grandmother was still myself, I had never seen her save in my own soul, always at the same place in the past, through the transparent sheets of contiguous, overlapping memories, suddenly in our drawing room which formed part of a new world, that of time, saw, sitting on the sofa, beneath the lamp, red-faced, heavy and common, sick, lost in thought, following the lines of a book with eyes that seemed hardly sane, a dejected old woman whom I did not know.

Proust starts from the premise that love blinds us to the changes which the beloved object is undergoing in the course of time. It is therefore logical that he should emphasize emotional detachment as the photographer's foremost virtue. He drives home this point by comparing the photographer with the witness, the observer, the stranger — three types supposed not to be entangled in the events they happen to watch. They may perceive anything because nothing they see is pregnant with memories that would captivate them and thus limit their vision. The ideal photographer is the opposite of the unseeing lover. He resembles the indiscriminating mirror; he is identical with the

camera lens. Photography, Proust has it, is the product of complete alienation.

The onesidedness of this definition is obvious. Yet the whole context suggests that Proust was primarily concerned with the depiction of a state of mind in which the impact of involuntary memories blurs the external phenomena touching them off. And the desire to contrast, in the interest of clarity, this state of mind with the photographer's may have led him to adopt the credo of the extreme nineteenth-century realists, according to which the photographer — any artist, for that matter — holds a mirror up to nature.

Actually there is no mirror at all. Photographs do not just copy nature but metamorphose it by transferring three-dimensional phenomena to the plane, severing their ties with the surroundings, and substituting black, gray, and white for the given color schemes. Yet if anything defies the idea of a mirror, it is not so much these unavoidable transformations — which may be discounted because in spite of them photographs still preserve the character of compulsory reproductions — as the way in which we take cognizance of visible reality. Even Proust's alienated photographer spontaneously structures the inflowing impressions; the simultaneous perceptions of his other senses, certain perceptual form categories inherent in his nervous system, and not least his general dispositions prompt him to organize the visual raw material in the act of seeing. And the activities in which he thus unconsciously engages are bound to condition the pictures he is taking.

But what about the candid photographs mentioned above — prints obtained almost automatically? In their case it falls to the spectator to do the structuring. (The aerial reconnaissance photos referred to by Newhall interfere with the conventional structuring processes because of their unidentifiable shapes which cause the spectator to withdraw into the aesthetic dimension.) Objectivity in the sense of the realist manifesto is unattainable. This being so, there is no earthly reason why the photographer should suppress his formative faculties in the interest of the necessarily futile attempt to achieve that objectivity. Provided his choices are governed by his determination to record and reveal nature, he is entirely justified in selecting motif, frame, lens, filter, emulsion and grain according to his

sensibilities. Or rather, he must be selective in order to transcend the minimum requirement. For nature in unlikely to give itself up to him if he does not absorb it with all his senses strained and his whole being participating in the process. The formative tendency, then, does not have to conflict with the realistic tendency. Quite the contrary, it may help substantiate and fulfill it — an interaction of which the nineteenth-century realists could not possibly be aware. Contrary to what Proust says, the photographer sees things in his "own soul."

And yet Proust is right in relating the photographic approach to a state of alienation. Even though the photographer who acknowledges the properties of his medium rarely, if ever, shows the emotional detachment which Proust ascribes to him, he cannot freely externalize his inner vision either. What counts is the "right" mixture of his realist loyalties and formative endeavors — a mixture, that is, in which the latter, however strongly developed, surrender their independence to the former. As Lewis Mumford puts it: the photographer's "inner impulse, instead of spreading itself in subjective fantasy, must always be in key with outer circumstances." Some early artist-photographers, such as Nadar, David Octavius Hill, and Robert Adamson, knew how to establish this precarious balance. Much as they were influenced by painting, they primarily aimed at bringing out the essential features of any person presented; the photographic quality of their portraits, says Newhall, must be traced to the "dignity and depth of their perception."

This means that the photographer's selectivity is of a kind which is closer to empathy than to disengaged spontaneity. He resembles perhaps most of all the imaginative reader intent on studying and deciphering an elusive text. Like a reader, the photographer is steeped in the book of nature. His "intensity of vision," claims Paul Strand, should be rooted in a "real respect for the thing in front of him." Or in Weston's words, the camera "provides the photographer with a means of looking deeply into the nature of things, and presenting his subjects in terms of their basic reality." Due to the revealing power of the camera, there is also something of an explorer about him; insatiable curiosity stirs him to roam yet unconquered expanses and capture the strange patterns in them. The photographer summons up his being, not to discharge it in autonomous creations but to

dissolve it into the substances of the objects that close in on him. Once again, Proust is right: selectivity within this medium is inseparable from processes of alienation.

Let me insert here an observation on the possible role of melancholy in photographic vision. It is certainly not by accident that Newhall in his *History of Photography* mentions, on two different occasions, melancholy in connection with pictorial work in a photographic spirit. He remarks that Marville's pictures of the Paris streets and houses doomed under Napoleon III have the "melancholy beauty of a vanished past"; and he says of Atget's Paris street scenes that they are impregnated with the "melancholy that a good photograph can so powerfully evoke." Now melancholy as an inner disposition not only makes elegiac objects seem attractive but carries still another, more important implication: it favors self-estrangement, which on its part entails identification with all kinds of objects. The dejected individual is likely to lose himself in the incidental configurations of his environment, absorbing them with a disinterested intensity no longer determined by his previous preferences. His is a kind of receptivity which resembles that of Proust's photographer cast in the role of a stranger. Film makers often exploited this intimate relationship between melancholy and the photographic approach in an attempt to render visible such a state of mind. A recurrent film sequence runs as follows: the melancholy character is seen strolling about aimlessly: as he proceeds, his changing surroundings take shape in the form of numerous juxtaposed shots of house façades, neon lights, stray passers-by, and the like. It is inevitable that the audience should trace their seemingly unmotivated emergence to his dejection and the alienation in its wake.

The formative tendency may not only become so weak that the resultant prints just barely fulfill the minimum requirements, but it may also take on proportions which threaten to overwhelm the realistic tendency. During the last few decades many a noted photographer has indulged in pictures which are either meant to explore the given raw material or serve to project inner images of their authors, or both. Characterizing a photograph of tree trunks with eye-like hollows in their bark, Moholy-Nagy observed: "The surrealist often *finds* images in nature which express his feelings." Or think of Moholy-Nagy's own picture,

From Berlin Wireless Tower and certain abstract or near-abstract compositions which on closer inspection reveal themselves to be rock and soil formations, unconventional combinations of objects, faces in big close-up, and what not.

In pictures of this type the balance between empathy and spontaneity is rather fragile. The photographer producing them does not subordinate his formative impulses to his realistic intentions but seems eager to manifest both of them with equal vigor. He is animated, perhaps without being aware of it, by two conflicting desires — the desire to externalize his inner images and the desire to render outer shapes. However, in order to reconcile them, he relies on occasional coincidences between those shapes and images. Hence the ambiguity of such photographs, which are a veritable *tour de force*. A good case in point is Mary Ann Dorr's photograph, *Chairs in the Sunlight*. On the one hand, it does justice to the properties of the medium: the perforated chairs and the shadows they cast do exist. On the other, it is palpably intended as an artistic creation: the shadows and the chairs affect one as elements of a free composition rather than natural objects.

The experimental photographer tends to trespass the border region marked by these blends of divergent intentions. Are his products still in the nature of the photographs? Photograms or rayographs dispense with the camera; and those "creative" achievements which do not, radically consume — by molding it — the recorded raw material possibly going into them. The same holds true of photomontage. It might be best to classify all compositions of this type as a special genre of the graphic arts rather than photography proper. Despite their obvious affilia-

Unsettled borderline cases like these certainly retain a photographic quality if they suggest that their creators are devoted to the text of nature. And they are on the verge of losing that quality if the impression prevails that the photographer's "finds" merely reflect what he has already virtually found before training his camera on the external world; then he does not so much explore nature as utilize it for a pseudo-realistic statement of his own vision. He might even manufacture the coveted coincidence between his spontaneous imagery and actuality by slightly tampering with the latter.

tions with photography, they are actually remote from it. Indeed, as we have seen, the experimental photographers themselves assert that their prints belong to a peculiar medium and, being artistic creations, should not be confused with such quasi-abstract records of reality as are, perhaps, no less attractive aesthetically. But if these creations are no records, they do not fall into the dimension of paintings or drawings either. James Thrall Soby once remarked of them that they do not "wear well when hung as pictures." It is as if the use of photography for strictly artistic purposes led into a sort of no man's land somewhere between reproduction and expression.

Affinities

Photographs in keeping with the photographic approach — where no misunderstanding is possible, they may just be called photographs — show certain affinities which can be assumed to be as constant as the properties of the medium to which they belong. Four of them call for special attention.

First, photography has an outspoken affinity for unstaged reality. Pictures which strike us as intrinsically photographic seem intended to render nature in the raw, nature as it exists independently of us. Now nature is particularly unstageable if it manifests itself in ephemeral configurations which only the camera is able to capture. This explains the delight of the early photographers in such subjects as "an accumulation of dust in a hollow moulding," or a "casual gleam of sunshine." (It is worth mentioning that Fox Talbot — it was he who exclaimed over the sunbeam — was still so little sure of the legitimacy of his preferences that he tried to authenticate them by invoking the precedent of the "Dutch school of art.") In the field of portraiture, it is true, photographers frequently interfere with the given conditions. But the boundaries between staged and unstaged reality are very fluid in this field; and a portraitist who provides a special setting or asks his model to lower the head a bit may well be trying to bring out the typical features of the client before his lens. What counts is his desire to picture nature at its most characteristic so that his portraits look like casual self-revelations, "instinct with the illusion of life." If, on the other hand, the expressive artist in him gets the better of the imaginative reader or curious explorer, his portraits inevitably turn into

those ambiguous borderline cases dealt with above. They give you the impression of being overcomposed in terms of lighting and/or subject matter; they no longer catch reality in its flux, you feel, but arrange its elements into a pattern reminiscent of painting.

Second, through this concern with unstaged reality, photography tends to stress the fortuitous. Random events are the very meat of snapshots. "We want to seize, in passing, upon all that may present itself unexpectedly to our view and interest us in some respect," said a Frenchman about instantaneous photography nearly ten years before the first films appeared. Hence the attractiveness of street crowds. By 1859, New York stereography took a fancy to the kaleidoscopic mingling of vehicles and pedestrians, and somewhat later Victorian snapshots reveled in the same inchoate agglomerates. Marville, Stieglitz, Atget — all of them, as has been remarked, acknowledged city life as a contemporary and photogenic major theme. Dreams nurtured by the big cities thus materialized as pictorial records of chance meetings, strange overlappings, and fabulous coincidences. In portraiture, by the same token, even the most typical portraits must retain an accidental character — as if they were plucked en route and still quivered with crude existence. This affinity for the adventitious again implies that the medium does not favor pictures which seem to be forced into an "obvious compositional pattern." (Of course, photographs of the compositional inventions of nature or man-made reality are quite another thing.)

Third, photography tends to suggest endlessness. This follows from its emphasis on fortuitous complexes which represent fragments rather than wholes. A photograph, whether portrait or action picture, is in character only if it precludes the notion of completeness. Its frame marks a provisional limit; its content refers to other contents outside that frame; and its structure denotes something that cannot be encompassed — physical existence. Nineteenth-century writers called this something nature, or life; and they were convinced that photography would have to impress upon us its infinity. Leaves, which they counted among the favorite motifs of the camera, cannot be "staged" but occur in endless quantities. In this respect, there is an analogy between the photographic approach and scientific investigation: both probe into an inexhaustible universe whose entirety forever eludes them.

Fourth and finally, the medium has an affinity for the indeterminate of which Proust was keenly aware. Within the passage partially quoted, Proust also imagines the photograph of an Academician leaving the Institute. What the photograph shows us, he observes, "will be, instead of the dignified emergence of an Academician who is going to hail a cab, his staggering gait, his precautions to avoid tumbling upon his back, the parabola of his fall, as though he were drunk, or the ground frozen over." The photograph Proust has in mind does not intimate that the Academician must be thought of as being undignified; it simply fails to tell us anything about his behavior in general or his typical attitudes. It so radically isolates a momentary pose of the Academician that the function of this pose within the total structure of his personality remains everybody's guess. The pose relates to a context which, itself, is not given. Photographs, implies Proust, transmit raw material without defining it.

No doubt Proust exaggerates the indeterminacy of photographs just as grossly as he does their depersonalizing quality. Actually the photographer endows his pictures with structure and meaning to the extent to which he makes deliberate choices. His pictures record nature and at the same time reflect his attempt to assimilate and decipher it. Yet, as in pointing up the photographer's alienation, Proust is again essentially right, for however selective photographs are, they cannot deny the tendency toward the unorganized and diffuse which marks them as records. It is therefore inevitable that they should be surrounded with a fringe of indistinct multiple meanings. (To be sure, the traditional work of art carries many meanings also. But due to its rise from interpretable human intentions and circumstances, the meanings inherent in it can virtually be ascertained, whereas those of the photograph are necessarily indeterminate because the latter is bound to convey unshaped nature itself, nature in its inscrutability. As compared with a photograph, any painting has a relatively definite significance. Accordingly, it makes sense to speak of multiple meanings, vague meaningfulness, and the like only in connection with camera work.)

Appeals

Products of a medium with so outspoken affinities may well exert specific appeals differing from those of the art media proper. Three such appeals are discernible.

265

We know, says Newhall, that subjects "can be misrepresented, distorted, faked . . . and even delight in it occasionally, but the knowledge still cannot shake our implicit faith in the truth of a photographic record." This explains a common reaction to photographs: since the days of Daguerre they have been valued as documents of unquestionable authenticity. Baudelaire, who scorned both art's decline into photography and photography's pretense to art, at least admitted that photographs have the merit of rendering, and thus preserving, all those transient things which are entitled to a place in the "archives of our memory." It would be difficult indeed to overestimate their early popularity as souvenirs. There is practically no family which does not boast an album crowded with generations of dear ones before varying backgrounds. With the passing of time, these souvenirs undergo a significant change of meaning. As the recollections they embody fade away, they increasingly assume documentary functions; their impact as photographic records definitely overshadows their original appeal as memory aids. Leafing through the family album, the grandmother will re-experience her honeymoon, while the children will curiously study bizarre gondolas, obsolete fashions, and old young faces they never saw.

And most certainly they will rejoice in discoveries, pointing to odd bagatelles which the grandmother failed to notice in her day. Or think of the satisfaction people are deriving from the scrutiny of an enlargement in which, one by one, things emerge they would not have suspected in the original print — nor in reality itself, for that matter. This too is a typical reaction to photographs. In fact, we tend to look at them in the hope of detecting something new and unexpected — a confidence which pays tribute to the camera's revealing faculty.

Finally, photography has always been recognized as a source of beauty. Yet beauty may be experienced in different ways. All those who do not expect a photograph to impress them as would a painting, are agreed that the beauty of, say, Nadar's portraits, Brady's Civil War scenes, or Atget's Paris Streets is inseparable from their being sensitive and technically impeccable readings rather than autonomous creations. Generally speaking, photographs stand a chance of being beautiful to the extent that they comply with the photographic approach. This would account for

266

the frequent observation that pictures extending our vision are not only gratifying as camera revelations but appeal to us aesthetically also — no matter, for the rest, whether they result from high selectivity or amount to purely mechanical products like the aerial reconnaissance photographs.

Fox Talbot called it one of the "charms" of photographs that they include things unknown to their maker, things which he himself must discover in them. Similarly, Louis Delluc, one of the key figures of the French cinema after World War I, took delight — aesthetic delight — in the surprising revelations of Kodak pictures: "This is what enchants me: you will admit that it is unusual suddenly to notice, on a film or a plate, that some passer-by, inadvertently picked up by the camera lens, has a singular expression; that Mme. X . . . preserves the unconscious secret of classic postures in scattered fragments; and that the trees, the water, the fabrics, the beasts achieve the familiar rhythm which we know is peculiar to them only by means of decomposed movements whose disclosure proves upsetting to us." The aesthetic value of photographs would in a measure seem to be a function of their explorative powers.*

In our response to photographs, then, the desire for knowledge and the sense of beauty interpenetrate one another. Often photographs radiate beauty because they satisfy that desire. Moreover, in satisfying it by penetrating unknown celestial spaces and the recesses of matter, they may afford glimpses of designs beautiful in their own right.

The Issue of Art
At this point the controversial issue of whether or not photography is an art comes into view again. The controversy in its present form is strongly determined by the unwillingness of the champions of creativity to put up with the limitations which the photographic process imposes upon their formative urges. They consider any photographer who is following the photographic approach something less than an artist and, on their part, revolt against the recording duties he readily assumes. The issue, as they see it, could not be more poignantly characterized than by Moholy-Nagy's definition of the experimental photographer as an artist who "will not only select what he finds but . . . produce situations, introduce devices so far unused and neglected, which

267

for him contain the necessary qualities of photographic expression." The emphasis is on the elimination of accidental reality for the sake of art. Barbara Morgan, who builds a universe of her own with the aid of synchroflash and speedlamps, declares that she is "grateful for man-made light and the creative freedom it gives."

Yet much as the concept of art or creativity behind these statements applies to the traditional arts, it fails to do justice to the high degree of selectivity of which photographic records are susceptible. To be more precise, it overshadows the photographer's peculiar and truly formative effort to represent significant aspects of physical reality without trying to overwhelm that reality — so that the raw material focused upon is both left intact and made transparent. No doubt this effort carries aesthetic implications. Stieglitz's group of huddled trees is a memorable image of autumnal sadness. Cartier-Bresson's snapshots capture facial expressions and interrelationships between human figures and architecture which are strangely moving. And Brassai knows how to make walls and wet cobblestones eloquent.

Why, then, reserve the term "art" for the free compositions of the experimental photographers which, in a sense, lie outside the province of photography proper? This threatens to divert the attention from what is really characteristic of the medium. Perhaps it would be more fruitful to use the term "art" in a looser way so that it covers, however inadequately, achievements in a truly photographic spirit — pictures, that is, which are neither works of art in the traditional sense nor aesthetically indifferent products. Because of the sensibility that goes into them and the beauty they may breathe, there is something to be said in favor of such an extended usage.

*Valéry, *Degas, dance, dessin*, p. 73, remarks that, in the case of flying birds, instantaneous photographs corroborate the prints of Japanese artists. For the resemblances between instantaneous photography and Japanese art, see Wolf-Czapek, *Die Kinematographie* . . . , pp. 112–13.

Rhetoric of the Image

Roland Barthes (b. 1915)

The French semiologist Roland Barthes studied literature and classics at the University of Paris. While a student, he founded the Groupe Théâtral Antique at the University, and, later, helped to found the magazine Théâtre Populaire. *During World War II, Barthes pursued sociological and lexicological research at the Centre National de la Recherche Scientifique. Barthes has taught at the Sorbonne, as well as in Egypt, Roumania, and as a visiting professor at The Johns Hopkins University. At present he is the director of studies in the sixth section of the Ecole Practique des Hautes Etudes, where he instructs a course in the sociology of signs, symbols, and collective representations.*

According to an ancient etymology, the word *image* should be linked to the root *imitari*. Thus we find ourselves immediately at the heart of the most important problem facing the semiology of images: can analogical representation (the 'copy') produce true systems of signs and not merely simple agglutinations of symbols? Is it possible to conceive of an analogical 'code' (as opposed to a digital one)? We know that linguists refuse the status of language to all communication by analogy — from the 'language' of bees to the 'language' of gesture — the moment such communications are not doubly articulated, are not founded on a combinatory system of digital units as phonemes are. Nor are linguists the only ones to be suspicious as to the linguistic nature of the image; general opinion too has a vague conception of the image as an area of resistance to meaning — this in the name of a certain mythical idea of Life: the image is re-presentation, which is to say ultimately resurrection, and, as we know, the intelligible is reputed antipathetic to lived experience. Thus from both sides the image is felt to be weak in respect of meaning: there are those who think that the image is an extremely rudimentary system in comparison with language and those who think that signification cannot exhaust the image's ineffable richness. Now even — and above all if — the image is in a certain manner the *limit* of meaning, it permits the consideration of a veritable ontology of the process of signification. How does meaning get into

269

the image? Where does it end? And if it ends, what is there *beyond*? Such are the questions that I wish to raise by submitting the image to a spectral analysis of the messages it may contain. We will start by making it considerably easier for ourselves: we will only study the advertising image. Why? Because in advertising the signification of the image is undoubtedly intentional; the signifieds of the advertising message are formed *a priori* by certain attributes of the product and these signifieds have to be transmitted as clearly as possible. If the image contains signs, we can be sure that in advertising these signs are full, formed with a view to the optimum reading: the advertising image is *frank,* or at least emphatic.

The Three Messages

Here we have a Panzani advertisement: some packets of pasta, a tin, a sachet, some tomatoes, onions, peppers, a mushroom, all emerging from a half-open string bag, in yellows and greens on a red background.[1] Let us try to 'skim off' the different messages it contains.

The image immediately yields a first message whose substance is linguistic; its supports are the caption, which is marginal, and the labels, these being inserted into the natural disposition of the scene, *'en abyme'*. The code from which this message has been taken is none other than that of the French language; the only knowledge required to decipher it is a knowledge of writing and French. In fact, this message can itself be further broken down, for the sign *Panzani* gives not simply the name of the firm but also, by its assonance, an additional signified, that of 'Italianicity'. The linguistic message is thus twofold (at least in this particular image): denotational and connotational. Since, however, we have here only a single typical sign,[2] namely that of articulated (written) language, it will be counted as one message.

Putting aside the linguistic message, we are left with the pure image (even if the labels are part of it, anecdotally). This image straightaway provides a series of discontinuous signs. First (the order is unimportant as these signs are not linear), the idea that what we have in the scene represented is a return from the market. A signified which itself implies two euphoric values: that of the freshness of the products and that of the essentially

domestic preparation for which they are destined. Its signifier is the half-open bag which lets the provisions spill out over the table, 'unpacked'. To read this first sign requires only a knowledge which is in some sort implanted as part of the habits of a very widespread culture where 'shopping around for oneself' is opposed to the hasty stocking up (preserves, refrigerators) of a more 'mechanical' civilization. A second sign is more or less equally evident; its signifier is the bringing together of the tomato, the pepper and the tricoloured hues (yellow, green, red) of the poster; its signified is Italy or rather *Italianicity*. This sign stands in a relation of redundancy with the connoted sign of the linguistic message (the Italian assonance of the name *Panzani*) and the knowledge it draws upon is already more particular; it is a specifically 'French' knowledge (an Italian would barely perceive the connotation of the name, no more probably than he would the Italianicity of tomato and pepper), based on a familiarity with certain tourist stereotypes. Continuing to explore the image (which is not to say that it is not entirely clear at the first glance), there is no difficulty in discovering at least two other signs: in the first, the serried collection of different objects transmits the idea of a total culinary service, on the one hand as though Panzani furnished everything necessary for a carefully balanced dish and on the other as though the concentrate in the tin were equivalent to the natural produce surrounding it; in the other sign, the composition of the image, evoking the memory of innumerable alimentary paintings, sends us to an aesthetic signified: the *'nature morte'* or, as it is better expressed in other languages, the 'still life'[3]; the knowledge on which this sign depends is heavily cultural. It might be suggested that, in addition to these four signs, there is a further information pointer, that which tells us that this is an advertisement and which arises both from the place of the image in the magazine and from the emphasis of the labels (not to mention the caption). This last information, however, is co-extensive with the scene; it eludes signification insofar as the advertising nature of the image is essentially functional: to utter something is not necessarily to declare *I am speaking,* except in a deliberately reflexive system such as literature.

Thus there are four signs for this image and we will assume that they form a coherent whole (for they are all discontinuous),

271

require a generally cultural knowledge, and refer back to signifieds each of which is global (for example, *Italianicity*), imbued with euphoric values. After the linguistic message, then, we can see a second, iconic message. Is that the end? If all these signs are removed from the image, we are still left with a certain informational matter; deprived of all knowledge, I continue to 'read' the image, to 'understand' that it assembles in a common space a number of identifiable (nameable) objects, not merely shapes and colours. The signifieds of this third message are constituted by the real objects in the scene, the signifiers by these same objects photographed, for, given that the relation between thing signified and image signifying in analogical representation is not 'arbitrary' (as it is in language), it is no longer necessary to dose the relay with a third term in the guise of the psychic image of the object. What defines the third message is precisely that the relation between signified and signifier is quasi-tautological; no doubt the photograph involves a certain arrangement of the scene (framing, reduction, flattening) but this transition is not a *transformation* (in the way a coding can be); we have here a loss of the equivalence characteristic of true sign systems and a statement of quasi-identity. In other words, the sign of this message is not drawn from an institutional stock, is not coded, and we are brought up against the paradox (to which we will return) of a *message without a code*. This peculiarity can be seen again at the level of the knowledge invested in the reading of the message; in order to 'read' this last (or first) level of the image, all that is needed is the knowledge bound up with our perception. That knowledge is not nil, for we need to know what an image is (children only learn this at about the age of four) and what a tomato, a string-bag, a packet of pasta are, but it is a matter of an almost anthropological knowledge. This message corresponds, as it were, to the letter of the image and we can agree to call it the literal message, as opposed to the previous symbolic message.

If our reading is satisfactory, the photograph analysed offers us three messages: a linguistic message, a coded iconic message, and a non-coded iconic message. The linguistic message can be readily separated from the other two, but since the latter share the same (iconic) substance, to what extent have we the right to separate them? It is certain that the distinction between the two iconic messages is not made spontaneously in ordinary reading:

the viewer of the image receives *at one and the same time* the perceptual message and the cultural message, and it will be seen later that this confusion in reading corresponds to the function of the mass image (our concern here). The distinction, however, has an operational validity, analogous to that which allows the distinction in the linguistic sign of a signifier and a signified (even though in reality no one is able to separate the 'word' from its meaning except by recourse to the metalanguage of a definition). If the distinction permits us to describe the structure of the image in a simple and coherent fashion and if this description paves the way for an explanation of the role of the image in society, we will take it to be justified. The task now is thus to reconsider each type of message so as to explore it in its generality, without losing sight of our aim of understanding the overall structure of the image, the final inter-relationship of the three messages. Given that what is in question is not a 'naive' analysis but a structural description,[4] the order of the messages will be modified a little by the inversion of the cultural message and the literal message; of the two iconic messages, the first is in some sort imprinted on the second: the literal message appears as the *support* of the 'symbolic' message. Hence, knowing that a system which takes over the signs of another system in order to make them its signifiers in a system of connotation,[5] we may say immediately that the literal image is *denoted* and the symbolic image *connoted*. Successively, then, we shall look at the linguistic message, the denoted image, and the connoted image.

The Linguistic Message
Is the linguistic message constant? Is there always textual matter in, under, or around the image? In order to find images given without words, it is doubtless necessary to go back to partially illiterate societies, to a sort of pictographic state of the image. From the moment of the appearance of the book, the linking of text and image is frequent, though it seems to have been studied from a structural point of view. What is the signifying structure of 'illustration'? Does the image duplicate certain of the informations given in the text by a phenomenon of redundancy or does the text add a fresh information to the image? The problem could be posed historically as regards the classical period with its passion for books with pictures (it was inconceivable in the eigh-

teenth century that editions of La Fontaine's *Fables* should not be illustrated) and its authors such as Menestrier who concerned themselves with the relations between figure and discourse.[6] Today, at the level of mass communications, it appears that the linguistic message is indeed present in every image: as title, caption, accompanying press article, film dialogue, comic strip balloon. Which shows that it is not very accurate to talk of a civilization of the image — we are still, and more than ever, a civilization of writing,[7] writing and speech continuing to be the full terms of the informational structure. In fact, it is simply the presence of the linguistic message that counts, for neither its position nor its length seem to be pertinent (a long text may only comprise a single global signified, thanks to connotation, and it is this signified which is put in relation with the image). What are the functions of the linguistic message with regard to the (twofold) iconic message? There appear to be two: *anchorage* and *relay*.

As will be seen more clearly in a moment, all images are polysemous; they imply, underlying their signifiers, a 'floating chain' of signifieds, the reader able to choose some and ignore others. Polysemy poses a question of meaning and this question always comes through as a dysfunction, even if this dysfunction is recuperated by society as a tragic (silent, God provides no possibility of choosing between signs) or a poetic (the panic 'shudder of meaning' of the Ancient Greeks) game; in the cinema itself, traumatic images are bound up with an uncertainty (an anxiety) concerning the meaning of objects or attitudes. Hence in every society various techniques are developed intended to *fix* the floating chain of signifieds in such a way as to counter the terror of uncertain signs; the linguistic message is one of these techniques. At the level of the literal message, the text replies — in a more or less direct, more or less partial manner — to the question: *what is it?* The text helps to identify purely and simply the elements of the scene and the scene itself; it is a matter of a denoted description of the image (a description which is often incomplete) or, in Hjelmslev's terminology, of an *operation* (as opposed to connotation).[8] The denominative function corresponds exactly to an *anchorage* of all the possible (denoted) meanings of the object by recourse to a nomenclature. Shown a plateful of something (in an *Amieux* advertisement), I may hesi-

tate in identifying the forms and masses; the caption *('rice and tuna fish with mushrooms')* helps me to choose *the correct level of perception,* permits me to focus not simply my gaze but also my understanding. When it comes to the 'symbolic message', the linguistic message no longer guides identification but interpretation, constituting a kind of vice which holds the connoted meanings from proliferating, whether towards excessively individual regions (it limits, that is to say, the projective power of the image) or towards dysphoric values. An advertisement (for *d'Arcy* preserves) shows a few fruits scattered around a ladder; the caption *('as if from your own garden')* banishes one possible signified (parsimony, the paucity of the harvest) because of its unpleasantness and orientates the reading towards a more flattering signified (the natural and personal character of fruit from a private garden); it acts here as a counter-taboo, combatting the disagreeable myth of the artificial usually associated with preserves. Of course, elsewhere than in advertising, the anchorage may be ideological and indeed this is its principal function; the text *directs* the reader through the signifieds of the image, causing him to avoid some and receive others; by means of an often subtle *dispatching,* it remote-controls him towards a meaning chosen in advance. In all these cases of anchorage, language clearly has a function of elucidation, but this elucidation is selective, a metalanguage applied not to the totality of the iconic message but only to certain of its signs. The text is indeed the creator's (and hence society's) right of inspection over the image; anchorage is a control, bearing a responsibility — in the face of the projective power of pictures — for the use of the message. With respect to the liberty of the signifieds of the image, the text thus has a *repressive* value[9] and we can see that it is at this level that the morality and ideology of a society are above all invested.

Anchorage is the most frequent function of the linguistic message and is commonly found in press photographs and advertisements. The function of relay is less common (at least as far as the fixed image is concerned); it can be seen particularly in cartoons and comic strips. Here text (most often a snatch of dialogue) and image stand in a complementary relationship; the words, in the same way as the images, are fragments of a more general snytagm and the unity of the message is realized at a

higher level, that of the story, the anecdote, the diegesis (which is ample confirmation that the diegesis must be treated as an autonomous system[10]). While rare in the fixed image, this relay-text becomes very important in film, where dialogue functions not simply as elucidation but really does advance the action by setting out, in the sequence of messages, meanings that are not to be found in the image itself. Obviously, the two functions of the linguistic message can co-exist in the one iconic whole, but the dominance of the one or the other is of consequence for the general economy of a work. When the text has the diegetic value of relay, the information is more costly, requiring as it does the learning of a digital code (the system of language); when it has a substitute value (anchorage, control), it is the image which detains the informational charge and, the image being analogical, the information is then 'lazier': in certain comic strips intended for 'quick' reading the diegesis is confided above all to the text, the image gathering the attributive informations of a paradigmatic order (the stereotyped status of the characters); the costly message and the discursive message are made to coincide so that the hurried reader may be spared the boredom of verbal 'descriptions', which are entrusted to the image, that is to say to a less 'laborious' system.

The Denoted Image
We have seen that in the image properly speaking, the distinction between the literal message and the symbolic message is operational; we never encounter (at least in advertising) a literal image in a pure state. Even if a totally 'naive' image were to be achieved, it would immediately join the sign of naivety and be completed by a third — symbolic — message. Thus the characteristics of the literal message cannot be substantial but only relational. It is first of all, so to speak, a message by eviction, constituted by what is left in the image when the signs of connotation are mentally deleted (it would not be possible actually to remove them for they can impregnate the whole of the image, as in the case of the 'still life composition'). This evictive state naturally corresponds to a plenitude of virtualities: it is an absence of meaning full of all the meanings. Then again (and there is no contradiction with what has just been said), it is a sufficient message, since it has at least one meaning at the level of the

276

identification of the scene represented; the letter of the image corresponds in short to the first degree of intelligibility (below which the reader would perceive only lines, forms, and colours), but this intelligibility remains virtual by reason of its very poverty, for everyone from a real society always disposes of a knowledge superior to the merely anthropological and perceives more than just the letter. Since it is both evictive and sufficient, it will be understood that from an aesthetic point of view the denoted image can appear as a kind of Edenic state of the image; cleared utopianically of its connotations, the image would become radically objective, or, in the last analysis, innocent.

This utopian character of denotation is considerably reinforced by the paradox already mentioned, that the photograph (in its literal state), by virtue of its absolutely analogical nature, seems to constitute a message without a code. Here, however, structural analysis must differentiate, for of all the kinds of image only the photograph is able to transmit the (literal) information without forming it by means of discontinuous signs and rules of transformation. The photograph, message without a code, must thus be opposed to the drawing which, even when denoted, is a coded message. The coded nature of the drawing can be seen at three levels. Firstly, to reproduce an object or a scene in a drawing requires a set of *rule-governed* transpositions; there is no essential nature of the pictorial copy and the codes of transposition are historical (notably those concerning perspective). Secondly, the operation of the drawing (the coding) immediately necessitates a certain division between the significant and the insignificant: the drawing does not reproduce *everything* (often it reproduces very little), without its ceasing, however, to be a strong message; whereas the photograph, although it can choose its subject, its point of view and its angle, cannot intervene *within* the object (except by trick effects). In other words, the denotation of the drawing is less pure than that of the photograph, for there is no drawing without style. Finally, like all codes, the drawing demands an apprenticeship (Saussure attributed a great importance to this semiological fact). Does the coding of the denoted message have consequences for the connoted message? It is certain that the coding of the literal prepares and facilitates connotation since it at once establishes a certain discontinuity in the image: the 'execution' of a drawing itself

constitutes a connotation. But at the same time, insofar as the drawing displays its coding, the relationship between the two messages is profoundly modified: it is no longer the relationship between a nature and a culture (as with the photograph) but that between two cultures; the 'ethic' of the drawing is not the same as that of the photograph.

In the photograph — at least at the level of the literal message — the relationship of signifieds to signifiers is not one of 'transformation' but of 'recording', and the absence of a code clearly reinforces the myth of photographic 'naturalness': the scene *is there*, captured mechanically, not humanly (the mechanical is here a guarantee of objectivity). Man's interventions in the photograph (framing, distance, lighting, focus, speed) all effectively belong to the plane of connotation; it is as though in the beginning (even if utopian) there were a brute photograph (frontal and clear) on which man would then lay out, with the aid of various techniques, the signs drawn from a cultural code. Only the opposition of the cultural code and the natural non-code can, it seems, account for the specific character of the photograph and allow the assessment of the anthropological revolution it represents in man's history. The type of consciousness the photograph involves is indeed truly unprecedented, since it establishes not a consciousness of the *being-there* of the thing (which any copy could provoke) but an awareness of its *having-been-there*. What we have is a new space-time category: spatial immediacy and temporal anteriority, the photograph being an illogical conjunction between the *here-now* and the *there-then*. It is thus at the level of this denoted message or message without code that the *real unreality* of the photograph can be fully understood: its unreality is that of the *here-now*, for the photograph is never experienced as illusion, is in no way a *presence* (claims as to the magical character of the photographic image must be deflated); its reality that of the *having-been-there*, for in every photograph there is the always stupefying evidence of *this is how it was*, giving us, by a precious miracle, a reality from which we are sheltered. This kind of temporal equilibrium *(having-been-there)* probably diminishes the projective power of the image (very few psychological tests resort to photographs while many use drawings): the *this was so* easily defeats the *it's me*. If these remarks are at all correct, the photograph must be related to a

pure spectatorial consciousness and not to the more projective, more 'magical' fictional consciousness on which film by and large depends. This would lend authority to the view that the distinction between film and photograph is not a simple difference of degree but a radical opposition. Film can no longer be seen as animated photographs: the *having-been-there* gives way before a *being-there* of the thing; which omission would explain how there can be a history of the cinema, without any real break with the previous arts of fiction, whereas the photograph can in some sense elude history (despite the evolution of the techniques and ambitions of the photographic art) and represent a 'flat' anthropological fact, at once absolutely new and definitively unsurpassable, humanity encountering for the first time in its history *messages without a code*. Hence the photograph is not the last (improved) term of the great family of images; it corresponds to a decisive mutation of informational economies.

At all events, the denoted image, to the extent to which it does not imply any code (the case with the advertising photograph), plays a special role in the general structure of the iconic message which we can begin to define (returning to this question after discussion of the third message): the denoted image naturalizes the symbolic message, it innocents the semantic artifice of connotation, which is extremely dense, especially in advertising. Although the *Panzani* poster is full of 'symbols', there nonetheless remains in the photograph, insofar as the literal message is sufficient, a kind of natural *being-there* of objects: nature seems spontaneously to produce the scene represented. A pseudo-truth is surreptitiously substituted for the simple validity of openly semantic systems; the absence of code disintellectualizes the message because it seems to found in nature the signs of culture. This is without doubt an important historical paradox: the more technology develops the diffusion of information (and notably of images), the more it provides the means of masking the constructed meaning under the appearance of the given meaning.

Rhetoric of the Image
It was seen that the signs of the third message (the 'symbolic' message, cultural or connoted) were discontinuous. Even when the signifier seems to extend over the whole image, it is nonetheless a sign separated from the others: the 'composition' carries

an aesthetic signified, in much the same way as intonation although suprasegmental is a separate signifier in language. Thus we are here dealing with a normal system whose signs are drawn from a cultural code (even if the linking together of the elements of the sign appears more or less analogical). What gives this system its originality is that the number of readings of the same lexical unit or *lexia* (of the same image) varies according to individuals. In the *Panzani* advertisement analysed, four connotative signs have been identified; probably there are others (the net bag, for example, can signify the miraculous draught of fishes, plenty, etc.). The variation in readings is not, however, anarchic; it depends on the different kinds of knowledge — practical, national, cultural, aesthetic — invested in the image and these can be classified, brought into a typology. It is as though the image presented itself to the reading of several different people who can perfectly well co-exist in a single individual: *the one lexia mobilizes different lexicons*. What is a lexicon? A portion of the symbolic plane (of language) which corresponds to a body of practices and techniques.[11] This is the case for the different readings of the image: each sign corresponds to a body of 'attitudes' — tourism, housekeeping, knowledge of art — certain of which may obviously be lacking in this or that individual. There is a plurality and a co-existence of lexicons in one and the same person, the number and identity of these lexicons forming in some sort a person's *idiolect*.[12] The image, in its connotation, is thus constituted by an architecture of signs drawn from a variable depth of lexicons (of idiolects); each lexicon, no matter how 'deep', still being coded, if, as is thought today, the *psyche* itself is articulated like a language; indeed, the further one 'descends' into the psychic depths of an individual, the more rarified and the more classifiable the signs become — what could be more systematic than the readings of Rorschach tests? The variability of readings, therefore, is no threat to the 'language' of the image if it be admitted that that language is composed of idiolects, lexicons and sub-codes. The image is penetrated through and through by the system of meaning, in exactly the same way as man is articulated to the very depths of his being in distinct languages. The language of the image is not merely the totality of utterances emitted (for example at the level of the combiner of the signs or creator of the message), it is also the totality of

utterances received:[13] the language must include the 'surprises' of meaning.

Another difficulty in analysing connotation is that there is no particular analytical language corresponding to the particularity of its signifieds — how are the signifieds of connotation to be named? For one of them we ventured the term *Italianicity*, but the others can only be designated by words from ordinary language (*culinary preparation, still life, plenty*); the metalanguage which has to take charge of them at the moment of the analysis is not specialized. This is a difficulty, for those signifieds have a particular semantic nature; as a seme of connotation, 'plenty' does not exactly cover 'plenty' in the denoted sense; the signifier of connotation (here the profusion and the condensation of the produce) is like the essential cipher of all possible plenties, of the purest idea of plenty. The denoted word never refers to an essence for it is always caught up in a contingent utterance, a continuous syntagm (that of verbal discourse), oriented towards a certain practical transitivity of language; the seme 'plenty', on the contrary, is a concept in a pure state, cut off from any syntagm, deprived of any context and corresponding to a sort of theatrical state of meaning, or, better (since it is a question of a sign without a syntagm), to an *exposed* meaning. To express these semes of connotation would therefore require a special metalanguage and we are left with barbarisms of the *Italianicity* kind as best being able to account for the signifieds of connotation, the suffix *-icity* deriving an abstract noun from the adjective: *Italianicity* is not Italy, it is the condensed essence of everything that could be Italian, from spaghetti to painting. By accepting to regulate artificially — and if needs be barbarously — the naming of the semes of connotation, the analysis of their form will be rendered easier.[14] These semes are organized in associative fields, in paradigmatic articulations, even perhaps in oppositions, according to certain defined paths or, as A. J. Greimas puts it, according to certain semic axes:[15] *Italianicity* belongs to a certain axis of nationalities, alongside Frenchicity, Germanicity or Spanishicity. The reconstitution of such axes — which may eventually be in opposition to one another — will clearly only be possible once a massive inventory of the systems of connotation has been carried out, an inventory not merely of the connotative system of the image but also of those of other

281

substances, for if connotation has typical signifiers dependent on the different substances utilized (image, language, objects, modes of behaviour) it holds all its signifieds in common: the same signifieds are to be found in the written press, the image or the actor's gestures (which is why semiology can only be conceived in a so to speak total framework). This common domain of the signifieds of connotation is that of *ideology,* which cannot but be single for a given society and history, no matter what signifiers of connotation it may use.

To the general ideology, that is, correspond signifiers of connotation which are specified according to the chosen substance. These signifiers will be called *connotators* and the set of connotators a *rhetoric,* rhetoric thus appearing as the signifying aspect of ideology. Rhetorics inevitably vary by their substance (here articulated sound, there image, gesture or whatever) but not necessarily by their form; it is even probable that there exists a single rhetorical *form,* common for instance to dream, literature and image.[16] Thus the rhetoric of the image (that is to say, the classification of its connotators) is specific to the extent that it is subject to the physical constraints of vision (different, for example, from phonatory constraints) but general to the extent that the 'figures' are never more than formal relations of elements. This rhetoric could only be established on the basis of a quite considerable inventory, but it is possible now to foresee that one will find in it some of the figures formerly identified by the Ancients and the Classics;[17] the tomato, for example, signifies *Italianicity* by metonymy and in another advertisement the sequence of three scenes (coffee in beans, coffee in powder, coffee sipped in the cup) releases a certain logical relationship in the same way as an asyndeton. It is probable indeed that among the metabolas (or figures of the substitution of one signifier for another[18]), it is metonymy which furnishes the image with the greatest number of its connotators, and that among the parataxes (or syntagmatic figures), it is asyndeton which predominates.

The most important thing, however, at least for the moment, is not to inventorize the connotators but to understand that in the total image they constitute *discontinuous* or better still *scattered traits.* The connotators do not fill the whole of the lexia, reading them does not exhaust it. In other words (and this would be a valid proposition for semiology in general), not all the elements of the lexia can be transformed into connotators; there always

remaining in the discourse a certain denotation without which, precisely, the discourse would not be possible. Which brings us back to the second message or denoted image. In the *Panzani* advertisement, the Mediterranean vegetables, the colour, the composition, the very profusion rise up as so many scattered blocks, at once isolated and mounted in a general scene which has its own space and, as was seen, its 'meaning': they are 'set' in a syntagm *which is not theirs and which is that of the denotation*. This last proposition is important for it permits us to found (retroactively) the structural distinction between the second or literal message and the third or symbolic message and to give a more exact description of the naturalizing function of the denotation with respect to the connotation. We can now understand that *it is precisely the syntagm of the denoted message which 'naturalizes' the system of the connoted message*. Or again: connotation is only system, can only be defined in paradigmatic terms; iconic denotation is only syntagm, associates elements without any system: the discontinuous connotators are connected, actualized, 'spoken' through the syntagm of the denotation, the discontinuous world of symbols plunges into the story of the denoted scene as though into a lustral bath of innocence.

It can thus be seen that in the total system of the image the structural functions are polarized: on the one hand there is a sort of paradigmatic condensation at the level of the connotators (that is, broadly speaking, of the symbols), which are strong signs, scattered, 'reified'; on the other a syntagmatic 'flow' at the level of the denotation — it will not be forgotten that the syntagm is always very close to speech, and it is indeed the iconic 'discourse' which naturalizes its symbols. Without wishing to infer too quickly from the image to semiology in general, one can nevertheless venture that the world of total meaning is torn internally (structurally) between the system as culture and the syntagm as nature: the works of mass communications all combine, through diverse and diversely successful dialectics, the fascination of a nature, that of story, diegesis, syntagm, and the intelligibility of a culture, withdrawn into a few discontinuous symbols which men 'decline' in the shelter of their living speech.

1. The *description* of the photograph is given here with prudence, for it already constitutes a metalanguage.

2. By *typical sign* is meant the sign of a system insofar as it is adequately defined by its substance: the verbal sign, the iconic sign, the gestural sign are so many typical signs.

3. In French, the expression *nature morte* refers to the original presence of funereal objects, such as a skull, in certain pictures.

4. 'Naive' analysis is an enumeration of elements, structural description aims to grasp the relation of these elements by virtue of the principle of the solidarity holding between the terms of a structure: if one term changes, so also do the others.

5. Cf. R. Barthes, *Eléments de sémiologie, Communications* 4, 1964, p. 130 [trans. *Elements of Semiology,* London 1967 & New York 1968, pp. 89–92].

6. Menestrier, *L'Art des emblèmes,* 1684.

7. Images without words can certainly be found in certain cartoons, but by way of a paradox; the absence of words always covers an enigmatic intention.

8. *Eléments de sémiologie,* pp. 131–2 [trans. pp. 90–4].

9. This can be seen clearly in the paradoxical case where the image is constructed according to the text and where, consequently, the control would seem to be needless. An advertisement which wants to communicate that in such and such a coffee the aroma is 'locked in' the product in powder form and that it will thus be wholly there when the coffee is used depicts, above this proposition, a tin of coffee with a chain and padlock around it. Here, the linguistic metaphor ('locked in') is taken literally (a well-known poetic device); in fact, however, it is the image which is read first and the text from which the image is constructed becomes in the end the simple choice of one signified among others. The repression is present again in the circular movement as a banalization of the message.

10. Cf. Claude Bremond, 'Le message narratif', *Communications* 4, 1964.

11. Cf. A. J. Greimas, 'Les problèmes de la description mécano-graphique', *Cahiers de Lexicologie,* 1, 1959, p. 63.

12. Cf. *Eléments de sémiologie,* p. 96 [trans. pp. 21–2].

13. In the Saussurian perspective, speech (utterances) is above all that which is emitted, drawn from the language-system (and constituting it in return). It is necessary today to enlarge the notion of language [*langue*], especially from the semantic point of view: language is the 'totalizing abstraction' of the messages emitted *and received.*

14. *Form* in the precise sense given it by Hjelmslev (cf. *Eléments de sémiologie,* p. 105 [trans. pp. 39–41], as the functional organization of the signifieds among themselves.

15. A. J. Greimas, *Cours de Sémantique*, 1964 (notes roneotyped by the Ecole Normale Supérieure de Saint-Cloud).

16. Cf. Emile Benveniste, 'Remarques sur la fonction du language dans la découverte freudienne', *La Psychanalyse* 1, 1956, pp. 3–16 [reprinted in E. Benveniste, *Problèmes de linguistique générale*, Paris 1966, Chapter 7; translated as *Problems of General Linguistics*, Coral Gables, Florida 1971].

17. Classical rhetoric needs to be rethought in structural terms (this is the object of a work in progress); it will then perhaps be possible to establish a general rhetoric or linguistics of the signifiers of connotation, valid for articulated sound, image, gesture, etc. See 'L'ancienne Rhétorique (Aide-mémoire)', *Communications* 16, 1970.

18. We prefer here to evade Jakobson's opposition between metaphor and metonymy for if metonymy by its origin is a figure of contiguity, it nevertheless functions finally as a substitute of the signifier, that is a metaphor.

Hubert Damisch and John Berger

From the beginnings of photography, criticism had concerned it-self above all with what it took to be the unique inherent properties of the medium. Following tendencies in other fields, especially in linguistics and in literary and art criticism, critics have recently put aside the traditional quest for an absolute definition of the photo-graph, and have turned instead to questions of the actual experi-ence of photographs, attempting to locate the differences between photographs and other graphic media in the viewer's response. Structuralism represents one instance of this recent emphasis; phenomenology and Marxism represent others. In these brief es-says by two art critics quite different in their outlooks, we see current philosophical, social, and political interests brought to bear on the act of reading photographs.

A teacher of the history and theory of art at the Ecole Pratique des Hautes Etudes in Paris, Hubert Damisch has written on various topics, including the relation of chess to art. His works include Theorie du nuage *(1972). Born in London in 1926, John Berger is widely known as a critic of art and politics, and as a novelist. His* Ways of Seeing *(1972) emerged from a BBC television series. His interest in photography appears in a number of essays and in his collaboration with the Swiss photographer Jean Mohr in* A Fortu-nate Man *(1967). Other books include* Permanent Red *(1960),* Suc-cess and Failure of Picasso *(1965),* Art and Revolution *(1969), and the novels* G *and* Pig Earth.

Five Notes for a Phenomenology Of the Photographic Image

Hubert Damisch

1. Theoretically speaking, photography is nothing other than a process of recording, a technique of *inscribing*, in an emulsion of silver salts, a stable image generated by a ray of light. This definition, we note, neither assumes the use of a camera, nor does it imply that the image obtained is that of an object or scene from the external world. We know of prints obtained from film directly exposed to a light source. The prime value of this type of

endeavor is to induce a reflection on the nature and function of the photographic image. And insofar as it successfully eliminates one of the basic elements of the very idea of "photography" (the camera obscura, the camera), it produced an experimental equivalent of a phenomenological analysis which purports to grasp the essence of the phenomenon under consideration by submitting that phenomenon to a series of imaginary variations.

2. The reluctance one feels, however, in describing such images as photographs is a revealing indication of the difficulty of reflecting phenomenologically — in the strict sense of an eidetic experience, a reading of essences — on a *cultural* object, on an essence that is historically constituted. Moreover, the full purview of a photographic document clearly involves a certain number of "theses" which, though not of a transcendental order, appear nevertheless as the conditions for apprehending the photographic image as such. To consider a document of this sort like any other image is to claim a bracketing of all knowledge — and even, as we shall see, of all prejudice — as to its genesis and empirical functions. It therefore follows that the photographic situation cannot be defined a priori, the division of its fundamental components from its merely contingent aspects cannot be undertaken in the absolute.

The photographic image does not belong to the natural world. It is a product of human labor, a cultural object whose being — in the phenomenological sense of the term — cannot be dissociated precisely from its historical meaning and from the necessarily datable project in which it originates. Now, this image is characterized by the way in which it presents itself as the result of an objective process. Imprinted by rays of light on a plate or sensitive film, these figures (or better perhaps, these signs?) must appear as the very *trace* of an object or a scene from the real world, the image of which inscribes itself, without direct human intervention, in the gelatinous substance covering the support. Here is the source of the supposition of "reality," which defines the photographic situation. A photograph is this paradoxical image, without thickness or substance (and, in a way, entirely unreal), that we read without disclaiming the notion that it retains something of the reality from which it was somehow released through its physiochemical make-up. This is

the constitutive deception of the photographic image (it being understood that every image, as Sartre has shown, is in essence a deceit). In the case of photography, however, this ontological deception carries with it a *historical* deceit, far more subtle and insidious. And here we return to that object which we got rid of a little too quickly: the black box, the photographic camera.

3. Niepce, the successive adepts of the Daguerreotype, and those innumerable inventors who made photography what it is today, were not actually concerned to create a new type of image or to determine novel modes of representation; they wanted, rather, to fix the images which "spontaneously" formed on the ground of the camera obscura. The adventure of photography begins with man's first attempts to retain that image he had long known how to make. (Beginning in the 11th century, Arab astronomers probably used the camera obscura to observe solar eclipses.) This long familiarity with an image so produced, and the completely objective, that is to say automatic or in any case strictly mechanical, appearance of the recording process, explains how the photographic representation generally appeared as *a matter of course,* and why one ignores its highly elaborated, arbitrary character. In discussions of the invention of film, the history of photography is most frequently presented as that of a *discovery.* One forgets, in the process, that the image the first photographers were hoping to seize, and the very *latent image* which they were able to reveal and develop, were in no sense naturally given; the principles of construction of the photographic camera — and of the camera obscura before it — were tied to a conventional notion of space and of objectivity whose development preceded the invention of photography, and to which the great majority of photographers only conformed. The lens itself, which had been carefully corrected for "distortions" and adjusted for "errors," is scarcely as objective[1] as it seems. In its structure and in the ordered image of the world it achieves, it complies with an especially familiar though very old and delapidated system of spatial construction, to which photography belatedly brought an unexpected revival of current interest.

(Would the art, or rather the craft, of photography not consist partly in allowing us to forget that the black box is not "neutral" and that its structure is not impartial?)

4. The retention of the image, its development and multiplication, form an ordered succession of steps which composed the photographic act, taken as a whole. History determined, however, that this act would find its goal in reproduction, much the way the point of film as spectacle was established from the start. (We know that the first inventors worked to fix images and simultaneously to develop techniques for their mass distribution, which is why the process perfected by Daguerre was doomed from the very outset, since it could provide nothing but a *unique* image). So that photography's contribution, to use the terms of classical economy, is less on the level of *production*, properly speaking, than on that of *consumption*. Photography creates nothing of "use" (aside from its marginal and primarily scientific applications); it rather lays down the premises of an unbridled destruction of utility. Photographic activity, even though it generally takes the form of craft, is nonetheless, in principle, industrial; and this implies that of all images the photographic one — leaving aside its documentary character — wears out the most quickly. But it is important to note that even when it gives us, through the channels of publishing, advertising, and the press, only those images which are already half consumed, or so to speak, "predigested," this industry fulfills the initial photographic project: the capturing and restoration of an image already worn beyond repair, but still, through its physical nature, unsuited to mass consumption.

5. Photography aspires to art each time, in practice, it calls into question its essence and its historical roles, each time it uncovers the contingent character of these things, soliciting in us the producer rather than the consumer of images. (It is no accident that the most *beautiful* photograph so far achieved is possibly the first image Nicéphore Niepce fixed in 1822, on the glass of the camera obscura — a fragile, threatened image, so close in its organization, its granular texture, and its emergent aspect, to certain Seurats — an incomparable image which makes one dream of a photographic *substance* distinct from subject matter, and of an art in which light creates its own metaphor.)

1. The play here is on the French word for lens: *objectif.* — ed.

Understanding a Photograph

John Berger

For over a century, photographers and their apologists have argued that photography deserves to be considered a fine art. It is hard to know how far the apologetics have succeeded. Certainly the vast majority of people do not consider photography an art, even whilst they practise, enjoy, use and value it. The argument of apologists (and I myself have been among them) has been a little academic.

It now seems clear that photography deserves to be considered as though it were *not* a fine art. It looks as though photography (whatever kind of activity it may be) is going to outlive painting and sculpture as we have thought of them since the Renaissance. It now seems fortunate that few museums have had sufficient initiative to open photographic departments, for it means that few photographs have been preserved in sacred isolation, it means that the public have not come to think of any photographs as being *beyond* them. (Museums function like homes of the nobility to which the public at certain hours are admitted as visitors. The class nature of the 'nobility' may vary, but as soon as a work is placed in a museum it acquires the *mystery* of a way of life which excludes the mass.)

Let me be clear. Painting and sculpture as we know them are not dying of any stylistic disease, of anything diagnosed by the professionally horrified as cultural decadence; they are dying because, in the world as it is, no work of art can survive and not become a valuable property. And this implies the death of painting and sculpture because property, as once it was not, is now inevitably opposed to all other values. People believe in property, but in essence they only believe in the illusion of protection which property gives. All works of fine art, whatever their content, whatever the sensibility of an individual spectator, must now be reckoned as no more than props for the confidence of the world spirit of conservatism.

By their nature, photographs have little or no property value because they have no rarity value. The very principle of photography is that the resulting image is not unique, but on the contrary infinitely reproducible. Thus, in twentieth-century terms, photographs are records of things seen. Let us consider them no

closer to works of art than cardiograms. We shall then be freer of illusions. Our mistake has been to categorize things as art by considering certain phases of the process of creation. But logically this can make all man-made objects art. It is more useful to categorize art by what has become its social function. It functions as property. Accordingly, photographs are mostly outside the category.

Photographs bear witness to a human choice being exercised in a given situation. A photograph is a result of the photographer's decision that it is worth recording that this particular event or this particular object has been seen. If everything that existed were continually being photographed, every photograph would become meaningless. A photograph celebrates neither the event itself nor the faculty of sight in itself. A photograph is already a message about the event it records. The urgency of this message is not entirely dependent on the urgency of the event, but neither can it be entirely independent from it. At its simplest, the message, decoded, means: *I have decided that seeing this is worth recording*.

This is equally true of very memorable photographs and the most banal snapshots. What distinguishes the one from the other is the degree to which the photograph explains the message, the degree to which the photograph makes the photographer's decision transparent and comprehensible. Thus we come to the little-understood paradox of the photograph. The photograph is an automatic record through the mediation of light of a given event: yet it uses the *given* event to *explain* its recording. Photography is the process of rendering observation self-conscious.

We must rid ourselves of a confusion brought about by continually comparing photography with the fine arts. Every handbook on photography talks about composition. The good photograph is the well-composed one. Yet this is true only in so far as we think of photographic images imitating painted ones. Painting is an art of arrangement: therefore it is reasonable to demand that there is some kind of order in what is arranged. Every relation between forms in a painting is to some degree adaptable to the painter's purpose. This is not the case with photography. (Unless we include those absurd studio works in which the photographer arranges every detail of his subject before he takes the picture.) Composition in the profound, formative sense of the word cannot enter into photography.

292

The formal arrangement of a photograph explains nothing. The events portrayed are in themselves mysterious or explicable according to the spectator's knowledge of them prior to his seeing the photograph. What then gives the photograph as photograph meaning? What makes its minimal message—*I have decided that seeing this is worth recording*—large and vibrant?

The true content of a photograph is invisible, for it derives from a play, not with form, but with time. One might argue that photography is as close to music as to painting. I have said that a photograph bears witness to a human choice being exercised. This choice is not between photographing x and y: but between photographing at x moment or at y moment. The objects recorded in any photograph (from the most effective to the most commonplace) carry approximately the same weight, the same conviction. What varies is the intensity with which we are made aware of the poles of absence and presence. Between these two poles photography finds its proper meaning. (The most popular use of the photograph is as a memento of the absent.)

A photograph, whilst recording what has been seen, always and by its nature refers to what is not seen. It isolates, preserves and presents a moment taken from a continuum. The power of a painting depends upon its internal references. Its reference to the natural world beyond the limits of the painted surface is never direct; it deals in equivalents. Or, to put it another way: painting interprets the world, translating it into its own language. But photography has no language of its own. One learns to read photographs as one learns to read footprints or cardiograms. The language in which photography deals is the language of events. All its references are external to itself. Hence the continuum.

A movie director can manipulate time as a painter can manipulate the confluence of the events he depicts. Not so the still photographer. The only decision he can take is as regards the moment he chooses to isolate. Yet this apparent limitation gives the photograph its unique power. *What it shows invokes what is not shown.* One can look at any photograph to appreciate the truth of this. The immediate relation between what is present and what is absent is particular to each photograph: it may be that of ice to sun, of grief to a tragedy, of a smile to a pleasure, of a body to love, of a winning race-horse to the race it has run.

A photograph is effective when the chosen moment which it records contains a quantum of truth which is generally applica-

ble, which is as revealing about what is absent from the photograph as about what is present in it. The nature of this quantum of truth, and the ways in which it can be discerned, vary greatly. It may be found in an expression, an action, a juxtaposition, a visual ambiguity, a configuration. Nor can this truth ever be independent of the spectator. For the man with a Polyfoto of his girl in his pocket, the quantum of truth in an 'impersonal' photograph must still depend upon the general categories already in the spectator's mind.

All this may seem close to the old principle of art transforming the particular into the universal. But photography does not deal in constructs. There is no transforming in photography. There is only decision, only focus. The minimal message of a photograph may be less simple than we first thought. Instead of it being: *I have decided that seeing this is worth recording,* we may now decode it as: *The degree to which I believe this is worth looking at can be judged by all that I am willingly not showing because it is contained within it.*

Why complicate in this way an experience which we have many times every day—the experience of looking at a photograph? Because the simplicity with which we usually treat the experience is wasteful and confusing. We think of photographs as works of art, as evidence of a particular truth, as likenesses, as news items. Every photograph is in fact a means of testing, confirming and constructing a total view of reality. Hence the crucial role of photography in ideological struggle. Hence the necessity of our understanding a weapon which we can use and which can be used against us.

Sources

Abbott, Berenice. "Photography at the Crossroads." *Universal Photo Almanac*, pp. 42–47. Falk Publishing Co. (New York): 1951.

Arago, Dominique François. "Report." In *History of Photography*, by Josef Maria Eder, pp. 233–41. E. Epstean, trans. Columbia University Press: 1945, 1972.

Barthes, Roland. "Rhetoric of the Image," *Image, Music, Text*, pp. 32–52. Farrar, Straus and Giroux: 1977.

Baudelaire, Charles. "The Modern Public and Photography." In *Art in Paris 1845–1862*. Jonathan Mayne, trans. Phaidon Press, Ltd. (London): 1965. First appeared in *Le Boulevard* (Sept. 14, 1862).

Bazin, André. "The Ontology of the Photographic Image." *What Is Cinema?* Hugh Gray, trans. University of California Press: 1967.

Benjamin, Walter. "A Short History of Photography." *Literarische Welt* 1931. Reprinted from *Artforum* (Feb. 1977), vol. 15. Phil Patton, trans.

Berger, John. "Understanding a Photograph." *The Look of Things*. Viking Press: 1974.

Daguerre, Jacques Louis Mandé. "Daguerreotype." In *L.M.J. Daguerre: The History of the Diorama and the Daguerreotype*, by Helmut and Alison Gernsheim. Martin Secker and Warburg. London: 1956.

Damisch, Hubert. "Five Notes for a Phenomenology of the Photographic Image." *October 5, Photography: A Special Issue* (Summer 1978). First published in *L'Arc* (Paris, 1963).

De Zayas, Marius. "Photography." *Camera Work* (1913), no. 41.

———. "Photography and Artistic-Photography." *Camera Work* (1913), no. 42/43.

Eastlake, Lady Elizabeth. "Photography." *London Quarterly Review* (1857), pp. 442–68.

Emerson, Peter Henry. "Hints on Art." *Naturalistic Photography for Students of the Art*, chap. 4. London: 1889.

Evans, Walker. "The Reappearance of Photography." *Hound and Horn* (Oct.-Dec. 1931), vol. 5.

Hine, Lewis. "Social Photography, How the Camera May Help in the Social Uplift." *Proceedings, National Conference of Charities and Corrections* (June 1909).

Holmes, Oliver Wendell. "The Stereoscope and the Stereograph." *Atlantic Monthly* (1859), pp. 124–281. Excerpted.

"Is Photography a New Art?" *Camera Work* (1908), no. 21.

Ivins, William M., Jr. "New Reports and New Vision: The Nineteenth Century." *Prints and Visual Communication,* chap. 7. MIT Press unabridged republication of the first edition published in 1953 by Routledge and Kegan Paul.

Kracauer, Siegfried. "Photography." *Theory of Film: The Redemption of Physical Reality,* chap. 1. Oxford University Press: 1960. Originally published under title *Nature of Film* by Dobson Books, London.

Moholy-Nagy, Laszlo. "Photography." *Painting, Photography, Film.* Janet Seligman, trans. Lund Humphries Publishers: 1969.

Niepce, Joseph Nicéphore. "Memoire on the Heliograph." A supplement to Daguerre's *Historique et description des procédés du daguerréotype et du diorama* (Paris 1839). In *History of Photography,* by Josef Maria Eder, pp. 218–23. E. Epstean, trans. Columbia University Press: 1945, 1972.

Poe, Edgar Allan. "The Daguerreotype." *Alexander's Weekly Messenger* (Jan. 15, 1840), p. 2.

Ray, Man. "The Age of Light." In *Man Ray Photographs 1920–1934, Paris,* ed. James T. Soby. East River Press: 1934.

Robinson, Henry Peach. "Idealism, Realism, Expressionism." *The Elements of a Pictorial Photograph,* chap. 9. London: 1896.

Roh, Franz. "Mechanism and Expression, the Essence and Value of Photography." In *Photo-Eye, 96 Photos of the Period,* ed. Franz Roh and Jan Tschichold, pp. 14–18. Akademischer verlag dr. wedekind (Stuttgart): 1929.

Stieglitz, Alfred. "Pictorial Photography." *Scribner's Magazine* (Nov. 1899), pp. 528–36.

Strand, Paul. "Photography." *Seven Arts* (Aug. 1917), pp. 524–26.

———. "Photography and the New God." *Broom,* vol. 3(4). 1922.

Talbot, William Henry Fox. "A Brief Historical Sketch of the Invention of the Art." Introduction to *The Pencil of Nature*. London: 1844–46.

Valéry, Paul. "The Centenary of Photography." *Occaisions,* pp. 158–67. Roger Shattuck and Frederick Brown, trans. In *The Collected Works in English of Paul Valéry,* of which *Occaisions* is vol. 11. Princeton University Press: 1970. Originally "Centenaire de la Photographie," à la Sorbonne, le 7 janvier 1939, Discours de M. Paul Valéry, deligue de l'Academie Française, Paris. Firmin-Didot, Imprimeurs de l'Institut de France, 1939.

Weston, Edward. "Seeing Photographically," *Encyclopedia of Photography,* vol. 18. Greystone Press (New York): 1965.

Further Readings

Rudolph Arnheim. "On the Nature of Photography." *Critical Inquiry* (Sept. 1974), pp. 149–61.

Jonathan Bayer, ed. *Reading Photographs: Understanding the Aesthetics of Photography.* New York: 1977.

Howard Becker. "Photography and Sociology." *Afterimage* (May-June 1975), pp. 22–32.

Michel F. Braive. *The Era of the Photograph: A Social History.* London: 1966.

Charles H. Caffin. *Photography as a Fine Art.* New York: 1901.

Victor Burgin. "Photographic Practice and Art Theory." *Studio International* (July-August 1975), pp. 39–51.

———. "Looking at Photographs." *Tracks* (Fall 1977), pp. 36–44.

Paul Byers. "Cameras Don't Take Pictures." *Afterimage* (April 1977), pp. 8–11.

A. D. Coleman. *Light Readings: A Photography Critic's Writings, 1968–1978.* New York: 1979.

Robert Doty. *Photo-Secession: Photography as a Fine Art.* Rochester: 1960.

Helmut Gernsheim. *Creative Photography: Aesthetic Trends 1839 to Modern Times.* New York: 1962.

Sadakichi Hartmann. *The Valiant Knights of Daguerre.* Berkeley: 1978.

Volker Kahmen. *Art History of Photography.* New York: 1974.

Max Kosloff. *Photography and Fascination.* Danbury, New Hampshire: 1979.

Nathan Lyons, ed. *Photographers on Phŏ ography.* Englewood Cliffs, New Jersey: 1966.

Beaumont Newhall. *The History of Photography, from 1839 to the Present Day.* New York: 1964.

Aaron Scharf. *Art and Photography.* Baltimore: 1969.

Leroy Searle. "Poems, Pictures and Conceptions of 'Language.'" *Afterimage* (May-June 1975), pp. 33–39.

Allan Sekula. "The Invention of Photographic Meaning." *Artforum* (Jan. 1975), pp. 27–45.

Joel Snyder and Neil Walsh Allen. "Photography, Vision, and Representation." *Critical Inquiry* (Autumn 1975), pp. 143–69.

Susan Sontag. *On Photography*. New York: 1977.

John Szarkowski. *The Photographer's Eye*. New York: 1966.

_____. *Looking at Photographs*. New York: 1973.

Van Deren Coke. *The Painter and the Photograph*. Albuquerque: 1972.

_____, ed. *One Hundred Years of Photographic History: Essays in Honor of Beaumont Newhall*. Albuquerque: 1975.

John L. Ward. *The Criticism of Photography as Art: The Photographs of Jerry Uelsmann*. Gainsville, Florida: 1970.

"Photography," *Massachusetts Review* (Winter 1978) includes essays by Wright Morris, Bill Jay, August Sander, Estelle Jussim, Elizabeth Lindquist-Cock, Roger Copeland, Carl Chiarenza, Alan Trachtenberg, Allan Sekula.

"Photography: A Special Issue," *October 5* (Summer 1978) includes essays by Rosalind Krauss, Hollis Frampton, Craig Owens, Douglas Crimp, Jean Clair, Thierry de Duve.